# The
# Advent
# of
# Modernism

High Museum of Art
Atlanta, Georgia

Center for the Fine Arts
Miami, Florida

The Brooklyn Museum
Brooklyn, New York

Glenbow Museum
Calgary, Alberta, Canada

*Bright Rocks* by David Milne (page 130) is reproduced under license of The David Milne Estate © 1986.

Cover: Maurice Prendergast, *Picnic*, detail (see page 146)

Published by the High Museum of Art, Atlanta, Georgia

Edited by Kelly Morris, assisted by Susan V. Davis and Amanda Woods. Designed by Jim Zambounis, Atlanta. Type set by Katherine Gunn, Williams Printing Company, Atlanta. Printed by Balding + Mansell, Wisbech, England.

Library of Congress Catalogue No. 85-82270
ISBN 0-939802-24-4

# The Advent of Modernism

## Post-Impressionism and North American Art, 1900-1918

Essays by Peter Morrin, Judith Zilczer, and William C. Agee

## High Museum of Art, Atlanta

This exhibition and catalogue have been made possible by a grant from the IBM Corporation.

# Lenders to the Exhibition

Addison Gallery of American Art, Phillips Academy
Anonymous
Archives of American Art, Smithsonian Institution
Art Gallery of Ontario
Babcock Galleries
Mr. and Mrs. Carl M. Beren
The Blount Collection
Boston Public Library, Print Department
Maurice Corbeil Collection
Colby College Museum of Art
Columbia University
Columbus Museum of Art, Ohio
Corcoran Gallery of Art
David David Gallery
Sid Deutsch Gallery
Terry Dintenfass, Inc.
Forum Gallery
Georgia Museum of Art, The University of Georgia
Mr. and Mrs. Elliott Goldstein
Dr. and Mrs. Wesley Halpert
John Davis Hatch
High Museum of Art
Hirshhorn Museum and Sculpture Garden, Smithsonian Institution
Hood Museum of Art, Dartmouth College
Mrs. Glenn C. Janss
Jordan-Volpe Gallery, Inc.
Kennedy Galleries
Mrs. M. H. Knox
Lehigh University Art Galleries
London Collection
Holly and Arthur Magill Collection
Barbara Mathes Gallery
Bernice and Edwin Mazo
The McMichael Canadian Collection
Mead Art Museum, Amherst College
Milne Family Collection
The Mint Museum of Art
Montclair Art Museum
Montreal Museum of Fine Arts
Munson-Williams-Proctor Institute
Musée du Québec
Museum of Art, Carnegie Institute
National Gallery of Canada
National Museum of American Art, Smithsonian Institution
Neuberger Museum, State University of New York at Purchase

# Acknowledgements

We wish to acknowledge the generous assistance of those individuals who offered their assistance, advice, and expertise. Our gratitude is extended to members of the artists' families: Earl Davis, William Dove, Brenda Kuhn, and Emily A. Nordfeldt; collectors, scholars, and colleagues at other galleries and institutions: Claudia Esko, Liza Kirwin, and Colleen Hennessey (Archives of American Art), Elnora Kennedy (Arnot Art Museum), Trevor Fairbrother (Museum of Fine Arts, Boston), Yves Pepin (Department of External Affairs, Government of Canada), Jeffrey E. Smith (Canadian Consulate of Atlanta), William Scheele (Cleveland Artists Foundation), Hugh J. Gorley, III (Colby College Museum of Art), Jean Robertson and Steven W. Rosen (Columbus Museum of Art), Cecily Langdale (Davis and Langdale Gallery), William Homer (University of Delaware), Katherine Bennett, Kathleen Brewin, Julia Emmons, Dorinda Evans, Bill Holding, and Brett Miller (Emory University), Martha R. Severens (Gibbes Art Gallery), James Keny (Keny and Johnson Gallery), Paul Kruty (Princeton University), John Baker (Massachusetts College of Art), Thomas Glenn (McGill University), Ian Thom (Curator of Collections, The McMichael Canadian Collection), Micheline Moisan and Alexander Gaudieri (Montreal Museum of Fine Arts), William Gerdts (City University of New York), Bruce Weber (Norton Gallery and School of Art), Francis Broun, Christine Boyanosky, and Dennis Reid (Art Gallery of Ontario), Denise LeClerc and Jeremy Adamson (National Gallery of Ottawa), Jean Trudel (Musée du Québec), Anne Lower (Southern Methodist University), Eric Zafran (Walters Art Gallery), Carol Nathanson (Wright State University), Henry Dulaurence, Sally Gross, and Ron Pisano. Guy Dawson of the printers Balding + Mansell and designer Jim Zambounis went beyond the call of duty.

Staff members at the High Museum of Art have borne the brunt of this project, especially curatorial assistants Rhetta Kilpatrick, Kate McClintock, and Liz Lane; editors Kelly Morris, Susan Davis, and Amanda Woods; registrars Marjorie Harvey, Frances Francis, and Alice Nightingale; educators Paula Hancock, Ellen Dugan, and Patricia Phagan. The offices of Communications, Development, and Art Handling have also had principal roles in the evolution of this exhibition. The director of the High Museum of Art, Gudmund Vigtel, has been extremely supportive of this project from the beginning. We wish to echo his expression of gratitude to the IBM Corporation and the Government of Canada.

W.C.A.
P.M.
J.Z.

# Preface

It seems remarkable that this exhibition, which contains so much new visual information, has only now been realized. There is a tendency to regard early 20th century art as an overworked field, but it's a testament to the fertility of that period that an extraordinary amount of art of the highest quality remains to be discovered. A full-scale, international survey of Cézannesque and Matissean paintings has not yet been essayed, but this exhibition at least makes a first attempt at documenting the North American responses to Post-Impressionist innovations.

This project is one in which I have taken a strong personal interest: as a youth I studied with Isaac Grünewald, one of the Scandanavian artists who studied at the Académie Matisse. At the Corcoran Gallery of Art in 1963, I organized an exhibition of early American abstract artists, all of whom are included in this exhibition. Only recently, however, have critical viewpoints sufficiently altered so that the earlier accomplishments in color painting may be seen on their own merits, and not as a minor part of a determinist evolution in which abstraction was an endpoint.

This exhibition was conceived by Peter Morrin, the High Museum's Curator of 20th Century Art. However, it could not have been realized without the guidance and scholarly input of William C. Agee and Judith Zilczer. I am grateful to the directors of the other museums participating in the tour of *The Advent of Modernism*: Robert H. Frankel of the Miami Center for the Fine Arts; Robert T. Buck of the Brooklyn Museum; and Duncan E. Cameron of the Glenbow Museum. The many museums and collectors who have lent to the exhibition and the scholars who contributed the fruits of their researches are acknowledged elsewhere, but I wish to add my grateful thanks for their assistance. The Government of Canada has aided this enterprise with travel and shipping funds. Our greatest debt of gratitude is to the IBM Corporation, whose generous encouragement and substantial material support has made this exhibition possible.

Gudmund Vigtel
*Director*

# Foreword

From the turn of the century until the end of World War I, American and Canadian artists pursued new stylistic directions in response to the chromatic and formal innovations of the European Post-Impressionists, principally Paul Cézanne, Vincent van Gogh, Paul Gauguin, Georges Seurat, and Henri Matisse. These diverse modern masters provided a model of artistic freedom for the North Americans. In the words of the British critic C. J. Holmes, "The tradition of Post-Impressionism . . . if any principles so youthful can be called a tradition, is the expression of personal vision."[1]

The definition of Post-Impressionism adopted in this exhibition is derived from the art criticism of Roger Fry, who invented the term:

> There comes a point when the accumulation of an increasing skill in the mere representation begins to destroy the expressiveness of the design, and then though a large section of his public continues to applaud, the artist becomes uneasy. He begins to try to unload, to simplify the drawing or painting by which natural objects are evoked, in order to recover the lost expressiveness and life. He aims at synthesis in design . . . he is prepared to subordinate consciously his power of representing the parts of his picture as plausibly as possible, to the expressiveness of the whole design.[2]

Many of the artists in this exhibition called themselves Post-Impressionists.

It is the purpose of this exhibition to demonstrate that Post-Impressionism constituted the initial phase of modern art in North America. American Impressionism, Tonalism, Symbolism, and concurrent academic styles in the late nineteenth century have been the subjects of major exhibitions. Similarly, the rise of the American avant-garde in the early twentieth century has been rigorously reexamined in recent scholarship. However, investigations of the origins of abstract painting, New York Dada, American Cubism, Synchromism, and the like have overshadowed scholarly study of the primary stage of North American modernism—Post-Impressionism.

Although a number of the artists included in this exhibition have been the subjects of monographs and retrospective exhibitions, a comparative selection of Cézannesque, neo-Impressionist, and Fauve paintings by these North American modernists has never been attempted. Furthermore, there have been few museum exhibitions devoted to the comparison of American and Canadian achievements in the Post-Impressionist vein.[3] The interaction between American and Canadian artists has been largely overlooked, and the high quality of Canadian Post-Impressionist painting remains unrecognized in the United States.

The historical neglect of North American Post-Impressionism has resulted, in part, from a failure to reconcile the chronological disparity between the genesis of modernism in Europe and North America. According to the standard histories, European Post-Impressionism not

only encompassed a range of stylistic reactions to French Impressionism, but the term also defined a distinct chronological period from the dissolution of Impressionism in 1886 to the birth of Cubism in 1906/1907.[4] In stylistic terms, North America did not produce Post-Impressionist painting until the end of the Post-Impressionist era in Europe. Consequently, North American Post-Impressionism, if recognized at all, has been dismissed as *retardaire*.

Although European Post-Impressionism came first, it is important to remember that the concept of "Post-Impressionism" arose *after* the supposed demise of the movement in Europe. Fry coined the term in 1910 to describe the full stylistic range of modern painting produced after Impressionism. North American Post-Impressionism evolved contemporaneously with Fry's efforts in Great Britain. To the extent that the Americans and Canadians responded to the example of Matisse and the Fauves, the chronological disparity between the Europeans and the North Americans is diminished.

For the purpose of this exhibition, we have excluded Symbolism and Art Nouveau from our definition of Post-Impressionism. Although both stylistic phenomena are considered integral to European Post-Impressionism, there are sound historical reasons for their exclusion from the North American Post-Impressionist movement. It is a paradox of history that while a full generation separates the advent of European from American Post-Impressionism—Symbolism and Art Nouveau evolved simultaneously on both sides of the Atlantic. Thus, in North America, Symbolism preceded the arrival of full color painting, synthetism, and Cézannesque formal structure. In the United States, then, Symbolism was more closely allied to late Romanticism than to Post-Impressionism.

In order to demonstrate the high quality of North American Post-Impressionism, we have selected 135 works by 54 of the most representative American and Canadian artists between 1900 and 1918. Included in the group are painters such as Maurice Prendergast and James Wilson Morrice, for whom Post-Impressionism marked the achievement of a mature, signature style. For many other artists— from Patrick Henry Bruce to William Zorach—Post-Impressionism provided an introduction to the principles of modern art. Although the Post-Impressionist paintings of Arthur Carles, Stuart Davis, Arthur Dove, and a number of other modernists have been dismissed as juvenilia or transitional works, their chromatic and formal power represent significant achievements of lasting value. Lesser-known painters such as Henry McCarter, Ben Benn, E. Ambrose Webster, and Middleton Manigault are presented here in context with their more famous contemporaries. No doubt there are still other accomplished painters of this period who might have been added. Given the inherent limitations of such an enterprise, we believe that the present

selection reflects the high quality and cohesive style of an overlooked body of painting. North American Post-Impressionism provided a foundation for the subsequent evolution of modern art in the United States and Canada. Although the manifestations of North American Post-Impressionism were diffuse, it may be characterized and described as a stylistic movement.

William C. Agee
Peter Morrin
Judith Zilczer

## Notes

[1] C. J. Holmes, *Notes on the Post Impressionist Painters: Grafton Galleries, 1910-1911* (London: Philip Lee Warner, 1910), p. 11.

[2] From Desmond McCarthy and Rober Fry's preface to *Manet and Post-Impressionism*, London, 1910, quoted in Alfred H. Barr, *Matisse: His Art and His Public* (Museum of Modern Art, New York, 1951), p. 111.

[3] William Homer, Katherine Lochridge, and Marcia Allentuck, *Seven/Eight*, a comparative exhibition of the Canadian Group of Seven and the American Painters, The Eight (Huntington, NY: Hecksher Museum, 1972).

[4] John Rewald established the classic definition of Post-Impressionism as a chronological period in *Post-Impressionism from Van Gogh to Gauguin* (New York: The Museum of Modern Art, 2nd ed., 1962). See also Alan Bowness, "Introduction" to *Post-Impressionism: Cross-Currents in European and American Painting, 1880-1906* (Washington, D.C.: National Gallery of Art, 1980), pp. 11-12.

# An Overview: Post-Impressionism and North American Art

PETER MORRIN

The revolution which Post-Impressionism brought to North American artists was the possibility of thoroughly rejecting academic methods for an art of spontaneity, pure color, simplified forms, and coherent structure. The transformation was from art as a mode of description to art as a mode of experience. Although Impressionism and "The Eight" initiated the rupture with the nineteenth century genteel values of truth, beauty, and morality,[1] it is in Post-Impressionism that North American painting most emphatically declares its independence from established standards and traditions. This exhibition is a first survey of the common threads in American and Canadian reactions to French developments in the late nineteenth and early twentieth centuries; a definitive art history of these events is not as yet possible. Indicating some of the factors which contributed to these manifestations, however, may suggest the complexity of the circumstances which set these developments into motion.

In an earlier exhibition devoted to the broadest international records of Post-Impressionism, Wanda Corn and John Wilmerding proposed that the term does not fully apply to American art until after the formation of the Stieglitz Circle. They point out that it is not until the mid-1880s that the history of Impressionism begins for America, when artists started to gather around Monet at Giverny, and when Durand-Ruel organized the first major Impressionist exhibition in New York in 1886.[2] By this time the revisions of Impressionism which began in France around 1880 were already well established.

While chronology is a problem, a greater hindrance to the recognition of the impact of Post-Impressionism in America has been the clouding issue of interpretation, even allowing for the ill fit of European terminology to American art movements. Impressionism has frequently been used as a catch-all term for any late nineteenth or early twentieth century artist working in luminous, broken colors. To describe Lawson, Morrice, Prendergast, or Hassam after 1900 as Impressionists is to overlook the synthetic nature of their art, its emphasis on paint surface and decorative qualities. On the other end of the time frame, the determinist view that saw abstraction as an endpoint of a logical progression has led to a slighting of earlier divergent work. The acknowledgement of Post-Impressionism as a distinct factor in early twentieth century art history has been further obscured by a bewildering variety of virtually simultaneous styles. It is symptomatic of the disparate character of this era that Ernest Flagg's florid beaux-arts Singer Tower in New York and Frank Lloyd Wright's spare Coonley House in Riverside, Illinois, were both completed in 1908.

The diffuse character of Post-Impressionism in North America is not surprising when one considers that its base was in Paris, and although it had early adherents in Philadelphia, New York, Boston, and Chicago, it lacked a central focus, event, or charismatic leader. Robert Henri and the Ashcan School overshadowed Post-Impressionist developments precisely because no modernist figure had the stature of Henri. Maurice Prendergast in the United States and James Wilson Morrice in Canada would have been the logical candidates by age and talent, but neither was a leader. Although Prendergast before 1914 had more of a coterie in Boston than is generally acknowledged, he was shy and retiring. Morrice, an expatriate, could not provide leadership in his occasional visits to Canada, and his bon vivant way of life discouraged the adherence of students.[3]

The absence of recognizably American subject matter may also have hampered earlier recognition of American Post-Impressionism. Because the style received its initial expression among expatriates, the truth and life of America, in Henri's terms, was secondary to a self-consciousness of *style* (as opposed to *technique*) and a departure from the rule of appearance. American iconography comes more fully into the art of many of the artists in this exhibition when they engage Cubist or Futurist styles, as in the case of Weber's cityscapes, Marin's skyscrapers, or Stella's Brooklyn Bridge. Post-Impressionism brimmed with bright optimism for the new century, but generally eschewed such local genre as Lower East Side waifs for more meditative subject matter. Lee Simonson commented on the inhibitions of the "liberated" American painters in Paris from 1905 to 1914:

> Despite the acknowledged unimportance of subject matter, there seemed to be a surprisingly limited number of objects which, if painted, could be counted on to produce art – apples and oranges, a few varieties of green pears, and bananas; furniture, simple wooden chairs and tables, preferably unvarnished; houses, not too broken up with fenestration, preferably the large expanses of stucco surfaces to be found in the villages of southern France and northern Italy; landscapes – low mountains and hills rather than flat plains, not too solidly wooded and showing rocky ledges or escarpments at their summits. Water might be added at discretion provided it was not too agitated, near long quais or harbor fronts; human beings – when not in violent motion, preferably doing nothing in particular, the traditional académie, or coming from an open-air bath, the white towel replacing the obligatory white tablecloth.[4]

The situation in Canadian painting was very different. Canadian art early in the century was less diverse stylistically: involvement with Cubism came very late – not until the 1930s in fact – and full-color styles in the early twentieth century are acknowledged as the beginnings of modernism in Canada. Furthermore, Canadian painting fulfilled patriotic feelings in an era of pan-nationalism, unlike the American Cézannesque and Matissean painters, who at first strove to

14

master an international visual vocabulary.

Among the Canadians who were to constitute the Group of Seven, the nationalist impulse may have intervened in their modernism, as they attempted to convey the grandeur of the Canadian landscape and the romantic isolation of man in the Northlands. Within the time frame of this exhibition, these painters seldom employed simultaneous contrast of colors, they retained an interest in perspectival devices, and they heightened natural colors rather than distorting them. That resilient relationship between paint layer and support, a hallmark of art inspired by Fauvism, does not obtain in their work. On the other hand, their interest in a thickly impastoed surface, a rhythmic application of brushstrokes, startling color, and boldly simplified description amply justifies describing their art as Post-Impressionist – as indeed it was described when first exhibited.[5]

For the Group of Seven, as for many other art colonies and artists' groups, from Nagybanya and Worpswede to Pont Aven and Old Lyme, *plein air* painting brought the possibility of communing with the uncorrupted native land and celebrating in fellowship the unique beauty of the fatherland.[6] The landscape as a vehicle for the expression of subjective feelings played an increasing role in art colonies in the twentieth century and contributed to the international growth of a Post-Impressionist sensibility.

Landscape had a further role in Post-Impressionism, in the attraction to exotic climates. Morrice, who once wrote in a notebook "un paysage est un état d'âme," is also reputed to have said, "A painter should go south; it cleans your palette for you."[7] While Morrice's 1911 and 1912 trips to Tangiers in the company of Matisse and Marquet are the most notable of these excursions, destinations in southern France, North Africa, the Caribbean, Asia, and the American Southwest play a part in the art lives of an inordinate number of artists of this generation. Quite apart from its French models, Post-Impressionism had an impetus in the heightened colors of nature seen under brilliant conditions.

That landscape should evolve naturally in America as a means of emotional expression is not surprising when one considers that Impressionism and Post-Impressionism arrived in North America simultaneously, and that Post-Impressionism was a subcurrent in the history of American Impressionism from the beginning. At the première show of Impressionism in North America, the 1886 Durand-Ruel exhibition at the National Academy of Design, both Seurat (three major paintings and twelve studies) and Signac were represented.[8] Seurat received favorable mention from the critic of *The Art Amateur*, who noted his qualities in common with early Italian frescoes.[9] Theodore Robinson, writing in 1892, felt sufficiently apprehensive about Pointillism to warn his readers against "the men of small talent ...notably the genius who invented the fly-speck or dot facture."[10]

Six months earlier, Cecilia Waern, in a perceptive survey of Impressionism for the *Atlantic Monthly*, had enthusiastically described work by Cézanne, Gauguin, Signac, Seurat, and Dubois-Pillet. Waern reserved her most vivid prose for van Gogh:

> One man in particular has the faculty of inflaming your imagination, till you feel ready to declare him one of the bringers of heavenly fire. And yet his art is mad. Your first impulse is to laugh at these staggering cottages with flowing red roofs, or at this blaze of rockets and Catharine-Wheels supposed to represent night.[11]

Despite her sensationalism, Waern concluded that van Gogh's work was "sincere," and that on occasion his work was "superb." Nevertheless, definitive accounts of Cézanne, Gauguin, and Neo-Impressionism were not available to the North American reader until the publication in 1903 of English translations of Camille Mauclair's books *The French Impressionists, 1860-1900* and *The Great French Painters and the Evolution of French Painting from 1830 to the Present Day*.[12]

While Waern's appreciation of van Gogh was not echoed in painting until Allen Tucker and Stuart Davis adapted van Gogh's mannerisms, Pointillism and Synthetism made sporadic early appearances in American and Canadian art. By 1907 W. H. Clapp, the Montreal painter who subsequently was instrumental in the Oakland-San Francisco Society of Six, had broached a proto-expressionist style.[13] Thomas Buford Meteyard, working in Scituate, Massachusetts, experimented with a modified Pointillism and a Synthetist palette as early as 1890. Another Boston-area artist, Philip Leslie Hale, seems to have emulated the Nabi adaptation of Neo-Impressionism is his 1892 *Girls in Sunlight* (Boston Museum of Fine Arts), which appears to reflect Maurice Denis.[14] In the early 1890s, under the influence of the Irish artist and Gauguin pupil Roderick O'Conor, a third Boston artist, Robert Vonnoh, painted small landscapes which began to approach Synthetism in their broad brushwork and coloristic intensity.[15] It is against the background of such experiments that Maurice Prendergast emerged in Boston in the mid-1890s, employing his modified *cloisonnisme*.

In Philadelphia, the art instruction of Hugh Breckenridge, Henry McCarter, and Thomas Anshutz at the Pennsylvania Academy encouraged experimentation and a fresh approach to artistic problems. Anshutz was the most important of these teachers, both at the Academy and at his summer school in Darby, Pennsylvania. His 1896 *Steamboat on the Ohio* (Museum of Art, Carnegie Institute, Pittsburgh) may be an *ébauche*, or unfinished canvas, but it clearly suggests a studio practice of building a composition through the juxtaposition of complementaries. More remarkable still are Anshutz's highly individualistic watercolor studies, which convey the undoctrinaire attitudes he imparted to his students. Executed after his 1892 trip to Paris, these

study notes are distinguished by their flowing spectral color and habitual use of the purple-orange chord. Anshutz appears to have occasionally reworked these watercolors, or subsequently cropped them so as to emphasize the abstract juxtapositon of colors and shapes. One may safely surmise that much of this bold attitude was passed on to his pupils: Luks's watercolor technique, for example, seems very close to Anshutz's. It is known that Anshutz had protracted discussions on color theory in Paris in 1911 with his former student, Henry Lyman Saÿen, and that they collaborated in the fabrication of new kinds of paints and pastels.[16] It may be symbolically significant that John Sloan includes Maurice Prendergast as a spectator in his 1912 etching *Anshutz on Anatomy*.[17] Anshutz's pupils included Breckenridge, Carles, Demuth, Glackens, Henri, Luks, Marin, Sheeler, and Sloan.

A more widely noted precursor to Post-Impressionism was the poster movement. Beginning in the 1880s European artists of the caliber of Eugène Grasset, Felix Vallotton, and Henri de Toulouse-Lautrec designed posters for American publishers.[18] America fully participated in the international poster craze of the 1890s, and Americans had access to information on the best and most up-to-date designers. When Arnold Bennett met the American poster artist Louis Rhead in 1896, Bennett reported in his diary that Rhead "criticized English, American, and French art comparatively, in a way that proved his depth; also with a sharp condescension to all and sundry."[19] The formal implications of the poster movement for incipient modernism are apparent in a spoof on the poster fad that was published in *Harper's* in 1895:

> Oh the sky it must be green and the tree it must be blue!
> And the lake must look a claret-colored bubble;
> And a foreground must be found
> That can be a far background
> But a fashionable poster's worth the trouble![20]

While newspaper illustration was a common thread among Henri's followers, poster lithography and sign card design furnished many of the artists in this exhibition with an early source of income—including Dove, Dow, Harris, Jackson, McCarter, Milne, Maurice Prendergast, Thomson, and William Zorach. Their schooling in the use of brilliant, flat color and strong patterning is echoed in their mature work.

A predisposition to thinking in terms of two-dimensional design and coherent pictorial structure was also encouraged by the popularity and wide influence of the art theoreticians Arthur Wesley Dow, Denman Ross, and Hardesty Maratta.[21] Dow's book *Composition*, first published in 1899, was the most important of their publications. Influenced by Japanese woodcuts, Dow stressed spacing and harmonious arrangement as opposed to modelling and perspective. Line, *notan* (patterns of dark and light), and color were emphasized as

means to a constructive compositional unity. The significance of Dow's theory lay in the fact that he encouraged decorative treatment in the fine arts, and not simply in the design of utilitarian goods.[22] Dow's theory was never explicit on the use of color, but in combination with the new palette adumbrated by Impressionism and Art Nouveau posters, Dow's book offered the possibility of a complete transformation in visual thinking.

Without question, the Fauve inoculation did not take in one decisive moment. (In this context, the Armory Show was anti-climactic, a confirmation of existing tendencies rather than a fresh revelation.) The artists' memoirs and surviving correspondence almost universally stress the protracted struggle to come to terms with the new tendencies. Walter Pach, one of the greatest critical champions of modernism, had an especially painful psychomachia in learning to appreciate Matisse. Pach was among the first Americans to admire Cézanne, whose work he first encountered in a Dresden exhibition in 1904.[23] Then a teaching assistant to William Merritt Chase, Pach had the temerity to try to convince Chase of Cézanne's merits, but with decidedly disappointing results.[24] Pach's "Matisse campaign" included consultation with Monet as to the younger artist's merits. Shortly thereafter Pach wrote to a friend, Alice Klauber, "I've been to Mr. Leo Stein's and the Matisses haven't gained any. I've about given up."[25] And in a subsequent letter he writes earnestly,

> I shall never have to reproach myself with having given the Matisse pictures an insufficient trial. I've gone to see them, thought over them, and the arguments intended to uphold them, studied the masters they're supposed to descend from....[26]

Finally, five months later, Pach admits,

> I feel lots more at rest about Matisse – admitting some points, denying others, thinking him a man of great possibilities (did I tell you I saw an early landscape of his that was splendid in color?) and not by any means incapable of big mistakes. I imagine I shall have to go back and look up work.[27]

*The will to understand* is perhaps the most startling note struck among the Americans and Canadians in Paris who embraced the new movements. Typically, Walt Kuhn wrote to his wife in 1912 while gathering art for the Armory Show,

> Van Gogh and Gauguin are perfectly clear to me. Cézanne only in part, although they say his exhibit is not evenly good, two or three are perfectly beautiful, a couple of portraits and one or two still lifes, his landscapes are still Greek to me, but wait, I'll understand before I get home.[28]

Comparably, Sheeler in Paris in 1909 noted that the new paintings "made too great a chasm to be taken in stride."[29]

Almost universally, however, it was color painting which provided

18

the initial challenge, even after the onset of Cubism. Marsden Hartley, recalling "the period of my own, spiritually speaking, triumphal entry in Paris" (1912), wrote:

> As for Picasso, Braque, Derain, Gleizes, Leger, Metzinger, Delaunay, et Cie., only the rarely understanding were taking them on and disposing of them, for there was the terrible beast Matisse still to encounter and over-power in his own jungle.[30]

Joseph Stella, in Paris in 1913, took cognizance of the "new sort of language" of Cubism and Futurism, but described himself taking up Post-Impressionism "not as a fad, but as a necessity at the time."[31]

If there is a key figure in the dissemination of Post-Impressionist aesthetics for Americans, Leo Stein would be the prime candidate. Stein's role as an influential theoretician in avant-garde Paris circles between 1905 and 1913 has not been sufficiently recognized. The subsequent fame of his sister Gertrude, his defection from support of Matisse and Picasso, and his removal from Paris to Florence in 1913 have all served to obscure the fact that Leo was the primary enthusiast responsible for the collection at 27, rue de Fleurus (at least until 1910), and an energetic and active propagandist in support of the new trends in painting to be seen there.[32] Leo succinctly reported, "On Saturday evenings I explained."[33]

Stein had a neurotic inability to complete the tasks he started and his reputation has suffered from the fact that he did not codify his aesthetic theory until 1927.[34] His advocacy of modernism was focused on Cézanne, and his principal contribution to his young compatriots was his analysis of the problem of depicting three-dimensional objects on a two-dimensional surface. Schooled by Berenson to admire the achievements of Italian Quattrocento painting, Stein was especially drawn to the grasp of form which he found in Cézanne:

> Cézanne's essential problem is mass and he has succeeded in rendering mass with a vital intensity that is unparalleled in the whole history of painting. No matter what his subject is—the figure, landscape, still life—there is always this remorseless intensity, this endless unending gripping of the form, the unceasing effort to force it to reveal its absolute self-existing quality of mass. There can scarcely be such a thing as a completed Cézanne. Every canvas is a battlefield, and victory an unattainable ideal.[35]

With the problem of form went an exacting analysis of the internal dynamics of the picture plane. The artist's ultimate aim, Stein believed, was a "plenum," a fullness created not by objects but by relationships of color and direction. In a successfully made picture,

> The whole of its actual or implied space would be filled with forms that organize in terms of rhythmic continuity, and in order that this completeness shall be appreciated, the spectator would have to realize the significance of organization in the perspective lines.[36]

Stein expected perspectival elements to establish recession and the linkage of surface design simultaneously. He found a solution to this

seeming paradox in Japanese prints, which he knew intimately both as a collector and as a connoisseur. He asserted the usefulness of the Japanese practice of raising the ground plane sharply:

> The value of this mode is that it makes a compromise between planes that break the continuity of the two-dimensional space by running inward, and planes that conserve it by running across.[37]

While it was Stein's conservatism that led him to an insistence on the creation of both spatial recession and two-dimensional design through perspective, his encouragement of a rethinking of the role of depth undoubtedly had fruitful consequences for the many artists Stein advised.

By the beginning of 1908, when Steichen wrote to Stieglitz, "I have another cracker-jack exhibition for you,"[38] the resultant show of Matisse works on paper was as much the outcome of a revolving set of circumstances as it was a beginning. As scattered and discontinuous as this history was, it was a solid base for the further evolution of a modern aesthetic in North American art. For many, it was a foundation to return to after a transitory adventure with abstraction. The complex interchange of ideas and artistic experiments added up to a common direction and a broad consensus on the basic characteristics of art for the new century. Confidence in the new direction was imparted to a further generation. Raymond Johnson, a young student of B. J. O. Nordfeldt's in Chicago, wrote home to his family about his teacher in November, 1912:

> He is called a "Post-Impressionist." We call it "Expressionism" and it seems to be the core of art.[39]

# Notes

[1] For a discussion of these developments see Arthur Frank Wertheim, *The New York Little Renaissance: Iconoclasm, Modernism, and Nationalism in American Culture* (New York: New York University Press, 1976), pp. 131-147.

[2] Wanda Corn and John Wilmerding, "The United States," in *Post-Impressionism: Cross-Currents in European and American Painting, 1880-1906* (Washington: National Gallery of Art, 1980), p. 219.

[3] On Prendergast's personality see Hedley Howell Rhys, *Maurice Prendergast, 1859-1924* (Cambridge: Harvard University Press, 1960), p. 19. On Morrice see G. Blair Laing, *Morrice, A Great Canadian Rediscovered* (Toronto: McClelland and Stewart, 1984), pp. 86-87 and passim. Clive Bell, however, credited Morrice as a great cicerone and teacher: Clive Bell, *Old Friends, Personal Recollections* (London: Chatto and Windus, 1956), pp. 66-67, 138-69, and passim.

[4] Lee Simonson, *Part of a Lifetime: Drawings and Designs 1919-1940* (New York: Duell, Sloan and Pearce, 1943), p. 21. For further remarks on the relationship between artistic innovation and American iconography see William C. Agee, "Synchromism: The First American Movement," *Art News* 64, no. 6 (October 1965): 30.

[5] "Nobody visiting this exhibition is likely to miss having his or her sense of colour, composition, proportion and good taste affronted by these canvasses – all tinged with the same blustering spirit of post-impressionism." Quoted in J. Russell Harper, *Painting in Canada: A History*, 2nd ed. (Toronto: University of Toronto Press, 1977), p. 16. For the Group of Seven, see Joan Murray, *The Best of the Group of Seven* (Edmonton: Hurtig Publishers, 1984) and Dennis Reid, *The Group of Seven* (Ottawa: National Gallery of Art, 1970).

[6] For art colonies in America, see Karal Ann Marling, *Federal Patronage and the Woodstock Colony*, doctoral dissertation (Bryn Mawr: Bryn Mawr College, 1971).

[7] Donald W. Buchanan, *James Wilson Morrice, A Biography* (Toronto: Ryerson Press, 1936), pp. 115, 147.

[8] Hans Huth, "Impressionism Comes to America," *Gazette des Beaux Arts* (April 1946): 239. See also Lionello Venturi, *Les Archives de L'Impressionnisme* II (reprint, New York: Burt Franklin, 1968), p. 216.

[9] Huth, p. 242. Other commentators were less sympathetic; Seurat's *Bathers* was called "a huge absurdity." (Ibid.) Another early American response was equally damning: "Mr. Seurat, a hardened offender, contributes ten startling compositions, the least incoherent of which is perhaps a trio of *Poseuses* innocent of raiment – unless a pair of stockings count as raiment." *The New York Herald*, Paris, March 22, 1888, quoted in John Rewald, *Georges Seurat* (New York: Wittenborn, 1943), p. 66.

[10] Theodore Robinson, "Claude Monet," *Century Magazine* 47, no. 5 (September 1982): 696.

[11] Cecelia Waern, "Some Notes on French Impressionism," *Atlantic Monthly* 69, no. 414 (April 1892): 541. On Waern see also William H. Gerdts, *American Impressionism* (Seattle: Henry Art Gallery, 1980), p. 27.

[12] Camille Mauclair, *The French Impressionists, 1860-1900*, trans. P. G. Konody (New York: E. P. Dutton and Co., 1903); Camille Mauclair, *The Great French Painters and the Evolution of French Painting from 1830 to the Present Day* (New York: E. P. Dutton and Co., 1903).

[13] On Clapp, see William H. Gerdts, *American Impressionism* (New York: Abbeville Press, 1984), p. 256 and Joan Murray, *Impressionism in Canada* (Toronto: Art Gallery of Ontario, 1973), pp. 64-73. Gerdts, in correspondence, has suggested other Post-Impressionists worthy of investigation: the San Francisco painter Joseph Raphael and the expatriates Louis Ritman and Theodore Butler (whose awareness of Post-Impressionism has been studied by Sally Gross).

[14] Hale in 1908 encouraged Marsden Hartley by remarking on the "fine insanity" of his work. See William Innes Homer, ed., *Heart's Gate: Letters Between Marsden Hartley and Horace Taubel* (Highlands, North Carolina: The Jargon Society, 1982), p. 64.

[15] Gerdts, *American Impressionism*, 1984, pp. 120-123.

[16] Philadelphia Museum of Art, *Philadelphia: Three Centuries of American Art* (Philadelphia, 1976), pp. 503, 508.

[17] Ibid., pp. 494, 495.

[18] Victor Margolin, *American Poster Renaissance* (New York: Watson-Guptil, 1975), pp. 18, 37, 204, 217.

[19] Arnold Bennett, *The Journal of Arnold Bennett*, vol. 1 (New York: The Viking Press, 1932), p. 13.

[20] Margolin, p. 21.

[21] Arthur Wesley Dow, *Composition* (Boston: J. M. Bowles, 1899); Denman Waldo Ross, *A Theory of Pure Design* (Boston: Houghton Mifflin, 1907); Denman Waldo Ross, *On Drawing and Painting* (Boston: Houghton Mifflin, 1912); Hardesty Gilmore Maratta, *The Web of Equilateral Triangles* (New York: Colonial Printing Company, 1915); Hardesty Gilmore Maratta, *The Maratta Scales of Artists' Oil Pigments* (New York: privately published, 1916).

[22] Frederick C. Moffatt, *Arthur Wesley Dow, 1857-1922* (Washington: Smithsonian Institution Press, 1977), pp. 81-91.

[23] Sandra S. Phillips, "The Art Criticism of Walter Pach," *Art Bulletin* 65 (March 1983): 107.

[24] Alice Klauber Papers, microfilm roll 583, frames 556-557, Archives of American Art.

[25] Ibid., frame 558, letter of November 16, 1907.

[26] Ibid., frame 563, letter of February 18, 1908.

[27] Ibid., frame 593, letter of June 29, 1908.

[28] Philip Rhys Adams, *Walt Kuhn, Painter: His Life and Work* (Columbus: Ohio State University Press, 1978), p. 47.

[29] John Driscoll, "Charles Sheeler's Early Work: Five Rediscovered Paintings," *The Art Bulletin* 62, no. 1 (March 1980): 127.

[30] Marsden Hartley, "A Propos du Dôme, etc.," *Der Querschnitt* 2, no. 2 (December 1922): 235.

[31] Irma B. Jaffe, *Joseph Stella* (Cambridge: Harvard University Press, 1970), pp. 35-36.

[32] Linda Simon, *The Biography of Alice B. Toklas* (Garden City: Doubleday, 1977), pp. 41, 43, 50, 67.

[33] Leo Stein, *Appreciation: Painting, Poetry and Prose* (New York: Crown, 1947), p. 200.

[34] Aspects of Stein's aesthetic theory were considered in William M. Bransford, " A Little Too Late: The Aesthetic Theory of Leo Stein," unpublished manuscript, Institute of Liberal Arts, Emory University, 1984. See also Leo Stein, *The A-B-C of Aesthetics* (New York: Boni and Liveright, 1927).

[35] Edmund Fuller, ed., *Journey Into the Self; being the Letters, Papers and Journals of Leo Stein* (New York: Crown, 1950), p. 15.

[36] Leo Stein, *The A-B-C of Aesthetics*, p. 164.

[37] Ibid., p. 165.

[38] Alfred H. Barr, Jr., *Matisse, His Art and His Public* (New York: The Museum of Modern Art, 1951), p. 113.

[39] Ed Garman, *The Art of Raymond Johnson, Painter* (Albuquerque: University of New Mexico Press, 1976), p. 20.

# The Dissemination of Post-Impressionism in North America: 1905-1918

JUDITH ZILCZER

In 1910, when Roger Fry presented his exhibition *Manet and the Post-Impressionists*, he defined Post-Impressionism as a movement of international scope:

> The movement in art represented in this exhibition is widely spread. Although, with the exception of the Dutchman, Van Gogh, all the artists exhibited are Frenchmen, the School has ceased to be specifically a French one. It has found disciples in Germany, Belgium, Russia, Holland, Sweden. There are Americans, Englishmen and Scotchmen in Paris who are working along the same lines.[1]

In fact, by 1910, the diffusion of Post-Impressionism throughout the United States already had begun. American artists, critics, dealers, and collectors all contributed to the advent and growth of Post-Impressionism in North America.

Although Roger Fry and his contemporaries recognized the American contribution to the international Post-Impressionist movement, the transmission of Post-Impressionism to the United States and Canada has never been documented fully. In retrospective accounts of the period, Post-Impressionism has been overshadowed by the simultaneous emergence of Cubist modernism, Synchromism, and early abstract painting. Historians such as John Baur have claimed that no real Post-Impressionist movement existed in America.[2]

In part the historical neglect of American Post-Impressionism has resulted from confusion over terminology. According to Milton Brown, "Post-Impressionism in itself is a negative and rather vague term. But its use in America was especially reprehensible since it lumped the Post-Impressionists with the Fauves, the Cubists and, indeed, any radical movement in art after Impressionism."[3] While it is true that the term "Post-Impressionism" often was used to denote all species of modern art, the most knowledgeable artists and critics of the early twentieth century accepted Post-Impressionism as the proper designation for all forms of pre-Cubist modernism after Impressionism. Roger Fry himself identified several aesthetic factors common to the art of Cézanne, Gauguin, van Gogh, Seurat, and Matisse, the chief masters of Post-Impressionism:

> [I]t is the boast of those who believe in this school, that its methods enable the individuality of the artist to find completer self-expression in his work than is possible to those who have committed themselves to representing objects more literally. . . . [B]y our simplification of nature we shock and disconcert our contemporaries.[4]

Even the conservative critics, such as the American writer Frank Jewett Mather, understood the essential elements of Post-Impressionism:

> The platform of Post-Impressionism is a simple one—complete spontaneity

independent of all images of outer nature; swift, succinct, and powerful execution of symbolic color—these are the chief tenets of the movement.[5]

Brilliant, saturated color, formal simplification and distortion, and artistic freedom were the hallmarks of Post-Impressionism in the first two decades of this century.

The period from 1905 to 1918 witnessed the concurrent introduction of French and American Post-Impressionist painting into the United States. Exhibitions, critical commentary, and the formation of private collections evidenced the diffusion of Post-Impressionism in North America. While the French Post-Impressionists preceded their American counterparts in artistic innovation, the American public experienced the arrival of European and American Post-Impressionism simultaneously, and the American Post-Impressionists were frequently the first to be exhibited and collected in major American metropolitan centers.

# Origins

American artists and expatriate intellectuals living in Paris constituted the primary source for the dissemination of information about French Post-Impressionism in the United States. Before the turn of the century, a succession of American and Canadian artists had begun to gravitate toward Paris for artistic training and intellectual interchange. Maurice Prendergast, James Wilson Morrice, and Alfred Maurer were among the earliest arrivals. By 1908, such painters as Arthur Carles, Lyman Saÿen, John Marin, Max Weber, Abraham Walkowitz, Morgan Russell, Andrew Dasburg, and Stanton Macdonald-Wright had been exposed to French Post-Impressionism in Paris. These North American artists and their compatriots formed an informal community in the French capital.

Several Americans played a key role in introducing the North Americans to the French avant-garde. The leading members of this expatriate community were Leo and Gertrude Stein and their brother and sister-in-law, Michael and Sarah Stein. Their collections of new European painting made a lasting impression on many American visitors to their Paris salons.[6] Moreover, Sarah Stein was largely responsible for the formation of the Matisse School. Many American Post-Impressionists studied directly with Henri Matisse during the three years his classes continued.[7]

In addition to the Steins, the American photographer Edward Steichen and the American painter Walter Pach served as intermediaries between the visiting Americans and members of the Paris art world. In 1908, at the same time that Sarah Stein was encouraging the formation of the Académie Matisse, Steichen founded the New Society of American Artists in Paris. The organization numbered among its

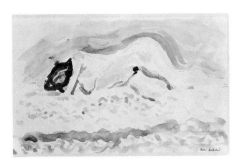

Fig. 1. Henri Matisse, *Nude*, ca. 1907, watercolor, The Metropolitan Museum of Art, New York: The Alfred Stieglitz Collection (49. 70. 5).

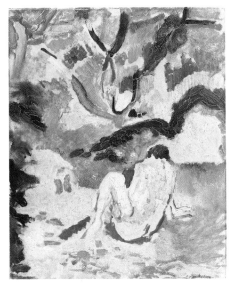

Fig. 2. Henri Matisse, *Nude in a Wood*, ca. 1906, oil on canvas, Brooklyn Museum.

fourteen members several leading practitioners of American Post-Impressionism – Bruce, Carles, Marin, Maurer, and Weber.[8]

Americans traveling in Europe did not have to visit Paris to become acquainted with French Post-Impressionism. Charles Loeser, a wealthy expatriate living in Florence who was a friend of Bernard Berenson, had amassed an art collection which included several paintings by Paul Cézanne. It was through Loeser's collection that Gertrude Stein in 1904 had her first opportunity to study the work of Cézanne.[9]

Inevitably, the activities of the artists and intellectuals abroad filtered back to the United States and Canada. Among the first examples of full-color painting to reach North America was the work of Maurice Prendergast (see page 146). Prendergast exhibited frequently in watercolor society exhibitions in New York and Boston. His solo show at the Macbeth Gallery in New York in 1905 was one of the first exhibitions of Post-Impressionism in the United States.[10] Certainly, by the time Prendergast participated in the 1908 exhibition of "The Eight" – a show which later toured to nine cities across the United States – his connection to French Post-Impressionism was well recognized. At the time, the critic for the *Newark Evening News* remarked:

> But do not think that Prendergast has spoken the final word with his Cézanne technique. We will hear more of it when the influence of France upon the young artists studying there now becomes better known.[11]

This observation proved prophetic. In the five years preceding the Armory Show, the full-color paintings of dozens of Americans working abroad were included in group and solo exhibitions across the United States.

Concurrently, knowledge of European Post-Impressionism grew as exhibitions and publications contributed to the process of dissemination. In terms of exhibitions, Alfred Stieglitz's Little Galleries of the Photo-Secession at 291 Fifth Avenue, called "291," dominated the field before 1910. With the help of his friend Edward Steichen, Stieglitz mounted the first American exhibition of the work of Henri Matisse in April 1908. The show, which included drawings, lithographs, watercolors (fig. 1), etchings, and one oil painting, excited considerable controversy.[12] The painter and framemaker George F. Of provided Stieglitz with the single oil painting in the exhibition, *Nude in a Wood* (fig. 2). Two years earlier, in 1906, Of had admired the Matisse paintings which Sarah and Michael Stein had brought with them on a visit to the United States. He asked Sarah to select a work by the French master and thereby became the first collector in the United States to acquire the work of Matisse.[13]

Stieglitz's subsequent activities in the field of European Post-Impressionism included a show of Toulouse-Lautrec lithographs from December 20, 1909, to January 14, 1910; a second exhibition of Matisse

drawings and reproductions of paintings in February and March 1910; and a lithograph exhibition including graphic work by Cézanne and Toulouse-Lautrec late in 1910. Stieglitz also presented the first American exhibition of Cézanne's work in March 1911. A year later he mounted his third Matisse show, which included both sculptures and drawings.[14] Newspaper criticism of these exhibitions heightened public awareness of European Post-Impressionism. In his journal *Camera Work*, Stieglitz reprinted extracts from the critical commentary in newspapers. By 1912, he had also published texts by such influential European writers as Henri Bergson and Julius Meier-Graefe, as well as translations from the letters of Vincent van Gogh.

While *Camera Work* provided the most comprehensive coverage of advanced art available in the United States, scattered reports of French Post-Impressionism began to appear elsewhere in the American press. In January 1909, for example, W. H. Fox, a writer and dealer affiliated with the Chicago firm of Albert Roullier, gave the readers of the *Indianapolis News* a brief description of the French paintings at the Salon d'Automne:

> During the last summer, the writer saw a collection of works by Matisse, Van Gogue [sic], Goguin [sic], and others of the living followers of Cézanne, who figure very prominently at the autumn salon. The subjects were not out of the common. There were landscapes, still life, people in the fields, in the street, and in the interior, but the apparent crudeness in the manipulation of the paints and the singularity of the drawing was at first glance astounding....[15]

In May 1910, Gelett Burgess, a humorous writer and sometime painter, contributed a vivid report on Matisse and his fellow "Wild Men of Paris" to the *Architectural Record*.[16]

Fuller accounts of modern French painting were available in newly published books. By 1912, American readers had access to such works as Clive Bell's *Since Cézanne* and the English edition of Meier-Graefe's *Modern Art*. Among the American critics, Charles Caffin, Sadakichi Hartmann, and James Gibbons Huneker all wrote from a cosmopolitan perspective. Huneker's collection of critical essays *Promenades of an Impressionist*, published in 1910, included appreciative discussions of Paul Cézanne, Gauguin, and Toulouse-Lautrec.[18]

# American Exhibitions

As knowledge of French Post-Impressionism was increasing in the years immediately preceding the Armory Show in 1913, American artists, many returning from abroad, had begun to exhibit Post-Impressionist and full-color paintings in solo and group exhibitions.[19] In the spring of 1909 three exhibitions in New York featured American Post-Impressionist works. From March 30 to April 19, Stieglitz presented a joint exhibition of the work of Alfred Maurer and John

**O. BLUEMNER**
**NEW YORK**

| ÖLGEMÄLDE | AQUARELLE |
|---|---|
| 1. South River N. J. Nachmittag | 9. Dover N. J. Sonnenaufgang |
| 2. Passaic River N. J. Märzlicht | 10. Manursing Island N.Y. Herbsttag |
| 3. South River N. J. Sandbruch | 11. Morris Canal N. J. Herbst. |
| 4. Rockaway N. J. Alter Kanal | 12. Sheepshead Bay N.Y. Alte Flutmühle |
| 5. Blackwells Hills N.J. Abendlicht | 13. Harlem River Vormittag |
| 6. Hackensack River Erster Schnee | 14. Van Cortlandt Im März |
| 7. Winfield L. J. Maimorgen | 15. Patterson N. J. Winter |
| 8. Perth Amboy N.J. Morgenlicht | |

Fig. 3. Catalogue for Oscar Bluemner exhibition, Galerie Fritz Gurlitt, Berlin, May 1912, Oscar Bluemner Papers, Archives of American Art, Smithsonian Institution.

Marin. The following month, Max Weber debuted at the Haas Gallery. At the same time, Stieglitz mounted a show of Marsden Hartley's "Segantini-stitch" landscapes. The Haas Gallery was also the site of Abraham Walkowitz's first solo exhibition. Perhaps the most important of these early American Post-Impressionist exhibitions was Stieglitz's presentation of *Younger American Painters* in the spring of 1910. The show included the work of D. Putnam Brinley, Arthur B. Carles, Arthur Dove, Lawrence Fellows, John Marin, Alfred Maurer, Edward Steichen, and Max Weber, most of whom belonged to the New Society of American Artists in Paris.

It is indicative of the international character of American Post-Impressionism that an impressive number of these Americans participated successfully in European exhibitions before their professional exposure in North America. Patrick Henry Bruce, Arthur Carles, Arthur Dove, Lyman Saÿen, Max Weber, and William and Marguerite Zorach all contributed work to the Paris Salon d'Automne between 1908 and 1910. In May 1912, Oscar Bluemner's new oil paintings and watercolors of New Jersey landscapes were featured in an exhibition at the Galerie Fritz Gurlitt in Berlin (fig. 3).[20]

After 1910, the number and variety of American Post-Impressionist shows increased. While Maurice Prendergast and Walt Kuhn showed regularly at the Macbeth and Madison Galleries, respectively, Stieglitz continued to sponsor new artists at "291." Between 1911 and 1913 Arthur Carles, Marsden Hartley, and John Marin had solo shows at Stieglitz's gallery. Hartley's 1912 exhibition featured Cézannesque still life paintings such as *The Faenza Jar* (page 99). Martin Birnbaum's Berlin Photographic Company was the site of Maurice Sterne's first New York show in February 1912.

In other cities across the United States, exhibitions of American Post-Impressionism stirred the first local controversies over modern art. In the midwest, B. J. O. Nordfeldt pioneered with solo exhibitions in Chicago and Milwaukee between 1912 and 1913. In November 1912, several months after the Chicago Galleries of W. Scott Thurber presented an exhibition of Arthur Dove's abstractions, an *Exhibition of Paintings by B. J. Olson Nordfeldt of Chicago* opened at Thurber's. The show became the focus for critical discussions of Post-Impressionism in the Chicago press. Harriet Monroe, writing in the *Chicago Tribune*, offered an enthusiastic assessment of the movement in general and Nordfeldt in particular:

> Undoubtedly these pictures would never have been painted if Monet and his followers, Manet and his methods, Cézanne, Gauguin, and their ideas, Matisse and other recent radicals of the autumn Salon, had not formed so to speak a line of succession. But within those discreet limits proper in any use of human language, this artist is original....[21]

The show, which included Chicago cityscapes, still life paintings, and

Fauve portraits such as *The Red Cap* (page 141) and *Robert Friedel* (page 140), traveled to the Milwaukee Art Society in December and remained on view through January 15, 1913.[22] Nordfeldt's show marked the introduction of modern art to the city of Milwaukee. Art critic Louis Mayer devoted many articles in *The Milwaukee Free Press* to coverage of the show and to the issue of Post-Impressionism:

> A few years ago...a new "movement" was started by Matisse and his followers in Paris. These men have been called Post Impressionists because they are the logical successors to the Impressionists of the past. They return to the principles of Edouard Manet, the emphasis of colorful but well massed and strongly outlined forms. And to escape the dangers which infested impressionism through Claude Monet's tendency to dissolve all masses by infinitely fine gradation, they jump in the other extreme....
>
> Milwaukee is placed much in advance of other cities in as much as it will be given opportunity to see the works of one of the strongest American exponents of post-impressionism at the Milwaukee Art Society.[23]

Mayer's commentary reflected Roger Fry's premise that French Post-Impressionist painting had evolved from the tradition of Manet. Moreover, Mayer's assessment of Nordfeldt's work was well informed and enthusiastic.

Elsewhere in the United States, early modernist painters began to show their brilliantly colored Post-Impressionist canvases to a largely unsympathetic public. In 1912 William Zorach displayed his new paintings at the Taylor Galleries in Cleveland. That same year his future wife, Marguerite Thompson, introduced modern art to California with her first solo exhibitions at the Royar Galleries in Los Angeles and the Parlor Club in Fresno.[24]

Thus, on the eve of the Armory Show in New York, American Post-Impressionism had already been introduced in cities across the North American continent. It was symptomatic of public curiosity about the new movement that New York's Folsom Gallery staged an exhibition of Alfred Maurer's Fauve paintings just weeks before the Armory Show. The catalogue for Maurer's show, which reprinted excerpts from Roger Fry's and Clive Bell's statements for the Grafton Galleries' *Second Post-Impressionist Exhibition* in London, proclaimed the international diffusion of Post-Impressionism:

> Post-Impressionism as a form of very real, sincere and vital art is now accepted by progressive artists, connoisseurs and cultivated people everywhere....
>
> France, Germany, Russia and Holland have long since recognized Post-Impressionism as a very legitimate, logical development of the work of the great masters Cézanne, Van Gogh....[25]

For the New York public, Alfred Maurer's recent work represented the international Post-Impressionist movement.

# Diffusion to Canada

The transmission of Post-Impressionist painting to Canada paralleled the process of dissemination in the United States. Although full-color painting arrived in Canada somewhat later than in the United States, Canadian artists and critics helped to disseminate the aesthetics of Post-Impressionism in North America. A. Y. Jackson, John Lyman, and James Wilson Morrice all had studied in Europe. David Milne was exposed to Post-Impressionism during his thirteen-year residence in New York City. The writings of both Roger Fry and Clive Bell were known to Canadian painters. Moreover, Walter Abell, the influential founder of *Maritime Arts*, published formalist criticism in the tradition of Roger Fry.[26]

Just as American Post-Impressionist painting often preceded the actual arrival of European modern art in the United States, so Canadian Post-Impressionists were the first to display modernist work publicly in Canada. John Lyman participated in both the 1912 and 1913 Spring Exhibitions at the Art Association of Montreal. The Thirtieth Spring Exhibition, which opened on March 26, 1913, marked the first public controversy over modern painting in Canada.

The boldly colored paintings of Lyman and Jackson astonished both the critics and the Canadian public. A headline in *The Montreal Daily Witness* announced, "Post Impressionists Shock Local Art Lovers at the Spring Art Exhibition." The article went on to explain that:

> Immensity of canvas, screamingly discordant colors, and execrable drawing are the chief methods they have employed to jar the public eye, and having jarred it they are satisfied. That is their mission, and they are proud of it.[27]

There ensued a spate of articles and critical commentary about Post-Impressionism in the Montreal press. The debate even extended to an exchange of letters in *The Montreal Daily Star* over Julius Meier-Graefe's interpretation of Post-Impressionism.[28]

In May, immediately following the Spring Exhibition, the Art Association of Montreal presented a solo exhibition of John Lyman's paintings. Corinne Lyman, in her introductory statement for the exhibition catalogue, attacked the aesthetics of naturalism:

> L'art n'est pas une imitation de la nature;....Un art qui a l'air naturel est un non-sens; l'art doit être artificiel; où cesse l'imitation l'art commence....[29]

The exhibition of more than forty of John Lyman's works aroused even greater hostility than the paintings in the Spring Exhibition. It is therefore significant that Lyman's show, the first exclusively modern art exhibition in Montreal, was presented under the official auspices of the Art Association of Montreal.

The two successive exhibitions of Canadian Post-Impressionism at the Art Association of Montreal came only weeks after the closing of *The International Exhibition of Modern Art* at the 69th Regiment

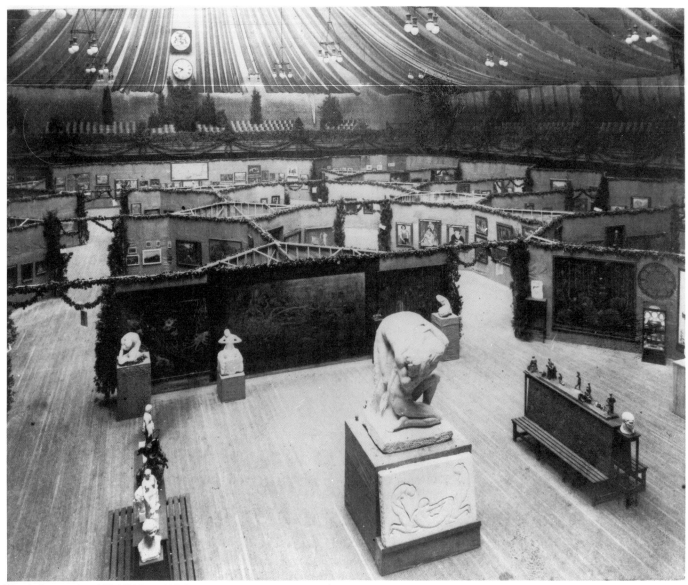

Fig. 4. *International Exhibition of Modern Art*, 1913, 69th Regiment Armory, New York. Photograph: Archives of American Art, Smithsonian Institution, Washington, D.C.

Armory in New York. The Canadian shows coincided exactly with the subsequent tour of the Armory Show to Chicago and Boston. Repercussions from that enormous traveling exhibition extended across the United States and into Canada.

## The Armory Show and Its Aftermath

The Armory Show, which opened in New York on February 5, 1913, marked a turning point in the history of the diffusion of Post-Impressionism in North America. The exhibition (fig. 4) comprised the single greatest concentration of Post-Impressionist painting assembled in this hemisphere during the first two decades of the twentieth century.[30] Included in the show were more than 120 works by fifteen French Post-Impressionists. The major masters – Cézanne, Gauguin,

van Gogh, and Matisse—were each represented in such quantity and depth that their respective sections constituted solo exhibitions within the larger show. Works by Derain, Dufy, Marquet, and Vlaminck were introduced to the American public for the first time. An almost equal number of Post-Impressionist paintings by twenty-five American artists formed another important segment of the exhibition. Early American modernists from Oscar Bluemner to William Zorach contributed full-color or Cézannesque paintings to the Armory Show.

Arthur B. Davies, president of the Association of American Painters and Sculptors, and his protégé Walt Kuhn, secretary of the society, patterned the exhibition after European and British models, particularly the Cologne Sonderbund and Roger Fry's first and second Post-Impressionist exhibitions at the Grafton Galleries in London. Fry had served for two years (1906-1907) as a curator at the Metropolitan Museum in New York. During his residence in the city he had befriended Arthur B. Davies, and their contacts continued after Fry's return to England.[31] John Quinn, legal counsel to the Association, was equally well informed about Fry's activities through his friendships with the English painter Augustus John and the American critic James Gibbons Huneker.[32]

Press coverage of the exhibition in New York, Chicago, and Boston brought the issue of Post-Impressionism before the American public on an unparalleled scale. The term recurred so frequently in banner headlines and newspaper articles that Post-Impressionism became a household word. The *New York Times Magazine* even published a full interview with Matisse by Clara T. MacChesney.[33] Nevertheless, journalistic accounts of the Armory Show contributed to widespread confusion over stylistic terminology. Reporters used the term Post-Impressionism interchangeably with Cubism, Futurism, and modernism.

Ironically, the international scope of the Armory Show resulted in the partial eclipse of the American Post-Impressionists. Although American entries were as numerous as those of the European Post-Impressionists, public attention focussed on the Europeans, particularly the French. Furthermore, the most advanced forms of modernism, especially Cubist and abstract paintings, almost overshadowed both the French and American Post-Impressionist works in the exhibition.

The Armory Show transformed the New York art market. Between 1914 and 1915, half a dozen commercial galleries devoted to modern art opened in New York City. Older firms, notably the Montross Gallery and Knoedler's, began to display modern art. In the five years following the Armory Show, thirty-four galleries and organizations mounted more than 250 shows of European and American modern art.[34]

In many of these exhibitions, American Post-Impressionist paintings hung side by side with more advanced modernist work. The mixture of progressive with more radical styles characterized three of the most significant group shows mounted in New York City in the aftermath of the Armory Show: *The Exhibition of Paintings and Drawings* in February 1914 at the Montross Gallery (fig. 5); the *Exhibition of Contemporary Art* from February 5 to March 7, 1914, at the National Arts Club (fig. 6); and the *Forum Exhibition of Modern American Painters* in March 1916 at the Anderson Galleries (fig. 7).[35]

The 1914 Montross exhibition was the first group show of American modern art to be presented at a commercial gallery in the post-Armory Show period. Arthur B. Davies and Walt Kuhn (fig. 8) joined forces to organize the exhibition and to enlist the support of gallery owner N. E. Montross. The show had originated at the Carnegie Institute in Pittsburgh in December 1913 and was also seen at the Detroit Institute of Arts in early March 1914 and the Cincinnati Art Museum in late March and early April.[36] The exhibition's impact extended far beyond New York City since the tour helped disseminate modern art to other metropolitan centers. Four of the fourteen participating artists—Walt Kuhn, George Of, Maurice Prendergast, and Allen Tucker—contributed Post-Impressionist paintings to the show. While abstract paintings by Joseph Stella, Henry Fitch Taylor, and Charles Sheeler attracted the most notice, Post-Impressionism remained a central issue in newspaper coverage of the show (figs. 9, 10).

The Montross Gallery continued to provide an exhibition forum for American Post-Impressionist painters. In the spring of 1915, N. E. Montross presented a major exhibition of mural-scale paintings by Arthur B. Davies, Walt Kuhn, and Maurice Prendergast. The show included three major Post-Impressionist canvases—Prendergast's *Picnic* (page 146) and *Promenade* (Detroit Institute of Arts) and Walt Kuhn's *Man and Sea Beach* (lost). Kuhn and Prendergast showed their work at Montross frequently during the teens.[37]

The Daniel Gallery, which opened in 1914, offered even greater support to American Post-Impressionists, who regularly participated in Daniel Gallery group shows and solo exhibitions. Charles Daniel supported such artists as Lawson and Marin as well as lesser known painters like Middleton Manigault.[38]

While American modernists benefitted from the expansion of the New York gallery scene, the growing art market also provided new outlets for European modernism. Harriet Bryant's Carroll Galleries and Robert Coady's Washington Square Gallery began exhibiting European vanguard works in 1914. These new firms joined Stieglitz's "291" and Marius de Zayas's Modern Gallery in showing advanced work by the Cubists. At the same time, Coady promoted the values of Post-Impressionism through the publication program of his gallery.[39]

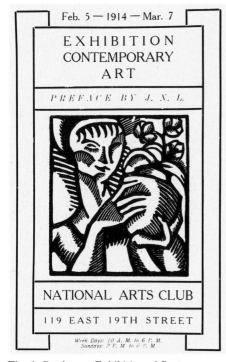

Fig. 5. Catalogue, *Exhibition of Paintings and Drawings*, February 1914, Montross Gallery, New York. Photograph: Archives of American Art, Smithsonian Institution, Washington, D.C.

Fig. 6. Catalogue, *Exhibition of Contemporary Art*, 1914, National Arts Club, New York. Photograph: Archives of American Art, Smithsonian Institution, Washington, D.C.

# THE FORUM EXHIBITION OF MODERN AMERICAN PAINTERS

MARCH THIRTEENTH TO MARCH TWENTY-FIFTH, 1916

## COMMITTEE

DR. CHRISTIAN BRINTON     ALFRED STIEGLITZ

ROBERT HENRI     DR. JOHN WEICHSEL

W. H. DE B. NELSON     WILLARD HUNTINGTON WRIGHT

## ARTISTS

BEN BENN     ALFRED MAURER

THOMAS H. BENTON     HENRY L. McFEE

OSCAR BLUEMNER     GEORGE F. OF

ANDREW DASBURG     MAN RAY

ARTHUR G. DOVE     MORGAN RUSSELL

MARSDEN HARTLEY     CHARLES SHEELER

S. MACDONALD-WRIGHT     A. WALKOWITZ

JOHN MARIN     WM. AND MARGUERITE ZORACH

### ON VIEW AT THE ANDERSON GALLERIES

Fig. 7. Catalogue, *Forum Exhibition of Modern American Painters*, March 1916, Anderson Galleries, New York. Photograph: Archives of American Art, Smithsonian Institution, Washington, D.C.

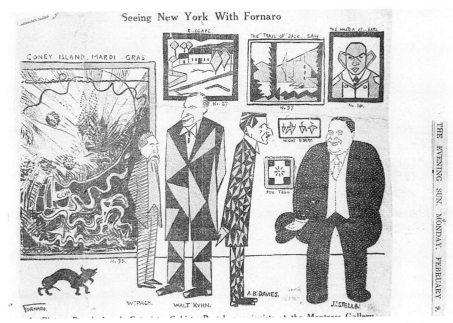

Fig. 8. Carlo de Farnaro, cartoon of *Exhibition of Paintings and Drawings*, Montross Gallery, clipping from *The Evening Sun* (New York), February 9, 1914.

Fig. 9. *The Detroit News*, February 26, 1914, p. 2.

Fig. 10. *The Commercial Tribune* [Cincinnati], March 29, 1914, p. 7.

The Washington Square Gallery and the Carroll Galleries imported major paintings by Derain, Dufy, and other Fauve painters.[40]

Several galleries mounted major solo exhibitions devoted to two of the leading European Post-Impressionist masters—Paul Cézanne and Henri Matisse. Arthur B. Davies persuaded N. E. Montross to present an exhibition of seventy-four works by Henri Matisse in January 1915 (fig. 11) and an equally impressive show of forty-four oil paintings and watercolors by Paul Cézanne in January of the following year (fig. 12). Davies's friend Walter Pach arranged for and selected both exhibitions in France. The Montross exhibitions provided the most comprehensive representations of each artist yet mounted in the United States. By the time the Arden Gallery organized another Cézanne exhibition in March 1917, several American collectors, notably John Quinn, Agnes Meyer, and Lillie Bliss, were in a position to lend significant works by the French master to the show.[41]

Dissemination of modern art beyond New York City continued with exhibitions mounted at commercial galleries. In the spring of 1916 Morton Schamberg and the dealer Stéphan Bourgeois organized Philadelphia's first *Exhibition of Advanced Modern Art* at the McClees Gallery. Not only did the show combine European and American modernism, but the organizers also demonstrated the stylistic diversity of modern art. The thirty-one works ranged from Post-Impressionism to Cubist abstraction. The fact that three of the European entries in the exhibition came from the Quinn collection was indicative of the growth of modern art collections.[42]

It was the paradoxical legacy of the Armory Show that, as modern art exhibitions proliferated after 1913, public controversy over Post-Impressionism diminished. Given broader exhibition opportunities, American painters continued to produce and exhibit Post-Impressionist work of high quality. Artists like Stuart Davis first began painting in a Post-Impressionist style in response to the Armory Show. Others, notably Ben Benn and Walt Kuhn, created their strongest Post-Impressionist works after 1913. Yet these American painters and their allies in the Post-Impressionist movement now found themselves competing with more daring European and American modernists for public support and private patronage.

# Collecting and Patronage

The years immediately following the Armory Show witnessed the formation of the first major modern art collections in the United States. Albert Barnes, John Quinn, Walter Arensberg, Arthur Jerome Eddy, and Ferdinand Howald all began to amass sizeable holdings of European and American modern art around 1913. Few of these collectors concentrated exclusively on Post-Impressionism, but French and

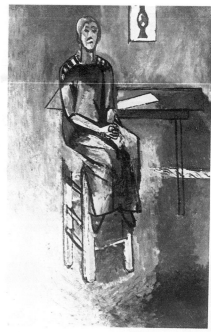

CATALOGUE NUMBER 59

Fig. 11. Catalogue illustration, *Henri Matisse Exhibition*, 1915, Montross Gallery, New York. Photograph: Archives of American Art, Smithsonian Institution, Washington, D.C.

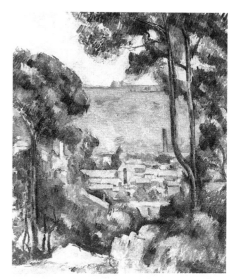

"L'ESTAQUE"

Fig. 12. Catalogue illustration, *Cézanne Exhibition*, January 1916, Montross Gallery, New York. Photograph: Archives of American Art, Smithsonian Institution, Washington, D.C.

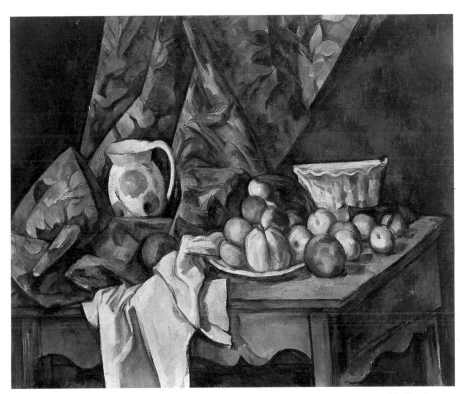

Fig. 13. Paul Cézanne, *Still Life with Apples and Peaches*, ca. 1905, oil on canvas, National Gallery of Art, Washington, D.C. Gift of Eugene and Agnes Meyer, 1959.

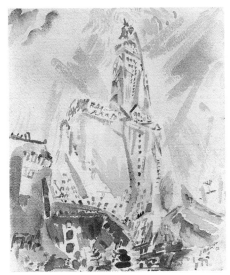

Fig. 14. John Marin, *Woolworth Building #29*, 1912, watercolor. National Gallery of Art, Washington, D.C. Gift of Eugene and Agnes Meyer, 1959.

American Post-Impressionist paintings came to occupy an important place in these pioneer collections. In building their collections American patrons offered vital encouragement and support to Post-Impressionist painters in the United States.

While the Armory Show provided the major stimulus for modern art patronage in North America, the first acquisitions of Post-Impressionist works predate the historic exhibition. Aside from the collections formed by the expatriate Stein family in Paris and Charles Loeser in Florence, French and American paintings began to enter private collections in America between 1906 and 1912. In 1909, Harriet Levy, a friend of the Steins' from San Francisco, purchased Matisse's *Girl with Green Eyes* (San Francisco Museum of Modern Art). Around the same time, the Cone sisters from Baltimore began to acquire the work of Matisse. Thomas Whittemore, an American archaeologist, and the art historian Bernard Berenson were among the first Americans to buy works by Matisse.[43]

Alfred Stieglitz and his associates began to acquire works from the exhibitions at "291." Stieglitz owned watercolors and drawings by Matisse (fig. 1), as well as the art of his American protégés. Among the most adventurous collectors in Stieglitz's circle was Agnes Ernst Meyer. In 1910, she and her husband purchased a still life by Paul Cézanne (fig. 13).[44] While the Meyers acquired notable examples of European modern art, they also patronized American modernists. Post-Impressionist paintings by Marsden Hartley and John Marin (fig. 14) entered their collection at an early date.

The New York attorney John Quinn made some of the most significant modern art acquisitions of the pre-Armory Show era. Between 1910 and 1912, Quinn decided to build a modern art collection. Virtually all the modern art he purchased in this two-year interval was Post-Impressionist. In April 1911 Quinn acquired a Fauve painting, *The Iron Table* by Alfred Maurer (fig. 15), from an Independent Exhibition organized by Rockwell Kent at New York's Beaux Arts Gallery.[45] Subsequently, Quinn acquired two Matisse drawings from Stieglitz's third Matisse show. In May 1912, before Quinn owned any work by Cézanne, he purchased Hartley's Cézannesque still life *The Faenza Jar*.[46]

It was only after these daring purchases that Quinn in the fall of 1912 added three major canvases by Paul Cézanne, Vincent van Gogh, and Paul Gauguin to the nucleus of his modern art collection. Quinn later lent these European Post-Impressionist paintings to the Armory Show.[47]

Although Quinn was the single greatest lender to and buyer from the Armory Show, a handful of other Americans also contributed European Post-Impressionist paintings to the exhibition. Katherine Dreier, future founder of the Société Anonyme, lent a van Gogh painting to the exhibition.[48] Several paintings by Cézanne and a drawing by Gauguin included in the show came from American collections.[49]

A number of Post-Impressionist works entered American collections as a direct result of the Armory Show. John Quinn (fig. 16), Walter Arensberg, Arthur Jerome Eddy, and Albert Barnes acquired European paintings from the show. Two American Post-Impressionists found buyers for their work. Middleton Manigault sold a painting to Eddy, while Frederick C. Torrey purchased four *Color Notes* by D. Putnam Brinley.[50] Finally, the Metropolitan Museum of Art acquired Cézanne's *La Colline des pauvres* (fig. 17), the first Post-Impressionist painting to enter an American museum collection.

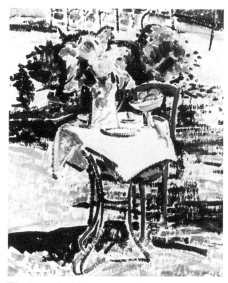

Fig. 15. Alfred Maurer, *The Iron Table*, ca. 1911, oil on canvas, private collection.

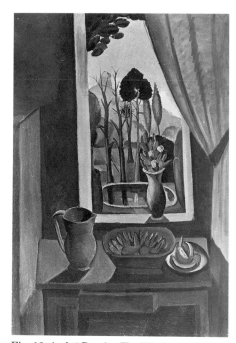

Fig. 16. André Derain, *The Window on the Park*, 1912, oil on canvas, The Museum of Modern Art, New York.

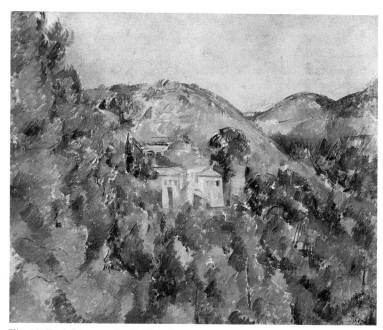

Fig. 17. Paul Cézanne, *La Colline des pauvres*, ca. 1877, oil on canvas, The Metropolitan Museum of Art, New York.

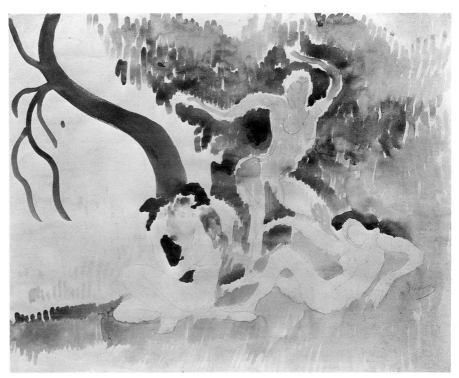

Fig. 18. André Derain, *Bacchic Dance*, ca. 1906, watercolor, The Museum of Modern Art, New York. Gift of Abbey Aldrich Rockefeller.

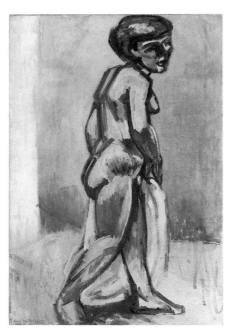

Fig. 19. Henri Matisse, *Standing Nude*, 1907, oil on canvas, The Tate Gallery, London.

In addition to their activities as collectors, the two principal buyers at the Armory Show—John Quinn and Arthur Jerome Eddy—contributed to the dissemination of modernism. Eddy published a compendium of modern art criticism, *Cubists and Post-Impressionism*, in which he defined the Post-Impressionist movement as "the art development *following* Impressionism....It means a *reaction* from Impressionism."[51] Quinn successfully campaigned for congressional tariff reform to permit the importation of European modern art.[52] His victory in the campaign against the modern art tariff had a direct impact on the New York art world. For the first time, importation of modern art became commercially feasible.

The expansion of the New York art market allowed American collectors to purchase European Post-Impressionists' works in greater quantity. John Quinn amassed considerable holdings of the works of Matisse, Derain (fig. 18), Dufy, and Vlaminck from New York galleries. By 1918, Walter Arensberg had purchased paintings by Cézanne, Derain, and Matisse.[53] The painter Arthur B. Davies began to amass an important collection, including works by Cézanne and Matisse (fig. 19).[54]

The growth of these new private collections proved beneficial for American Post-Impressionists. John Quinn provided sustained support to Walt Kuhn and assembled an important group of his works. During World War I, he added American Post-Impressionist works by George Of, Patrick Henry Bruce, Ernest Lawson, and the Prendergast brothers to his growing collection. Maurice Prendergast's work was so

Fig. 20. Installation of Impressionist and Post-Impressionist Exhibition, 1921, Metropolitan Museum of Art, New York.

highly prized by the new modern art patrons that in 1915 Barnes and Quinn engaged in a bitter dispute over the sale of a group of his watercolors from an exhibition at the Carroll Galleries.[55]

Among the foremost patrons of the American modernists in this period was Ferdinand Howald, a wealthy mining engineer from Columbus, Ohio. A visit to the Daniel Gallery in February 1914 sparked Howald's interest in American modernism. His first acquisition, a painting by Middleton Manigault, led to a succession of purchases from the Daniel Gallery. Howald's collection, comprising one of the single largest concentrations of American Post-Impressionism, attested to his considerable role as a patron of living American artists.[56]

While private patronage of modern art flourished in the teens, institutional support for the artistic vanguard lagged behind the achievements of commercial galleries and individual collectors. The Metropolitan Museum of Art's acquisition of a painting by Paul Cézanne in 1913 remained an isolated instance of institutional investment in modernism. It would be nine years before the Detroit Institute of Arts in 1922 purchased Matisse's *Window* (1916) and van Gogh's *Self-Portrait* (1887) with city appropriations.[57] The Metropolitan Museum resisted pressure to display or purchase other European or American Post-Impressionist paintings until 1921, when the Museum finally mounted its first *Exhibition of Impressionist and Post Impressionist Painting* (fig. 20).[58]

Museums and official art societies outside Manhattan proved more receptive to sponsoring modern art exhibitions at a relatively early date. In cities from Montreal to Detroit, exhibitions of Canadian, American, and European modernism were presented under the auspices of official arts organizations. Nevertheless, no museums acquired significant examples of European or American modernism before 1920.

During the twenties, museums began to display and acquire modern art with greater frequency. The Société Anonyme, founded in 1920, circulated vanguard exhibitions to such notable institutions as the Brooklyn Museum and the Worcester Art Museum. The Newark Museum, which had displayed Max Weber's Cubist abstractions in 1913, consistently exhibited and acquired contemporary American art.[59] The Phillips Memorial Collection opened in Washington, D.C., in 1921 to serve as a "museum of modern art and its sources." In December 1922, the Commonwealth of Pennsylvania granted a charter to Albert Barnes's Foundation in Merion. The Art Institute of Chicago received the Helen Birch Bartlett Memorial Collection of French Post-Impressionist paintings in 1926, while on the west coast, William Preston Harrison made the first of a series of modernist donations to the Los Angeles County Museum. Finally, in 1927, the Detroit Institute made a major acquisition of American Post-Impressionism with the purchase of Maurice Prendergast's *Promenade* from the final New York auction of the John Quinn collection.[60]

American museums absorbed Post-Impressionism as modern art gained institutional recognition. The establishment of the Museum of Modern Art in 1929 signalled the final acceptance of European Post-Impressionism. The Museum's founders owned significant collections of Post-Impressionist painting. Moreover, the Museum's inaugural exhibition in 1929 featured Cézanne, Gauguin, Seurat, and van Gogh, the masters of nineteenth-century Post-Impressionism.

American Post-Impressionism achieved comparable institutional status with the gift of the Ferdinand Howald collection to the Columbus Gallery of Fine Arts in 1931. Within a year the Art Institute of Chicago accepted the Arthur Jerome Eddy Memorial Collection. With this succession of major donations of modern art, both European and American Post-Impressionism entered American museum collections a quarter century after the advent of modernism in North America.

# Notes

[1] Roger Fry, "The Post-Impressionists," *Manet and the Post-Impressionists* (London: Grafton Galleries, November 8, 1910-January 15, 1911), pp. 12-13. C. J. Holmes reiterated Fry's contention: "Post-Impressionism, if we trust its exponents, has become a 'movement' all over Europe and in America...." See C. J. Holmes, *Notes on the Post-Impressionist Painters: Grafton Galleries, 1910-1911* (London: Philip Lee Warner, 1910), p. 38.

[2] John I. H. Baur, *Revolution and Tradition in American Art* (New York, Washington, and London: Frederick A. Praeger, 1967), p. 84.

[3] Milton W. Brown, *American Painting from the Armory Show to the Depression* (Princeton, N.J.: Princeton University Press, 1972), pp. 43-44.

[4] Fry, "The Post-Impressionists," pp. 7, 9. According to Benedict Nicholson, Fry himself preferred the term "Expressionism." See Benedict Nicholson, "Post Impressionism and Roger Fry," *Burlington Magazine* 93 (January 1951): 12; Roger Fry, "A Postscript on Post Impressionism," *The Nation* 8 (December 24, 1910): 536-537. Fry's definition of Post-Impressionism also encompassed the Pre-Cubist paintings of Pablo Picasso.

[5] F. J. M., Jr. [Frank Jewett Mather], "Art: Old and New Art," *The Nation* 96, no. 2488 (March 6, 1913): 241.

[6] See Gertrude Stein, *The Autobiography of Alice B. Toklas* (New York: Vintage Books, 1960 [originally published 1933]); James R. Mellow, *Charmed Circle: Gertrude Stein & Company* (New York: Avon, 1974); and *Four Americans in Paris: The Collections of Gertrude Stein and Her Family* (New York: The Museum of Modern Art, 1970).

[7] See Alfred H. Barr, *Matisse: His Art and His Public* (New York: The Museum of Modern Art and Boston: New York Graphic Society, 1974), pp. 103-104, 116-117.

[8] William Innes Homer, *Alfred Stieglitz and the American Avant-Garde* (Boston: New York Graphic Society, 1977): 87; *The New Society of American Artists in Paris, 1908-1912* (Flushing, New York: Queens Museum, February 1-April 6, 1986).

[9] Irene Gordon, "A World Beyond the World: The Discovery of Leo Stein," *Four Americans in Paris*, pp. 24-25.

[10] See Hedley Howell Rhys, *Maurice Prendergast, 1859-1924* (Cambridge, Massachusetts: Harvard University Press in association with The Museum of Fine Arts, Boston, 1960), p. 63.

[11] "'The Eight' Stir Up Many Emotions," *Newark Evening News*, May 8, 1909, sec. 2, p. 4. See also Judith Zilczer, "The Eight on Tour, 1908-1909," *The American Art Journal* 16, no. 3 (Summer 1984): 20-48.

[12] Homer, *Alfred Stieglitz and the American Avant-Garde*, pp. 58-60; Barr, *Matisse: His Art and His Public*, pp. 111-114.

[13] Homer, *Alfred Stieglitz*, pp. 58-60; Barr, *Matisse: His Public*, pp. 82-83, 112; Lucile M. Golson, "The Michael Steins of San Francisco: Art Patrons and Collectors," *Four Americans in Paris*, p. 43.

[14] Homer, *Alfred Stieglitz*, Appendix I: Exhibitions at 291, pp. 296-297.

[15] W. H. Fox, "'Eight Painters' Work Gives Shock to Many," *Indianapolis News*, January 9, 1909, p. 4. Fox compared the more advanced work of the French Post-Impressionists with the paintings of "The Eight," whom he described as "conservative in the extreme." See Zilczer, "The Eight on Tour," p. 37. W. H. Fox's affiliation with Albert Roullier is documented through his correspondence on Roullier Galleries' letterhead with the head of the firm regarding the sale of woodcuts by B. J. O. Nordfeldt. (B. J. O. Nordfeldt Papers, Archives of American Art, Smithsonian Institution, Washington, D.C., microfilm roll D-166, frame 90.)

[16] Gelett Burgess, "The Wild Men of Paris," *Architectural Record* 27 (May 1910): 400-414.

[17] These books were included in the libraries of American collectors such as John Quinn and Walter Arensberg. See Judith Zilczer, "The Aesthetic Struggle in America, 1913-1918: Abstract Art and Theory in the Stieglitz Circle" (Ph.D. dissertation, University of Delaware, 1975), pp. 12, 36.

[18] James Huneker, *Promenades of an Impressionist* (New York: Charles Scribner's Sons, 1910). Huneker dedicated the book to his close friend Frederick James Gregg, a journalist who did a great deal to promote the modernist cause in the New York press.

[19] For documentation of many of these exhibitions, see Zilczer, "The Aesthetic Struggle in America," Appendix I: Checklist of American Exhibitions of Modern Art: 1907-1918, pp. 236-244.

[20] See Donald Gordon, *Modern Art Exhibitions: 1900-1916, Selected Catalogue Documentation*, 2 vols. (Munich: Prestel-Verlag, 1974).

[21] Harriet Monroe, "Nordfeldt Pictures Monday," *Chicago Tribune*, November 3, 1912, B. J. O. Nordfeldt Papers, Scrapbook I, Archives of American Art, Smithsonian Institution, Washington, D.C., microfilm roll no. D-167, frame 58.

[22] *Exhibition of Paintings by Bror J. Olsson Nordfeldt and the Chicago Society of Miniature Painters* (Milwaukee Art Society, December 28, 1912-January 15, 1913), Nordfeldt Papers, microfilm roll no. D-167, frame 60.

[23] Louis Mayer, untitled clipping, *Milwaukee Free Press*, December 22, 1912, Nordfeldt Papers, microfilm roll no. D-167, frame 60.

[24] Roberta K. Tarbell, *Marguerite Zorach: The Early Years, 1908-1920* (Washington, D.C.: Smithsonian Institution Press for the National Collection of Fine Arts, 1973), pp. 34-35.

[25] *An Important Art Event of the Season Is the Exhibit of the Recent Paintings of Mr. Alfred H. Maurer of Paris* (New York: Folsom Galleries, January 15-29, 1913), Archives of American Art, Smithsonian Institution, Washington, D.C., microfilm roll no. N-435, frames 67-74.

[26] Terry Fenton, *Modern Painting in Canada: A Survey of Major Movements in Twentieth Century Canadian Art* (Edmonton, Alberta: The Edmonton Art Gallery, 1978), pp. 16-18.

[27] "Post Impressionists Shock Local Art Lovers at the Spring Art Exhibition," *The Montreal Daily Witness*, March 26, 1913. I am deeply grateful to Louise Dompierre for sharing with me documentation on early modern art exhibitions in Canada.

[28] "Post-Impression: What Julius Meier-Graefe Really Thinks of It," *The Montreal Daily Star*, April 16, 1913.

[29] Corinne St. P. Lyman, "Avant-Propos," *Exhibition of Paintings and Drawings by John G. Lyman* (Montreal: Art Association of Montreal, May 21-31, 1913).

[30] For the definitive history of the Armory Show, see Milton W. Brown, *The Story of the Armory Show* (Greenwich, Connecticut: New York Graphic Society for the Joseph H. Hirshhorn Foundation, 1963). Analysis of the exhibition is based on Brown's catalogue raisonné, pp. 217-301.

[31] *The Letters of Roger Fry*, ed. Denys Sutton, 2 vols. (New York: Random House, 1972), I: 28, 311.

[32] See Judith Zilczer, *"The Noble Buyer": John Quinn, Patron of the Avant-Garde* (Washington, D.C.: Smithsonian Institution Press for the Hirshhorn Museum and Sculpture Garden, 1978), pp. 23-27.

[33] See Jack D. Flam, *Matisse on Art* (London: Phaidon, 1973), pp. 49-53.

[34] Judith Zilczer, "The World's New Art Center: Modern Art Exhibitions in New York City, 1913-1918," *Archives of American Art Journal* 14, no. 3 (1974): 2-7.

[35] Ibid. See also Judith K. Zilczer, "Modern Art and Its Sources: Exhibitions in New York, 1910-1925, A Selective Checklist," in *Avant-Garde Painting and Sculpture in America, 1910-1925*, ed. William I. Homer (Wilmington: Delaware Art Museum, April 4-May 18, 1975), pp. 166-170. For the Forum Exhibition, see also William C. Agee, "Willard Huntington Wright and the Synchromists: Notes on the Forum Exhibition," *Archives of American Art Journal* 24, no. 2 (1984): 10-15.

[36] See Walt Kuhn, letters to Vera Kuhn, January-February 1914, Walt Kuhn Papers, Archives of American Art, Smithsonian Institution, Washington, D.C., microfilm roll no. D-240, frames 644-697. For the Pittsburgh show, see Aaron Sheon, "1913: Pittsburgh in the Cubist Avant-Garde," *Carnegie Magazine* 56, no. 4 (July-August 1982): 12-18; Aaron Sheon, "1913: Forgotten Cubist Exhibitions in America," *Arts Magazine* 57, no. 7 (March 1983): 104-107. Separate catalogues exist for both the Detroit and Cincinnati exhibitions: *Exhibition of Modern Art* (Detroit Institute of Art, March 1-14, 1914); *Special Exhibition: Modern Departures in Painting, "Cubism," "Futurism," Etc.* (Cincinnati Museum, March 19-April 5, 1914).

[37] See Zilczer, "The Aesthetic Struggle in America," Appendix I: Checklist of American Exhibitions of Modern Art: 1907-1918, pp. 245-261. All subsequent references to exhibitions are documented in this chronology unless otherwise noted.

[38] See Elizabeth McCausland, "The Daniel Gallery and Modern American Art," *Magazine of Art* 44 (November 1951): 280-285.

[39] See Judith K. Zilczer, "Robert J. Coady, Forgotten Spokesman for Avant-Garde Culture in America," *American Art Review* 2, no. 6 (November-December 1975): 77-89. See also Judith Zilczer, "Robert J. Coady, Man of *The Soil*," *Dada/Surrealism* (University of Iowa, New York Dada issue, no. 14, January 1986).

[40] John Quinn's acquisitions from these galleries serve to document their role in importing European Post-Impressionism. See Quinn's correspondence with both dealers in the John Quinn Memorial Collection, Rare Book and Manuscript Division, New York Public Library, Astor, Lenox and Tilden Foundations.

[41] For the organization of the Arden Gallery show, see Judith Zilczer, "John Quinn and Modern Art Collectors in America, 1913-1924," *The American Art Journal* 14, no. 1 (Winter 1982): 60-61.

[42] See Zilczer, *"The Noble Buyer"*, p. 35.

[43] Barr, *Matisse: His Art and His Public*, pp. 104-105; Margrit Hahnloser-Ingold, "Matisse und seine Sammler" in *Henri Matisse* (Zürich: Kunsthaus, October 15, 1982-January 16, 1983), pp. 41-63.

[44] Douglas K. S. Hyland, "Agnes Ernst Meyer, Patron of American Modernism," *The American Art Journal* 12, no. 1 (Winter 1980): 64-81.

[45] Zilczer, *"The Noble Buyer"*, pp. 22-23.

[46] See Judith Zilczer, "Alfred Stieglitz and John Quinn: Allies in the American Avant-Garde," *The American Art Journal* 17, no. 3 (Summer 1985): 20-33.

[47] Brown, *The Story of the Armory Show*, Appendix 3: Indexes of Lenders and Buyers, pp. 311-312.

[48] Ruth L. Bohan, *The Société Anonyme's Brooklyn Exhibition: Katherine Dreier and Modernism in America* (Ann Arbor, Michigan: UMI Research Press, 1982), pp. 6-7.

[49] Brown, *The Story of the Armory Show*, Appendix 3: Indexes of Lenders and Buyers, pp. 311-312.

[50] Ibid., pp. 312-313.

[51] Arthur Jerome Eddy, *Cubists and Post-Impressionism* (Chicago: A. C. McClurg & Co., 1914), p. 11.

[52] Zilczer, *"The Noble Buyer"*, pp. 28-31.

[53] See Francis Naumann, "Walter Conrad Arensberg: Poet, Patron, and Participant in the New York Avant-Garde, 1915-20," *Philadelphia Museum of Art Bulletin* 76, no. 328 (Spring 1980): 6-10.

[54] Unpublished "Inventory and Appraisal of the Art and Literary Property Belonging to the Estate of the Late Arthur B. Davies," Ferargil Galleries Papers, Archives of American Art, Smithsonian Institution, Washington, D.C.; *The Estate of the Late Arthur B. Davies* (New York: American Art Association, April 16-17, 1929); Andrea Kirsh, *Arthur B. Davies: Artist and Collector* (West Nyack, New York: Rockland Center for the Arts, October 15-November 20, 1977).

[55] Quinn's acquisitions are documented in his two-volume Art Ledger, now in the collection of Thomas F. Conroy. For the dispute with Barnes, see Zilczer, *"The Noble Buyer"*, p. 36.

[56] Howald's purchases are recorded in the unpublished *Ferdinand Howald Catalog*, Columbus Museum of Art Archive. See E. P. Richardson, "The Ferdinand Howald Collection," in *American Paintings in the Ferdinand Howald Collection* (Columbus, Ohio: Columbus Gallery of Fine Arts, 1969), pp. 1-6; Mahonri Sharp Young, "Ferdinand Howald and His Artists," *The American Art Journal* 1 (Fall 1969): 119-128.

[57] The sequence of exhibitions and acquisitions cited herein is based on an unpublished national "Survey of Museum Acquisitions and Exhibitions of Modern Art Before 1935," conducted between 1977 and 1982.

[58] See Zilczer, *"The Noble Buyer"*, pp. 54-55.

[59] *A Survey: 50 Years of the Newark Museum* (Newark, New Jersey, 1959), pp. 11-13.

[60] Judith Zilczer, "The Dispersal of the John Quinn Collection," *Archives of American Art Journal* 19, no. 3 (1979): 18-20.

# Into The New Century: After the First Wave

WILLIAM C. AGEE

In a century marked by seemingly countless movements, it is all too easy to think of the modern artist as moving inexorably forward to increasingly complex styles and leaving earlier modes of exploration forever behind. Indeed, many modernist artists in America moved at a dizzying pace toward a Cubist-based, abstracting art prior to 1918. Thus, it may appear that Post-Impressionism was but a brief if crucial stage, a passing moment quickly discarded in favor of more advanced pictorial explorations.

If we were to adhere to this view, we would miss the fundamental and continuing importance of the lessons concerning color and structure absorbed by American artists from the masters of Post-Impressionism. The first engagement of the American artist with Post-Impressionist art, as directly mirrored in his own art, was in fact generally brief. However, the painterly values and principles, and the methods and techniques gleaned from Cézanne, van Gogh, Gauguin, Seurat, and Matisse were, more often than not, indelibly etched into the artist's pictorial consciousness. Frequently, they shaped his mature art for years to come or reappeared periodically throughout his career in various ways. Further, it was through these masters that Americans established the model on which they built their own tradition of modernist art. Perhaps most importantly, the example set by Cézanne and Matisse through their probity in the search for a pictorial truth according to the laws of painting itself has extended long and deep into the art of this country. Artists looked to them as models of sheer determination in forging ahead on the long and difficult road to creating the modernist picture befitting their own American experience. That example might have been best summarized by Matisse himself when, in 1936, he gave to the city of Paris the small Cézanne painting of three bathers he had purchased at great sacrifice in 1899. On the occasion of the gift, Matisse could state that the Cézanne "has sustained me spiritually in the critical moments of my career as an artist. I have drawn from it my faith and perseverance."[1] Just how Post-Impressionism continued to manifest itself in American art was apparent in diverse ways, some obvious, some subtle, as a study of selected artists in this exhibition will demonstrate. Yet it is clear that it was far more than a brief stage in the shaping of modern American art.

We need first consider those artists whose mature work consisted of a personal synthesis of Post-Impressionist elements. We might usefully begin, if only briefly, with Maurice Prendergast, the oldest artist included in this exhibition. His art built on, then expanded the stroke and color of Seurat and Signac, the solidity of Cézanne and the surface patterning that ultimately can be traced to Gauguin and the Nabis. In addition, his watercolors took as their model the open, fluid touch of Cézanne and the color of Signac. Prendergast's oeuvre is indisputably one of the great innovative achievements of modern American art. Its

roots remained, however, quintessentially Post-Impressionist even when his later art approached an abstract state.

If Prendergast's reputation is secure, then the nature and quality of Walt Kuhn's achievement after 1918 remains vastly underrated. Kuhn, too, forged a remarkably strong and personal art grounded in a Post-Impressionist synthesis of Cézanne's density and Matisse's patterning and color. His crucial role in organizing the 1910 Independents exhibition and the 1913 Armory Show served him well as a painter, but it has deflected our attention away from his considerable accomplishments as an artist. He is best known for his paintings of circus performers, which are convincingly painted, psychologically compelling portraits in the mode of the monumental portraits of Cézanne. At their best, we can see that no one confronted Cézanne more directly, absorbed him more thoroughly and made a more personal or intense art from his example (see fig. 1).

Far less well known, however, are Kuhn's still lifes. His *Interior with Green Plant* of 1924 is a bold composition with the leaves forming a complex pattern that moves our eye in successive leaps across the picture surface. The greens, blues, and reds are gradated and contrasted in an astonishing sequence of color harmonies that testify to Kuhn's early grounding in color when he first engaged Post-Impressionism. Similar chromatic arrangements, almost never commented on, are found in the paintings of the circus performers, forcing us to give new consideration to Kuhn as a painter of color. The intricate rhythms of *Interior with Green Plant*, as well as the color, call to mind the early Matisse, but here again Kuhn has transformed these sources into original art through his own painterly gifts.

No artist is a better example of how Post-Impressionism could be subsumed and then continue to reemerge in new and unexpected ways well after the first wave of modernism. Kuhn's still life *Peaches on Red Cloth* (fig. 2), executed in 1944, only five years before his death, serves as an example. Here the very substance of the paint and the tautness of the composition clearly recall Cézanne, but so tightly did Kuhn construct this painting that Cézanne's mountains, as much as his still lifes, come to mind. The freshness of conception breathes new life into a stock motif, as if Kuhn were approaching still life for the first time, without preconception. Kuhn infuses the rock-solid structure of the painting with a chromatic intensity that bespeaks his admiration for Matisse as well as Cézanne, yet Kuhn wrests from these rich hues his own pictorial summation of a lifetime of painting. This still life is as uncompromising and as assertive in its own way as the circus performers. It combines an almost naive directness that borders on the awkward (surely a distinctly American trait) with a startling sophistication. Kuhn was an artist who learned from the example of Cézanne and Matisse to trust, and to record, his most intimate feelings.

Fig. 1. Walt Kuhn, *Electra*, 1929, oil on canvas, 40 x 30 inches, private collection.

Fig. 2. Walt Kuhn, *Peaches on a Red Cloth*, 1944, oil on canvas, 20 x 24 inches, private collection.

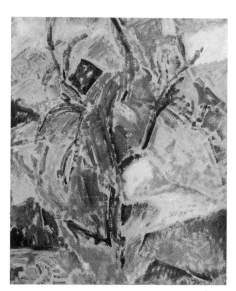

Fig. 3. Alfred Maurer, *Landscape,*
ca. 1914-1920, oil and gouache on paper,
21½ x 17½ inches, Salander-O'Reilly Galleries,
Inc., New York.

Alfred H. Maurer only recently has begun to again command the attention he deserves. Maurer was in Paris by 1897, and thereafter was one of the first Americans to assimilate Cézanne, Matisse, and Fauvism. His early Fauve landscapes of ca. 1907 are among the most brilliant and accomplished by an American artist. After returning to this country in 1914, Maurer resumed his engagement with Matisse and Fauvism in a series of landscapes (fig. 3) that extended well into the 1920s. These paintings, however, are far richer and denser than his earlier landscapes. Their impacted surfaces, while building on early Fauvism, extend his art into a mature, fully personal expressionism. Nor did Maurer abandon either his palette or touch when he turned to a series of Cubist still lifes in the late 1920s. On the contrary, Maurer imbued these works with a range of hues that can only be attributed to his early grounding in Fauvism. The Cubist still lifes are further distinguished by their rich, impastoed surfaces, in which each area contributes to the weight and balance of the picture, further evidence of his continuing dialogue with the sources of Post-Impressionist structure.

That art often develops in an incremental, cumulative manner is also evident in the strong, lingering ties to Post-Impressionism found in the painting of John Marin, Joseph Stella, Charles Demuth, and Arthur B. Carles, even as they worked in a more abstract mode. Marin's watercolor technique was indebted to Cézanne's fluid works in this medium, even in Marin's fragmented series of lower New York begun in 1912, which were related to the syncopated rhythms of Delaunay and the Futurists. Marin allowed untouched white paper to show through, giving the surface "breathing" space for the color to expand and contract, and acting as a color contrast and relief, all methods which derived from Cézanne. Yet, as with the other Americans we have looked at, the resultant art is in no way derivative in the perjorative sense, as we normally understand the term. Rather, it acknowledges that art, finally, comes from art, building on what has come before to create a personal expressiveness. The small oils of the Weehawken series, from ca. 1916, are similarly an intensification of Fauve color and stroke, as are many of Marin's later oils of the 1930s. Indeed, many of the Cubist-based watercolors of the '20s are as much carried by their brilliant Fauve-oriented color areas as they are by their linear structure.

The continuing role of Post-Impressionist technique is also evident in the Futurist paintings of Joseph Stella depicting the pulsating rhythms of urban life. Most especially in the dynamic Coney Island series, Stella incorporated a vivid palette that recalls van Gogh, Gauguin, and the Fauves, and the pointillist touch of Seurat, into the service of abstract art. Charles Demuth shifted his art to an investigation of Cubism in a series of watercolors in 1916-1917, a Cubism

remarked most often for its clean, precise architectonic lines. Yet just as important to these works is the isolation and centering of the image on the surface, the delicate nuancing of the color, all devices he had developed during his early encounters with Cézanne.

Arthur B. Carles, as much as any artist, established a bridge between early American modernism and post-1945 art. Carles believed in painting as, above all else, an art of color. In Paris in 1905, and then again from 1907 to 1910, Carles absorbed Cézanne and came to know Matisse. These two masters were the pivotal figures for Carles, as they were for so many Americans. From their example, Carles created the intense color and color application which informed his art until his career was ended in 1941 by a stroke. In the 1920s, Carles's color could range from the adjacent bands of hues in *Nude* (fig. 4), played against the almost negative space at center created by the figure, to the compact, densely painted *Landscape* (fig. 5), also of 1921. Or, later, in an untitled painting of 1930 (Corcoran Gallery of Art) Carles could apply the same type of loose and open color areas in the service of an almost purely abstract painting which makes minimal reference to a table and still life elements. In turn, Carles could then deploy his vivid color in the powerful *Compositions* of the mid- and late-1930s, filling

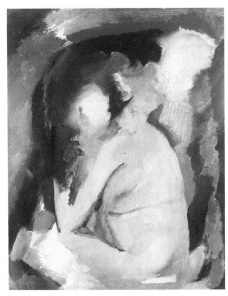

Fig. 4. Arthur B. Carles, *Nude in a Land-scape*, 1921, oil on wood, 16⅛ x 12⅞ inches, Hirshhorn Museum and Sculpture Garden, Smithsonian Institution.

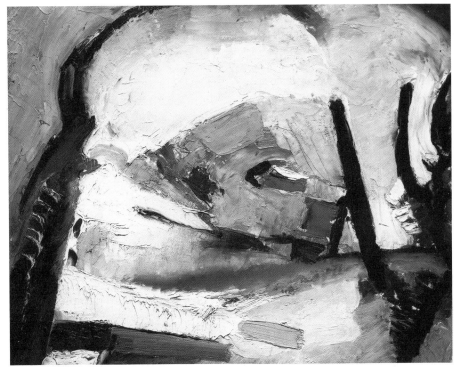

Fig. 5. Arthur B. Carles, *Landscape*, 1921, oil on wood, 12⅞ x 16⅛ inches, Hirshhorn Museum and Sculpture Garden, Smithsonian Institution.

the surface with swirling areas of color. These paintings contain an "all-over" intensity that parallels Gorky's great abstractions of the '30s and points directly to the painterly art of the generation that emerged in the '40s. By the end of his career, Carles had mastered color in a way equalled by few Americans. Yet as advanced as his color and his art were, we are always aware of their roots in his early experience with Post-Impressionism.

Other artists underwent periods of intense involvement with Cubist-based abstraction, then after 1917 sought a figurative style that would yield a personal and convincing art. Andrew Dasburg, for example, produced Synchromist-related abstractions from ca. 1914 to 1916, but thereafter found a model in Cézanne that better suited his temperament. If he was not an artist of the very first rank, he was able to extract from Cézanne the means to a sensitive and authentic art that continues to yield aesthetic rewards. A common view would have it that this pattern represents a pervasive "retreat" in American art from the "experiments" of a more "advanced" modernism. This view fails to take into account that international art followed a similar course after WWI. Most artists of the first generation of moderism, European and American, pulled back after 1918 from pursuing abstraction and its implications initiated prior to 1914. The war dramatically changed the course of art, as it did society; in its wake, artists sought a stable art embodying a more rational, deliberately constructed approach that would be more appropriate to the new world emerging from the ashes of the war. A full study of Cézannism in America during the '20s is beyond the scope of this essay and must await another occasion. However, it is partially in this world context that the development of a figurative style after 1918 by many Americans, most often using Cézanne as a model and guide, should be viewed. The matter is far too complex to see it simply as a manifestation of national isolationism.

Marsden Hartley at times remained the closest to Cézanne after 1918, forging a body of art that is one of this country's greatest. By 1908, Hartley's painting reflected the influence of van Gogh and Neo-Impressionism, and by 1912 he was well-acquainted with the art of Cézanne and Matisse. From 1912 to 1916, Hartley created his famous cubist abstractions, but, finally, his pictorial temperament was better suited for working with nature as the basis for his art. Thereafter, Hartley created intensely personal and powerful paintings. For the most part, we are only now finding out just how rich and complex this art was; far from a "retreat," Hartley shaped an independent expressionism virtually unique in American art. The path was uneven and arduous, and Hartley looked to artists as diverse as Picasso and Ryder as his guides. But above all, Cézanne, and to a lesser degree Matisse, were the sources that inspired Hartley in forging his later art.

In 1917, Hartley undertook a series of interior still lifes in Bermuda. We look past a still life on a table, through a window, to a view of the ocean. The motif is drawn from Matisse, as is much of the color, but the touch and structure are indebted to Cézanne. On a stay in New Mexico during 1918-1919, Hartley revived his engagement with the mountains and a plentiful sky, the motifs which had occupied him as early as 1907. The palette in these works is almost irridescent, and the mountain is often depicted through the parallel areas and bleeding planes of color long associated with Cézanne. Hartley was always a restless soul, often out of sorts and unhappy with himself, and his travels took him far and wide in the '20s and '30s. Such was his underlying affinity for the pictorial solidity of Cézanne that in 1925 he went to the south of France, first to Vence, then in 1926 to Aix-en-Provence itself. There, from 1927 to 1929, Hartley immersed himself in Cézanne, often painting the very motifs Cézanne had made famous, especially Mont Sainte-Victoire. Hartley constructed these paintings from the parallel strokes and open contours of Cézanne, in a manner apparently so literal that the originality of these paintings reveals itself slowly. They are, to be sure, an act of homage, but the results are startling. The touch is rougher, the image more condensed, the contrasts often sharper than those found in Cézanne; but finally it is the range of hue and the range of light effects that makes these works so original and such marvels of the art of painting. Hartley's colors can be almost florid, with multiple gradations of reds, pinks, yellows, blues and purples, an example of Matisse and Fauvism raised to new levels of expressiveness.

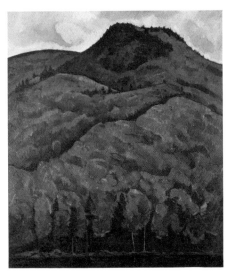

Fig. 6. Marsden Hartley, *Beaver Lake, Lost River Region*, 1930, oil on canvas, 35 x 30 inches, Collection of the Walker Art Center, Minneapolis.

When Hartley returned to the United States in 1930, he went to New Hampshire and continued his painterly encounters with the mountain motif. In *Beaver Lake, Lost Region* (fig. 6) of 1930 the Cézannesque touch remained fully in evidence, but the chromatic harmonies are of another order altogether. The Fauve palette is replaced by a cool range of hues, principally greens and grays, the surface permeated by myriad inflections of silver light. Even at the end of his career, he continued to confront and render massive mountains, now in his native Maine. In his paintings of Mount Katahdin of 1939-1940, the Cézannesque stroke is far less obvious, but the example of the monumentality of Cézanne, particularly the early Cézanne, still lies behind Hartley's art. In fact, most of Hartley's late landscapes, rendered with a certain deliberate crudeness, seem to emulate the density and weight, the solidity and durability of Cézanne, in which Hartley clearly found a continuing source of pictorial nourishment.

At an opposite pole, artists could retain painterly qualities learned from Post-Impressionism in far less apparent, but no less important ways, while their work remained squarely in the domain of Cubism and abstraction. Morgan Russell and Stanton Macdonald-Wright, the

Synchromists, were long relegated to a minor position in our art history because they seemed to have derived their abstract color compositions overnight from the example of Robert and Sonia Delaunay. We now know that their Synchromies, so named in early 1913, developed out of a careful study of the analysis of natural phenomena that Russell had begun as early as 1906. Russell had traveled to Paris and Italy in that year, and returned to Paris in 1908, where he met Matisse and began an intense study of Cézanne. Working closely with Andrew Dasburg, he made copies of a small Cézanne lent to them by Leo Stein. Through Cézanne, his single most important influence, Russell sought in 1910 to realize color sensations, modulations of warm and cold colors, and the abstract relationship of color in order to "create form through light to convey mass and solidity."[2] Rapidly, the figurative elements were removed, and the remaining abstract distillation of color and light then formed the core of the mature work. We should remember, however, that this process was far more difficult than it appears in retrospect.

The development of color in the art of Russell and Wright was fundamentally aided by the color principles established in the nineteenth century by Rood and Chevreul. These principles included the law of simultaneous contrasts, the law of harmony of analogous colors and the law of the harmony of contrasts. They were the same principles made famous by Seurat in the 1880s and later absorbed by Matisse and others who went through a Neo-Impressionist phase. Thus, the Synchromists and Orphists adapted nineteenth-century sources as a means to the pure, non-associative painting of the twentieth century. This pattern can be taken as paradigmatic of a larger pattern, of just how Post-Impressionism's touch, pattern, and structure, as well as color, were extended by American artists well into the twentieth century in the service of new art.

Although not a Synchromist, Patrick Henry Bruce used the same color principles to create an abstract art after 1912. Bruce was in Paris by early 1904, but it was not until 1907 that he began to absorb Post-Impressionism. He met Matisse at this time, and was a member of Matisse's school when it opened in January 1908. Matisse urged Bruce to study Cézanne, whom he called the "father of us all." By 1910, Bruce undertook what amounted to a three-year apprenticeship to Cézanne. Bruce saw Cézanne through Matisse's eyes, and Matisse's high-keyed color permeates Bruce's still lifes of 1910-1912, which were built on Cézanne's ordered and structural forms. Bruce concentrated on still life, on the immediate world around him, a practice deeply rooted in Cézanne. He focused on a single motif—a bowl with fruit, a vase with flowers, or at most two or three bowls around which were clustered a few pieces of fruit—studying intensely the problems of realizing separate but interrelated forms. Bruce looked closely to

Cézanne for multiple compositional formats: a "close-up" focus, tilted table planes, and high viewpoints to anchor forms more securely to the picture surface, devices which Matisse also used in his still lifes at this time. So, too, the facture of Bruce's paintings—open contours, planes bleeding into adjacent planes, and the modulation of planes through changes of hue as well as value—ultimately are dependent in Cézanne. However, it was Matisse's example that instilled Bruce's painting with the rich, tactile embodiment of color, the hallmark of Bruce's art throughout his life. Matisse's teachings, stemming from his innate sense of the chromatic substance of painting, indelibly shaped Bruce's approach. Bruce absorbed Matisse's lessons of selecting color equivalents from the motif and of carefully applying them so that each color modified the next and was modified in turn by new touches, until he had established a full, unifying color harmony over the entirety of the surface. Through this process, which demanded constant and exacting adjustments of color, Bruce constructed a pictorial order based primarily on the supremacy of color. In the "foliage" paintings and the *Still Life with Tapestry* (page 70), the color is embodied in a dense, almost abstract curtain of pigment that has no real precedent in either Matisse or Cézanne.

From 1912 to 1916, through the stimulus of Robert and Sonia Delaunay, Bruce extended his love of color to a Cubist-based abstraction to capture the dynamics of the modern city. In 1916, Bruce undertook his monumental *Compositions* (Yale University Art Gallery), which were based on the movement and color of the Bal Bullier, a fashionable dance hall in Paris frequented by artists. These abstractions were a modern version of the cafe-concert scene made popular by Manet, Degas, Toulouse-Lautrec, Seurat, and the early Picasso. The *Compositions* demonstrated Bruce's confidence in the power of color, for they are constructed by a myriad blend of hues and shifting planes, each painstakingly painted and repainted, adjusted and readjusted. The method stems directly from his still lifes of 1910-1912, now elevated to a grand abstract style in which a panoramic view of an interior becomes the motif.

The course of these works was from a Simultaneist, almost Futurist interpretation of multiple and overlapping planes representing countless figures, sights, sounds, and colors, to a more reductionist, orderly and stable geometry with clearly defined, discrete forms in the last two paintings of the series. In this progression, Bruce became one of the first artists to define the move to the classicizing art that became widespread after 1918. From these last *Compositions*, Bruce distilled the three-dimensional elements such as triangular blocks, wedges and half-cylinders that became the basis for the purist still lifes that occupied him from ca. 1917 until the end of his life. Although they are geometric, hard-edge paintings, they clearly continue Bruce's earlier

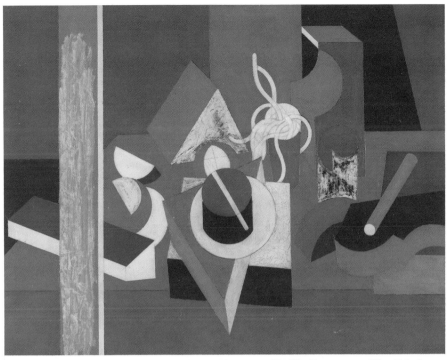

Fig. 7. Patrick Henry Bruce, *Peinture/Nature Morte*, ca. 1921-22, oil on canvas, 35 x 46 inches, The Museum of Fine Arts, Houston, gift of the Brown Foundation.

fascination with still life and take as their model the monumental still lifes of Cézanne that Bruce had studied so carefully (fig. 7). Like Cézanne, he strove to create a tightly constructed painting through a variety of viewpoints, an exacting placement of objects, and the ceaseless interplay of color chords. Here, as earlier, Bruce focuses on the immediate studio world around him. In more modern terms, these paintings seek to fulfill Cézanne's dictum that when "color is at its richest, form is at its fullest."[3] The cumulative, evolutionary nature of Bruce's painting (and, indeed, of many Americans who extended their training in Post-Impressionism to their mature art) is evident in the palette and color usage of the geometric still lifes, which are based on the color principles originally learned from Cézanne and Matisse. They share a deep affinity in the method of construction and in the relationship of the color planes with the early Fauvist-Cézannesque works and with the *Compositions*. The color volumes are more architectonic, but the hues themselves and their method of placement find their ultimate source in the earlier work.

A continuing fascination with color and color structure also marks the art of Morton Livingston Schamberg. Although he is best known for a 1917 Dada-related assemblage of a plumbing trap entitled *God* (Philadelphia Museum of Art, Louise and Walter Arensberg Collection) and for two paintings of machine imagery, Schamberg's art was a sustained achievement in color painting. He traveled frequently in Europe from 1904 to 1909, and in a crucial trip to Paris in 1908-1909, he rapidly absorbed the Post-Impressionist art of Cézanne, van Gogh, Gauguin, Matisse, and Derain, influences which were intensified after returning to this country. Further, Schamberg's quest for a strongly

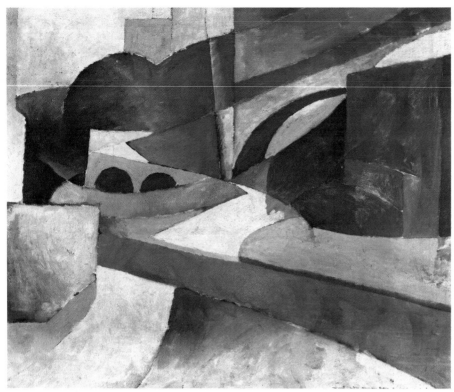

Fig. 8. Morton Livingston Schamberg, *Landscape (with Bridge)*, 1914, oil on canvas 26 x 32 inches, Salander-O'Reilly Galleries, Inc., New York.

patterned and structured art was influenced by Leo Stein, whom he met through Walter Pach. Stein equated the solidity of Italian Renaissance art with that found in Cézanne, stating "sufficient art is where composition and construction coincide."[4] From mid-1909 on, Schamberg's art moved toward a distinctly structural type of painting supported by a strong and vivid color sense, while concentrating on landscapes and portraits. By 1912, his color and structure incorporated the lessons of Cézanne, van Gogh, and Gauguin and an increasing appreciation of Matisse. At the famous Armory Show, Schamberg's exposure to Cubism and Matisse's color and design was heightened, and prepared him for a series of Cubist figures and landscapes (fig. 8).

These paintings of 1913-1915 are, above all, high points in the evolution of color painting in America. The hues are vivid and idiosyncratic; they are applied with a feathered, bleeding stroke, or as dense, impacted surfaces, both methods stemming from the art of Cézanne and Matisse. Less apparent, however, is the rich color of his machine paintings done in 1916. Yet even in the most highly distilled of these images, we find a rich array of gradated colors. However, his continuing passion for color bursts free in the recently discovered machine pastels, also of 1916. In these exquisite works, Schamberg's color reaches new heights in a series of chromatic arrangements that range from coal black and brassy red, to turquoise and pink, to light blues and yellows. In addition, the extreme clarity of the machine works is a modernist updating of Stein's belief concerning composition and construction.

Stuart Davis, the youngest artist in the present exhibition, was a major force in American art for over forty years. He was, indisputably, one of our most accomplished and influential modernists, capturing the spirit of the modern city with his own personal brand of Cubism. He had been profoundly affected by the Armory Show, which caused him to resolve to become a modern artist. In particular, he was most stimulated by van Gogh, Gauguin, and Matisse, and then later by Seurat and Cézanne. His paintings from 1914-1920 were informed by the texture and stroke of van Gogh, and the vivid hues of Matisse and Gauguin, as well as van Gogh. "They used color in a creative instead of a descriptive way, and this free color invention was easy for me to understand,"[5] he later remarked. This "color invention" remained with Davis throughout his life, for his mature paintings were marked by a brilliant and animated palette. His syncopated color rhythms were a crucial means of clarifying spatial definitions and relations. His love of the texture of paint was also apparent in later years. For although he was a "hard-edge" painter, Davis loved to distinguish his surfaces with varying layers of paint, always leaving clear evidence of his hand. It is also apparent that the planar structure of Davis's work, especially in certain paintings done in Gloucester in 1916 and in works of the mid-'20s, was influenced by Cézanne.

Seurat was an important artist for Davis, but it was not Seurat's color, as one might expect, but his space that captured Davis's attention. From Seurat, Davis learned, as he later described it, that "you could think about space as freely as you could about color. . . .[Seurat's] vision of objects in an environment of space taught me a great deal— and still does."[6] It was from the linear geometries of Seurat that Davis was led to Cubism, which he saw as continuing Seurat's sense of carefully analyzed and delineated space. Davis's mature art was predicated on establishing a distinct armature of drawing in a series of configurations that formed the space and structure of the painting. It is not hard to see how the precise graphic rendering of Seurat's paintings, filtered through Cubism, continued to serve as a model for Davis.

No artist was a more articulate or effective spokesman for modernism in this country. Through published statements and his public visibility Davis argued that modernist art was the most appropriate art for present-day America. Thus, he helped foster a sense of the modernist tradition in American art, and held out the idea that this tradition had universal validity. At a time when American art was mired in provincial regionalism, Davis insisted on the primacy of art itself. Several notes from his unpublished papers of 1940-1941 speak eloquently of his longstanding concerns, telling us how he continued to hold the masters of Post-Impressionism as models:

> Why are Cézanne's pictures better than Bougereau? Because their configuration expresses a greater awareness of the real world, an analytical under-

standing of it instead of a passive reflection of it.[7]

Art develops historically but its qualitative identity is constant. A Seurat is just as good at any point in the universe as in Paris and at any time.[8]

The work of Lautrec, for example, is not primarily interesting to us because it contains information about the night life of Montmarte in the 1890's, but because he found ways to integrate his emotional responses to life in terms of art.
   Similarly Seurat's "Grande Jatte" does not move us because of the light it sheds on the costume and habits of the bourgeoisie of that time, but because he found ways to organize his responses to the color-space aspects of it.[9]

Finally, he unequivocally stated his insistence on the necessity of the modernist tradition:

The American artist has recourse to all art tradition but must make a choice of the one most suited to contemporary needs. This must be the classic and objective tradition of Modern French art.[10]

For more than four decades, Davis demonstrated the continuing vitality of this tradition by transforming it into a twentieth-century American art that could capture his personal vision of the modern American experience.

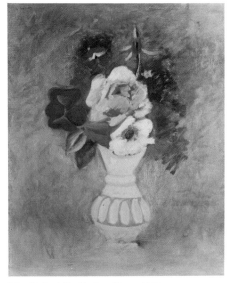

Fig. 9. Arshile Gorky, *Vase of Flowers*, ca. 1928, oil on canvas, 20 x 16 inches, private collection, New York.

The impact of Post-Impressionism moved deeper into American art than even the broad boundaries of this exhibition can suggest. How Cézanne and Matisse have impressed themselves on our art from 1940 to the present day would demand a study of its own. To be sure, specifically Post-Impressionist qualities become difficult to isolate after a certain point because they became so ingrained in the collective painterly vocabulary. But we can suggest some of the ways Post-Impressionism made itself clearly and distinctly felt on the generation of artists born after 1900, whose art underwent its formative stages and first maturity in the late '20s and early '30s. Foremost among them would be Arshile Gorky (1904-1948) who, in effect, aspired to absorb and recapitulate the history of modernism as he viewed it. After early Impressionist essays, he set his sights on mastering Cézanne and undertook a discipleship that was only rivaled in intensity by Patrick Henry Bruce. After Cézanne, he underwent a deliberate apprenticeship to Picasso in the 1930s. These paintings were formerly dismissed as too derivative, but we can now see how powerful they are, and how they embody Gorky's own painterly personality. As we look back, we can begin to discern the same in his Cézannesque pictures. We need only look at the *Vase of Flowers* (fig. 9), a sublimely beautiful painting of ca. 1928. These paintings do not try to hide their sources, and in them we can see Gorky developing his own color sense, his own touch and surface, his own design. From these elements there emerged his masterful paintings and pastels of the '40s, surely one of

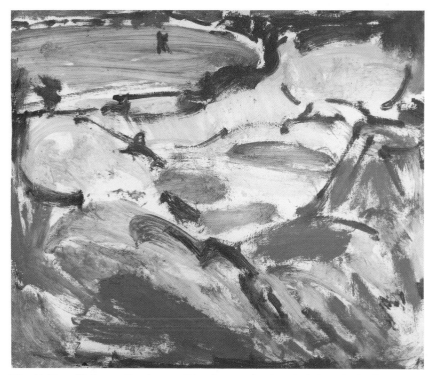

Fig. 10. Hans Hofmann, *Landscape*, 1941, oil on canvas, 25 x 30 inches, André Emmerich Gallery, New York.

this century's great achievements.

At the same time, two artists of decidedly different persuasions also experienced the impact of Cézanne. Burgoyne Diller (1906-1965) who was a student of Hans Hofmann in 1932-1933, developed the most important Neo-Plastic art in America. But it was only by absorbing the structural and volumetric concerns of Cézanne that he prepared himself to grasp Cubism and abstract art. So, too, the Precisionist and then hard-edged geometric paintings of Ralston Crawford (1906-1978) seem at first a great distance from the painterly concerns of Cézanne and Matisse. However, in later years Crawford spoke openly about the importance of these artists in his formative years: "Cézanne was a mountain in my young life, and still is."[11]

> When I was a student at the Barnes Foundation, with its really superb collection, I was most attentive to the work of Cézanne and Matisse. Matisse is an artist that I have thought of less frequently in recent years, but his expression was of tremendous importance to me. Perhaps these two artists, more than any others, influenced my development. Matisse's ideas about color stimulated my own searches. Cézanne deeply affected my entire attitude toward painting. I speak of the early influences, because the early ones really count.[12]

His experience is reflected in his intense colors and the clearcut planar divisions of his paintings.

Hans Hofmann (1880-1966), who was in Paris from 1904 to 1914, was a year older than Picasso. He had immersed himself in the same Neo-Impressionist and Fauve sources as did Delaunay, claiming that he had taught Delaunay about color. From what we know of his extant early work, it was only in the '30s that Hofmann began to produce consistently assured art. His Provincetown landscapes (fig. 10) of the time

are powerful late Fauve pictures, with landscape forms carried to an almost abstract state and the color pitch amplified to new levels. In these works, he began developing the late signature style, the paintings which for Hofmann meant "forming with color."[13] These glorious bursts of imploded color, which often move around and over an underlying geometric structure, might be seen as the last chapter in American art of a tradition that evolved from sources in Post-Impressionism. Yet the Fauve-based tradition continues to this day. The emerging work of newer artists such as Arthur Yanoff (born 1939), for example, openly embraces Fauve-type color and the watercolor techniques and imagery related to John Marin and Arthur Dove (fig. 11). His art is alive with early, hard-won accomplishment, while holding the promise of even richer achievements. It is clear that we are in the midst of an on-going tradition, begun many years ago, whose possibilities are still being defined at this moment.

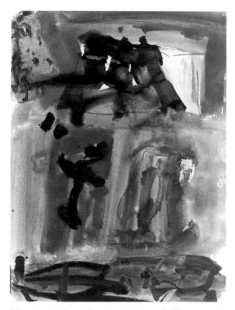

Fig. 11. Arthur Yanoff, *Andersen's Pasture, A Rainy Mood*, 1982, watercolor and gouache, 24 x 18 inches, collection of the artist.

## Notes

Rather than repeat in extensive footnotes material given elsewhere, the author urges the reader to consult the entries and bibliographies for information on individual artists. It should be remembered that the artists chosen for discussion in this essay are selective, not inclusive.

[1] See Alfred H. Barr, Jr., *Matisse: His Art and His Public* (New York: The Museum of Modern Art, 1951), pp. 39-40.

[2] For more on this matter, and for how the principles were applied, see William C. Agee, *Synchromism and Color Principles in American Painting, 1910-1930* (New York: M. Knoedler and Company, Inc., 1965).

[3] Ibid.

[4] Leo Stein, *Appreciation: Painting, Poetry and Prose* (New York: Crown Publishing, 1947), p. 153.

[5] John Ashberry, "Interview with Stuart Davis," in "Is Today's Artist with or Against the Past?" *Art News*, vol. 57 (Summer 1958): 43.

[6] Ibid.

[7] Stuart Davis Papers, Fogg Art Museum, Harvard University, Cambridge, Massachusetts, microfilm roll 3, August 11, 1940.

[8] Ibid., November 17, 1940.

[9] Ibid., April 1, 1941.

[10] Ibid., April 7, 1941.

[11] Ralston Crawford, Statement in *A New Realism: Crawford, Demuth, Sheeler, Spencer* (exhibition catalogue, Cincinnati Modern Art Society, at the Cincinnati Art Museum, March 12-April 17, 1941), p. 5. Reprinted in William C. Agee, *Ralston Crawford* (Pasadena, California: Twelvetrees Press, 1983), plate 6.

[12] Ralston Crawford, Statement in Edward H. Dwight, *Ralston Crawford* (exhibition catalogue, Milwaukee Art Center, February 6-March 9, 1958), pp. 11-12. Reprinted ibid., plate 1.

[13] Elaine de Kooning, "Hans Hofmann Paints a Picture," *Art News*, vol. 49 (February 1950).

# Artists in the Exhibition

# Thomas P. Anshutz

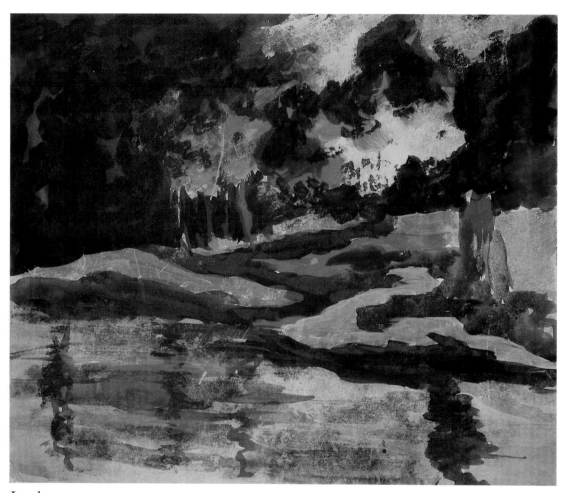

*Landscape*

Although primarily a realist committed to craftsmanship and truth to subject, Thomas Pollock Anshutz (1851-1912) played a role in the emergence of modern American art because of his early interest in color theory and his understanding of the underlying structure of a painting. He was also important for his liberating influence on his students, including the modernists Carles, Demuth, Saÿen, Schamberg, and Sheeler. In his classes he encouraged free paint application and experimentation with color while carrying on the program Thomas Eakins had established at the Pennsylvania Academy of Fine Arts. One obituary stated:

> It was the confirmed belief of Mr. Anshutz that no two students...ought to paint the same thing in the same way....He was the great exponent of personal expression, of leading a pupil along the lines of least resistance to a full development of his own individual powers....[1]

Anshutz was thoroughly trained in the academic fundamentals, having spent two years at the National Academy of Design in New York, starting in 1872. In Philadelphia, he worked under Eakins, first at the Sketch Club in 1875 and the next year in classes at the Pennsylvania Academy. In 1881 Anshutz began assisting his teacher, whom he succeeded as Instructor in Drawing, Painting, and Anatomy in 1886 after Eakins's forced resignation from the Academy. In 1909 Anshutz was made Director of the Pennsylvania Academy and in 1910 he became a member of the National Academy of Design.

By the late 1870s, Anshutz was taking photographs and using them as studies for his paintings.[2] When he travelled to France in 1892-93, he worked with William Bouguereau and Lucien Doucet at the Académie Julian, but he also was attracted to late Impressionist painting, particularly the work of Paul Albert Besnard, a fashionable portrait painter who used an Impressionist technique.[3] His own work became freer in brushwork and more brilliant in color. These traits can be seen in *Steamboat on the Ohio* (ca. 1896, Carnegie

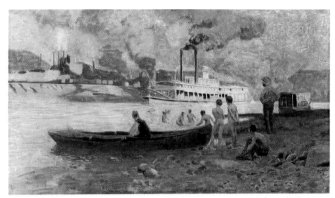

*Steamboat on the Ohio*, ca. 1896, oil on canvas, 27¼ x 48¼ inches (69.2 x 122.6 cm), Museum of Art, Carnegie Institute, Pittsburgh, Patrons Art Fund. Not in exhibition.

Institute), where the loose strokes of pure, brilliant orange and yellow are contrasted against complementary violet–a remarkably bold effect for American art at the time. Through color, Anshutz established space, form, and light, in some ways paralleling Cézanne in combining attention to surface design with analysis of spatial structure.

Anshutz often experimented with areas of bold, unmixed color in his pastels and watercolors. His understanding of color theory was deepened through his friendship with Hugh H. Breckenridge, with whom he taught at the Darby Summer School near his home in Fort Washington, Pennsylvania, for twelve summers starting in 1898. He made his own pastels to get the brilliant tones he wanted, and on a trip to Europe in the summer of 1911, he spent his days in Paris with H. Lyman Saÿen, visiting galleries, mixing pigments, and exploring color theory.[4]

Anshutz was fondly remembered by his students for his liberal attitudes, for encouraging them to paint directly, and for building up their confidence in their own ideas. He allowed the students to learn from each other, and claimed that he learned as much from his students as they from him. His interest in bold color and surface design was undoubtedly kept alive by his contact with younger painters. Anshutz was an important link between the era of

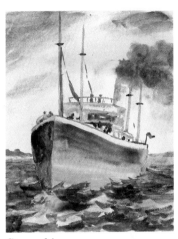

*Steamship*

Eakins and that of the Armory Show he did not live to see.

Barbara A. Wolanin

[1] "Thomas Anshutz Dies: Famed Art Educator," *The North American*, June 17, 1912.

[2] Ruth Bowman, "Nature, the Photograph, and Thomas Anshutz," *Art Journal* 32 (Fall 1973): 32.

[3] Sandra Heard Denney, *Thomas P. Anshutz, 1851-1912* (Philadelphia: The Pennsylvania Academy of the Fine Arts, 1973), p. 13.

[4] Adelyn D. Breeskin, *H. Lyman Saÿen* (Washington, D.C.: National Collection of Fine Arts, 1970), p. 17. There is a discrepancy between the Anshutz literature which places the beginning of the "Darby School of Art" in 1898, and the Breckenridge literature, which assigns the opening of the "Darby Summer School of Painting" to 1900. The fact that Anshutz was travelling in the summers of 1910 and 1911 suggests that the earlier date is correct.

# Ben Benn

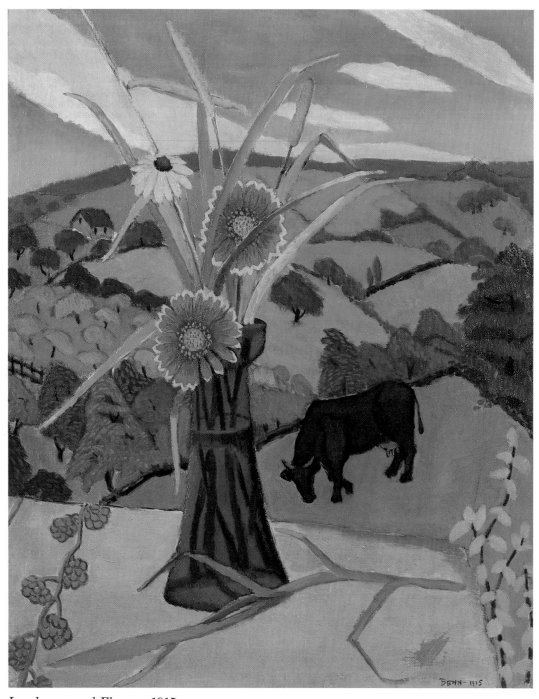

*Landscape and Flowers,* 1915

Ben Benn (1884-1983) studied at the National Academy of Design, beginning in 1904. Classmates included William Zorach and Leon Kroll. After four years at the Academy, Benn began to work on his own. While the Armory Show was a revelation, a 1915 El Greco exhibition at Knoedler Gallery was even more important:

> The Armory Show was, of course, exciting, and its introduction of geometry into painting had an intellectual influence, but it was the El Grecos— *that* really disturbed me. In him it was *the painting* that touched me, so intense, so fresh, done with a few colors. You feel the caress of the brush. When you look at a Greco you get the feeling that he has just laid the brush down.[1]

In the same year, Benn evolved his mature style, characterized by bold simplification, a limited use of intense color, and Cézannesque composition. At the time of the *Forum Exhibition of Modern American Painters*, Benn stated, "I put in my work only the selected essentials of my inspiration, desiring, above all, that my work shall be direct."[2]

Throughout his career, Benn paid extraordinary attention to the craft of painting, particularly as Post-Impressionism and Fauvism redefined it. Brushwork and structure are mutually reinforcing in his painting, and the intense color creates a reverbratory surface. At the same time Benn had a remarkable sensitivity to chromatic harmony. In later years Benn's example was comparable to Milton Avery's in fostering an appreciation for Matisse, although Benn's work has a linear quality and an expressionist tinge which Avery's does not.

Sidney Geist, who met the artist in 1933, has provided the following appreciation of Benn's methods:

> Benn once did a painting of a girl whose portrait I was modelling in clay. At the end of the session his canvas

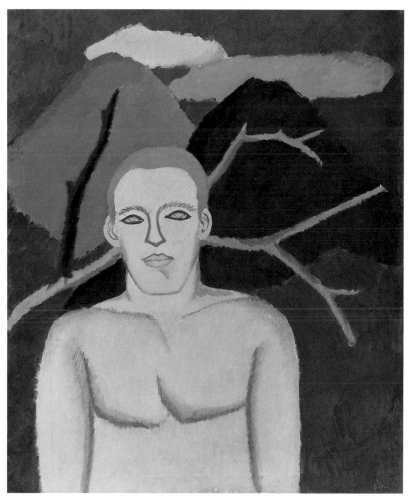

*White Torso*, 1917

was completely filled by large areas that already had a color harmony. At the same time I thought his approach sculptural because the surface seemed covered with planes. He completed the study in another sitting or two, hitting off a good likeness that was fresh and lively like everything he did. I remember a vigorous brushstroke on the underside of an arm that caused a drip of paint about an inch-and-a-half long; he didn't eliminate it. That was in 1933.

He worked in what I take to be a classical painting process, going gradually from "lean" to "fat." Benn placed great stock in his ability to manipulate paint—it was always a wonder to me that he could transform a canvas without muddying it. His attention to technique—and he was very knowledgeable about pigment, mediums, brushes—never constricted him, but helped him develop the dash and freedom of his mature period.

Benn admired the painterly artists like Veronese, Hals, and Manet; of the last he said that his painting had "good manners." The only art book in his house was one on El Greco, whom he thought the greatest of all. I can't remember speaking of it, but I'm sure he was much influenced by Cézanne, especially in his watercolors. He looked at everything.

For himself, painting was very much a physical act, a performance, a realm of wit and daring—but always in the service of a subject, and he would speak tenderly of the vase of flowers, the woman, or landscape that impelled him to pick up his brushes.

Peter Morrin

[1] Sidney Geist, "Ben Benn," *Art Digest* October 1, 1953: 26.
[2] Whitney Museum of American Art, *The Forum Exhibition: Selections and Additions* New York, 1983, p. 17.

# Thomas Hart Benton

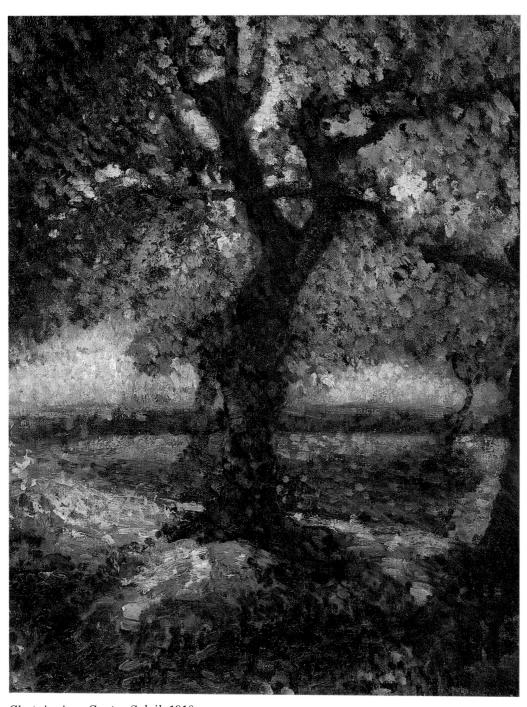

*Chataignier—Contre Soleil,* 1910

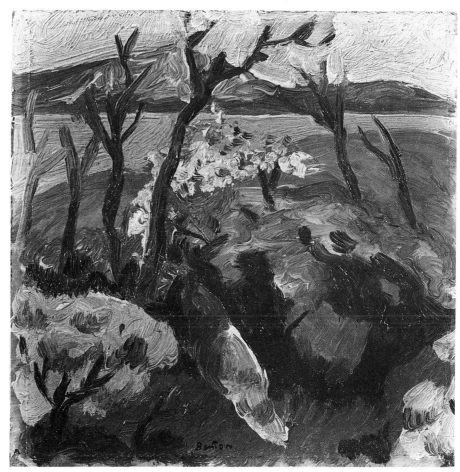

*Fauvist Landscape*, 1912

Having studied art at the Corcoran Gallery of Art in Washington, D.C., and the Art Institute of Chicago, Thomas Hart Benton (1889-1975) left for Paris in 1908. He had been living in Paris for more than a year when, in the late autumn of 1909, he met Stanton Macdonald-Wright, whom he later described as "the most gifted all-round fellow I ever knew."[1] By this time, Benton had become acquainted with fellow American expatriates George Carlock and John Thompson (who had the studio next door), both students of the Canadian color theorist Percyval Tudor-Hart, with whom Macdonald-Wright and Morgan Russell would study during 1911-13.

Thompson taught Impressionist techniques to Benton in the early winter of 1908-09; he also encouraged him to adopt a full-color palette. Carlock, "a disciple of Cézanne," first guided Benton in his study of Classical and Renaissance art in the Louvre, which Benton continued to explore with Macdonald-Wright. Benton also met another Cézanne enthusiast, the collector Leo Stein.

Benton soon began to experiment with Neo-Impressionism, particularly Signac's Pointillism. By the summer of 1910, he was working in the south of France, painting in a Neo-Impressionist stippling technique. Soon, however, he turned to an investigation of the art of Cézanne, which he found problematic. When his father cut off his support, Benton was forced to return home to Missouri in July 1911.

Struggling to find himself aesthetically, Benton was depressed and restless when he decided to move to New York City in June 1912. In 1913, he painted landscapes in a Fauvist palette, using Neo-Impressionist brushstrokes and areas of flat colors.

Soon, however, working on still lifes, he again focused on Cézanne's methods of design and began to break up "surfaces with gradated planes of color."[2] Benton's renewed interest in Cézanne was prompted by his friend Samuel Halpert. When Macdonald-Wright returned from Paris in late 1913, he further encouraged Benton's study of Cézanne.

Although he missed seeing the 1913 New York Armory Show because he was visiting his family in Missouri, Benton acknowledged the important impact of the many subsequent magazine articles and books on modern French art. Seeing reproductions of George Braque's work prompted him to "paint a series of flat, decorative still lifes in muted color," abstracting flowers from a seed catalogue and "stylizing them in decorative patterns."[3]

After absorbing the lessons of Post-Impressionism, Benton experimented briefly with Synchromist-inspired abstraction. He quickly rejected this stylistic departure, however, in favor of a return to representation and recognizable subject matter.

Gail Levin

[1]Thomas Hart Benton, *An Artist in America* (New York: Robert M. McBride & Co., 1937), p. 36.

[2]Thomas Hart Benton, *An American in Art: A Professional and Technical Autobiography* (Lawrence: The University Press of Kansas, 1969), p. 30.

[3]Ibid., p. 31.

# Oscar Bluemner

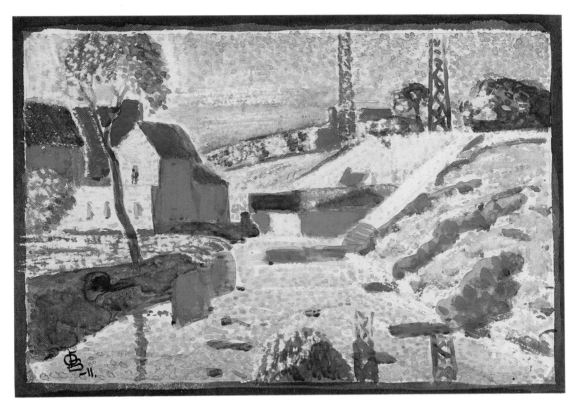

*First Painting Diary*, 1911-12

After graduating from Berlin's Königliche Technische Hochschule in 1892, Oscar Bluemner (1867-1938) left Germany to seek "in America...that freedom, especially from tradition... under which a new idea, in architecture if not in art, could take form all the better."[1] For more than a decade, he made an unsteady living as a freelance draftsman, first in Chicago at the World's Columbian Exposition and later in New York. During this difficult period, he found consolation in sketching trips throughout rural New Jersey and in visits to galleries showing Japanese prints, Impressionist and Neo-Impressionist paintings, and work by other strong colorists.

Between 1908 and 1910, Bluemner's interest shifted decisively from architecture to painting. Crucial encouragement came from Alfred Stieglitz, who welcomed him into the progressive fold of "291" and broadened his exposure to Post-Impressionism. Bluemner particularly admired Cézanne and van Gogh, whose respective color practices underlay his own initial efforts to couple formal order with bold personal expression. In 1911, he made his first oil paintings and began a diary that detailed his study of the color theorists Chevreul, Bezold, and Goethe.

Bluemner spent most of 1912 in Europe. He saw more work by Cézanne, van Gogh, and the Futurist innovators in Berlin, and showed his own paintings at Galerie Fritz Gurlitt. While summering in Paris, he inspected the pro-modernist galleries of Sagot, Druet, and Kahnweiler, and read important treatises by Signac, Denis, and Matisse. He also published an enthusiastic review of Cologne's Sonderbund survey of recent European art. His travels concluded in London with a careful tour of Roger Fry's second Post-

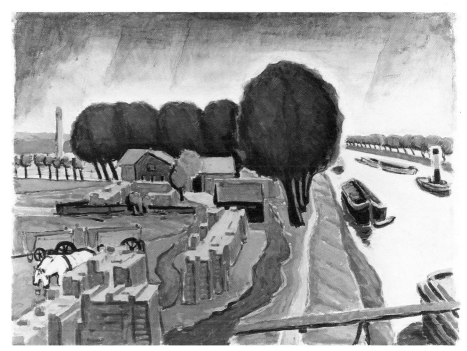

*Brickyard Canal (Güsen)*, 1913

Impressionist exhibition at Grafton Galleries.

Bluemner's familiarity with European developments prompted his involvement in New York's momentous Armory Show. Besides entering five paintings, he answered Stieglitz's call to defend the event against critical hostility and public dismay. Recognizing Matisse as heir to van Gogh, and Picasso as Cézanne's foremost beneficiary, Bluemner asserted the social and intellectual necessity of modernism's visual inventions: "In the light of evolution, of modern life, of science ...the new movement appears not at all revolutionary or arbitrary. On the contrary, it is a natural result, like all changes in art at any period have been logical forms into which the spirit of a time moulded itself."[2] New modes of expression were marked by the individualism, experimentation, and abstract thinking that characterized contemporary human endeavor.

Following the Armory Show, Bluemner returned to his studio to begin a series of oils that appeared in his first American one-man show at "291" (1915) and the select Forum Exhibition of Modern American Painters (1916). The paintings were based on his many earlier sketches of New Jersey towns, farms, canals, and factories. These recomposed, intensely colored landscapes signified a modern synthesis of nature and human industry, of matter and mind that found pictorial equivalence in conjugations of abstract and concrete form. That fundamental vision endured and evolved in Bluemner's art for another twenty years.

Jeffrey R. Hayes

[1] Oscar Bluemner, "Observations in Black and White," *Camera Work*: (January 1915), 51.
[2] Oscar Bluemner, "Audiator Et Altera Pars: Some Plain Sense On The Modern Art Movement," *Camera Work*, special no. (June 1913): 32.

# Jerome Blum

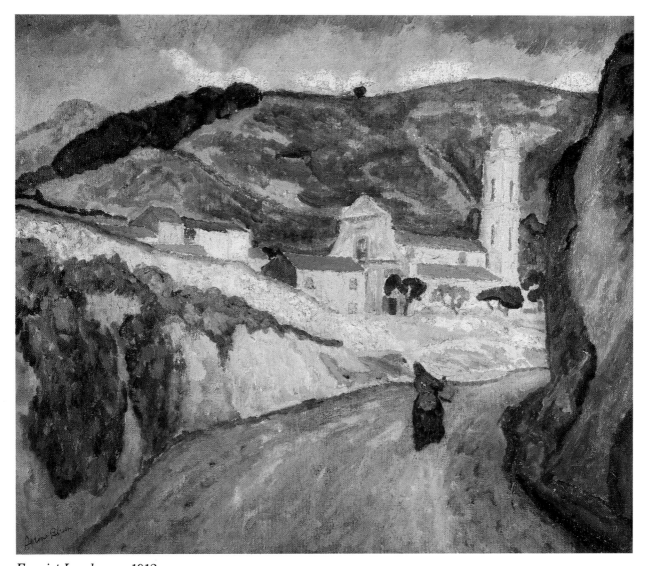

*Fauvist Landscape,* 1912

The details of the life of Jerome Blum (1884-1956) are obscure. Although he did not die until 1956, he lost his sanity in the 1930s, and his last twenty years were spent in a New York State facility for the mentally ill near Poughkeepsie.[1] The twenty-year hiatus in work and exhibitions contributed to his loss of reputation.

Blum was born in Chicago and studied at the Francis Smith Art Academy and at The Art Institute of Chicago. He was befriended by the Chicago writers Theodore Dreiser, Sherwood Anderson, and Ben Hecht. According to an exhibition introduction written by Dreiser, Blum's work from its inception was characterized by "an unappeasable desire for sunlight, color, romance."[2]

By 1906 Blum was in Paris, ostensibly to study with Luc-Olivier Merson at the Ecole des Beaux Arts. Blum participated in the Café du Dôme Circle with other expatriates like Marin and Maurer, and was soon befriended by Jo Davidson and Samuel Halpert, both of whom he assisted financially. Halpert, in particular, appears to have been a mentor and gave Blum lessons.[3] Halpert and Blum worked together in the summer at Chezy, near Paris, and Blum began to develop a Synthetist style, blocking in one landscape form against another. A chance encounter with a van Gogh painting in Auvers appears to have been another liberating influence.[4]

Blum showed portraits and landscapes in the Salon d'Automne in 1909 and 1910. In 1911 he was given an exhibition at the Thurber Gallery in Chicago, which was the occasion of a review by Harriet Monroe.[5] Blum's works may have been the first paintings in a Fauve palette to be seen in Chicago. In 1914 Blum assisted Frank Lloyd Wright in the decoration of Midway Gardens in Chicago. In later years he travelled almost continuously, painting in China, Cuba, Corsica, Tunisia, the South Pacific, the American West, and again in France. He is best remembered for his paintings of China.[6]

Blum's career is characteristic of Americans who responded to Post-Impressionism. Like many others, he learned to paint in full color from an English-speaking intermediary, rather than from a French modern master. His Fauvism is moderated by colors and compositions reminiscent of the Pont Aven school, and that too is typical of many of his North American contemporaries. The taste for the exotic, which occasionally also informs the work of Lyman, Morrice, Sterne, Webster, and the Zorachs, exemplifies a widespread Post-Impressionist search for strong local color in both a literal and a figurative sense, and reflects the primitivizing rejection of western culture current at that moment. His subsequent obscurity is shared by many other artists–Putnam Brinley, Carl G. Cutler, Louise Herreshoff, Harley Perkins, and Anne Estelle Rice, for example–whose work, like Blum's, did not evolve towards Cubist or Cézannesque models.

Peter Morrin

[1] Jerome S. Blum Papers, Archives of American Art, Washington, D.C.

[2] Theodore Dreiser, "Jerome Blum," Ainslie Galleries, Tanvazy, 1929.

[3] Jo Davidson, *Between Sittings, An Informal Autobiography* (New York: Dial Press, 1951), pp. 36-37.

[4] Frances Blum, "A Memoir," p. 1, Jerome S. Blum Papers, Archives of American Art, Washington, D.C.

[5] Ibid.

[6] "Jerome S. Blum, 82, U.S. Artist, Dead," *New York Times*, July 26, 1956.

# Hugh Breckenridge

*Study for Grotto,* 1916

Hugh Henry Breckenridge (1870-1937) was a versatile painter who was equally adept at academically correct commissioned portraits, freely-brushed jewel-like Post-Impressionist landscapes and still lifes, and later, in the 1920s, non-objective color studies. He refused to restrict himself to one mode of painting: "When I say that I do one thing today and another tomorrow, I don't mean that those things are unrelated; they play always upon the same instrument—that of color and form as the result of color...."[1]

His interest in art, developed through a Saturday drawing class in Leesburg, Virginia, became so strong that he left school at age fifteen. He enrolled at the Pennsylvania Academy of the Fine Arts in 1887, the beginning of a half-century-long association. During his first trip to Europe in 1892-93, made possible by a Cresson Travelling Scholarship, he studied at the French Academy with William Bouguereau, William Gabriel Ferrier, and Lucien Doucet, and spent much time at the Louvre. But it was the Impressionist art he saw in the galleries that most deeply affected him, and after his return he painted landscapes with free strokes of intense color. Breckenridge once said, "I must have been born an Impressionist."[2]

Back in Philadelphia, he began teaching at a school for girls and in 1894 was appointed the secretary of the faculty of the Pennsylvania Academy, where he conducted the Antique Class. In 1900, he and Thomas Anshutz, with whom he shared an interest in color theory, taught summer art classes in a barn in Darby, Pennsylvania.[3] Two years later, The Darby Summer School of Painting moved near Anshutz's home at Fort Washington. Anshutz died in 1912 but the school flourished until 1918. In 1920, Breckenridge opened his own school in East Gloucester, Massachusetts.[3]

Breckenridge always remained open to new ideas. A 1909 trip to Europe to check on the progress of Pennsylvania Academy students, including Carles and Saÿen, stimulated his interest in the work of the Post-Impressionists and Matisse. He had visited Alfred Stieglitz's "291" gallery in New York by early 1912, and he became an enthusiastic subscriber to *Camera Work*. He wrote to Stieglitz asking for photographs of Matisse's work and urged his students to see the Armory Show in New York.[4] In 1913, he let Arthur Carles share his studio in the Fuller Building on South 18th Street to paint nudes and still lifes. Their still lifes of this period, strongly inspired by Cézanne and Matisse, are very closely related and include many of the same objects. Carles wrote to Breckenridge many years later: "I always think of you a lot when I'm painting, for you are the one from whom I learned that color resonance is what you paint pictures with...."[5]

Breckenridge read widely on color theory and owned books by Chevreul and Rood as well as many books on Cézanne, Gauguin, and van Gogh.[6] He spoke often of "color resonance" and called Cézanne "perhaps the greatest painter during the modern revolution of changing forms."[7] His love of Cézanne can be seen in his *Study for Grotto*, in which small patches of pure and mixed shades of blue, violet, and green are contrasted with complementary reds, pinks, and ochres. Like Cézanne, Breckenridge established form through color changes, creating in this study an almost abstract all-over design by focusing on the rocks. The large finished version is much more vivid in color, suggesting that it was painted at a different time of day or that it represents a more deliberate manipulation of prismatic color.

Breckenridge showed his work all over the country, consistently winning prizes and serving on juries. His logbook shows that he sent many of his canvases to dozens of exhibitions. After his death his work dropped from sight until his estate became available to the public in 1967 and the high quality of his work once more became apparent.

Barbara A. Wolanin

[1] Margaret Vogel, *The Paintings of Hugh H. Breckenridge (1870-1937)* (Dallas: Valley House Gallery, 1967), p. 20.
[2] Gerald L. Carr, "Hugh Henry Breckenridge (1870-1937)," *American Art Review* 4 (May 1978): 95.
[3] Vogel, p. 13. She gives the date of 1900 for the beginning of the school, but the Anshutz literature places it in 1898. See Sandra Heard Denney, *Thomas P. Anshutz* (Philadelphia: Pennsylvania Academy of the Fine Arts, 1973), pp. 16-18.
[4] Wilford W. Scott, "The Artistic Vanguard in Philadelphia, 1905-1920" (Ph.D. dissertation, University of Delaware, 1983).
[5] Undated, unmailed latter, ca. 1931, Arthur Carles Papers, The Archives of American Art, Smithsonian Institution, Washington, D.C., roll 1052, frame 268.
[6] Carr, p. 122, n. 17.
[7] Carr, p. 98.

# Patrick Henry Bruce

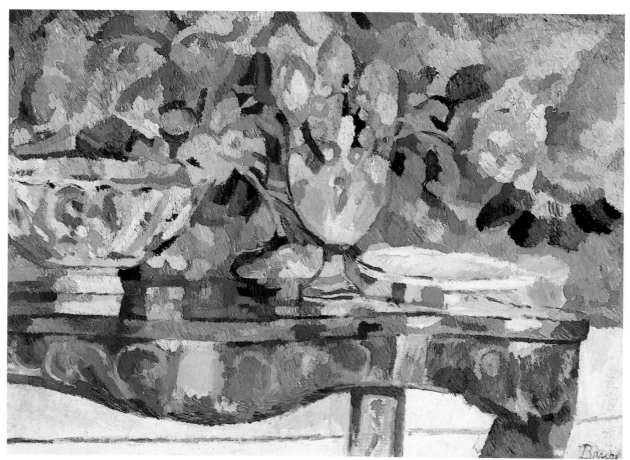

*Still Life with Tapestry,* ca. 1912

*Leaves*, ca. 1912

*Still Life*, ca. 1911

Patrick Henry Bruce (1880-1937) stands as an important early figure in the development of Post-Impressionist tendencies in modern American art. Certainly, no American studied Cézanne with quite the intensity and thoroughness of Bruce. A descendant of Patrick Henry, he was born in Campbell County in southern Virginia. His family moved to Richmond when he was a boy, and there he studied art from ca. 1898 to 1902. By early 1902 he was in New York, studying with William Merritt Chase, Kenneth Hayes Miller, and Robert Henri at the New York School of Art. He became friends with Edward Hopper and Guy Pène du Bois, and his art reflected the slashing, painterly style of Henri. However, like his fellow Virginian Thomas Jefferson, Bruce believed Paris was the seat of all culture, and he had settled there by late 1903 or January 1904. He lived in Paris for over thirty years, returning to the United States only in 1936, shortly before he took his life at the age of fifty-five.

Little of his work prior to 1907 remains, but it is clear from Bruce's letters to Henri that in Paris he did not immediately react to the newer art. Rather, his painting continued to reflect his former teacher's influence for the first two years. Through

Henri's introduction, Bruce met James Wilson Morrice shortly after arriving in Paris, and doubtless Morrice played an important role in turning Bruce's attention to Impressionist and Post-Impressionist art by the fall of 1906. He had met Gertrude and Leo Stein by late 1906 and began to frequent their salon in 1907. He exhibited two landscapes at the 1907 Salon d'Automne; by then his art was showing Impressionist influences, particularly that of Renoir. He met Hopper in Paris, and Hopper later credited Bruce with introducing him to Impressionism at this time.

Through Walter Pach, an important catalyst for American art, Bruce met Arthur B. Frost, Jr., who became his best friend. That same year, he met Matisse, who was to exert an enormous influence on him. Bruce was a member of the famous Matisse School when it opened on January 10, 1908. At the urging of Matisse, Bruce undertook what amounted to a three-year apprenticeship to Cézanne, whom Matisse termed the "father of us all." Bruce saw Cézanne through Matisse's eyes, and Matisse's color came to permeate Bruce's art as he rigorously pursued Cézannesque structure and paint application.

Working closely with Frost, Bruce devoted himself to still life and, like Cézanne, studied single and multiple

objects from every conceivable vantage point. By the fall of 1912, Bruce's painting, which demonstrates that art can be both derivative and good, had fused into a palpable fabric of tightly knit strokes and rich, high-keyed color. This period of his art culminated in the ornate color mosaic of table, tapestry, and still life in the *Still Life with Tapestry* of 1912, which took the lessons he drew from Cézanne and Matisse to a new pitch. In this painting, the first influence of Sonia and Robert Delaunay, whom he had met that spring, was evident in areas of swirling color. At this time Bruce exhibited regularly in both salons and was well known in Paris art circles.

Thereafter, Bruce's painting moved from Post-Impressionism to a full-blown modernism, first in works related to Orphic Cubism and then in his abstract color *Compositions* of 1916. In 1917-18, his work evolved into a mode of geometric still life. Although these paintings most immediately relate to late Cubist, purist tendencies, they ultimately, and deliberately, depend on the monumental still lifes of Cézanne and the rich, carefully composed color harmonies Bruce had learned from Matisse.

William C. Agee

# Charles Burchfield

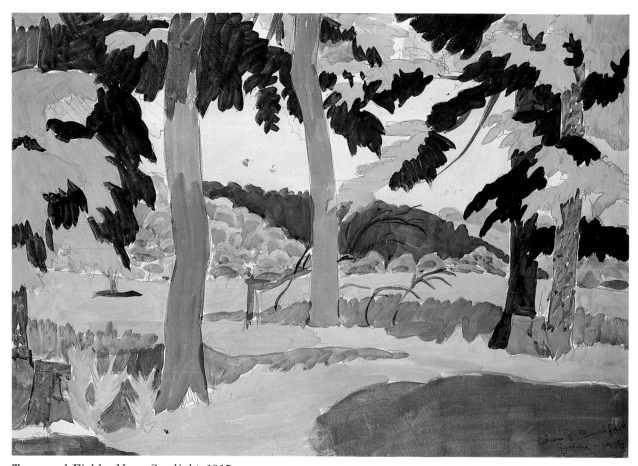

*Trees and Fields, Noon Sunlight,* 1915

The claims for the inclusion of Charles Burchfield (1893-1967) in this exhibition are based on a few works executed in 1915 and 1916. For most of his career he responded to impulses suggested by Oriental art, art nouveau, and symbolism. That inheritance, along with a profound pantheism and a visual hunger to record the moods of nature in his native Midwest, provides the departure points for much of Burchfield's varied career. In his last year of study at the Cleveland School of Art, however, Burchfield made several studies of the effects of full sunlight which approximate Fauvism in a startling manner. Decoratively and freely brushed, planar and luminous, these watercolors are an outgrowth of classes in design and illustration. They have much in common with poster schemes Burchfield entered in student competitions.[1]

"Conventionalize in broad masses,"[2] Burchfield wrote in a note to himself between 1912 and 1914. One means to this goal was a delimitation of color, as he explained later:

> I devised a simple formula. Everything was reduced to the twelve colors of the color wheel plus black and white, with minimum modifications. Thus sunlit earth would be orange; shadows on it, red-violet; sun-lit grass, yellow; shadows, blue or blue-green and so on. They were executed in flat patterns with little or no evidence of a third dimension.[3]

The resulting immediacy and economy of expression in works like *Trees and Fields, Noon Sunlight* detach these watercolors from the poetic and descriptive goals Burchfield's later works serve. Less personal and introspective, they answer Matisse's prescription for "that condensation of sensations which makes a painting."[4] The autonomy of compositional concerns, the avoidance of neutral tints, and the overall decorative qualities of these works did not satisfy Burchfield for long: "I have been missing the big phenomenal feeling of nature's moods—I have been looking solely for design and rhythm."[5] Nonetheless, the artist was later to assert that his mature work began in 1915, and he felt great nostalgia for this period all of his life.

Burchfield may have been aware of other artists working in a similar style. In December 1913, the Gage Gallery in Cleveland had a group show of E. Ambrose Webster, Carl G. Cutler, Charles Hovey Pepper, and Maurice Prendergast. Webster's special subject was the abstracting effect of glaring sunlight. In January 1913, William Zorach visited his Cleveland home, and may have called on his former (and Burchfield's favorite) teacher, Henry G. Keller, to report on his own experiments in Paris with full color painting. William and Marguerite Zorach exhibited in Cleveland in 1913 and 1914.[6] Certainly the Zorachs imparted a great deal of the new doctrine to Keller's former Munich Academy classmate, the Cleveland painter William Sommer, whose work strongly reflected Parisian developments by 1914. Whatever models may have been available to him, Burchfield's work of this era has strong continuities with the art of other American and Canadian artists of that moment.

Peter Morrin

[1] John I. H. Baur, *The Inlander: Life and Work of Charles Burchfield, 1893-1967* (Newark: University of Delaware Press, 1984), pp. 26, 27.
[2] Ibid.
[3] Ibid., p. 31.
[4] Henri Matisse, "Notes of a Painter," in Jack D. Flam, *Matisse on Art* (New York: E. P. Dutton, 1978), p. 36.
[5] Baur, p. 33.
[6] Roberta Tarbell, *Marguerite Zorach: The Early Years, 1908-1920* (Washington: Smithsonian Institution Press, 1973), p. 64.

# Arthur B. Carles

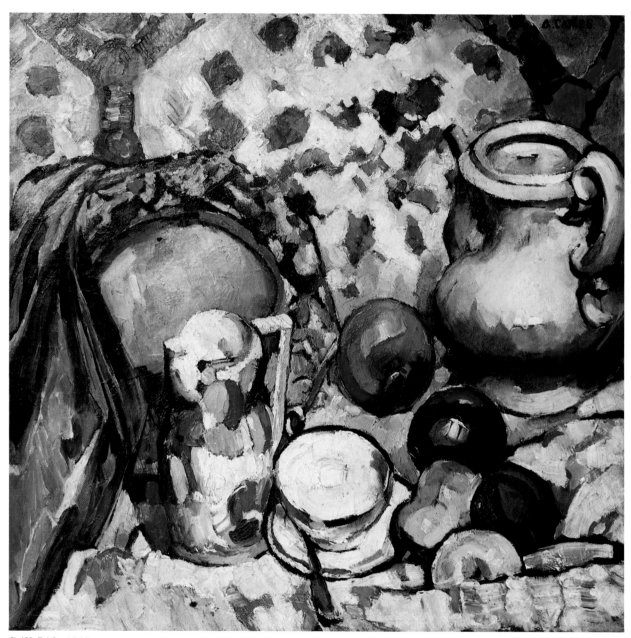

*Still Life*, 1913

"If there's one thing in all the world I believe, it's *painting with color*,"[1] Arthur Beecher Carles (1882-1952) asserted. The work of Cézanne and Matisse made a deep impression on him during his early years in France, and he remained a Fauve in his use of resonating color combinations for expressive effect.

When Carles attended the Pennsylvania Academy of Fine Arts between 1900 and 1907, many of his teachers, especially William Merritt Chase, Cecilia Beaux, Thomas Anshutz, Hugh Breckenridge, and Henry McCarter, encouraged his sensitivity to color and two-dimensional design. They also made him eager to see modern European art for himself. Through Cresson Travelling Scholarships, Carles was able to go abroad for the summer of 1905 and for a two-year stay in France in 1907 (which he extended through 1910).

Carles was in Paris at a time of great ferment in all the arts. He wrote that he had seen "a lot of Cézanne canvasses a great many times and became acquainted with their influences to painting,"[2] probably at the Cézanne retrospective at the 1907 Salon d'Automne and at Gertrude and Leo Stein's apartment. He was fascinated and puzzled by the paintings by Matisse and Picasso he saw at the Steins'. Although he knew Matisse and was later called a "student of Matisse," he was not actually in the Matisse class. His closest friend was Edward Steichen, and Carles went to live in Voulangis-par-Crécy-en-Brie, a little village outside of Paris where Steichen had a house. Carles painted the light on the French landscape and turned the plain Romanesque village church into a dramatic structure of vivid color. From Cézanne and early Matisse, Carles learned to build forms through color and to maintain a dynamic tension between the illusion of three-dimensional form and the flat surface design.

In 1909 and 1910, much of his energy was taken up with reluctantly completing a full-size copy of Raphael's *Transfiguration* for a

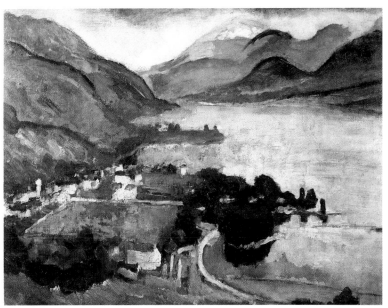

*The Lake, Annecy*, 1912

church in Philadelphia. After he got it installed early in 1911, he was free to explore color again through still lifes and portraits. Through Steichen, Carles had become part of the Stieglitz circle, and he had his first one-man exhibition at Alfred Stieglitz's "291" gallery in 1912. On a short trip to France in 1912, he visited Lake Annecy, making sketches that strongly recall Cézanne in their high viewpoint and patches of color. The vibrant contrast of warm violets with greens, related to early works by Matisse, became characteristic of Carles, as did the strong curves, which flow in space as well as on the surface. Two of his French canvases were exhibited in the Armory Show.

Back in Philadelphia, he painted nudes and still lifes in Breckenridge's studio, creating especially bold effects with pure color and pattern in his fruit still lifes, again based on Cézanne and Matisse. *Still Life* (1913) was one of several owned by Breckenridge. The nudes received acclaim at academic annuals across the country, and Carles was hired to teach the Saturday morning sketching class at the Pennsylvania Academy in 1917. In general, he did not move further in the direction suggested by Matisse's work until the 1920s.

Carles was an important spokesman for modernism in Philadelphia and in the early 1920s played a vital role in bringing three exhibitions of modern European and American art to the Academy. The theories on art he expounded in a 1913 article entitled "Nature and Life as Post-Impressionist Sees Them" sounded much like Matisse's: "Pictorial art is not so much a matter of imitation as of selection and arrangement. . . . Accuracy is an intellectual quality, while art is an affair of the emotions. . . .When an artist makes light and shade he spoils color. Paint lies flat."[3] It was not until the last years of his career, which was cut short in 1941 by a stroke, that Carles finally achieved his early aims, producing canvases which were amazingly prophetic of Abstract Expressionism.

### Barbara A. Wolanin

[1] Jo Mielziner, "Arthur Carles: The Man Who Paints with Color," *Creative Art* 2 (February 1928): 35.

[2] Rough draft of letter to John Trask, November 27th [ca. 1911], Arthur Carles papers, Archives of American Art, Smithsonian Institution, Washington, D.C., roll 1052 frame 265.

[3] "'True Art Emotional,' Carles Says," *Philadelphia Press*, July 21, 1913, p. 21.

# Emily Carr

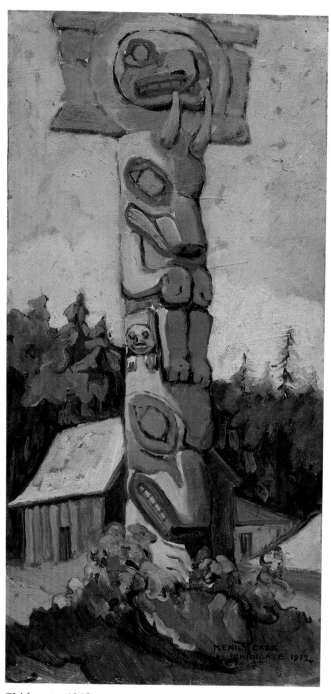

*Skidegate*, 1912

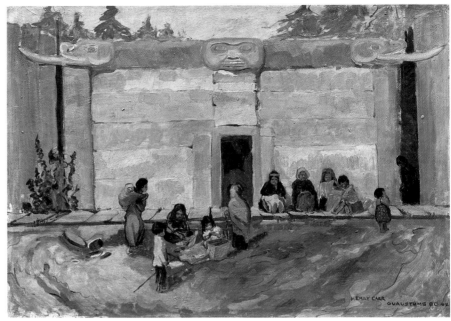

*Old Village of Guyasdoms*, 1912

Emily Carr (1871-1945), from the remote city of Victoria on Vancouver Island, is revered by Canadians as an author and painter. As early as 1911, two years before the Armory Show, she began to fuse the spirit of her native land with the sophistication of European modernism.

Carr studied from 1890 to 1893 with Arthur Frank Mathews at the California School of Art and Design, and in England from 1899 to 1904, but found both periods of study uninspiring.[1]

Armed with a letter of introduction to a "very modern artist named Harry Gibb," Emily Carr and her older sister Alice arrived in Paris in the early fall of 1910, Alice to study the city's history and Emily to pursue her art. "I wanted every moment of Paris for art..., to find out what the 'New Art' was about. I heard it ridiculed and praised, liked, hated. Something in it stirred me."[2] Her first month was spent as a student at the Académie Colarossi. Then she joined the private studio of the Scottish artist John Duncan Fergusson.

When Fergusson began to teach with the portrait painter Jacques-Emile Blanche at La Palette, he invited Carr to join him, and though her studies were interrupted by two long bouts of illness,[3] she undoubtedly absorbed much of the "new art" from Fergusson that winter. Marguerite Thompson attended La Palette during this time and met her future husband William Zorach there; Anne Estelle Rice, an American Fauve artist, was also associated with Fergusson's group.[4]

In late April of 1911, after a month-long trip to Sweden with Alice, Emily Carr was in Crecy-en-Brie, a little village outside Paris, painting landscapes in a class formed by Henry Gibb. She wrote of her mentor, "He was convinced as I that the New Art was going to help my work out west, show me a bigger way of approach."[5] Carr traveled with Gibb to St. Efflam in Brittany that summer.

The final six weeks of Carr's studies in France were with the New Zealand expatriate Frances Hodgkins at Concarneau in Brittany. Hodgkins was the first woman to teach at the Académie Colarossi and was there in the fall of 1910 when Carr was attending classes. A portrait and landscape painter, Hodgkins handled watercolor with a spontaneity and vibrancy which Carr found refreshing. In addition, their similar struggles as female artists in a foreign land with meager funds and few friends must have given Carr strength.[6]

The first of October marked the opening of the 1911 Salon d'Automne in which Emily Carr was represented by two paintings, *La Colline* and *Le Paysage*. The Salon included works by Matisse, Valadon, Marquet, Le Fanconnier, Leger, Duchamp, and Duchamp-Villon, as well as paintings by Marguerite Thompson and the Canadian James Wilson Morrice, a wealthy expatriate who had arrived in France in 1889.[7]

Carr returned to Canada, but felt that her new work was unappreciated. She continued to paint and exhibit, although sporadically. Using vigorous color and agitated forms, she captured the spirit of British Columbia in vibrant landscapes. Finally, in the late 1920s, she began to receive national attention.

Ruth A. Appelhof

[1] Edythe Hembroff-Schleicher, *Emily Carr: The Untold Story*, Saanichton, B.C. and Seattle, WA., 1978, p. 23. See also Emily Carr, *Growing Pains: The Autobiography of Emily Carr* (Toronto: Clarke, Irvin and Co., 1966), p. 26.
[2] *Growing Pains*, p. 215.
[3] Maria Tippett, *Emily Carr, A Biography* (Toronto: Oxford University Press, 1979), p. 89.
[4] Roberta K. Tarbell, *Marguerite Zorach: The Early Years, 1908-1920* (Washington; National Collection of Fine Arts, 1973), p. 58.
[5] *Growing Pains*, pp. 271-218.
[6] E. H. McCormick, *The Expatriate: A Study of Frances Hodgkins* (Wellington: New Zealand University Press, 1954), p. 251.
[7] Doris Shadbolt, *The Art of Emily Carr* (Toronto: Clarke, Irwin and Co., Ltd., 1979), p. 34.

# Andrew Dasburg

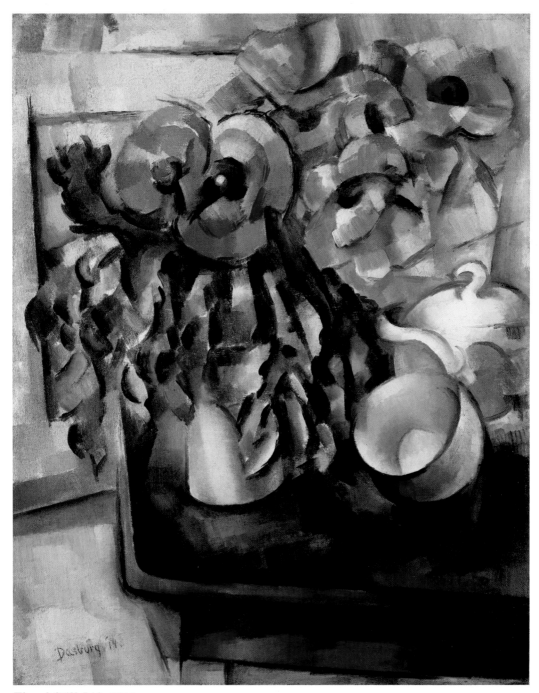

*Floral Still Life,* 1914

Andrew Dasburg (1887-1979) studied art at the Art Students League in New York from the age of fifteen. After several years, he enrolled in the night classes of the liberal teacher Robert Henri at the nearby rival institution, the New York School of Art. At the Art Students League's 1906 summer classes in Woodstock, Dasburg led his fellow students in a rebellion against their teacher, the landscape painter Birge Harrison, who stressed a subtle tonalist palette and night and twilight subjects. Instead, Dasburg painted bright colors in full sunlight. That same summer, he organized a group of independent students known as the Sun Flower Club.

Dasburg heard about modern French art, particularly the work of Monet, Cézanne, Gauguin, and Matisse, from Morgan Russell, his close friend from the League who had gone to Paris. Dasburg went to Paris himself in April 1909, where, in the company of Russell, he visited Matisse's studio and observed the French artist at work on *Music*, now in the Pushkin Museum in Moscow. Dasburg was fascinated by Matisse's working process and later vividly recalled the impact of this visit.[1]

Like his American expatriate friends Arthur Lee and Morgan Russell, Dasburg concentrated on sculpture when he first arrived in Paris, but he was soon overwhelmed by modern French painting. He found many examples of the work of Cézanne in the gallery of Ambrose Vollard, and met Leo and Gertrude Stein and saw their marvelous collection of works by Cézanne, Matisse, Picasso, and others.

Working together with Russell, Dasburg made copies of Cézanne's small painting *Pommes*, lent to them by Leo Stein. He was fascinated by

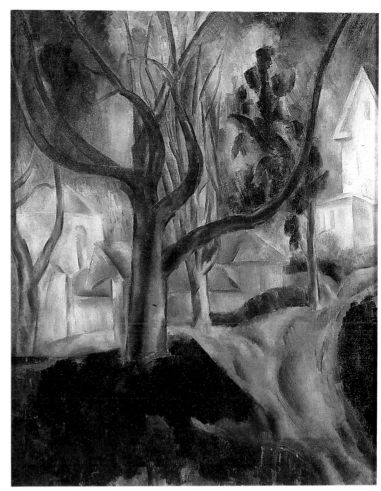

*Finney Farm, Croton-on-Hudson*, ca. 1917

Cézanne's ability to achieve a sense of mass and he explored Cézanne's techniques over and over again in his copies. He also discussed Cézanne with Leo Stein, who later wrote: "Cézanne did two things; he emphasized color and he simplified forms."[2]

Many of Dasburg's early paintings in a Post-Impressionist style have been lost and are now known only from old black and white photographs. The photographs and the extant works demonstrate his use of short, choppy brushstrokes and broken areas of light-dark contrasts, indicating his assimilation of the lessons of French modernism. His brushstrokes and his pigment show his careful emulation of Cézanne.

Back in New York, Dasburg frequented Stieglitz's gallery "291," where he was impressed by the Matisse sculpture exhibition in the

spring of 1912. Although Dasburg began to paint abstractions during the next several years which created a stir in even the most avant-garde circles, he eventually decided to return to nature. Landscapes remained a lifelong pursuit for Dasburg, who found in Post-Impressionism the way to his own most personal expression.

Gail Levin

[1] See Gail Levin, "Andrew Dasburg: Recollections of the Avant-garde," *Arts Magazine*, 52, June 1978: 129.

[2] Leo Stein, *Appreciation: Painting, Poetry and Prose* (New York: Random House, 1947), p. 58.

# Stuart Davis

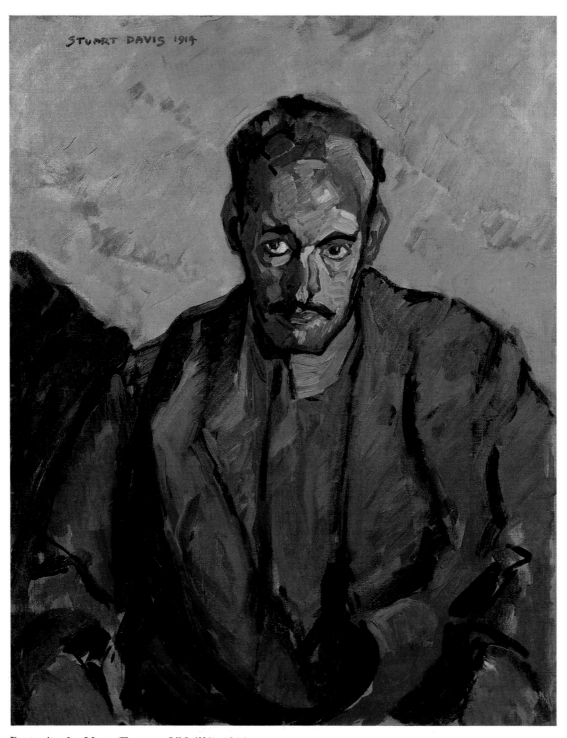

*Portrait of a Man (Eugene O'Neill?)*, 1914

*Street in Gloucester*, ca. 1918

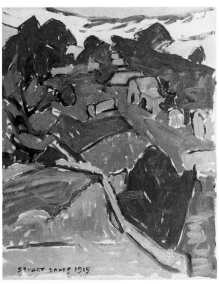

*Village with Countryside*, 1915

Stuart Davis (1892-1964)[1] cast a giant shadow across a half-century of American art, touching and affecting virtually every vital aesthetic, political, and social issue from Ash Can Realism to post-1945 art. Like many of America's leading artists of the modern movement—Marin, Carles, Demuth, Schamberg, and Sheeler among them—Davis was born in Philadelphia. His early talents were encouraged and assisted by his father, Edward Wyatt Davis, then art editor of the *Philadelphia Press,* and his mother, Helen Stuart Foulke, who was a sculptor. Davis's father was an associate of Robert Henri and other artists who contributed to the newspaper, including John Sloan, George Luks, Edward Shinn, and William Glackens. Davis had his parents' full support when he left high school in 1909 to pursue his art full-time as a pupil at Henri's school in New York.

From Henri, as well as from John Sloan, Davis learned that the "contemporary artist had to find inspiration in his own life and environment, rather than going back to the masters of the past."[2] Together with his friends and fellow artists Glenn O. Coleman and Henry Glintenkamp, Davis found in the streets of New York the pulsating visual data of urban life that animated him and his art. By 1910, at the age of 18,

Davis had developed a highly charged type of Ash Can Realism that was indebted to Sloan and Henri.

Five of Davis's watercolors were included in the 1913 Armory Show. The show was a pivotal experience for him and he resolved to become a modern artist. He was stimulated by a wide range of Post-Impressionist and modernist artists, but van Gogh, Gauguin, and Matisse were the most immediate influences, followed by Cézanne and Seurat. Davis went through a period of assimilation, gradually adapting these new approaches in 1913, and then systematically incorporating them in 1914.

The intensity of color and touch in his 1914 portraits shows the influence of van Gogh, Cézanne, and Matisse, and thereafter his landscapes increasingly reflect a concentrated focus on textured, broadly brushed surfaces related to van Gogh. The high-keyed color of van Gogh and Gauguin showed Davis the possibilities of color used in a "creative instead of a descriptive way," and of a method of "free color invention" that permeated his work both then and later.[3] Seurat's sense of carefully analyzed and delineated space, rather than his color, became increasingly important to Davis. Even late in life Davis was learning from Seurat, who taught him that "you could think

about space as freely as you could about color."[4]

In 1917, Davis began to experiment with multiple Cubist views, which initiated his move from a perceptual to a conceptual type of art. However, his landscapes continued to employ a van Gogh texture and color through 1920. By 1921, Davis had fully shifted into a study of Cubism, which he saw as continuing the spatial analysis begun by Seurat. Thereafter, Davis became one of America's most inventive and innovative artists, fusing the dynamics of urban life with a distinctive Cubist vocabulary. In addition, Davis became this country's most committed and articulate advocate of modernism during the 1930s, when social realism and American scene painting were the prevailing modes.

William C. Agee

[1] Davis publicly gave his date of birth as 1894, but John R. Lane discovered in Davis's Journal for September 7, 1922 (formerly collection of Wyatt H. Davis) an entry reading "Stuart Davis, born 1892 and still going strong September 7, 1922." See John R. Lane, *Stuart Davis: Art and Art Theory* (New York: The Brooklyn Museum, 1977), for a thorough study of his life and art.

[2] John Ashberry, "Interview with Stuart Davis," in "Is Today's Artist With or Against the Past?", *Art News,* 57 (Summer 1958): 43.

[3] Ibid.

[4] Ibid.

# Charles Demuth

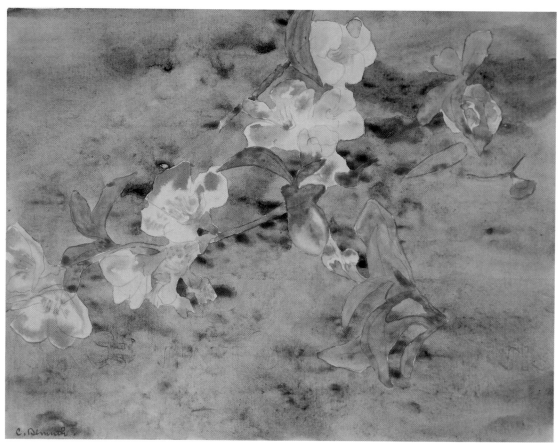

*Peach Blossoms,* ca. 1915

When Marcel Duchamp wrote in 1949 that he regarded the art of Charles Demuth (1883-1935) as "a living illustration of the disappearance of a 'Monroe Doctrine' applied to Art," he was referring to the independent approach to European modernism characteristic of the work of the best of the American avant-garde.[1] This view had also been advanced by Willard Huntington Wright, who not only felt that there was "little subservient imitation" in the work of Demuth and that of his contemporaries, but also that "America [was] second only to France in the quantity and quality of its more modern painting."[2]

Demuth was more fortunate than many of his modernist colleagues. His family's tobacco business provided him with financial security that eluded the majority of his contemporaries, and his paintings and watercolors were not subjected to the derisive dismissal that greeted the showings of many of his friends. Advanced collectors, including Albert Barnes, Albert E. Gallatin, Ferdinand Howald, and Walter and Louise Arensberg acquired his paintings, and his work was often received favorably by those who were otherwise unenthusiastic about modern art. His appealing vaudeville scenes and still lifes, although formally very advanced, were not as visually jarring as the stronger color schemes and radical formal disjunctures favored by some moderns. When the critics were troubled by Demuth's work, it was usually due to his subject matter rather than to his style.

The sources of Demuth's visual language, which never became totally abstract, are various. In 1905 he began his studies at the Pennsylvania Academy of the Fine Arts, where his instructors included such progressive

*Acrobats – Balancing Act*, 1916

figures as Thomas Anshutz, Hugh Breckenridge, and Henry McCarter. Demuth was one of a coterie of artists who gathered around Alfred Stieglitz; he particularly admired Georgia O'Keeffe, Marsden Hartley, and John Marin, whom he saw during his frequent visits to New York. Several trips abroad, especially in 1907-8 and 1912-14, provided important exposure to European modernism. The assured calligraphic quality of Demuth's graphic style, evident in his vaudeville and illustrative watercolors, reveals the influence of Toulouse-Lautrec, Rodin, and Matisse.

The example of both Cézanne and, even more importantly, Picasso, was critical to Demuth during the winter of 1916-17, which he spent in Bermuda with Hartley. The crisp architectonic watercolors inspired by his stay there, composed of clean lines and simplified formal elements, were his first serious exploration of the Cubist style. Indeed, Henry McBride observed that Demuth "may be said to have translated cubism 'into American.'"[3] Demuth responded more readily to the scientific precision of Picasso's Cubist works than he did to the Fauves' painterly technique and

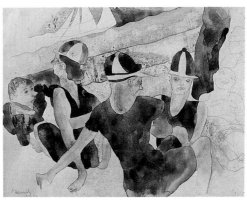

*Figures on the Beach, Gloucester*, 1918

emotional color, although many of the colors he employed in his works, where they have not faded, are surprisingly intense. Dada too, which he embraced with a slyly perceptive understanding, had an effect. Futurist elements, however, did not become evident in his art until later.

These European and New York influences were filtered through the lens of his native Lancaster, the historic Pennsylvania city which was his lifelong home and provided him with his characteristic subject matter and visual orientation. Most of his works were painted in Lancaster, which emerges as a force in his art as significant as New York and Paris. A sophisticated blend of European modernism with a strongly localized sense of place is characteristic of Demuth's work. This is true of several of the leaders of the American avant-garde, particularly those who became identified with the Precisionist style, including Charles Sheeler and Georgia O'Keeffe.

Betsy Fahlman

[1] Marcel Duchamp, "A Tribute to the Artist," in Andrew C. Ritchie, *Charles Demuth* (New York: Museum of Modern Art, 1950), p. 17.
[2] Willard Huntington Wright, "The New Painting and American Snobbery," *Arts and Decoration* 7 (January 1917): 129.
[3] Henry McBride, "Demuth Memorial Exhibition," *The New York Sun* 18 December 1937, published in *The Flow of Art, Essays and Criticisms of Henry McBride*, edited by Daniel Caton Rich (New York: Athenaeum, 1975), p. 356.

# Arthur Dove

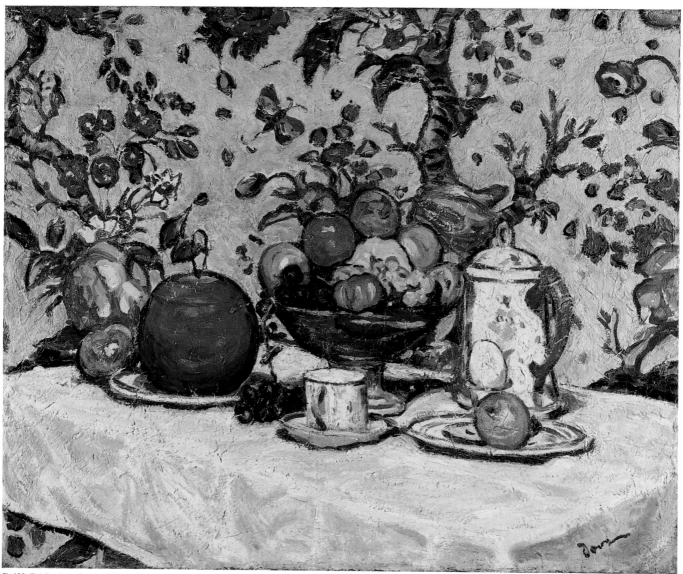

*Still Life Against Flowered Wallpaper*, 1909

Arthur G. Dove (1880-1946) has been recognized as the boldest American pioneer of abstraction among the first generation of early modernists.[1] His encounter with Post-Impressionism between 1908 and 1909 proved catalytic for the subsequent development of his independent, abstract style.

Born in rural upstate New York, Dove received instruction in art from his neighbor Newton Weatherly, who was both a truck farmer and an amateur painter and philosopher. Dove entered Hobart College in 1899 and two years later transferred to Cornell University, where he studied law and art. After his graduation in 1903, he embarked on a successful career as a magazine illustrator in New York City. His contacts there with William Glackens, John Sloan, and Alfred Maurer probably contributed to his decision to give up full-time commercial illustration in order to concentrate on painting. Overcoming his family's objections to his artistic career, Dove left New York in 1908 for a fourteen-month European sojourn.[2]

In Paris, Dove and his wife Florence were welcomed by Alfred Maurer. They also befriended American expatriate artists Jo Davidson and Arthur Carles. Maurer, an habitué of the Stein Salon, introduced Dove to the art of Cézanne, Matisse, and the Fauves. Dove became familiar with European modernism in Paris but he preferred to paint in the countryside around Cagnes: "I was free. . ., working in the country."[3] He contributed work to both the 1908 and 1909 Salons d'Automne.

Dove's experimentation with Post-Impressionist, particularly Fauve, painting proved liberating. In France he renounced the muted tonalism of his earliest known paintings for a high-keyed palette and more vigorous brushwork. His French landscapes ranged from brilliant late Impressionism to bold, full-color painting akin to the work of Matisse and the Fauves. In *The Lobster* (Amon Carter Museum, Fort Worth), an extant still life from this period, Dove skillfully blended Fauve colorism with Cézannesque formal simplification and compositional structure.

After returning to New York in July 1909, Dove briefly exhibited his new paintings at Hobart College. Through his friend Alfred Maurer, he gained an introduction to the noted photographer and impressario of "291," Alfred Stieglitz. In 1910, Stieglitz invited Dove to participate in the exhibition of *Younger American Painters* at "291" with John Marin, Marsden Hartley, Max Weber, Arthur Carles, and Alfred Maurer.

Dove continued to experiment with Fauve color compositions in both landscape and still life painting after his return to the United States. His fascination with the visual impact of color and form led from Fauvism to more daring color abstractions based on natural motifs: "There was a long period of searching for a something in color which I then called 'a condition of light.'"[4] The chromatic brilliance of Post-Impressionism freed Dove to pursue his vision.

Judith Zilczer

[1] Duncan Phillips, "Foreword," to *Arthur G. Dove* by Frederick S. Wight (Berkeley and Los Angeles: Art Galleries, University of California, Los Angeles, 1958), p. 13.

[2] The chronology of Dove's trip abroad was established by William Innes Homer, *Alfred Stieglitz and the American Avant-Garde* (Boston: New York Graphic Society, 1977), pp. 108-110.

[3] Arthur G. Dove, letter to Samuel M. Kootz, published in Samuel M. Kootz, *Modern American Painters* (New York: Brewer & Warren, Inc., 1930), p. 36.

[4] Arthur G. Dove, letter to Samuel M. Kootz, Ibid., p. 37.

# Arthur Wesley Dow

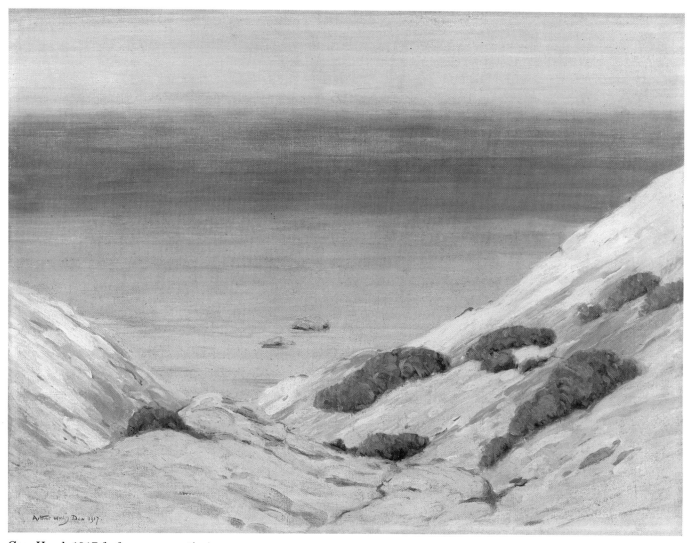

*Gay Head,* 1917 (before conservation)

Arthur Wesley Dow (1857-1922) was not at heart a modernist, but his teaching and the design principles he advocated did much to counter the traditionalism of the American Renaissance movement. Dow studied in Boston and in 1884 went to Paris to work at the Académie Julian. From 1885 to 1888 he worked intermittently in Brittany at Pont Aven and Concarneau, but contact with Gauguin and his followers had absolutely no effect.[1]

Dow worked in a modified Barbizon style until 1891, when, having returned to Boston, he discovered the work of Hokusai and met Ernest F. Fenollosa, curator of Japanese art at the Boston Museum of Fine Arts.[2] With Fenollosa's encouragement, Dow adopted a Synthetist style based on linear spatial divisions, *notan* (flat patterns of light and dark), and simplified color schemes. During the 1890s Dow progressively eliminated from his art tonal modelling, incidental detailing, and strict perspectival progressions from his work, which became flatter and more decorative, with strong linear emphases and an even distribution of light and dark elements. Color woodcuts in the Japanese manner became Dow's quintessential medium, usually with undulating, asymmetrical compositions and close, rather subdued color harmonies. Dow's Japanese taste coincided with, and was reinforced by, the *Japonisme* immanent in the American arts and crafts movement.[3]

Though Dow was in contact with other Boston art world figures such as Charles Hovey Pepper and the Prendergast brothers, his widest influence came after his departure from Boston in 1895 to teach first at The Pratt Institute in Brooklyn and then at Teachers College, Columbia University. Students such as Jane

*Modern Art*, 1895, color lithograph, 17⅝ x 13⅝ inches (44.9 x 34.7 cm), gift of L. Prang & Co., Boston, M10688, Courtesy Museum of Fine Arts, Boston. Not in exhibition.

Peterson, Alfred Langdon Coburn, Max Weber, and Georgia O'Keeffe found inspiration in Dow's insistence on working in "an imaginative manner."[4] Dow's influence was consolidated with the publication of *Composition* in Boston in 1899. In the book and in his teaching, Dow elucidated his belief in rhythmic harmonies of lines and spaces, and archetypal dynamic forms of composition: "opposition, transition, subordination, repetition, and symmetry."[5] Color took a subordinate role.

Spirituality remained a core aspect of art-making for Dow, and his recurring marsh landscapes evoke the commonalities of thought between American Tonalists and Symbolists, rather than the innovations of European modernism. Puvis de Chavannes was Dow's notion of a successful formalist, although he was also outspoken in his admiration of Maurice Prendergast.[6] While some of

his late landscapes, notably the Grand Canyon series, show an openness in brushwork which invites comparison with other American Post-Impressionism, Dow's importance remains that of a teacher and a theoretician, a link between arts and crafts taste and more radical departures.

Peter Morrin

[1] Frederick C. Moffatt, *Arthur Wesley Dow, (1857-1922)* (Washington, Smithsonian Institution Press, 1977), p. 29.
[2] Ibid., pp 48-49.
[3] Several of Dow's students became prominent woodcut artists in Provincetown, Massachusetts. See Janet Altic Flint, *Provincetown Printers: A Woodcut Tradition* (Washington, Smithsonian Institution Press, 1983). Among Dow's students were Provincetown printmakers Maud Ainslie, Edna Hopkins, and Margaret Patterson.
[4] Moffatt, p. 78.
[5] Ibid., p. 59.
[6] Ibid., pp. 61-62, 115-116.

# A. B. Frost, Jr.

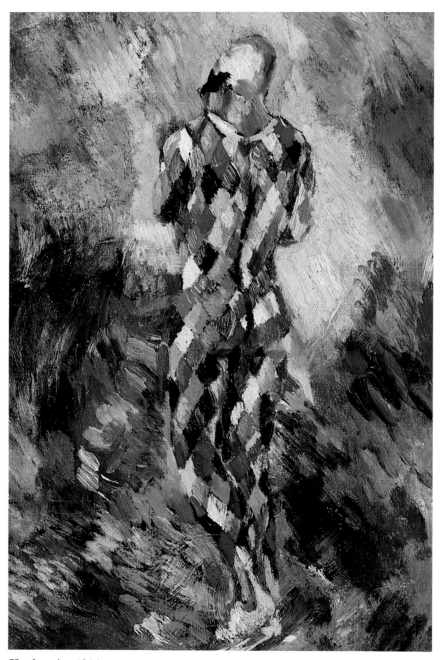

*Harlequin*, 1914

Arthur Burdett Frost, Jr. (1887-1917) first studied art with his father, the famous illustrator A. B. Frost. After a year of study with both Robert Henri and William Merritt Chase at the New York School of Art, Frost left for Paris in the fall of 1906. Like many of his classmates, he had benefitted from Henri's openness and progressive attitudes, and he wrote to Henri to express his gratitude: "I did not know that I had any ideas until you told me I had."[1]

Frost met fellow expatriate artist Patrick Henry Bruce through another American colleague, Walter Pach, who introduced them in 1907. By 1908, Frost and Bruce had joined the class at the Académie Matisse, a move that the elder Frost deplored. Frost and Bruce quickly assimilated many of the ideas of modernism, especially those put forth by artists at the salon of Gertrude and Leo Stein.

It was at the Steins' home that Frost first became acquainted with Robert Delaunay, whose influence on his development would be significant. The young American wrote to his mother: "Leo Stein is not interested except in one man, Delaunay. We are all interested in Delaunay. He seems to be the strong man who has come out of cubisme as Matisse was the strong man who came out of the Fauves."[2] Delaunay had just passed through a Neo-Impressionist period during which he had learned much from Henri-Edmond Cross, who was in the circle of Seurat and Signac. Delaunay was exploring theories about light and color based on the scientific findings by M. E. Chevreul and others, and taught Frost and Bruce about optical mixtures of colors and light effects.[3]

Frost's first work in Paris was closer to Renoir than to Matisse, but as he spent more time with Robert Delaunay and his artist wife, Sonia, he began to evolve his own style of modernist painting, emphasizing Delaunay's simultaneous contrast of colors. Frost lived for a while with his friend Bruce in Brittany. There, in 1914, he produced *Harlequin*, a small figurative canvas which employed Delaunay's color theories.

Frost also worked on abstractions during this period, none of which his conservative father could accept. When he painted his *Harlequin*, he thought he had finally created an image that would please his father. He wrote to him: "I have at last got *something* in painting....Pure Renoir as to convention. It is not composed in relation to the carré of the canvas as my simultané things were. It looks like a sunny day in the country where as my simultané things look like 'la vie moderne,' autos, grands boulevards, lights, etc."[4]

Frost, who suffered from tuberculosis, died suddenly in 1917, having settled in New York a few years earlier. His distraught father evidently destroyed most of his work, accounting for the fact that so little survives today.

Gail Levin

[1]Arthur Burdett Frost, Jr. to Robert Henri, September 24, 1906, Beinecke Rare Book Library, Yale University.

[2]Arthur Burdett Frost, Jr. to his mother, letter of December 1912, Collection of Mr. and Mrs. Henry M. Reed, Montclair, New Jersey.

[3]See M. E. Chevreul, *The Principles of Harmony and Contrast of Colors* (New York: Van Nostrand Reinhold Company, 1981, 1854 translation of 1839 edition).

[4]Arthur Burdett Frost, Jr. to his father, letter of August 1, 1914, Collection of Mr. and Mrs. Henry M. Reed, Montclair, New Jersey.

# Anne Goldthwaite

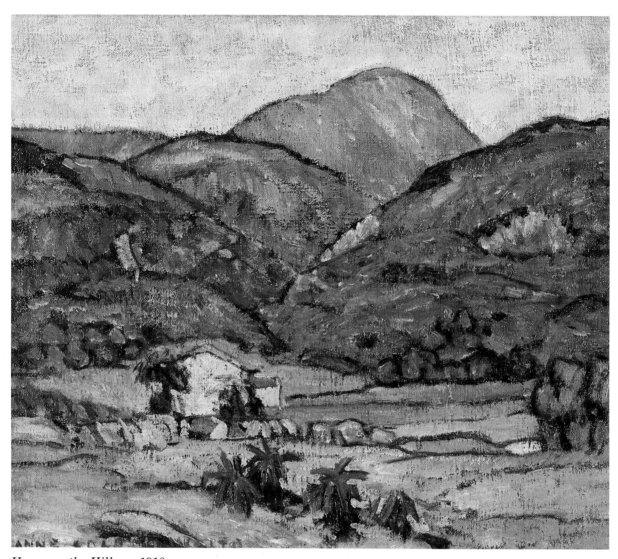

*House on the Hill,* ca. 1910

During her lifetime, Anne Goldthwaite (1869-1944) won praise for her portraits and etchings. She was repeatedly called one of the best "woman painters" of her generation and the best in her native South. An early reviewer praised the spontaneity of her portraits and landscapes and cited the influence of Cézanne in the "freedom of her outlines, the directness of her touch, and the simplicity of her paint."[1] Other critics writing in the teens also mentioned her debt to Cézanne or, simply, to the "post-impressionists."[2]

Although she seems not to have admitted direct influence, saying "It has been unconsciously,"[3] Goldthwaite had many opportunities to see and study Cézanne's paintings. Living in Paris from 1906 to 1913, she could have seen his canvases at the Salon d'Automne retrospectives and the 1907 Bernheim Jeune exhibition as well as at Gertrude and Leo Stein's atelier. Goldthwaite met Gertrude Stein six days after arriving in Paris in the fall of 1906. An invitation to tea introduced this American student, who had studied painting under Walter Shirlaw and then etching under C. F. W. Mielatz and others at the National Academy of Design in New York, to modernist painting. In her memoirs, Goldthwaite recalled seeing on that first visit Henri Matisse's *Joie de Vivre* (which had just been acquired by Leo), a small gray canvas by Cézanne, and a painting of a head by Pablo Picasso that looked "like a design made of the backbones of fish."[4]

Cézanne's method of modeling through color in order to express the underlying forms of objects was taught to Goldthwaite and her colleagues in a group they formed in Paris called the Académie Moderne. Active from around 1906 to 1913, these American artists held exhibitions each spring, with most of their work being shown as a group at the Salon d'Automne. Cézanne's style was discussed by Charles Guérin, head of the painters' section of the Salon d'Automne, who visited and criticized their work regularly.[5] Others invited to speak to the group included Albert Marquet and Émile-Othon Friesz.[6]

Together with Matisse and others, Marquet and Friesz had been labeled Fauves, or "wild beasts," because of the jarring canvases they had exhibited at the 1905 Salon d'Automne. Although Marquet's and Friesz's colors were not as pure as the other Fauves' and their styles had grown more conservative, Goldthwaite became familiar with Fauvist intentions through them, and their influence is apparent in her landscapes and portraits of these years. Other paintings by Goldthwaite recall some of Matisse's Collioure landscapes, examples of which she could have studied at the Steins'. It is in Goldthwaite's etchings of these years, however, that the Fauvist energy comes through most clearly.

*House on the Hill* (called *Church on the Hill* at the Armory show in 1913) characterizes her painting style of this period. It is Cézannesque not only in subject, vantage point, and palette but also in the use of color as a modeling tool. Her flat planes and elegant contours recall Gauguin. Though her subject and colors are Cézannesque, the work is not executed with Cézannesque brushstrokes or *passage*.

Goldthwaite returned to the United States in 1913 and was not able to go back to Paris because of the war. She was one of many American painters who brought a knowledge and absorption of Post-Impressionist styles to the United States, in her case to the Art Students League in New York, where she taught from 1922 until shortly before her death in 1944. Her style, though never "progressive"–she did not experiment with Cubist or Futurist idioms– indicates her assimilation of Post-Impressionism.

Patricia E. Phagan

[1] A. D. Defries, "Anne Goldthwaite as a Portrait Painter," *International Studio* LIX, no. 233 (July 1916): p. IV.
[2] Ibid.; "Exhibition of Modern American Painters: The Macdowell Club of New York," *New York Times*, 2 November 1913, sec. 7, p. 5; and "A Modern Painter with a Strong Sense of Style," *New York Times Magazine*, 24 October 1915, p. 21.
[3] Defries, "Anne Goldthwaite": IV.
[4] Anne Goldthwaite, unpublished memoirs written in 1935, extracts of which are published in Adelyn Dohme Breeskin, *Anne Goldthwaite; A Catalogue Raisonné of the Graphic Work* (Montgomery, Alabama: Montgomery Museum of Fine Arts, 1982), pp. 13-33; reference cited on p. 24.
[5] Martin Birnbaum, *Exhibition of Paintings, Water Colors and Etchings by Anne Goldthwaite* (New York: Berlin Photographic Company, 1915), Introduction; cited in "A Modern Painter," *New York Times Magazine*, p. 21.
[6] Breeskin, *Goldthwaite*, p. 26.

# Samuel Halpert

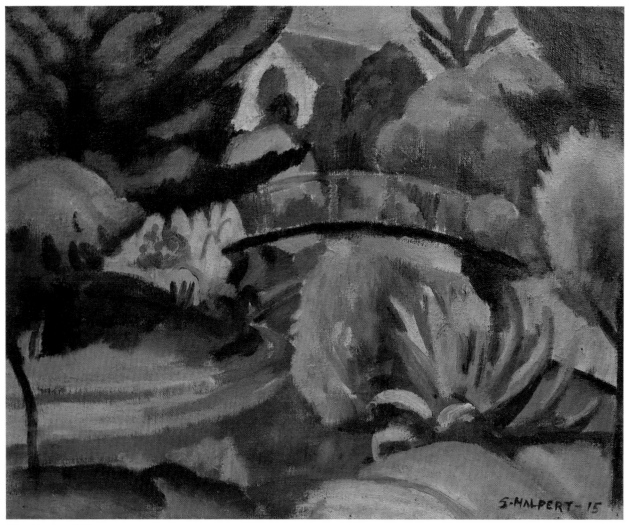

*The Park*, 1915

Had none of his early paintings survived, Samuel Halpert (1884-1930) would still be regarded as a pioneer of American Post-Impressionism. As one of the first twentieth century American artists to work in Paris, he generously shared with Thomas Hart Benton and other colleagues first-hand knowledge of new developments abroad.[1] Benton recalled:

> Sam's somewhat decorative adaptions of Cézanne so strongly impressed me...I began studying and copying the many detailed photographs of Cézanne's work which he had collected. Following his example, I began to break up my surfaces with graduated planes of color....[2]

Halpert was born in Bialostock, Russia, and moved with his family to New York in 1889. Jacob Epstein and Henry McBride at the Educational Alliance, among others, nurtured his precocious talent. He enrolled at the National Academy of Design in 1899 and went to Paris in 1902, where he studied at the Ecole des Beaux Arts under Léon Bonnat. But he learned most from other artists, in the museums, galleries, and streets of Paris. He spoke French fluently, saw few Americans, and later spoke of French colleagues – including (after 1914) Léger and Metzinger – as his best friends. By 1905 his painting had changed from academic art to Impressionism; a year later a Fauvist mode of Post-Impressionism began to appear. Three of his paintings were included in the 1905 Salon d'Automne and in 1911 he attained the rank of Sociétaire.

Back in New York between 1912 and 1914, Halpert acted as agent for Patrick Henry Bruce and Robert Delaunay at the Armory Show; Halpert himself exhibited two paintings. He told his colleagues about Cézanne and Matisse and about his admiration for the work of Albert

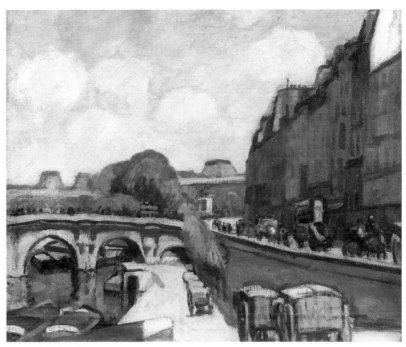

*Pont Neuf,* 1911

Marquet. The paintings he showed at the Daniel Gallery (1914, 1916, 1918, and 1919) were acclaimed for their "sane" affinities with Cézanne (rather than with Cubism); in fact, they are more directly related to Marquet.

By 1911 Halpert's paintings, such as *Pont Neuf*, showed his first mature style and his indebtedness to Marquet, using color as an essential means of expression. He constructed economical, carefully balanced, bold compositional schemes. Their solid, broad structural masses of pure color, outlined in dark, solid contours, were considered "decorative." Their intense color, thick outlines, and simplification strongly suggest a summary representation, as in a stained glass window (the subject of at least three of Halpert's paintings). He rarely allowed light to affect his color; thus the nearly equal foreground and background tones produce an all-over surface quality.

Until 1918 Halpert primarily painted still lifes and *plein air* landscapes and cityscapes. His landscapes were usually based on a specific place. Often he made two nearly identical views of the same subject; the smaller one, like the lush *Park*,

might be in an experimental mode, though more finished than a *pochade*.

Halpert exhibited regularly during his life. Following his 1918 marriage to Edith Gregor Fein (née Fiviosioovitch), who founded the Downtown Gallery in 1926, his compositions became softer and less bold. Nudes and populated domestic interiors reinvigorated his oeuvre. From September 1927 until his death on April 5, 1930, Halpert headed the painting department at the School of the Detroit Society of Arts and Crafts.

Diane Tepfer

[1] Halpert enjoyed three extended Paris-based residencies: 1902-1905/6, 1906/7-1911 (spending much of 1909 in Italy and Vernon, France, with Abel Warshawsky), and summer 1914-April 1916. He traveled with Robert and Sonia Delaunay in 1915 to London and Spain. During the summer they stayed in Portugal. In addition, he returned to Paris for the summer of 1925 with his wife, Edith.

[2] Thomas Hart Benton, *An American in Art, A Professional and Technical Autobiography* (Lawrence: The University Press of Kansas, 1969), p. 30. J. Richard (Rick) Gruber kindly alerted me to this reference.

# Lawren Harris

*Building the Ice House,* 1912

Lawren S. Harris (1885-1970) was the catalyst and leader in the creation of the Group of Seven. Born in Brantford, Ontario, Harris went to the University of Toronto, where he was encouraged by his mathematics professor to study art in Berlin. After four years of study (1904-08), Harris returned to Canada. In 1908 he went on a sketching trip to the Laurentians. The next year, he sketched in Haliburton with J. W. Beatty, went to Memphremagog, and drew and painted houses in downtown Toronto. By the winter of 1911-12, he was sketching with J. E. H. MacDonald and had become friendly with Tom Thomson.

In 1913, Harris and MacDonald were inspired by an exhibition of contemporary Scandinavian art at the Albright Art Gallery (now the Albright-Knox) in Buffalo. Beginning that year, Harris's works are marked by gorgeous color and solidified form, reflecting the Scandinavian painters. Their influence may be seen in Harris's way of flattening the picture plane and developing a flowing surface rhythm.

By the early 1920s, when the Group of Seven was formed, Harris had developed into an extraordinary landscape painter, transforming the forms of nature into powerful and elegant works such as *Above Lake Superior* (ca. 1924) and *Maligne Lake* (1924). In these and similar paintings he reduced the shapes of mountains, shoreline, trees, lakes, and clouds— always parallel to the picture plane— to their essentials for an austere, monumental effect. He painted for five successive autumns in Algoma and Lake Superior (1917-22), in the Rockies from 1924 on, and in the Arctic in 1930.

As artist-in-residence at Dartmouth College, New Hampshire, Harris moved through drawing into nonob-jective art. In Santa Fe, New Mexico, he worked with Dr. Emil Bisttram, leader of the Transcendental Group of Painters, which Harris helped found in 1939. His work in Vancouver (1940-70) continued to explore abstraction inspired by the rhythms of nature. Harris's belief in theosophy was intimately linked to his development as a nonobjective artist. Through abstract paintings (such as *Abstract Painting No. 20*) many of which use forms derived from landscape, he sought to portray a binding and healing conception of the universe —to make the sublime visible. His paintings have been criticized as cold, but they reflect the depth of his spiritual involvement. Harris's world view made him unusual among Canadian painters, and his philosophy kept him aloof from spontaneous creation, a crucial factor in later painters' abstraction. Nevertheless, his landscape paintings and some of his abstractions are among the icons of Canadian art.

Joan Murray

# Marsden Hartley

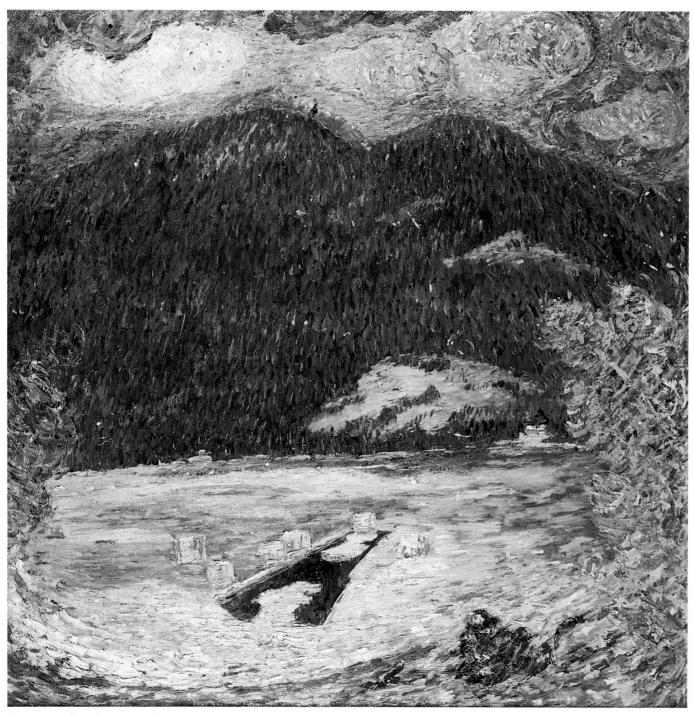

*The Ice Hole, Maine*, 1908

Marsden Hartley (1877-1943) moved from Maine to Boston at the end of the autumn of 1907. He had already begun a progression from a kind of American Impressionism to a Neo-Impressionist brushstroke. Inspired in part by reproductions in the magazine *Jugend*, Hartley particularly singled out the stitch technique of the Swiss painter Giovanni Segantini, whom he cited as his "first direct influence."[1]

In Boston, Hartley discovered the Post-Impressionist work of Maurice Prendergast, with whom he became acquainted. Some of the Bostonians who became Hartley's patrons, including Desmond Fitzgerald and Charles Hovey Pepper, already collected Prendergast. Pepper described Hartley's work of this period as "very fresh and jewel-like in color and painted in small dabs."[2]

Prendergast encouraged Hartley and shared with him his enthusiasm for the art of Cézanne. He also extended himself on behalf of Hartley, writing to recommend him to William Glackens and Arthur B. Davies when the young painter moved to New York in the spring of 1909. Glackens asked Hartley to bring his paintings to his Washington Square studio, where they were seen by other painters of The Eight, including Arthur B. Davies and Ernest Lawson. Hartley, however, found greater acceptance with a more avant-garde group and that May showed his work in a one-man show at Stieglitz's gallery, "291." The modernist art exhibited at "291," such as the 1910 Matisse show, which prompted Hartley to explore painting landscapes with a Fauvist palette, had an enormous impact on his development.

Hartley's interest in Cézanne was greatly enhanced by the attention

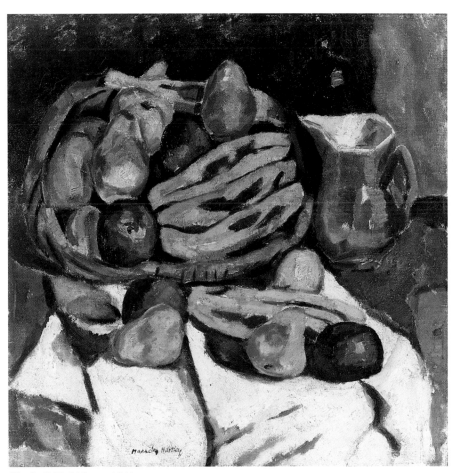

*Fruit Still Life*, ca. 1912

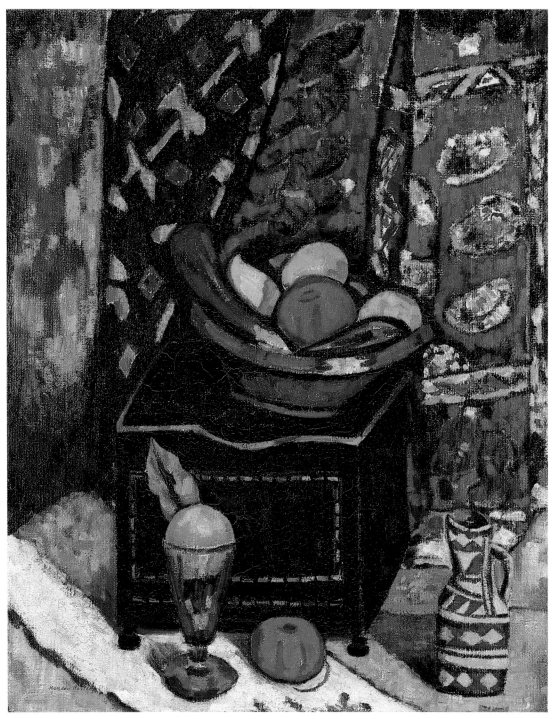

*Still Life No. 1,* 1912

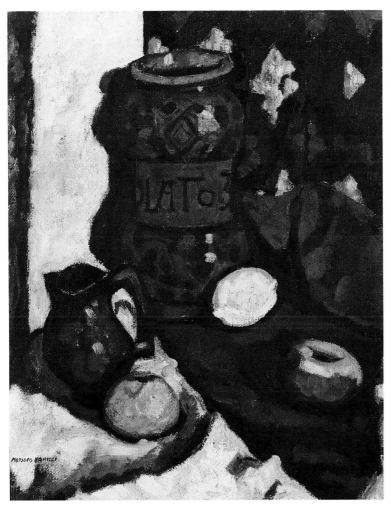

*The Faenza Jar*, 1912

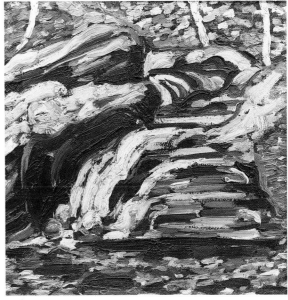

*Waterfall*, ca. 1909

created by an exhibition of the French artist's watercolors at "291" in March 1911. Although he evidently missed seeing the exhibition, he no doubt saw reproductions and read about Cézanne in the press. During the summer of 1911, Hartley produced a number of Cézannesque still lifes. Soon after that, he saw the Cézannes in the collection of Mrs. Havemeyer during a visit in the company of Arthur B. Davies.

Seeing Cézanne's work fueled Hartley's desire to go to Paris to live, which he did in April 1912. He spent the first summer living in the studio of Lee Simonson, whom he had known since their grammar school days in Maine. Simonson, also a Cézanne enthusiast, was then in the south of France painting with

Stanton Macdonald-Wright.

Hartley became friends with Gertrude Stein and came to know her collection well. The earliest works he painted in Paris demonstrate his interest in Cézanne, Matisse, and Picasso, whose work he had seen at Stein's 27 rue de Fleurus home. The decorative patterns and bright colors of the fabrics seen in some of his still lifes reflect the influence of Matisse's work. But Hartley soon became involved in a new discovery—the art of Kandinsky and the primitive objects published in the almanac *Der Blaue Reiter*. He put the lessons of the Post-Impressionists aside for the time being and moved on to Germany.[3]

Gail Levin

[1] Marsden Hartley, *Somehow a Past: A Journal of Recollection*, unpublished autobiography, Beinecke Rare Book and Manuscript Library, Yale University. See also the artist's statement in Samuel M. Kootz, *Modern American Painting* (New York: Brewer & Warren, Inc., 1930), p. 40.

[2] Joseph Coburn Smith, *Charles Hovey Pepper* (Portland, Maine: The Southworth-Anthoensen Press, 1945), p. 39.

[3] For a discussion of Hartley's interests at this time, see Gail Levin, "Marsden Hartley, Kandinsky, and *Der Blaue Reiter*," *Arts Magazine*, 52 (November 1977): 156-160, and Gail Levin, "American Art," in William Rubin, ed., *"Primitivism" in 20th Century Art: Affinity of the Tribal and the Modern* (New York, The Museum of Modern Art, 1984), pp. 453-473.

# Childe Hassam

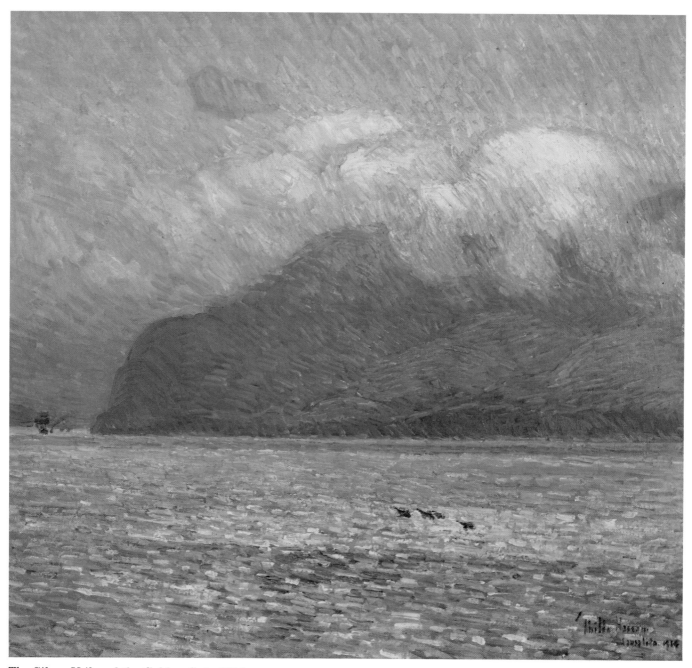

*The Silver Veil and the Golden Gate,* 1914

His reputation as an American artist is linked to the Impressionists, yet the mature works of Childe Hassam (1859-1935) herald Post-Impressionism in North American art. As early as 1900 Hassam's pale palette and staccato brushwork gave way to experiments with pure color, elongated, structured brushstrokes, and simplified compositions.

Hassam probably saw the modernists which Alfred Stieglitz exhibited in New York as early as 1908, and viewed the 1913 Armory Exhibition. But he found the art "insincere and on the fool-fringe."[1] His friend and fellow artist Joseph Pennell wrote to him in 1923, "...I like your work, built up 'on the knowledge of a lifetime,' and not upon expressions, cubism, incompetence and conceit, the backbone of the rot and rubbish foisted by strange sharpers and incompetents...."[2] Even though Pennell may not have associated Hassam's work with the modernists whom he despised, there is no denying that Hassam was influenced by Post-Impressionism.

Born in 1859 in Boston, Hassam was educated in Boston schools before studying art at the Boston Art Club and later under William Rimmer and I. M. Gaugengigl. He went to Paris in 1886 and studied under Gustave Boulanger and Jules Lefebvre at the Académie Julian. Hassam returned to America after three years in Paris and during the 1890s was recognized as one of the leading Impressionistic painters.

Around 1900 a new simplicity is evident in many of Hassam's paintings, especially in the views of Appledore and the other Isles of Shoals off the Maine and New Hampshire coast. These seascapes, which Hassam painted from 1890 to 1916, represent an evolution towards an abstraction of form as the artist explored the decorative patterns of jagged rock formations against the sea. The long, open brushstrokes in the later Appledore paintings flatten the space and enhance the abstracted forms of the composition.

In 1904 Hassam traveled west to do a commissioned mural; attracted by the landscape, he returned in 1908 and 1914 to paint a series of Oregon and California views. In several of these views Hassam used a square format which emphasized the flattened space and abstract compositional forms. For example, in the painting *The Silver Veil and the Golden Gate* (1914) the composition is simply a rectangle of sky resting on a smaller rectangle of water, relieved by a triangular wedge of land. Color is simplified to shades of blues, accented only occasionally with strokes of emerald green. His broad brushwork reinforces the simple forms—the brushwork in the water is patterned horizontally, in the sky it is diagonal and on the land rounded to indicate the contours of the hills. The structuring and patterning of the brushwork demonstrates an expressiveness not seen in his Impressionist paintings, in which color and brushwork served to model form.

Hassam's late paintings are a synthesis of Impressionism and Post-Impressionism He was a mentor to modernistic movements not only in the United States, but in Canada as well. For example, the Canadian artist Lawren Harris modeled his square paintings after Hassam's format.

Judy L. Larson

[1] Donelson F. Hoopes, *Childe Hassam* (New York: Watson-Guptill Publications, 1979), p. 84.
[2] *A Catalogue of an Exhibition of the Works of Childe Hassam at the American Academy of Arts and Letters* (New York: American Academy of Arts and Letters, 1927), p. 12.

# A. Y. Jackson

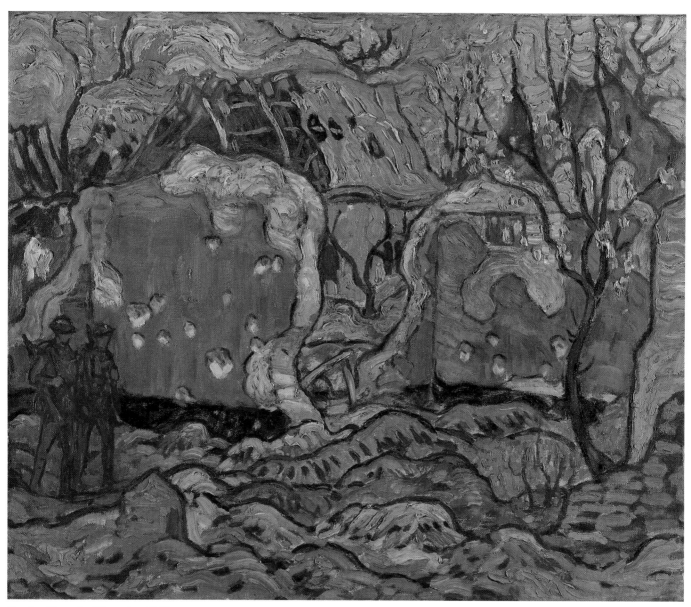

*Springtime in Picardy*, 1919

Alexander Y. Jackson (1882-1974) was, with Harris, the ablest organizer of the Group of Seven; when problems arose, he helped solve them. Along with Harris, he was also the Group's populist, through his writings and his presence on key committees of the National Gallery of Canada and the (then) Art Gallery of Toronto.

Born in Montreal, Jackson, like other members of the Group, was first a commercial artist. His early studies included night classes at Montreal's Le Monument National with Edmond Dyonnet. In 1905, under the influence of Maurice Cullen and James Wilson Morrice, he made his first trip to Paris. On his second trip, from 1907 to 1909, he enrolled at the Académie Julian, where he studied under Jean-Paul Laurens. He began to experiment with Post-Impressionism only on his third trip to Europe from 1911 to 1913. In paintings made in Cucq, Assisi, and Venice, he began to explore complementary color, a bolder paint handling, and a flattening of the picture plane. The result was works that have been called "free and assured."[1] At that point, Jackson said, he became a real painter.

In later years, Jackson translated the style to suit the Seven's Canadian landscape subject matter. Painting broadly and decoratively, he flattened the image to stress large, bold forms and movements. He believed in simplifying reality. In 1921, he described sketching in Algoma:

> Out of a confusion of motives the vital one had to be determined upon. Sketching here demanded a quick decision in composition, a summarizing of much...detail, a searching-out of significant form, and a color analysis that must never err on the side of timidity.[2]

He loved unusual compositions, odd

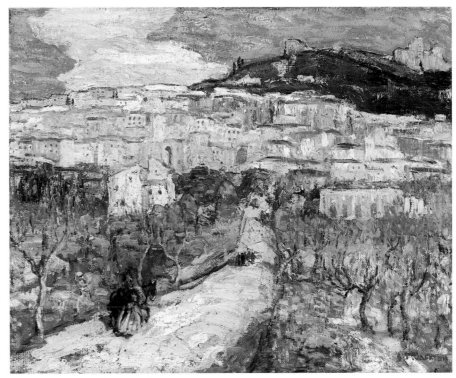

*Assisi from the Plain*, 1912

points of view, and ruddy colors. His sumptuously colored surfaces sometimes recall tapestries.

Of the Group of Seven, Jackson's work is the most similar to European art of the period, as seen in the Art Gallery of Ontario's *Mystic North* exhibition of 1984. Of all the Group he was the greatest traveller. Jackson's trail crossed and recrossed Canada "like the pattern of ski tracks on the fresh snow of a winter hillside," as Lismer said.[3] Jackson played out the explorer's pattern set long before in Algonquin Park by Tom Thomson.

Joan Murray

[1] Dennis Reid, *The Group of Seven* (Ottawa: The National Gallery of Canada, 1970), p. 44.

[2] A. Y. Jackson, "Sketching in Algoma," *The Canadian Forum* 1 (March 1921): 174-75, quoted in Joan Murray, *The Best of the Group of Seven* (Edmonton: Hurtig, 1984), p. 17.

[3] A. Lismer, "A. Y. Jackson," *A. Y. Jackson Paintings 1902-1953* (Toronto: The Art Gallery of Toronto, 1953), p. 7, quoted in Murray, p. 16.

# Walt Kuhn

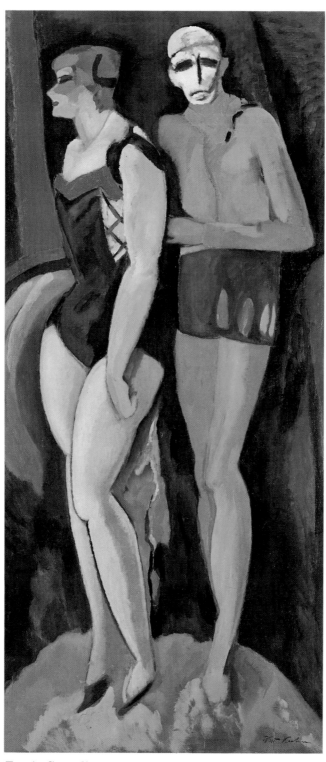

*Tragic Comedians,* ca. 1916

*Morning*, 1912

Walt Kuhn (1877-1949), artist, theatre designer, and co-organizer of the legendary Armory Show, has never been appreciated fully for his arresting portrayal of circus and theatrical performers. In fact his central role in the organization of the Armory Show has all but overshadowed his early achievements in Post-Impressionist painting.

The only son of a Bavarian-born hotel proprietor, Kuhn grew up in the Red Hook section of Brooklyn. His Spanish mother instilled in him a love of show business and encouraged his artistic inclinations. Although he sketched continually from an early age, Kuhn received little formal artistic training before going to work as a cartoonist for the San Francisco weekly *The Wasp*. In 1901, after two years on the west coast, he traveled to Paris for more traditional instruction in art. With his parents' support, he continued his art studies at the Royal Academy in Munich.

Returning to New York in 1903, Kuhn resumed work as a cartoonist.

In 1908, when he joined the faculty of the New York School of Art, his oil paintings had progressed from the dark tonalism of the Munich School to late impressionist landscapes. By 1909 he was already aware of the art of Cézanne, and his paintings reflected traces of Post-Impressionist influence.[1]

Kuhn's interest in progressive artistic causes led him to help organize modern art exhibitions in New York City. As a member of the Pastellists and the Madison Gallery group, he

*Girl with White Hat,* 1914-15

joined forces in 1911 with Elmer MacRae, Jerome Myers, and Henry Fitch Taylor to plan an anti-academic exhibition, a scheme which eventually resulted in the Armory Show. Through his intimate friendships with the lawyer John Quinn and Arthur B. Davies, a knowledgeable painter and president of the association formed to sponsor the Armory Show, Kuhn gained access to the most advanced European art. As Davies's lieutenant, Kuhn traveled to Germany, France, and England to select works for the historic exhibition. He alone among the organizers visited the Cologne Sonderbund, the Parisian galleries, and the Second Post-Impressionist Exhibition at the Grafton Galleries in London. After the success of the Armory Show, Kuhn worked closely with Davies to mount several important exhibitions of modern art at the Montross Gallery in New York. He also served as an informal advisor to John Quinn, who had begun to amass a significant modern art collection.

Kuhn's experiences as an exhibition organizer deeply influenced his own artistic development. While selecting works in Europe for the Armory Show, Kuhn confided to his wife, "Instead of being in any way depressed by seeing such great stuff, I feel great, and have mental material to last several years."[2] His exposure to European modernism, particularly the work of Cézanne, Matisse, and Derain, confirmed his Post-Impressionist tendencies.

He moved quickly from brilliant Neo-Impressionist landscapes, such as *Morning*, to a flat, colorful, and decorative style in beach scenes reminiscent of Fauve painting. His portraits and figure paintings from 1914 to 1916 range from daring Matisse-like simplicity to a personal

*Bathers on the Beach*, 1915

synthesis of Post-Impressionist and German Expressionist styles in several monumental-scale portrayals of circus performers. Although Kuhn later destroyed a portion of his early work, we see in his surviving Post-Impressionist paintings a sure foundation for his subsequent evolution as America's premier painter of the circus.

Judith Zilczer

[1] Kuhn's wife Vera recorded in her journal that her husband "spent a rainy day in the barn laying out Cézanne's palette." Vera Kuhn, cited by Philip R. Adams, "Walt Kuhn's *Salute.*" *Arts in Virginia* 25, nos. 2-3 [1985/Virginia Museum of Fine Arts]: 5.
[2] Walt Kuhn, letter to Vera Kuhn, November 11, 1912, Walt Kuhn Papers, Archives of American Art, Smithsonian Institution, Washington, D.C., microfilm roll no. D240, frame no. 450-51.

# Ernest Lawson

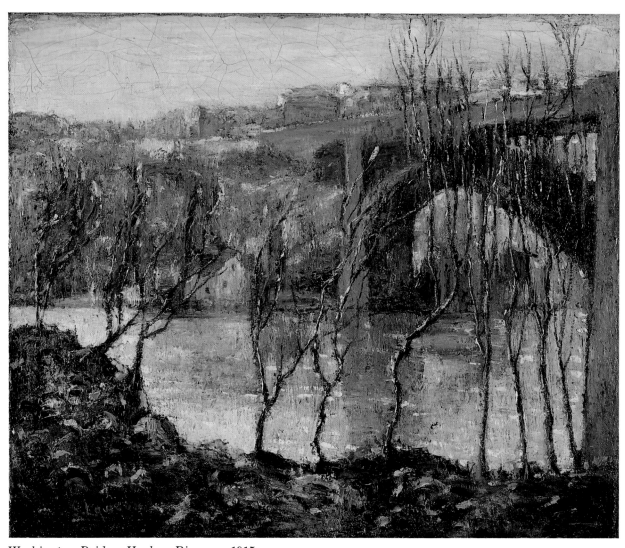

*Washington Bridge, Harlem River,* ca. 1915

Ernest Lawson (1873-1939) was born in Halifax, Nova Scotia to a family prominent in Canadian educational circles. After study in Kansas City and Mexico City, Lawson enrolled at the Art Students League in 1891 under the instruction of John Twachtman. The following year he studied in Cos Cob, Connecticut, at the school organized by Twachtman and J. Alden Weir. In 1893 Lawson went to France to study at the Académie Julian, but the formative experience of that trip was making the acquaintance of Sisley at Moret-sur-Loing. Following a brief visit to the United States in 1894, Lawson returned to France and remained there until 1896. His biographers, Henry and Sidney Berry-Hill, speculate that Lawson saw Ambrose Vollard's Cézanne exhibition in December 1895. It is more likely that at that time he was impressed by the Whistlerian tendencies in the work of North American artists in Paris like James Wilson Morrice, Maurice Prendergast, and Robert Henri. Nevertheless, by 1906 — less than ten years after his return to the United States — Lawson adopted a style that was clearly indebted to Post-Impressionism and which suggests generic relations to Cézanne's example.

Lawson strove more for form than for light and atmosphere in his landscapes, using tough densities of mottled pigments. Cézannesque skeins of trees frequently unify the surface of his compositions, and two-dimensional design is maintained through a stacking of motifs in zones to a high horizon line. An interest in architectonic structure is evident, not only in the general organization of Lawson's paintings, but also in his penchant for motifs such as bridges, buildings, and docks, which populate the Harlem River scenes he executed between 1898 and 1916. Factual description was not his primary interest, and he repeatedly painted the same motifs with minor differences of placement or of color orchestration.

It is above all in the quality of the paint surface that Lawson's work

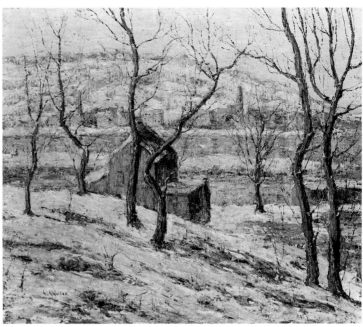

*Winter, Spuyten Duyvil*

separates itself from American Impressionism. Although indebted to the dry, crusty surface of Twachtman's snow scenes, Lawson's congeries of pigments suggest correspondences as well with the serial paintings of Monet, the dreamscapes of Ryder, and the tapestry canvases of Prendergast. His works have stronger surface resolution and a greater range of contrast than the paintings of most American Impressionists. His was an experimental, improvisatory technique, executed without preliminary studies, ranging in depth from layers of impasto to barely stained canvas. No matter how thick his paint relief, Lawson maintained a sense of relationship and contact with the surface of the support. Solidity of the paint film provided a metaphor for the solidity of form Lawson sought to achieve.

Although Lawson exhibited with "The Eight" starting in 1908 (Henri, Luks, Davies, Glackens, Sloan, Lawson, Shinn, and Prendergast), his only clear stylistic affinities are with Prendergast, the other anomalous member of the group. He served on the committee for "The Exhibition of Independent Artists" in 1910, as well as on the committee for the Armory

Show in 1913. From 1911 to 1915, Lawson exhibited at the Canadian Art Club in Toronto, but neither in Canada nor in the United States did he have any obvious imitators. A statement made late in his life makes clear that Lawson thought of his art as a mode of independent expression, rather than as an agent of description:

Color is my specialty in art. That's my special technique; experimenting with color. I did it from the beginning. . . . It affects me like music affects some persons — emotionally. I like to play with colors like a composer playing with counterpoint in music. It's sort of rhythmic proportion. You try one color scheme in a sort of contrapuntal fashion, and you get one effect. We don't actually copy nature in art. Nature merely suggests something to us, to which we add our own ideas. Impressions from nature are merely jumping off points for artistic creation.[1]

Peter Morrin

[1] Henry and Sidney Berry-Hill, *Ernest Lawson: American Impressionist, 1873-1939* (Leigh on Sea: F. Lewis, 1968), p. 46.

# John Lyman

*Portrait of the Artist*, ca. 1918

John Lyman (1886-1967), painter, critic, teacher, and mentor, was born at Biddeford, Maine, and died in Barbados, West Indies. Apart from occasional trips to Canada, Lyman spent the years 1907-1931 in Europe. He attended several art schools, including Atelier Pierre Marcel-Béronneau (1907), Royal College of Art (1907), Académie Julian (1908-09), and the Académie de la Grande Chaumière (1909). These provided him with basic technical competence, but the Académie Matisse (1910) exercised a deeper influence on his art and thinking.[1] Lyman met many artists during his European stay; the most important were the Canadian painter J. W. Morrice, who was living in exile in Paris, his lifelong friend the English artist Matthew Smith, whom he met at Etaples and with whom he was to study at Matisse, and his American cousin Henry Lyman Saÿen, who introduced him to the Steins. While Lyman apparently was aware of almost every exhibition that was held and was familiar with the work of a broad range of artists, he was drawn to Matisse's school by seeing a painting by Matisse at the 1909 Salon des Indépendants.

The impact that Matisse and other Post-Impressionists had on Lyman's development was fully revealed to the Montreal public in the spring of 1913, when Lyman participated in the Thirtieth Spring Exhibition of the Art Association. About a month later, he held his first solo exhibition. The shows caused an unprecedented stir among critics and gallery-goers; the exhibitions were considered as shocking and as provocative as the recent Armory Show in New York.

Lyman's emphasis on essential form and his disregard for the anecdotal and the picturesque soon ranked him as one of the country's most shocking "Futurists," as Post-Impressionists were often called in Montreal. His works showed summary compositions, flattened forms with dark and broken outlines, juxtapositions of unharmonious colors, and various patterns of brushwork within a single work.

*Swiss Landscape*, 1911

Lyman's awareness of Post-Impressionism was not only reflected in his art but was also revealed by two letters he wrote to the local papers. He did not defend himself nor even explain his position. Rather, in an articulate but slightly ironical statement, he traced the development of Post-Impressionism and discussed such artists as van Gogh, Gauguin, Cézanne, and Matisse. The task of stating his aims and position was left to his wife, Corinne Lyman, who, in the introduction to the catalogue for his 1913 solo show, declared that "...l'art n'est pas une imitation de la nature...l'art doit être artificiel," ("Art is not a copy of nature...art ought to be artificial").

Upon his return to Canada, Lyman's "gentlemanly" lifestyle gave way to a greater commitment to his career and to improving artistic conditions. As a critic for *The Montrealer* in 1936-42 he provided some of the most enlightened writing on art in that period, and was a key figure in emphasizing internationalism in Québec. Often he stressed the importance of the relationship of

form to form and color to color in art. However, he never insisted on formal values alone. He admitted the interplay of subjective states, and, like Matisse, he discussed the role of instinct and the expression of feelings. As an organizer of the Eastern Group of Painters and the Contemporary Arts Society, Lyman sought to improve exhibiting conditions. Here, as in his teaching at The Atelier and McGill University, Lyman was careful not to become dogmatic. While Lyman's art was to undergo various transformations as his career developed, essential form and the structural importance of color were to remain lifelong concerns.

Louise Dompierre

[1] It has not yet been possible to establish when and for how long Lyman was at Matisse. The evidence seems to contradict the artist's own recollection that he was there in 1909. See: J. Lyman, "Adieu Matisse," *Canadian Art*, vol. XII, no. 2 (Winter 1955): 44-46.

# Stanton Macdonald-Wright

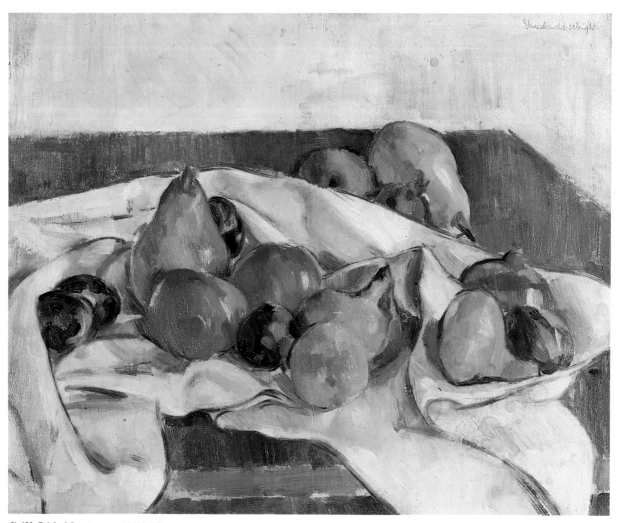

*Still Life No. 1*, ca. 1916-17

Stanton Macdonald-Wright (1890-1973) studied at the Art Students League of Los Angeles under Warren T. Hedges, a former student and colleague of Robert Henri. During the summer of 1907, at the age of seventeen, he went to Paris for the first time, accompanied by his new wife and mother-in-law. He studied briefly at the Ecole des Beaux-Arts and the Académies Julian and Colarossi, and experimented with Impressionist painting and the Pointillist techniques of Seurat and Signac.

An enthusiast for the work of Cézanne, Macdonald-Wright soon purchased four of the French artist's watercolors. He began experimenting with Cézannesque forms in his own work, and by the summer of 1912, he and future set designer Lee Simonson were working in Cassis, in the south of France, emulating Cézanne and attempting to paint the nude in the open air.[1]

Macdonald-Wright studied color theory in the classes of Percyval Tudor-Hart, where he met fellow expatriate Morgan Russell. His interest in the history of modern art was shared by his brother, the critic Willard Huntington Wright, whose book *Modern Painting: Its Tendency and Meaning* was published in 1915.[2] Years later, Macdonald-Wright, acknowledging some of his most important sources, wrote: "The body of my painting stems from Cézanne and Seurat, into the intricacies of whose great works I was first led by Morgan Russell—co-founder with me of Synchromism in 1913...."[3]

Interested in painting without naturalism in color or form, Macdonald-Wright espoused the art of both Gauguin and Matisse. But it was Cézanne's work that he truly celebrated, noting that "his art bypassed nature as it had been paint-

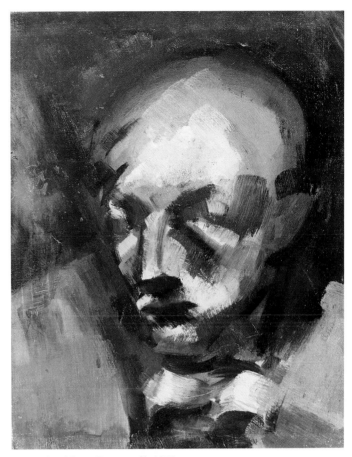

*Portrait of Jean Dracopoli*, 1912

ed up to that time and created a new cosmos imbued with mind and meaning, color and form, ideal and method."[4]

While Macdonald-Wright's involvement with the art of Cézanne is immediately apparent in his proto-Synchromist still lifes of about 1912, his highly emotive *Portrait of Jean Dracopoli*, also painted that year, is closer to Fauvism in its loose, slashing brushstrokes and its intensely bright palette. He did not, however, continue working with such a spontaneous method of execution, preferring instead the precisely calculated, submerged figures of his Synchromist abstractions. By the later 1910s, particularly in landscapes, but also in still lifes and figure paintings, Macdonald-Wright once again emulated the light, airy transparency found in much of Cézanne's work.

Unfortunately, much of Macdonald-Wright's early work, when he was

most closely involved with Post-Impressionist issues, is either lost or has been destroyed; some works are known only from old black and white photographs. Nonetheless, it is clear that Post-Impressionism was an important formative influence on the artist's development.

Gail Levin

[1] Lee Simonson, *Part of a Lifetime* (New York: Duell, Sloan and Pearce, 1943), p. 20.

[2] Willard Huntington Wright, *Modern Painting: Its Tendency and Meaning* (New York: John Lane Company, 1915).

[3] Quoted from Stanton Macdonald-Wright, "The Way I Paint," reprinted from the 1948 exhibition catalogue of The Stendahl Galleries, Los Angeles, in David W. Scott, *The Art of Stanton Macdonald-Wright* (Washington, D.C.: Smithsonian Press, 1967), p. 15.

[4] Stanton Macdonald-Wright, "The Artist Speaks: Stanton Macdonald-Wright," *Art in America*, 55, May/June 1967: 71.

# Edward Middleton Manigault

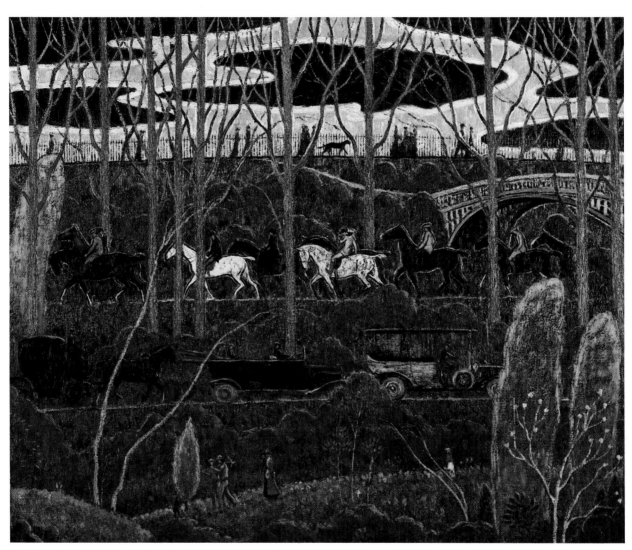

*Procession*, 1911

Edward Middleton Manigault (1887-1922) was born in London, Ontario.[1] His parents were natives of Charleston, South Carolina, and he grew up there and in New Hampshire and New York. Details of his education are obscure. Before 1914 he worked in Paris and Brittany[2] and studied with his close friend Kenneth Hayes Miller.[3] According to Miller, Manigault's earliest works derived from Impressionism. By 1909, the year he began showing at the Montross and Daniel Galleries, Manigault had acquired a knowledge of Divisionist theory and practice, as is evident from a painting of fireworks seen against a night sky (Columbus Museum of Art). Several characteristics of his work make their first appearance here: decorative surfaces, strong value contrasts, rhythmic effects of composition, and a penchant for dramatic skies. The paint is heavily encrusted over a blue ground with thick Pointillist dots and short strokes.

Reviews of Manigault's first one-person exhibition in March 1914, at the Daniel Gallery in New York, reveal that he was experimenting with a diversity of styles.[4] The most widely discussed painting in the exhibition was *Procession*, which recalls Maurice Prendergast in its mood of reverie, but is also reminiscent of Charles Prendergast in the precise decorative definition of each motif. Charles Caffin, writing in *The New York American*, surmised that each painting in the exhibition was intended to evoke a different mood:

> Here, for example, is a vision of a scene in Central Park. Down below is the motor drive: it is paralleled above by the riders' track, and above that by the pedestrians' pathway, while above all are the strata of clouds: the bands of varying activity being knit together by the tree stems and the foliage. It

has something of the suggestion of an enlarged, robuster Persian miniature. If, however, Manigault is conscious of the influence, it has but quickened his imagination. The feeling is of today and New York.[5]

A composite view of Providence, Rhode Island, entitled *New England Town* (location unknown), may have been intended to evoke a contrasting urban experience.

Other paintings in the exhibition resembled the work of Arthur B. Davies: *Adagio* (1914, location unknown) repeats Davies's favorite theme of allegorical nudes in a landscape, but with a shriller tone and more mordant sensibility. Figures, trees, and sky are made part of one flat, continual, re-echoing design. Manigault's attraction to mystical themes grew, and Oriental subjects became more frequent in his art— unfortunately, to the detriment of its quality.

Manigault married in April of 1915, and volunteered for service with the British Forces in World War I the same month. He was invalided home in November after being gassed and was in frail health thereafter.[6] Cubo-futurist paintings and sculpture followed a move to San Francisco in 1919, but Manigault later destroyed most of these works. His last years were preoccupied with mystical subjects and, alternately, with Cézannesque still-lifes. In 1922, Manigault starved to death in an attempt to experience colors more vividly through fasting.

Peter Morrin

[1] Arnot Art Museum, *Catalogue of the Permanent Collection*, Elmira, New York, 1973.

[2] Watercolors of New York, Connecticut, Paris, and Brittany are mentioned in "Exhibits Scenes in Fifth Avenue: Middleton Manigault Presents Familiar Views in Water Color Work," *New York Press*, March 22, 1914.

[3] Miller's 1941 reminiscences of Manigault are quoted in *Paintings by E. Middleton Manigault, 1887-1922* (West Palm Beach: Norton Gallery of Art, 1963). Introduction by E. Robert Hunter.

[4] Several clippings are preserved in the Manigault File, Gibbes Art Gallery, Charleston, South Carolina.

[5] Charles H. Caffin, "Invention and Artistry Displayed by Manigault," *The New York American*, March 23, 1914.

[6] Norton Gallery, *Paintings by Manigault*.

# John Marin

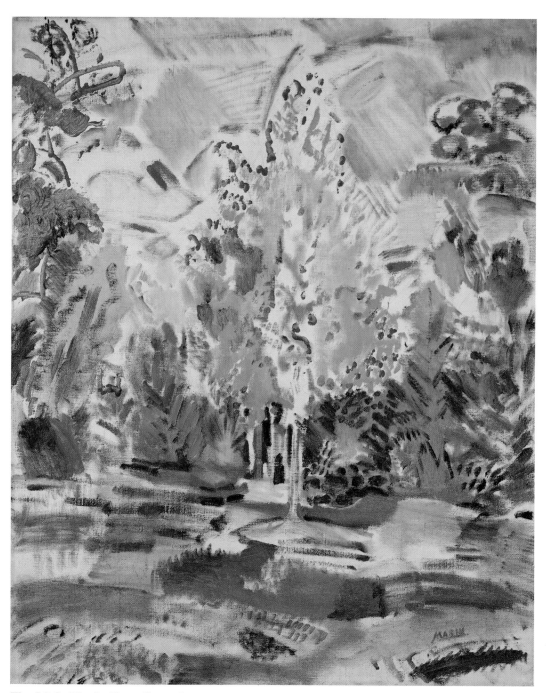

*The Little Maple Tree, Castorland,* 1913

Best remembered for his expressionist watercolors of lower Manhattan and the coast of Maine, John Marin (1870-1953) worked as an architect before enrolling at the Pennsylvania Academy of Fine Arts in 1899 for two years under Thomas Anschutz and Hugh Breckenridge. In 1905 Marin began a European sojourn which was to last, with few interruptions, until 1910. His vision and outlook were strongly determined by art currents in late nineteenth century America, but by 1907 his interest in the avant-garde had begun to kindle. Although he seems to have escaped the wide net cast by Leo and Gertrude Stein, Marin had extensive contacts with expatriate devotees of Cézanne and Matisse. He frequented the Café du Dome and was a member, along with Max Weber and Patrick Henry Bruce, of the forward-looking New Society of American Artists in Paris. Marin, whose palette remained subdued during this time, exhibited at the Salon des Indépendants in 1907 and at the Salon d'Automne between 1907 and 1909.

Through Arthur B. Carles, a Philadelphia friend, Marin was introduced to Edward Steichen who, in turn, brought him to the attention of Alfred Stieglitz. Almost immediately, Stieglitz became a staunch advocate, supporting and encouraging the artist for the rest of the career. In 1909 Marin and Alfred Maurer were featured in a joint exhibition at "291." The following year, Marin contributed, with Arthur Dove and Marsden Hartley, among others, to the *Younger American Painters* exhibition at Stieglitz's gallery and was also given his first one-man show there.

Back in New York, Marin reacted strongly to the pulse and energy of the city, and his gleaning of advanced methods began to crystallize. In

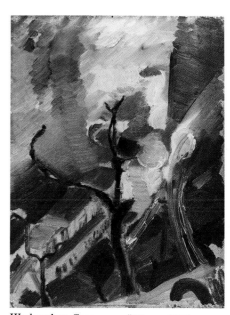

*Weehawken Sequence, #65,* ca. 1915

*Brooklyn Bridge,* for example, patterned touches of delicate color seem to float across the paper, areas of which have been left untouched, in a design full of movement. "Although he is usually accepted in this country as a follower of Matisse," it was written in 1910, "Mr. Marin derives more logically from Cézanne."[1] An intuitive painter, uninterested in questions of theory, Marin was forced to take the lessons of modernism into greater account through his association with the Stieglitz circle. The 1911 Cézanne exhibit at "291" was a revelation, according to the artist. By 1913 Marin's manipulation of color and his idiosyncratic expression were so closely interwoven that he was declared a Post-Impressionist in the press, and his show at "291" that year caused a sensation.

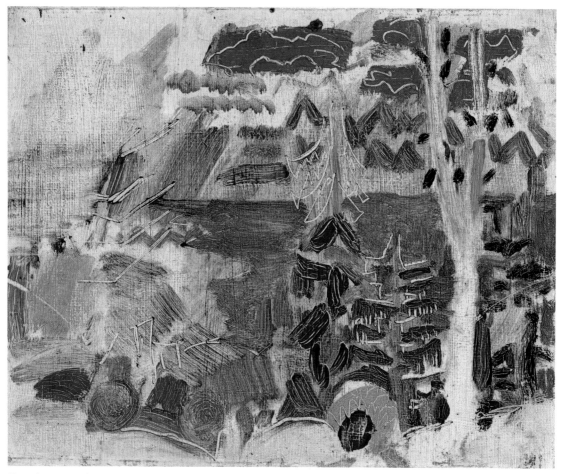

*Landscape*, ca. 1914

A series of small canvases, painted sometime between 1911 and 1916 around Weehawken, New Jersey, Marin's birthplace, offers substantial proof of his awareness of Fauvism. In a work such as *Weehawken Sequence #65*, with its thick dabs of paint, Marin is determined to capture, as quickly as possible, his emotional reaction to the scene before him. Such a sketch is Fauve in spirit if not in color. Four of Marin's urban watercolors were included in the Armory Show in 1913. That summer Marin traveled to Castorland in upstate New York. Responding to the beauty of the terrain and stimulated, no doubt, by the extensive display of modern art in New York earlier in the year, Marin produced his most vibrant and energetic landscapes. Working with intense oranges, reds, yellows, and greens, Marin transforms trees and hills into an agglomeration of expressive brushstrokes through which his heightened apprehension of the world is communicated.

Nick Madormo

[1] Elizabeth Luther Cary, "News and Notes of the Art World," *New York Times*, Feb. 13, 1910, magazine: 10.

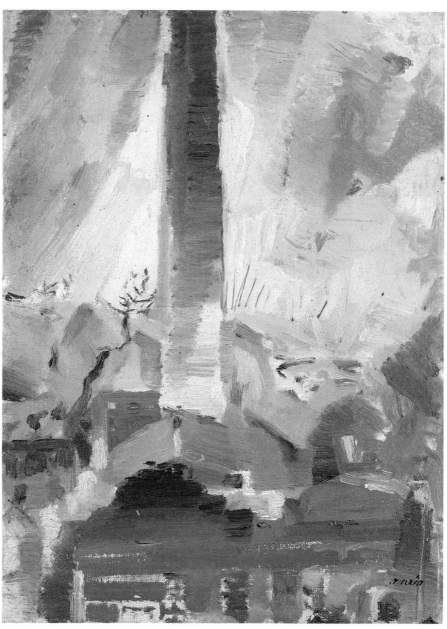

*Weehawken Sequence #2*, ca. 1916

# Jan Matulka

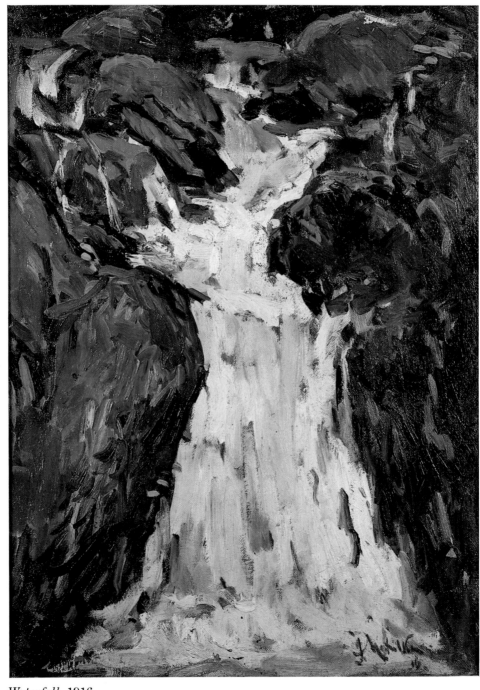

*Waterfall*, 1916

The career of Jan Matulka (1890-1972) vacillated between modernism and tradition, and his examination of Post-Impressionist ideas was decidedly brief, but the appearance of his Post-Impressionist-inspired works marked a break with a juvenile *retardataire* style and a turn to a more progressive mode of painting. An immigrant like many of the New York painters of his generation, Matulka had come to the city with his parents in 1907 and lived there for the rest of his life. Although he had studied art in Prague, he continued his art training at the National Academy of Design from 1908 to 1917 and was enrolled at the Art Students League for the 1924-25 season. Several years later he became a popular instructor at the Art Students League, where he taught from 1929 to 1931. Matulka's major production encompassed landscapes, still lifes, and nudes, but he was most innovative in a series of Cubist-inspired views of Manhattan that date from the 1920s.

Matulka's early flirtation with Post-Impressionism began with *Waterfall* (1916), an uncharacteristic example of a painting dated by the artist. One of his earliest extant works, the innovative *Waterfall* marked a break with his tepid, though competent, academic student works and established a new direction for the young artist. The rich surfaces, luminous color, loose paint application, and flattened spatial orientation of *Waterfall* are all hallmarks of his nod to Post-Impressionism.

Although Matulka divided his time between Paris and New York during the 1920s, he had not visited France by 1916 and would have known examples of European Post-Impressionism solely from their appearance in New York—for example at the Armory Show—or from reproductions in periodicals. It is most likely, however, that he came to modernism through an exposure to works by American moderns, for *Waterfall* closely resembles a group of paintings of waterfalls by Marsden Hartley that date from around 1910. By 1916 Hartley had returned to New York after spending several years in Europe, and that year Mutulka could have seen his work in the Forum Exhibition in March and in Hartley's one-man exhibition at "291" in April. Matulka appears to have been inspired by Post-Impressionism at a remove and therefore heralds a generation of American moderns not directly influenced by Europe.

Percy North

# Alfred Maurer

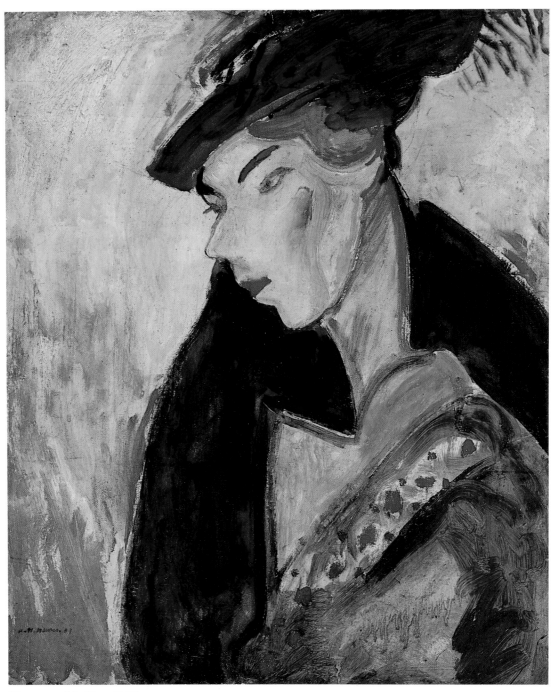

*Woman with Hat,* 1907

After studying at the National Academy of Design, Alfred H. Maurer (1868-1932) emigrated to Paris in 1897 and remained there, with occasional trips back home to New York, until 1914. During this period he painted in a variety of aesthetic modes with startling acumen and success. Between 1901 and 1905 Maurer won a number of medals on both sides of the Atlantic for his Whistlerian figure studies. Hailed as one of the most promising artists of his generation, by 1906 Maurer was caught up in the modern movement through his appreciation of Cézanne and Matisse.

Maurer was a regular at the Stein salon and befriended many other Americans abroad, including Max Weber and Patrick Henry Bruce, members of the Matisse painting school, which Maurer may also have visited. He contributed to the Salon d'Automne beginning in 1905, the year the Fauves made their spectacular debut; he also exhibited regularly at the Salon des Indépendants. The New Society of American Artists in Paris held its first meeting in 1908 in Maurer's studio at 9 rue Falguière.

Under this variety of radical influences, Maurer, in a daring move, completely reshaped his method and point of view. He was one of the first of the American artists (and certainly the best known) to paint in the Fauve manner. In *Woman with Blue Background*, brusquely executed in vivid shades of blue, red, and green with the underpainting clearly visible, the model is rendered as a planar structure that harks back to Cézanne. The decorative *Woman with Hat*, on the other hand, reflects the influence of Matisse. High color contrasts and brushstrokes darting about in every direction are balanced against an angular, exaggerated design.

Having committed himself to mod-

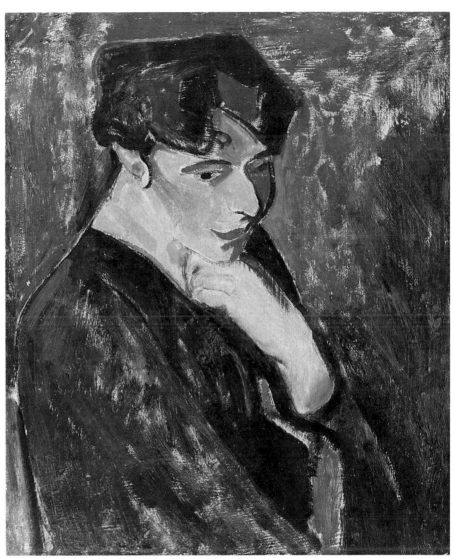

*Woman with Blue Background*, 1907-08

ernism, Maurer steadily sharpened his approach with landscape painting. In 1909, through the auspices of Edward Steichen, a Paris friend, a group of Maurer's landscape sketches were exhibited at "291," along with works by John Marin. Completely misunderstood by critics previously receptive to his work, Maurer was blasted as "the apostle of ugliness." His work was also seen in the *Young American Painters* show at the Stieglitz gallery in 1910 that highlighted the so-called "disciples of Matisse."

A master of technique, Maurer constantly modified and refined his methods. In a 1908 article in the *New*

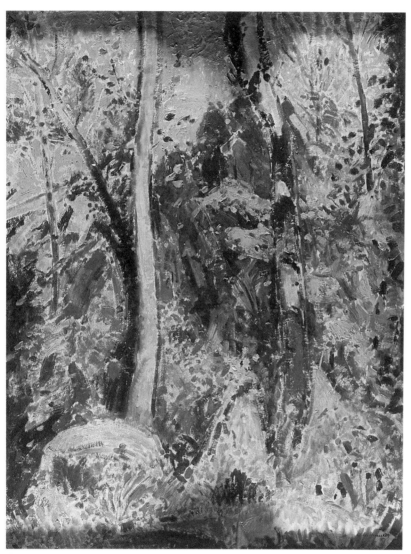

*Landscape with Trees,* ca. 1908

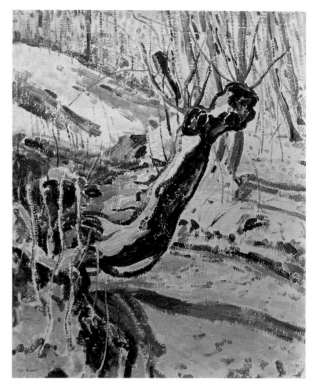

*Landscape,* ca. 1911

*York Times* entitled "Artist Maurer Now An Impressionist," he admitted, "I am still in transition, I know. I can't tell what tomorrow will bring about."[1] *Landscape with Trees* reveals the artist working in an open network of dots and dashes which seem to form a flickering screen of bright paint. *Landscape*, a muted view of a hillside in spring, with its spontaneous delineation of forms and shadows flecked with blue and yellow, bristles with a thick patterning of brushstrokes. During his last few years abroad, Maurer pushed his expressionist, high-color tendencies to the limit, producing brilliant yellow, green, and violet-hued landscapes with sharply outlined shapes, such as *Landscape with Train*. In *Pitcher and Three Croissants*, Maurer created an utterly flat design with sharp colors and simplified forms derived from Matisse and Cézanne.

Maurer's one-man show at the Folsom Gallery in New York in 1913 was greeted by critics as a Post-Impressionist display; its brochure contained excerpts from the writings of Clive Bell and Roger Fry. Regarded as one of the most advanced Americans working in Europe, Maurer was consulted by Walt Kuhn and Walter Pach in the organization of the Armory Show, to which Maurer contributed four works, including two still-lifes.

Nick Madormo

[1] *New York Times*, April 19, 1908, sec. 3: 5.

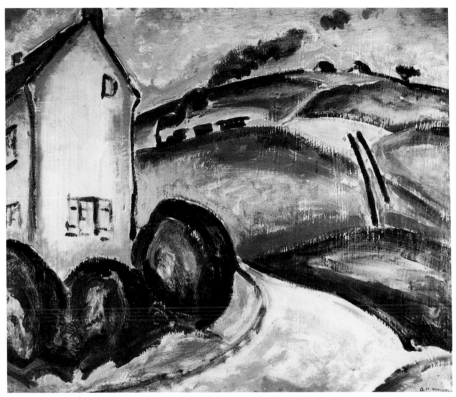

*Landscape with Train*, 1910

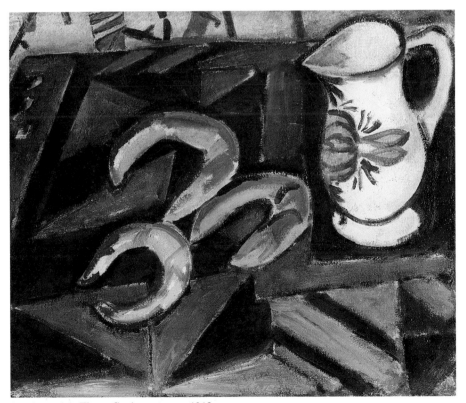

*Pitcher with Three Croissants*, ca. 1912

# Henry McCarter

*The Green Tree/For Sale Here*, 1894

A stimulating and beloved teacher, Henry McCarter (1864-1942) imparted his knowledge of French Post-Impressionism to generations of students at the Pennsylvania Academy of the Fine Arts. The son of an iron-works owner, McCarter became interested in art through an Irish priest who tutored him in the summers. Starting in 1879, he spent four years at the Pennsylvania Academy, but the academic program of Thomas Eakins was not to his liking, so he went to work as an illustrator for the *Philadelphia Press*.

In 1887 McCarter began a five-year stay in Paris that affected his art and his teaching for the rest of his life. He worked first with Léon Bonnat and Puvis de Chavannes, and then the art critic August Jaccaci introduced him to the writers and artists of the cafe society vividly depicted in Henri de Toulouse-Lautrec's posters. Toulouse-Lautrec allowed McCarter to work as an apprentice in his shop and asked him to help complete a commission to paint the portraits of prostitutes. From Lautrec he learned that a painter's use of color need not be naturalistic; he was also inspired by the strong curvilinear designs and flat patterns found in Lautrec's work and in Japanese woodcuts.[1]

McCarter admired the work of the most advanced artists of the time, including Degas, van Gogh, Renoir, and Whistler, many of whom he knew, and he was impressed by an exhibition of Cézanne landscapes he saw at the Georges Petit Gallery.[2]

After his return to the United States, McCarter became a highly successful illustrator, working for popular magazines such as *Colliers*, *The Century*, and *Scribner's*. His 1894 advertisement for The Green Tree Library was created at the height of the poster craze in America. The strong two-dimensional design, with its well-defined, rounded outlines and flat areas of pattern and color, reveals his debt to Japanese woodcuts as well as the art nouveau poster style he had encountered in France.

Based at first in New York, McCarter moved to the Philadelphia area a few years after beginning to teach the illustration class at the Pennsylvania Academy in 1902. He took an anti-academic approach in his classes, teaching his students to appreciate Hokusai, Gauguin, Toulouse-Lautrec, and Degas, and instilling in them the desire to experience Paris for themselves. Among his students were Carles and Demuth; the flowing curvilinear design and sensitivity to positive and negative shape that characterizes their work probably reflect McCarter's teaching.

In 1915, McCarter won a gold medal for "decoration and color" at the Panama-Pacific Exposition. The following year, he gave a series of lantern slide lectures on Cézanne, van Gogh, and Degas.[3] Later, he and Carles became allies in the promotion of modern art in Philadelphia. Their efforts culminated in the controversial showing of the Albert C. Barnes collection at the Academy in 1923.

McCarter turned to oil painting in the early 1900s, concentrating on light effects in rural landscapes. At the end of his life, his color became bolder and the level of abstraction greater. He became fascinated with the idea of painting "the color and movement of a chime of bells,"[4] an outgrowth of the turn-of-the-century interest in relating painting and music.

Barbara A. Wolanin

[1] Francis Biddle, *A Casual Past* (Garden City, New York: Doubleday, 1961), p. 390, and R. Sturgis Ingersoll, *Henry McCarter* (Cambridge: The Riverside Press, 1944), p. 34.
[2] Biddle, p. 390, and Ingersoll, p. 27.
[3] Wilford W. Scott, "The Artistic Vanguard in Philadelphia, 1905-1920," Ph.D. dissertation, University of Delaware, 1983.
[4] Ingersoll, p. 7.

# Thomas Buford Meteyard

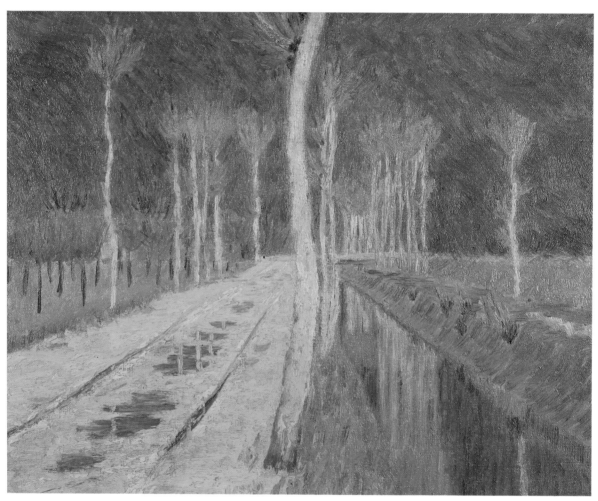

*The Purple Trees*, ca. 1890

Thomas Buford Meteyard (1865-1928) was a precocious experimenter with several techniques. An illustrator and book designer, he showed an early knowledge of Nabi design in the poster and endpapers he designed for Bliss Carman and Richard Hovey's *Songs from Vagabondia* (Copeland and Day, Boston, 1894).[1] Meteyard was educated at Harvard, studied in Europe in the late 1880s, and exhibited widely—at the Chicago Exposition of 1893, the Society of American Artists, New York, the Pennsylvania Academy, and the St. Louis Exposition of 1904. He may have worked at Giverny with Monet.[2]

Meteyard showed impressionistic canvases in Chicago in the 1890s, but had adopted a modified Pointillism by the early years of the twentieth century. *The Beach, Scituate* (Indianapolis Museum of Art) reflects the probable influence of Seurat's seascapes in its sweeping panorama of a coastline and the technique of short strokes applied to an unprimed canvas.[3] Meteyard's limited, very high-keyed palette is startlingly vibrant for an American artist working at the turn of the century.

*The Purple Trees* offers further evidence of Meteyard's freedom with color. The symmetrical, hieratic composition evokes French Post-Impressionist interest in highly ordered designs.

Meteyard's contacts with other American artists are not known. Although he lived in Scituate, Massachusetts, on the southern shore of Boston Harbor, there is no record of his relations with others of advanced taste living in the same region, such as the Prendergast brothers in Boston or Arthur Wesley Dow in Ipswich. After a period of travel,

*Songs from Vagabondia*, 1895

Meteyard settled in 1910 at Fernhurst, Sussex, with his English wife.

Peter Morrin

[1] *The Arts and Crafts Movement in America, 1876-1916*, ed. Robert Judson Clark, (Princeton: Princeton University Press, 1972), p. 99.
[2] Ellen Wardwell Lee, *The Aura of Neo-Impressionism: The W. J. Holliday Collection* (Bloomington: Indiana University Press, 1983), pp. 146-147.
[3] Ibid.

# David Milne

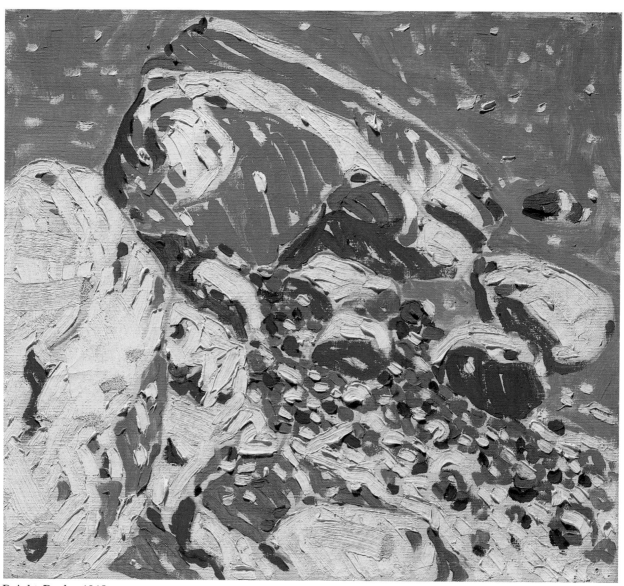

*Bright Rocks*, 1913

David Milne (1882-1953) spent his formative years as an artist, from 1903 to 1916, in New York. In 1903, at the age of twenty-one, he arrived in the city from rural Ontario to study commercial art. "I started off," he wrote later, "knowing no more about my destination than if I had been plunging into the sun."[1] But he knew enough to enroll at the Art Students League, and for the next several years attended the classes of George Bridgman, Frank Vincent DuMond, and Henry Reuterdahl. His principal ambition was to succeed as a magazine illustrator, an ambition he abandoned only when he seriously committed himself to painting in 1910-11.

The decision by Alfred Stieglitz in 1908 to begin exhibiting the work of contemporary European and American artists at "291" had a profound effect on the direction of Milne's art. He recalled visiting the gallery with friends:

> In those little rooms, under the skylights, we met Cézanne... Matisse, Picasso, Brancusi. For the first time we saw courage and imagination bare, not sweetened by sentiment and smothered in technical skill. We were fortunate in seeing it unfolded slowly, in unpretentious surroundings."[2]

Until 1910 Milne was primarily absorbed with atmospheric effects in his paintings, but between 1910 and 1912 he began to squeeze the Impressionist air out of his oils and watercolors. Two months after the Cézanne exhibition at "291," in March 1911, he produced a series of watercolors of rocks and dense foliage reminiscent of Cézanne's studies of the Bibemus Quarry. And by the time the Armory Show opened, he was on the way to finding an individual style of his own.

Milne was represented by five paintings in the Armory Show. *Billboards* may have been exhibited under the title *Columbus Circle*. In mood and subject matter, as well as in its mosaic patterning of color, the painting shows a marked affinity with the work of Maurice Prendergast. The affinity was not missed by the critic of the *Christian Science Monitor*, who categorized Milne and Prendergast, along with William Zorach and Walter Pach, as American "extremists."[3] But Milne's own attention at the Armory Show was focused on the Fauves, especially Matisse. In the summer of 1913 and 1914, a new urgency is recognizable in Milne's compositions, a charged handling of reds and blues, and a deliberate effort to play down lyrical associations of sun and water. In subsequent years, he wrote thoughtfully about art (particularly his own), partly under the influence of Roger Fry and Clive Bell. By the time he left New York in 1916 to live upstate, he had developed the sparse calligraphic style that would be characteristic of his work for the remainder of his career.

John O'Brian

[1] David Milne, unpublished autobiography, 1947 (Milne Family Papers, Toronto).
[2] Letter from Milne to Vincent and Alice Massey, August 20, 1934 (Massey College, University of Toronto).
[3] *Christian Science Monitor*, February 24, 1913.

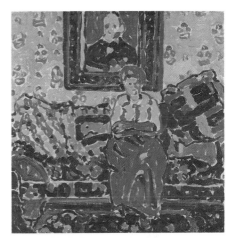

*The Bright Pillows*, ca. 1914

*Lilies*, 1914

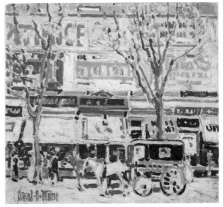

*Billboards*, 1912

# James Wilson Morrice

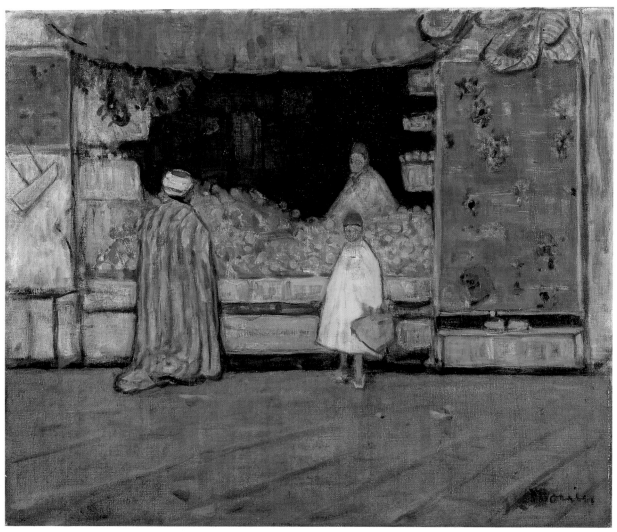

*Fruit Market, Tangiers,* ca. 1911-12

James Wilson Morrice (1865-1924), the third son in a wealthy Canadian textile family, chose to live as an expatriate in Paris for most of his adult life. In 1890, after completing a law degree in Toronto, he entered the Académie Julian in Paris. It was probably there that he met and became friends with Maurice Prendergast and Robert Henri. On occasion during the 1890s they sketched together with William Glackens in the forest at Fontainebleau. In later years, they saw each other primarily in the United States when Morrice stopped in New York on infrequent trips back to Canada.

Between 1900 and the outbreak of war, Morrice acquired a significant European reputation as a painter. His frequent contributions to exhibitions in Paris (to the Société Nationale des Beaux-Arts and the Salon d'Automne, among others) were reviewed regularly by leading critics. In 1909, Louis Vauxcelles, the critic responsible for coining "Fauvism" and "Cubism" as descriptive terms, wrote that since Whistler's death in 1903 Morrice had become "the [North] American painter who had achieved in France and in Paris the most notable and well-merited place in the world of art."[1]

Morrice himself expressed the opinion, in a letter of 1911, that the best painter in Paris since Gauguin had died was Bonnard. (Morrice wrote little, though he travelled in literary circles and was on close terms with Clive Bell, Roger Fry, Somerset Maugham, Arnold Bennett, and Paul Fort.) His work reflects admiration for both artists, especially Bonnard—and by the same token, Vuillard. Those paintings with an *intimiste* inflection—such as *Terrace at Capri*, with its nuancing of color and place—were described by Marius and Ary

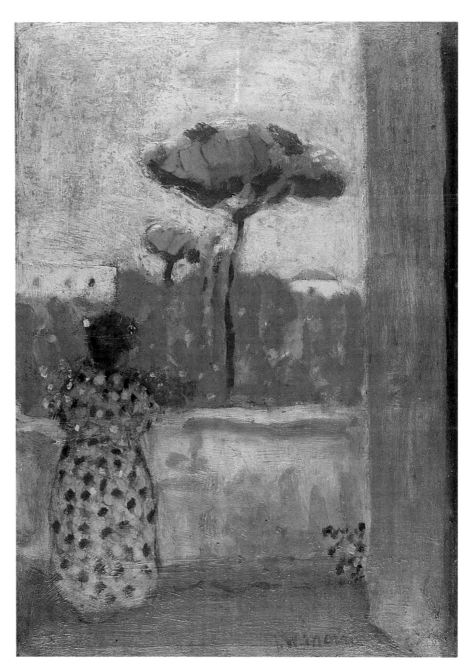

*Terrace at Capri*, ca. 1910-23

*House in Santiago*, ca. 1915

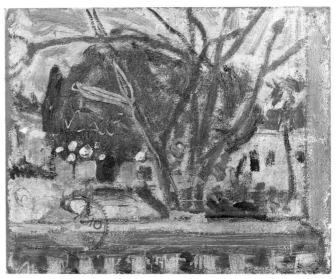

*Scène de rue à Alger*, 1912

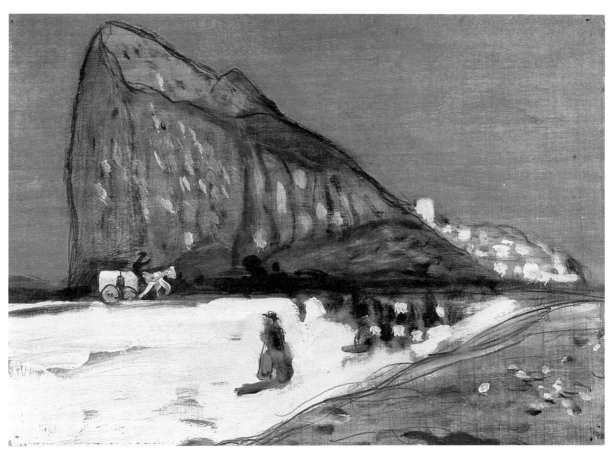

*Gibraltar*, ca. 1913

Leblond in 1909 as having about them "a sensuality of calm."[2]

In the winters of 1911-12 and 1912-13, Morrice followed Matisse, whom he had known only slightly in Paris, to Morocco. "About fifteen years ago," Matisse recalled in 1926, "I passed two winters in Tangier in the company of Morrice. You know the artist with the delicate eye, so pleasing with a touching tenderness in the rendering of landscapes of closely allied values. . . . We were, outside of our hours of work, always together."[3] For Morrice, the encounter proved significant. The example of Matisse, combined with extended sojourns in North Africa, Jamaica, and the Caribbean, brought a new vitality to his art in the last ten years of his life. Morrice's late paintings exhibit a comprehension and command of color matched by few artists of the time, in Europe or North America.

John O'Brian

[1] Louis Vauxcelles, "The Art of J. W. Morrice," *Canadian Magazine* XXXIV (November 1909-April 1910): 169.

[2] Marius and Ary Leblond, "Wilson-James Morrice," *Peintres de Races* (Brussels, 1909), p. 204.

[3] Matisse, undated letter to Armand Dayot [late 1925], printed in *James Wilson Morrice* (Paris: Galleries Simonson, 1926), pp. 6-7.

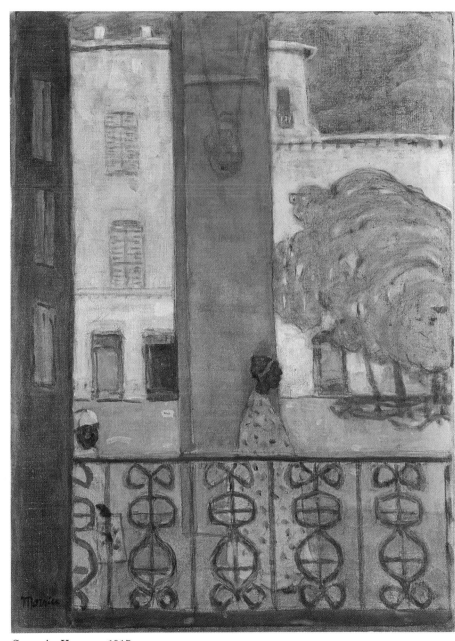

*Scene in Havana*, 1915

# Carl Newman

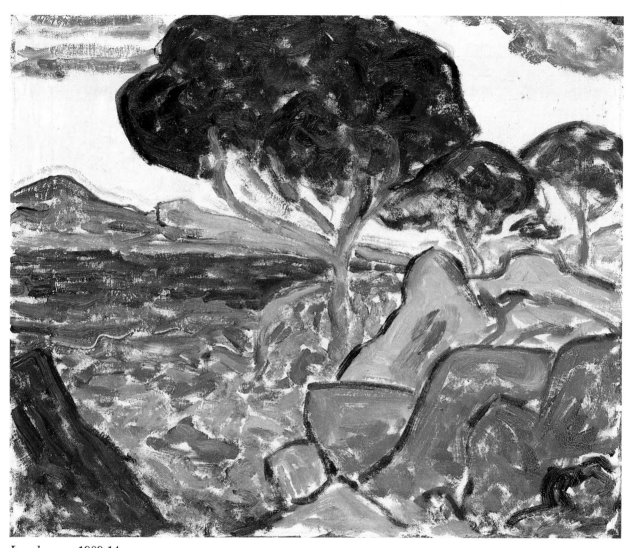

*Landscape,* 1909-14

Carl Newman (1858-1932) is one of the most obscure of the Philadelphia modernists; few of his paintings and little information about him have survived. European-born, he studied in Munich and Paris. In France in 1890 and 1892, he was deeply influenced by Impressionism. He visited Monet and may have worked in Giverny, and was a friend of the Swedish Impressionist Anders Zorn. Newman frequently travelled to France for the summer.

Wealthy enough to be free from the necessity of selling paintings or teaching for a living, Newman was open to new ideas. He taught at the Pennsylvania Academy from 1892 to 1895 alongside Thomas Anshutz,[1] and from 1885 into the early 1900s he exhibited regularly at the Academy annuals. His full-length portraits of women with bouquets of flowers or dogs were often reproduced in the catalogues. They stood out from the many paintings of similar subjects because of Newman's technique of painting in distinct strokes of pure pastel hues, entirely eliminating browns and blacks and achieving an effect of dappled sunlight.

Newman's interest in unmixed and expressive Fauve color was stimulated by his visits to H. Lyman Saÿen in Paris between 1907 and 1914. *Landscape* reveals Newman's awareness of Matisse in the use of pure primary and secondary hues and in the rough application of paint, which brings attention to the surface. Undulating blue lines relate the red and yellow rocks to the contours of the trees and mountains. In 1911, Newman joined Saÿen and Anshutz in experiments in mixing new colors.[2]

Newman strongly supported Saÿen's efforts to introduce modern art to Philadelphia after his return from France in 1914. He allowed Saÿen to use his studio in his Huntingdon Valley home near Bethayres, Pennsylvania, and he commissioned him to decorate the ceiling with a spectrum of color. Their mutual interest in creating an environment of color was most fully realized in an artists' masque entitled *Saeculum* which Saÿen directed in 1917. Newman designed the brightly colored and patterned hats, tunics, and pants worn by characters such as the "Spirit of Discontent," and helped Saÿen design the scenery. Most of the cosmic drama was created through Saÿen's colored lighting effects and music rather than through words. The production brought together all the art and architecture students and clubs in Philadelphia and placed concepts of modern art vividly before the public.[3]

Again paralleling Saÿen, Newman became interested in American Indian art and Cubism. His paintings, while still brilliantly colored, became much more planar and geometric, and at times very abstract. He continued to treat the human figure and attempted some large canvases on religious themes. He exhibited at the Society for Independent Artists in 1917; the nude he submitted to the 1918 show was so controversial that it was removed. He also was included in the 1921 *Later Tendencies* exhibition organized by Arthur B. Carles, although no evidence has been found of personal interaction between Newman and Carles.

Many of Newman's modern canvases were destroyed by his widow after his death. Since he had not sold many works, those that remain are the ones that his wife chose to leave in her estate.

Barbara A. Wolanin

[1] Notes by Ann Saÿen, "The Original Drawings of Carl Newman American," Smithsonian Institution Archives, 85-037, NCFA Department of 20th Century Painting and Sculpture, 1952-1980, Box 16.

[2] Jeannette Hope Saÿen, "Blossoms of Liberty—Notes of her Ninetieth Year and Some Conversations with her Daughter," Smithsonian Institution Archives, RU 315, NCFA, Department of 20th Century Painting and Sculpture, 1963-1974, Box 64.

[3] Some of the original costume designs are included in the notes on Newman, Smithsonian Institution Archives, 85-037, Box 16.

# B. J. O. Nordfeldt

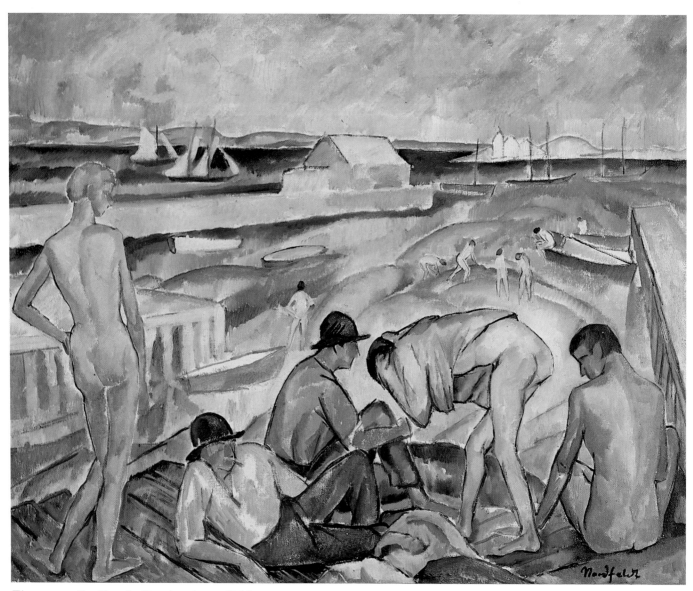

*Figures on the Beach, Provincetown,* 1916

*Steamship in Canal, Venice*, ca. 1910

Known today primarily as a master printmaker and an independent expressionist painter, Bror Julius Olsson Nordfeldt (1887-1955) first gained recognition as one of the most accomplished American practitioners of Post-Impressionism. Through his ties to artistic communities in Chicago, Provincetown, and Santa Fe, Nordfeldt helped disseminate modernism beyond New York City.

Born Bror Julius Olsson in Tullstrop, Sweden, in 1878, Nordfeldt in 1903 adopted his mother's maiden name for professional reasons.[1] The Olsson family had left Sweden in 1891 to settle in Chicago. There Nordfeldt had received only one year of artistic training at the Art Institute when he was selected in 1899 to assist Albert Herter on a mural commission. Herter rewarded his young assistant with a trip to Paris.

Although Nordfeldt enrolled in the Académie Julian, he quickly rejected all academic regimens. Intrigued by Japanese art and woodblock printing, he traveled to England in order to study woodcut techniques under Frank Morley Fletcher. Returning to Chicago in 1903, Nordfeldt established his studio in a section of the city that became an artistic enclave.

Nordfeldt's inventiveness in graphic art was matched by his enthusiasm for French modernism. Between 1909 and 1910, he abandoned the subtle, Whistlerian tonalism of his early oil paintings for the brilliant color and daring formal simplification of the French Post-Impressionists, notably Gauguin and Cézanne. Nordfeldt once attributed this decisive stylistic change to the seductive brilliance of North African light:

> I became impressionist in Tangiers. I went there one Summer and tried to paint. I had been using low tones in all my work, but I found it impossible to use low tones and paint those wonderfully brilliant scenes. . . .[2]

It is probable that Nordfeldt's growing awareness of Matisse and the Fauves prompted his conversion to Post-Impressionism. In the catalogue for his solo exhibition at the Milwaukee Art Society in 1912, Nordfeldt was identified as "the most able interpreter of Post-Impressionism in America."

> He saw the work of Matisse, father of the new Post-Impressionism, at Paris, and was reassured of his purpose to restore to art the strong decorative features which were the fundamental aim of primitive art.[3]

Nordfeldt's Post-Impressionist style evolved in three distinct phases. Initially, he produced high-keyed North African and Venetian landscapes in which the divisionist application of pigment resembles the tapestry-like canvases of Maurice Prendergast. Secondly, in a series of portraits from 1911 to 1912, Nordfeldt combined incisive line, brilliant color contrast, and dramatically asymmetrical compositions in flat space. He told a newspaper critic at that time: "I love to paint the radiance in animate life. . . . I accomplish this in masses of pure color, sustaining the sincerity of technique in

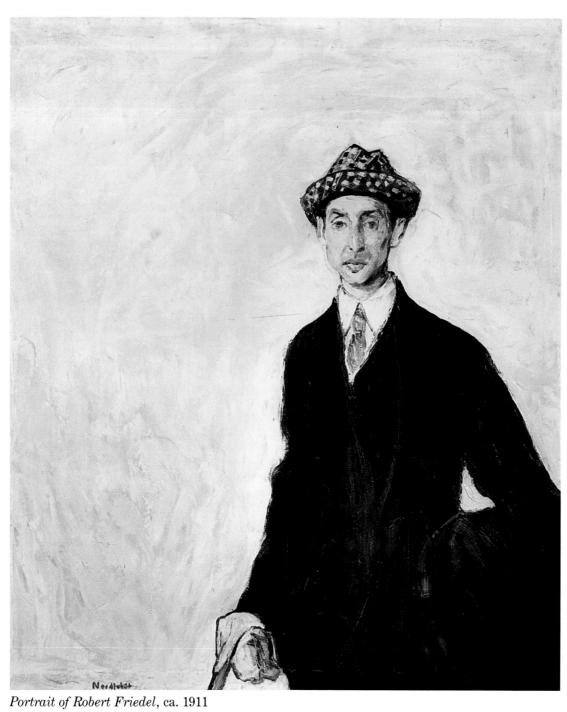

*Portrait of Robert Friedel*, ca. 1911

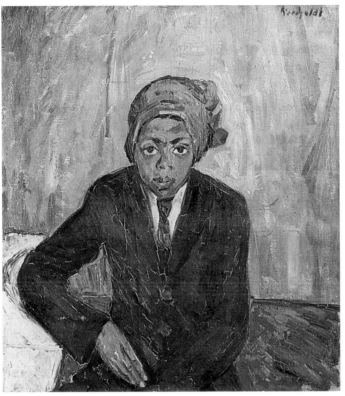

*The Red Cap*, 1912

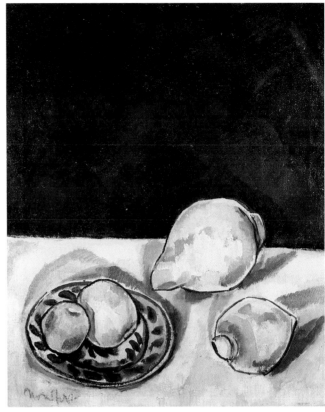

*Blue Plate*, ca. 1916

drawing. . . ."[4] Then, after a sojourn in Paris in 1913-14, Nordfeldt subordinated Fauve color to the formal structure and *passage* technique of Cézanne.

Nordfeldt's pre-war trip to France was inspired by the Armory Show in Chicago. After his exposure to the work of the Cubists, he "came to the conclusion [that] I was very conservative."[5] Nevertheless, he remained committed to the chromatic and formal concerns of Post-Impressionism. When the outbreak of World War I forced him to return to the United States, Nordfeldt settled in New York, where he exhibited at the Daniel Gallery with other American Post-Impressionists such as Marguerite Zorach, Ernest Lawson, and Samuel Halpert. From 1914 to 1918 he spent his summers in the artists' colony in Provincetown, Massachusetts. There he transmitted the Post-Impressionist style to a talented group of American printmakers. Working with Ethel Mars, Blanche

Lazzell, and other graphic artists, he perfected the technique of the single block color woodcut.[6] Nordfeldt's artistic career was interrupted by military service in 1918. When he moved to Santa Fe the following year, he adapted his Cézannesque style to landscape paintings of the Southwest.

Judith Zilczer

[1] Nordfeldt used his mother's surname to avoid confusion with the well-known painter Julius Olsson. Biographical data is based on Van Deren Coke, *Nordfeldt the Painter* (Albuquerque: University of New Mexico Press, 1972), and the B. J. O. Nordfeldt Papers, Archives of American Art, Smithsonian Institution, Washington, D.C.

[2] Nordfeldt, cited in "Seeks Radical Art in Paris. Near Futurist to Quit City," *Chicago Examiner*, April 10, 1913; Nordfeldt Papers, microfilm roll no. D-167, frame 73.

[3] Introduction to *Exhibition of Paintings by Bror J. Olsson Nordfeldt and the Chicago Society of Miniature Painters*, Milwaukee Art Society, December 28, 1912-January 15, 1913; Nordfeldt Papers, microfilm roll no. D-167, frames 60-61.

[4] Nordfeldt cited by H. Effa Webster, "Nordfeldt to Show Chicago on Canvas," *Chicago Examiner*, [November 1912]; Nordfeldt Papers, microfilm roll no. D-167, frame 57.

[5] Nordfeldt, cited in "Seeks Radical Art in Paris." In the interview, Nordfeldt specifically mentions visiting the exhibition in Chicago. Consequently, later accounts which claim that he saw the Armory Show in New York before leaving for France are in error. (Cf. Coke, *Nordfeldt*, p. 42.)

[6] See Janet Altic Flint, *Provincetown Printers: A Woodcut Tradition* (Washington, D.C.: Smithsonian Institution Press for the National Museum of American Art, 1983).

# George Of

*Landscape,* 1908

George Ferdinand Of (1876-1954) was one of several conservative American modernists who produced a small body of advanced work that attracted the notice of sophisticated observers. Of had many contacts with leading modernist artists, critics and collectors, and his work was enthusiastically praised by a loyal circle of friends, chief among them the painter Walter Pach, the author of the first major article on the artist.[1] Others who were impressed by his paintings included Alfred Stieglitz, Arthur B. Davies, Hamilton Easter Field, Charles H. Caffin, and Willard Huntington Wright, the last of whom regarded Of as "America's best landscapist."[2]

Although Of had responded positively to modernism before 1913, he, like many others, was further invigorated by the heady atmosphere of the New York art world in the years following the Armory Show. Although he was not represented in that landmark show, it had a liberating effect on his painting, and after that time his work appeared in advanced exhibitions, including the Forum Exhibition of 1916. Those exhibitions and his framing business brought him in contact with other modernists, including Georgia O'Keeffe, John Marin, Alfred Stieglitz, Charles Demuth, Max Weber, Oscar Bluemner, J. Nilsen Laurvik, and Paul B. Haviland.

Of was best known for his color and in the catalogue that accompanied the Forum Exhibition he declared: "I have tried to solve the problem of producing form by means of pure color, my ambition being to create a thing of joy." According to Pach, Sarah Stein, who with her husband Michael was an early collector of Matisse, felt that Of's "gifts as colorist went beyond those of anyone else she had known."[3] When Willard Huntington Wright described Of's

"hachures of pure color, rich and dense" as "Renoiresque,"[4] he clearly recognized Of's great debt to late Impressionism.

Yet the strength of the color and the boldness of its energetic and painterly application would not have been possible without exposure to Fauvism. Of studied in Paris around 1903, but it was not until 1906 that he saw his first Matisse. Of was deeply impressed and Fauve qualities are clearly evident in his *Landscape* of 1908, which once belonged to Pach.

The constant demands of his framing shop, which absorbed much of his time and energy until just a few years before his death, meant that Of was never able to realize the modernist promise admired by discerning viewers early on. Although he continued to paint in his spare time, he never recaptured "the old magic of form and color" for which he had been esteemed during the heady era of the teens.[5]

Betsy Fahlman

[1] Walter Pach, "Submerged Artists," *Atlantic Monthly* 199 (February 1957): 72.
[2] Willard Huntington Wright, "The New Painting and American Snobbery," *Arts and Decoration* 3 (January 1917): 130.
[3] Pach, p. 72.
[4] Wright, p. 130.
[5] Pach, p. 72.

# Charles Prendergast

*Decorative Composition*, 1918

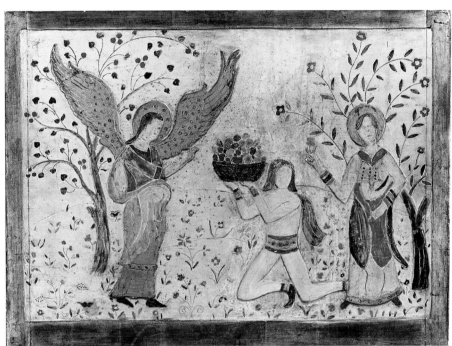

*The Annunciation*, ca. 1912

Charles Prendergast (1868-1948) began his career as a framemaker. Framemaking was far more profitable than painting, and it was often Charles's income that kept the brothers solvent. He had travelled to Italy and briefly to England with Maurice but was not exposed directly to painting in France until shortly after his brother's death.

Charles began painting in 1912, working generally on wood panels, often carved to create a low relief surface, which were covered with gesso and painted with tempera and gold leaf. The technique was clearly an outgrowth of his work as a craftsman of fine frames, but the subjects of his works, like those of his brother's art, were often friezes of figures in abstracted and simplified landscapes. The use of gold leaf, flat areas of unbroken color, and designs that emphasized the flatness of the painted surface made Charles's paintings distinctly his own.

Charles did not employ traditional Renaissance perspective and frequently used the convention often found in medieval art (as well as folk art) of placing figures higher up on the picture to indicate greater distance from the viewer. The use of this convention was obviously the conscious choice of an artist who was thoroughly familiar with painting traditions, though he had not attended art school. His earliest paintings showed the influence of a wide variety of sources in Oriental and Middle Eastern art.

After 1932, Charles began to draw his inspiration from contemporary life, and it is his later works that show the closest affinity with Maurice's paintings. *Decorative composition* is an interesting example of his use of ancient art. As Ross Anderson has observed, the running male figure at the right is copied from the fresco of the Tomb of the Triclinum at Tarquinia, which the artist must have known from a photograph.

Gwendolyn Owens

# Maurice Prendergast

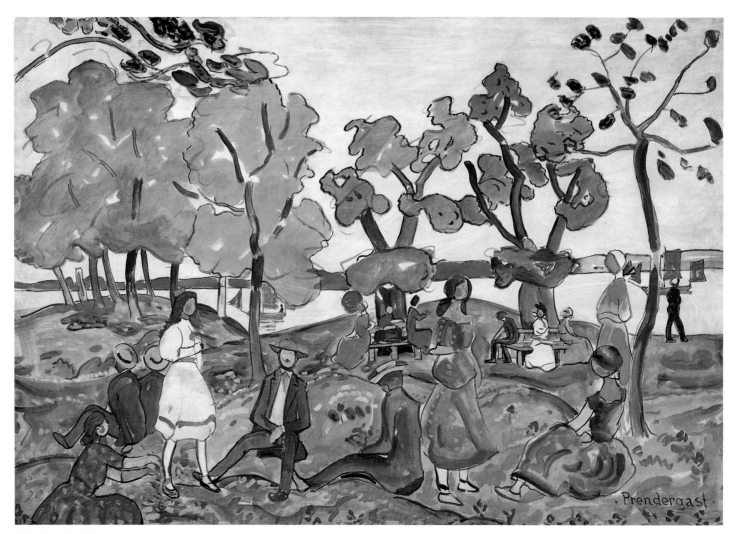

*Picnic,* 1914-15

Maurice Prendergast (1859-1924) and his brother Charles have always been difficult to categorize as part of any distinct movement in American art. Raised in Boston, they came from a poor family and did not have the educational and cultural opportunities of many of their fellow artists. This was not necessarily a disadvantage; they also escaped the sometimes pedantic instruction given in American art schools of the era. Both Prendergasts felt free to mix old and new ideas in their paintings. They drew upon sources that ranged from ancient art to depictions of Renaissance pageantry to the street scenes of Pierre Bonnard. Though they worked together closely until Maurice's death in 1924, each artist developed a distinctive personal style.

Maurice Prendergast did not begin his formal training in art until he went to Paris in 1891. Already in his thirties, he studied at Colarossi's and the Académie Julian and became friends with a number of artists, notably the Canadian painter James Wilson Morrice, with whom he made a number of sketching excursions. It was certainly through Morrice that Prendergast was first exposed to contemporary French art, though his own curiousity kept him abreast of new developments.

By 1901, Maurice had made the first of several trips to Venice and had begun to exhibit at home in large annual exhibitions and solo or two-person shows. His early works were mostly watercolors or monotypes of people in parks or at the seashore; patterns of color and rhythms of shapes gave the design of the works a lyrical quality. Critics found the colors garish and the figures stiff. In 1908, Maurice was included in the famous "Eight" show at the Macbeth Gallery, and most reviewers were

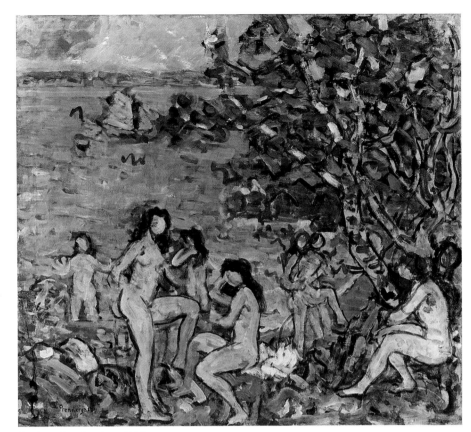

*Bathers by the Sea*, 1917

more disturbed by his bright promenade scenes than by Robert Henri's and John Sloan's depictions of the bleak side of urban life. It was apparent that for Prendergast the subject of a picture was neither an event nor a specific locale but rather a vehicle for a complex exploration of color, form, and light.

As his career progressed, Maurice's paintings became more abstract without losing the sense of an underlying foundation and structure. Whereas artists such as John Marin and Arthur Dove, who were also abstracting forms from nature, made the objects in their paintings weightless, Prendergast emphasized the horizon line and kept his objects rooted to the ground and controlled by gravity.

Shortly after the beginning of the century, he had begun to work more in oil. Unlike his watercolors, which have thin washes and made use of the white of the paper surface, the oils have paint thickly applied in lay-

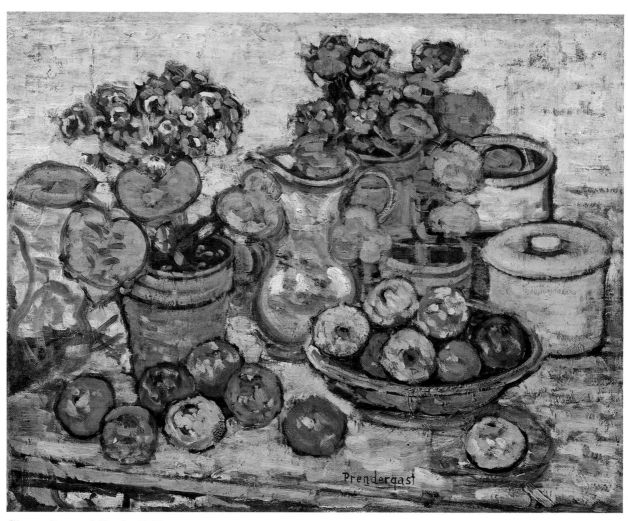

*Cinerarias and Fruit,* 1915

Round Table Library, 1895

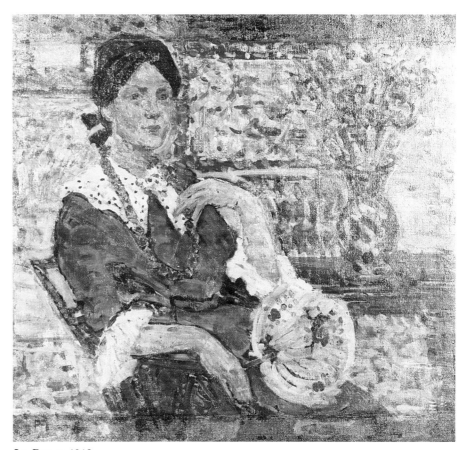

La Rouge, 1913

ers of short strokes to create a dense, almost palpable atmosphere. The solidity of his forms—which he often outlined—and the subject matter of his still lifes are reminiscent of the art of Cézanne. But there is a distinctive mystical quality to Prendergast's paintings: we seem to be looking into a world in which the air itself contains color. Maurice continued to experiment, producing works composed entirely of short dashes of paint and highly abstracted watercolors in which umbrellas have evolved into single semi-circular paint strokes.

Maurice was involved in the organization of the Armory Show in 1913, but the exhibition did not noticeably change his own artistic concerns or direction. He did not teach formally or publish any writings about art; thus our perception of his role in the modern movement comes from the memories of his contemporaries and the strong evidence of the art itself.

By the 1920s, Maurice was mentioned in reviews as "the first American modernist," and his fellow artists, such as Walter Pach, credited him with being the first American to understand Cézanne.

Both brothers, but especially Maurice, who went deaf, were reclusive. In Boston, they were out of the crosscurrents of modern art, and even after they moved to New York in 1914, they spent most of their time working on their own artistic pursuits. They traveled, read about art, and saw exhibitions of new developments. Maurice's surviving letters recount his delight in seeing the art of Cézanne and the Fauve painters in France in 1907, but before that he had already begun to disturb the critics with his loud colors and abstracted forms. Clearly, the new art of Paris in 1907 was not the direct source of his innovations but an encouragment to continue his explora-

tions of color and technique. Maurice's small pochade sketchbooks reveal a wide range of artistic and literary source material, with sketches from the work of Puvis de Chavannes and quotes from Nietzsche. At some crucial point early in their careers, it became clear to both brothers that art did not have to imitate nature but could create a new world.

Gwendolyn Owens

# Man Ray

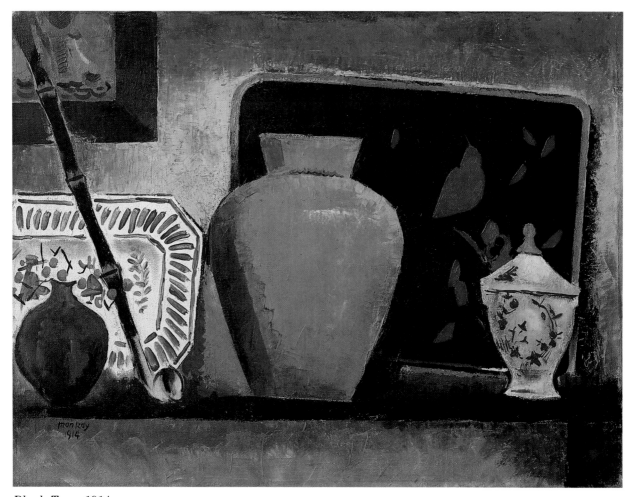

*Black Tray,* 1914

Man Ray (1890-1976) had his first extensive exposure to modern art through exhibitions at Stieglitz's "291" gallery; he recalled having seen most of the important exhibitions held there: drawings and watercolors by Rodin (1910), Cézanne watercolors (1911), Brancusi sculptures (1914), as well as drawings and collages by Picasso (1911 and 1914).[1] Although impressed by American painters– particularly Marin, Dove, Hartley and Weber–he felt an even greater attraction to the European artists, whose work he found more mysterious. He was drawn by the works' unfinished quality, the tendency not to present imagery in a fully resolved and finished state; later, he would even profess "an aversion to paintings in which nothing is left to speculation."[2] He was particularly impressed by the Cézanne watercolors: "I admired the economical touches of color and the white spaces which made the landscapes look unfinished but quite abstract, . . . so different from any watercolors I had seen before."[3]

In the spring of 1913, just a few months after the Armory Show had closed, Man Ray moved out of his parents' home to live in an artists' colony in Ridgefield, New Jersey, a village located across the Hudson River from Manhattan. The artist shared a small shack with Samuel Halpert, whom he had befriended in art classes at the Ferrer Center, an anarchist-supported school in Harlem for children and adults.[4] Halpert, who had recently returned from a trip to Paris, where he had studied briefly with Matisse, occasionally joined the young artist on painting excursions in the open air.

It may have been on such an occasion that he painted the distant view of a hillside in Ridgefield, a scene which, with its exceptionally high horizon, gives a sense of the hilly terrain that dominates this remote community. Although passages in this painting bear an obvious resemblance to the landscapes of several Cubist painters whose work Man Ray could have seen at the Armory Show (par-

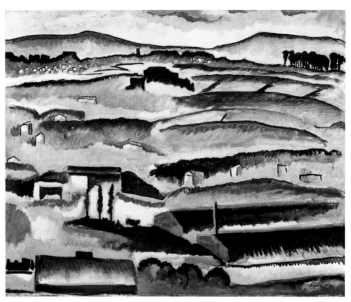

*Landscape at Ridgefield*, 1913

ticularly Roger de la Fresnaye), the bold black outline which the artist uses to clarify the contours of the landscape reveal the influence of a much closer source–Halpert himself.

Halpert's method–derived as it was from the style of Marquet–best accounts for the basic change in approach evidenced by Man Ray's terse paint application in this period. This "Marquet-via-Halpert" style is clearly in evidence in the artist's still lifes of 1913, such as in *Still Life No. 1*, a painting which resulted in a heated dispute with Halpert. The disagreement involved the glazed black vase pictured in the center of the composition; apparently it belonged to Halpert and he had planned to incorporate it in a still life of his own. Man Ray eventually apologized to his friend, but later confessed that he never really understood why Halpert had taken offense. "After all," he reasoned, "he [Halpert] hadn't made the vase any more than the landscape before which we both sat a couple of weeks ago."[5]

By 1914, Man Ray had begun to simplify and reduce the nature of his imagery, a tendency in the direction of abstraction that would not reach fruition in his work for several years to come. *Black Tray* represents a step toward a more abstract style.

Here Man Ray has so skillfully repressed the illusion of a depicted space that he has forced all the objects in the composition into the confines of a narrow, horizontal ledge. The sheer simplicity of its design, combined with the overwhelming frontality suggested by the planar elements in the background, allows us to confidently include the *Black Tray* among the paintings that reflect Man Ray's conversion to abstract painting.[6]

### Francis M. Naumann

[1] Unless otherwise noted, all biographical references are derived from Man Ray's autobiography, *Self Portrait*, New York and London: Andre Deutsch, 1963.

[2] Man Ray, *Self Portrait*, p. 181.

[3] Man Ray, *Self Portrait*, p. 18.

[4] On the artist's association with the Ferrer School and its artists, see Francis M. Naumann, "Man Ray and the Ferrer Center: Art and Anarchy in the Pre-Dada Period," *Dada/Surrealism*, vol. 14, 1985, forthcoming.

[5] In his autobiography, Man Ray recounts this incident in great detail (*Self Portrait*, p. 33). Quoting this same passage, Arturo Schwarz mistakenly concluded that this painting had disappeared (*Man Ray*, p. 31).

[6] On this phase of the artist's work, see Francis M. Naumann, "Man Ray: Early Paintings 1913-1916, Theory and Practice in the Art of Two Dimensions," *Artforum*, vol. XX, No. 9, May 1982, pp. 37-46.

# Morgan Russell

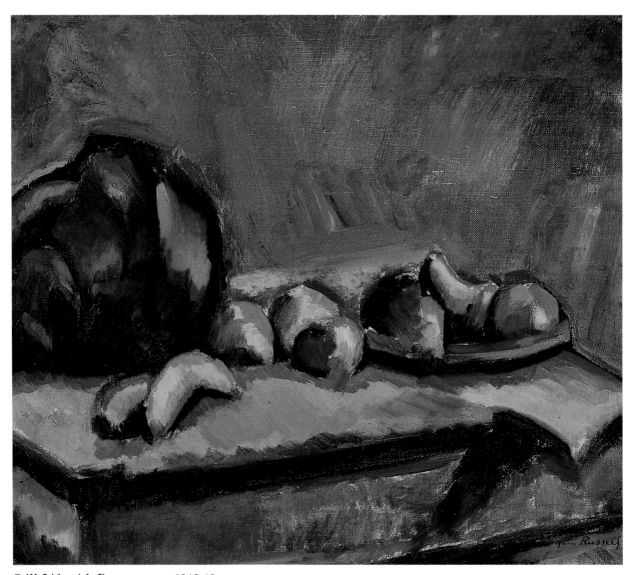

*Still Life with Bananas,* ca. 1912-13

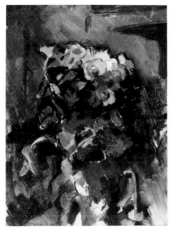
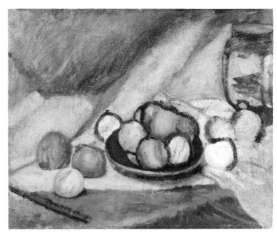

*Still Life with Flowers*, ca. 1913    *Still Life with Fruit*, ca. 1909-10

Morgan Russell (1886-1953) began painting in the summer of 1907 with a small landscape painted with a thickly textured brushstroke that might be termed Post-Impressionist. He was evidently encouraged to try painting by his future patron, Gertrude Vanderbilt Whitney. The back of the work is inscribed "*Ma Première peinture* Old Westbury L.I. *Printemps–Eté* 1907." Russell's use of French reflects his first trip to Europe, made during 1906. Visiting Paris and Italy, he was most impressed by Michelangelo's sculpture, and had been studying sculpture with James Earle Fraser at the Art Students League since his return.

When Russell began studying with Robert Henri, probably in the fall of 1907, he was exposed to a progressive attitude that eventually included Henri's own color experimentation.[1] Returning to Paris in the spring of 1908, Russell met Leo and Gertrude Stein, and through them, Matisse and Picasso. Russell then joined the Académie Matisse, which had been organized the previous fall by Gertrude and Leo's sister-in-law, Sarah Stein. There he was introduced firsthand to Matisse's own dramatic freedom with color and form, which had become known as Fauvism.

Under Leo Stein's influence, Russell came to have great admiration for the work of Cézanne. Leo even loaned Russell and his friend

Andrew Dasburg *Pommes* (*Apples*), a small Cézanne still life from his collection. From mid-1909 through August 1910, the two young American artists copied and made their own interpretations of Cézanne's composition from 1873-77.

Russell acknowledged that it was Cézanne's work that enabled him to discover "what was rhythm in color," noting in a letter to Dasburg on October 27, 1910, that "it was and could be nothing other than the play of lights and shadow...warm and cold light."[2] Russell also explained the necessity to "feel form if you will paint light" and insisted that "a painting should be a flat presentation of light and in this way only will one preserve the flatness of the canvas and convey the sensations of mass and solidity."[3]

About 1909, under Matisse's influence, Russell painted at least one reclining female nude with an intentionally primitive quality, including crudely rendered hands and feet. Since this lost painting is known only from a black-and-white photograph and a small related work on paper, its palette remains a mystery, but it is reasonable to assume that Russell had picked up something of the French artist's intense colors on the way to the development of his own Synchromist paintings with their vivid color schemes.

In 1911, Russell began to study with the Canadian Ernest Percyval

Tudor-Hart, who, in his own school in Paris, stressed color theory based on a musical system of color harmony with psychological rather than physical equivalents.[4] By August 1912, Russell wrote in his notebook: "Make lines colors...never paint 'the thing' or the subject. Paint the emotion not illustration."[5] In his still lifes in 1912-13, he began to employ color harmonies rather than local color, producing intensely colored representational works which soon led to his more abstract Synchromies.

Gail Levin

[1] In March 1909, Henri interviewed Hardesty Gillmore Maratta about his rationally ordered system of color harmony and the pigments he was selling. By the fall of 1910, Henri began to work directly with Maratta. See William Inness Homer, *Robert Henri and his Circle* (Ithaca: Cornell University Press, 1969), pp. 184-189.

[2] Morgan Russell to Andrew Dasburg, letter of October 27, 1910, Andrew Dasburg Collection, George Arendt Research Library for Special Collections at Syracuse University, Syracuse, New York.

[3] Ibid. For further information on Russell, Stein, and the influence of Cézanne, see Gail Levin, *Synchromism and American Color Abstraction, 1910-1925* (New York: George Braziller, 1978), pp. 12-14.

[4] See Levin, *Synchromism*, pp. 14-16, and Adrian Bernard Klein, *Colour Music: The Art of Light* (London, 1930), pp. 102-03.

[5] See Levin, *Synchromism*, p. 18.

# H. Lyman Saÿen

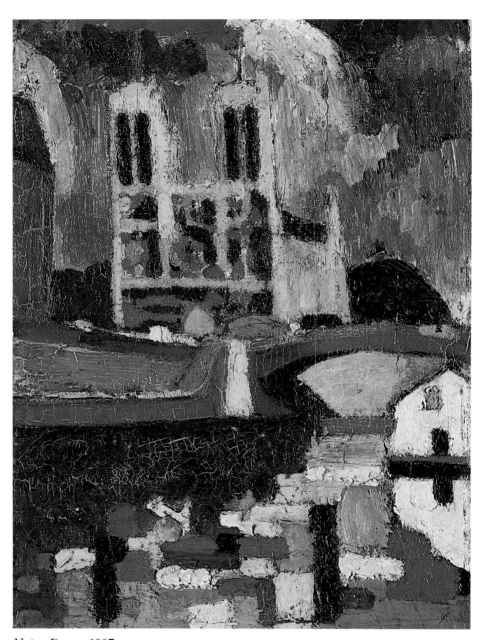

*Notre Dame,* 1907

An electrical engineer and inventor of scientific instruments as well as a painter, H. Lyman Saÿen (1875-1918) was one of the American artists closest to the Fauves.

Saÿen took up art after a bout with typhoid fever, enrolling in the Pennsylvania Academy of the Fine Arts in 1899. He studied mostly with Thomas Anshutz, and was so proficient in handling the human figure that he won a commission to create four allegorical lunettes for a committee room in the U.S. Capitol.

In 1906, Wanamaker's department store sent Saÿen and his wife, Jeannette Hope Saÿen, to Paris to design fashion catalogues. During their eight years there, the Saÿens became intimates of Gertrude and Leo Stein. Saÿen played billiards with Leo, who suggested that he join Matisse's class.[1] Saÿen had been impressed by Gauguin's 1906 retrospective, and he was ready for Matisse's ideas on expressive, arbitrary color.

*Notre Dame*, one of Saÿen's earliest works in Paris, depicts a view Matisse had painted earlier. Using impasto slabs of gold, red, and dark blue, Saÿen struggled to find the right balance, for several areas were completely repainted in a different color. The reflections in the lower part of the panel are rendered as abstract blocks of color, and all the forms hold tightly to the surface plane.

Saÿen's years in Paris included experiments with an instrument for testing the perception of colors in motion. He was visited by Carl Newman for a summer, and when Anshutz visited Paris they worked together, mixing brilliantly colored pastels and paints in a special paint mill. Saÿen's work was well received and he was invited to become a member of the Salon d'Automne in 1912. He often played billiards at the Café du Dôme, and he ranked as an amateur champion.[2]

Saÿen returned to Philadelphia in 1914 and continued to develop his Fauve approach. In 1916 he even exhibited colorfully painted furniture along with his canvases. Many of the landscapes he painted while visiting

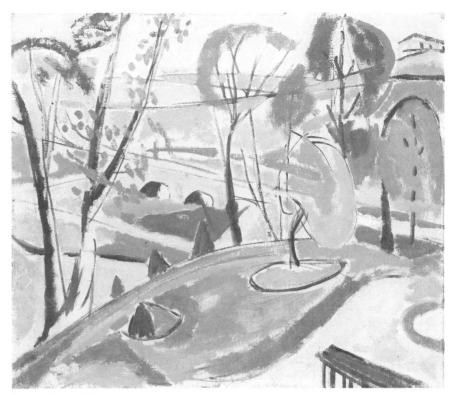

*Decor Plat*, 1915

Carl Newman at his house at Bethayres, in the Huntingdon Valley, are constructed through dynamic, tilted lines and areas of intense color. Blue is often used for outlining and structure, contrasted with brilliant pinks, oranges, and greens. In the spontaneous-looking *Decor Plat*, the canvas is left bare in many areas.

Saÿen's interests were wide-ranging and his outlook always experimental. In 1916 he and Schamberg organized "Philadelphia's First Exhibition of Advanced Modern Art" at the McClees Galleries. He decorated Newman's studio ceiling with a Synchromist spectrum of radiating color and in 1917 he and Newman designed and he directed *Saeculum*, an artists' masque written by William A. Young in which the drama was created through color, motion, and music rather than words.[3] In his last works, he combined the flat decorative patterns of American folk art and Indian art with planes derived from Picasso and Futurism.

Saÿen died suddenly at the age of 43, with most of his work unknown.

He had always believed he should earn his living as an engineer rather than as an artist, and he sold few works. Saÿen was one of the American modernists who most fully understood and applied Matisse's use of color. In 1914 he wrote, "Modern art has shown a distinctly novel way of looking at things.... It is all spontaneity and requires an equally spontaneous apprehension. To feel it requires a quickening of the spirit."[4]

Barbara A. Wolanin

[1] Adelyn D. Breeskin, *H. Lyman Saÿen* (Washington: National Collection of Fine Arts, 1970), p. 16.

[2] Jeannette Hope Saÿen, "Blossoms of Liberty—Notes of her Ninetieth Year and Some Conversations with her Daughter," Smithsonian Institution Archives, RU 315, NCFA, Department of Twentieth Century Painting and Sculpture, 1963-1974, Box 64.

[3] "Variously Setting the Stage of the Soul," *Boston Evening Transcript*, February 24, 1917.

[4] Henry Lyman Saÿen, "The United States and Modern Art," address given to the Philadelphia Sketch Club, 1914, Smithsonian Institution Archives, RU 315, Box 64.

# Morton Livingston Schamberg

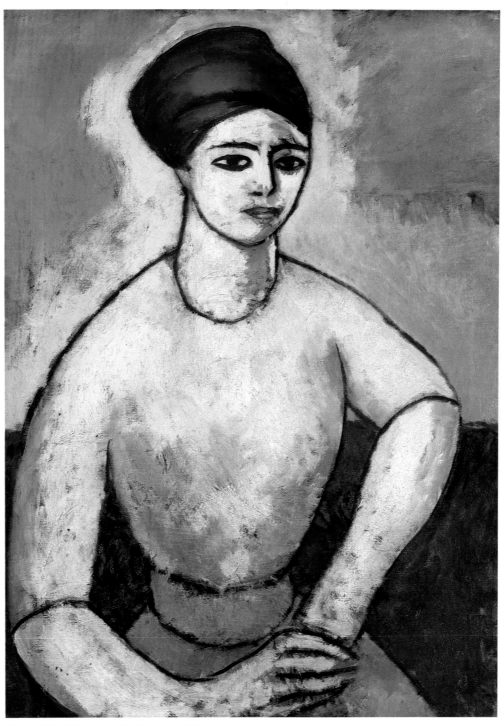

*Portrait of Fanette Reider,* ca. 1912

Morton Livingston Schamberg (1881-1918) is not as well known as his achievement warrants. He was born in Philadelphia on October 15, 1881,[1] the youngest of four children in a prosperous and conservative German family. He lived in Philadelphia his entire life, although he traveled frequently to Europe prior to 1910, and often visited New York thereafter.[2]

After college he enrolled at the Pennsylvania Academy of Fine Arts, where he studied until mid-1906, principally under the formidable William Merritt Chase. While there, Schamberg and Charles Sheeler became devoted, lifelong friends, later sharing a studio in Philadelphia and a house near Doylestown, where they painted on weekends.

After leaving the Academy, Schamberg went to Europe for a year, living and working primarily in Paris. By the end of 1907, his art demonstrated careful study of the *plein air* luminosity of Impressionism, as well as an early penchant for vivid and idiosyncratic color that marked his work throughout his life. Schamberg was soon disenchanted with what he and most members of his generation perceived as the fleeting, unstructured qualities of Impressionism.

In 1908, probably in the fall, Schamberg traveled again to Europe, going first to Paris and then to Italy, where he was joined by Sheeler in December. Together they made a "rapid survey" of the museums and monuments of Rome, Florence, Siena, Venice, and Milan.[3] The art of Giotto, Masaccio, Piero della Francesca and other early Renaissance masters taught Schamberg to look beyond the transitory effects of the Impressionist stroke, to seek solid and enduring qualities. This shift reflects the thinking of Leo Stein, whom we

*Studio Interior*, ca. 1912

*Landscape (Lake Placid)*, 1911

know Schamberg met in 1908 through Walter Pach, his friend and fellow student at the Academy. Influenced by Bernard Berenson, Stein believed that he had been well prepared to appreciate Cézanne by the similar structural qualities of early Renaissance art.[4]

In early 1909, Schamberg and Sheeler went directly from Italy to Paris, where they visited the modernist galleries, the collection of Sarah and Michael Stein (with its Matisses), and perhaps saw the collection of Gertrude and Leo Stein. They immersed themselves in the paintings of Cézanne, van Gogh, Matisse, Derain, Braque and Picasso. After returning to Philadelphia sometime in mid-1909, Schamberg incorporated the lessons of these masters into a series of landscapes and portraits with carefully constructed and patterned volumes, as well as vivid and intense color.

In *Portrait of Fanette Reider*, Schamberg showed an increasing affinity for the monumental figurative style and arbitrary color of Matisse, and the intense hues of Fauvism, as the basis for his rapidly maturing art. Schamberg was also an articulate advocate of modernist art, and helped prepare his native Philadelphia for the Armory Show with an article in the *Philadelphia Inquirer*.[5]

Later he organized an exhibition of modern art and held forth in debates on the coming of modernism.

The Armory Show had a profound effect on Schamberg. There, his further exposure to Cubism, as well as to Matisse's color and design, launched him into Cubist landscapes and figures that were the basis of his art from 1913 to 1915. Thereafter, Schamberg shifted into illusionist images of distilled machine imagery that relate his art to the subjects of Duchamp, Picabia, and Crotti.[6]

### William C. Agee

[1] Schamberg's birth sometimes has been given as 1882, but his death certificate verifies 1881 as the correct year.

[2] For a more complete biography, see William C. Agee, *Morton Livingston Schamberg* (New York: Salander-O'Reilly Galleries, Inc., 1982).

[3] Charles Sheeler, unpublished autobiography, Archives of American Art, Smithsonian Institution, Microfilm roll NSH1, frames 60-62.

[4] Leo Stein, *Appreciation: Painting, Poetry and Prose* (New York: Crown Publishing, 1947), p. 153.

[5] Morton Livingston Schamberg in "Post-Impressionism Exhibit Awaited," *Philadelphia Inquirer*, January 19, 1913, sec. 2, p. 3.

[6] For more on these works see Agee, *Schamberg*, pp. 10-16, and William C. Agee, *Morton Livingston Schamberg: The Machine Pastels* (New York: Salander-O'Reilly Galleries, Inc., 1986).

# Alice Schille

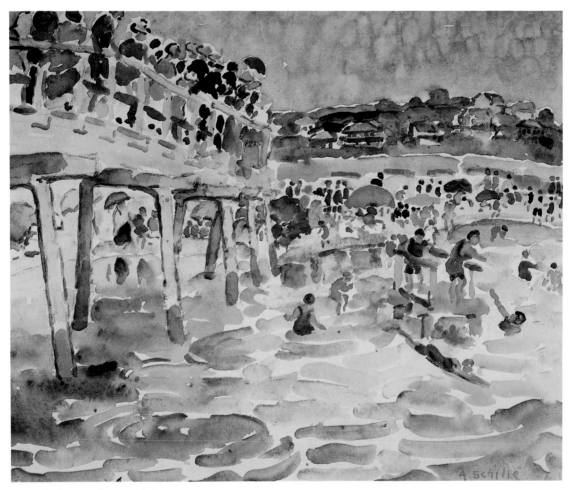

*Pier, Shinnecock*, ca. 1915

Alice Schille (1869-1955) adapted the vivid color and formal freedom of Post-Impressionism to her chosen medium of watercolor. Through her cosmopolitan pursuit of art, Schille surpassed her prosperous, middle-class background, but she never severed her ties to her native city of Columbus, Ohio.

At the age of 17, Alice Schille decided to pursue an artistic career. Her mother, who had taken control of the family soft-drink business after her husband's death in 1886, encouraged Alice's career plans. In 1889, after two years at the Columbus School of Art, Alice Schille enrolled at the Art Students League in New York. Her studies there under William Merritt Chase determined the progressive course of her artistic development. In 1893 she completed her American studies at the Pennsylvania Academy of the Fine Arts in Philadelphia, where she met William Glackens, John Sloan, and Robert Henri.

The six years Schille spent abroad from 1894 to 1900 proved decisive for her subsequent support of modern art. After a brief period of study at the Académie Colarossi in Paris, she traveled throughout Europe. In Paris, together with Glackens, she befriended a number of American and Canadian artists, notably Ernest Lawson, Maurice Prendergast, and James Wilson Morrice. Returning to Columbus at the turn of the century, Schille took a position as instructor at the Columbus Art School. From 1902 to 1914, she spent her summers traveling abroad. There she witnessed the growth of the Parisian vanguard. She later recalled in an interview:

> We saw the cubist movement from the beginning and spent an amusing, amazing evening at Gertrude Stein's, where she was showing the earliest work of cubists, mostly Picasso. And we saw the first showing of Cézanne's work after his death.[1]

It was, however, pre-Cubist modernism that directly influenced Schille's own work.

In response to the French Fauves, Schille abandoned the Whistlerian tonalism of her early work for the high-keyed, vibrant palette of Matisse and his followers. Working in watercolor, she produced landscapes and beach scenes of European and American locales. She owed her compositional arrangements, highly simplified treatment of figures, and dappled watercolor technique to the example of her friend Maurice Prendergast. Her watercolors earned her recognition and prizes, including a gold medal at the 1915 Panama Pacific Exposition in San Francisco.

Although Schille exhibited her work at New York's Daniel Gallery, she made her primary contribution as an art teacher in Columbus, Ohio. Together with her neighbor, collector Ferdinand Howald, Schille quietly introduced modern art and the principles of modernism to her native city.

Judith Zilczer

[1]Alice Schille, quoted by Cornelia Moore James, "Side Glances at Columbus Career Women," *Columbus Dispatch* [undated clipping, ca. 1940?], Columbus Museum of Art files.

# Charles Sheeler

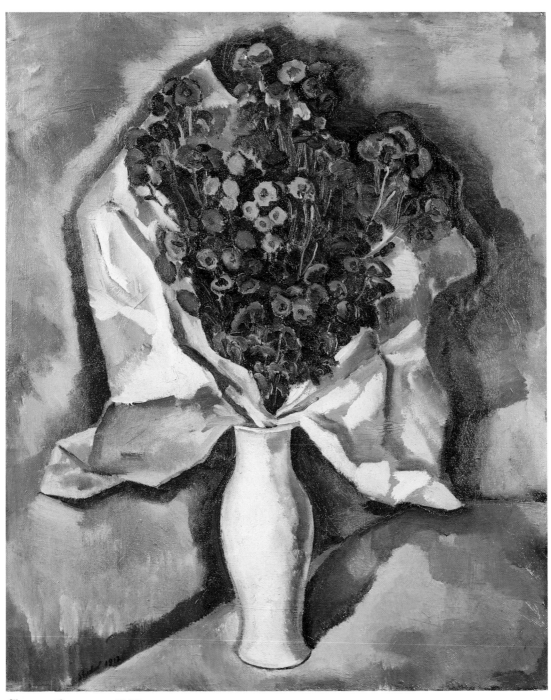

*Chrysanthemums, 1912*

Charles Sheeler (1883-1965) was exposed to Post-Impressionism during a 1909 trip to Paris with his close friend and fellow painter Morton Schamberg. They had arrived there from an art tour of Italy, where the two young artists had been struck by the notion of "design" in painting, something they had not encountered during their student days under William Merritt Chase at the Pennsylvania Academy. "Now we began to realize that forms could be placed with consideration for their relationship to all the other forms in a picture, not merely to those adjacent," Sheeler later recalled.[1] That discovery seems to have prepared the way for their introduction in Paris to the art of Cézanne, Matisse, and Picasso.

They visited the apartment of Michael and Sarah Stein, and spent considerable time with Leo Stein, whom Schamberg had known previously. There is little doubt that Leo Stein's ideas about the revolutionary aspects of the "timeless" art of Cézanne had great effect on the young Philadelphians. Certainly their efforts to find the elements in past and present art that were, in Sheeler's words, "outside time, place, or momentary considerations" reflected Stein's beliefs.[2]

Roger Fry's observation that Post-Impressionism was a "classic" movement in the historical sense, as opposed to the "romantic" movement of Impressionism, was something Sheeler seems to have taken to heart early in his career. Yet the paintings he had seen in his two months in Paris "made too great a chasm to be taken in a stride."[3] He returned to Philadelphia, rented a house on Chestnut Street where he and Schamberg set up separate studios, and began to contend with what he had seen.

"I had an entirely new concept of what a picture is," Sheeler later stated.[4] But his assertion that his work in these years lacked accomplishment or originality is too harsh. Certainly Schamberg, who was much more adventurous, led the way in this period, gaining a one-man exhibition in 1910 in Philadelphia. Sheeler sent a group of his paintings to William Macbeth in New York in the same year, but was turned down. Stung by this rejection, he wrote Macbeth that his painting would nevertheless continue to evolve in the direction of "the elimination of the unessentials and the striving after greater qualities to more forcefully present the essentials."[5]

In the meantime Schamberg had become close friends with Walter Pach, who was one of the most knowledgeable forces behind the selection of works for the Armory Show and who was a crucial source of information for the two isolated Philadelphia artists. Sheeler's work was subsequently seen and admired by Arthur B. Davies, who chose six paintings for the exhibition. There were still lifes and two landscapes of the countryside around Doylestown, where Sheeler and Schamberg shared a farmhouse. These works, painted in 1912, show an overriding concern for structural form heightened by the use of vivid, expressive color. Placed in probable sequence, the paintings reveal a progression from an illusionistic space to one based on form, design, and color.

Sheeler's exposure to the works in the Armory Show itself pushed his art more decisively towards Cubism and color abstraction, and his art entered a new phase. Even so, the chief source of his art throughout his formative years was the work of Cézanne, refined through his continu-

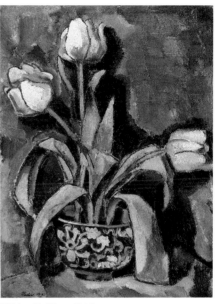

*White Tulips*, 1912

ing exposure to modernist art. In 1916, exhibiting in the Forum exhibition, he would still speak of art as perception guided by the intellect in order to obtain knowledge of the universal order of things. This would be his lifelong aesthetic.

Rick Stewart

[1] Constance Rourke, *Charles Sheeler: Artist in the American Tradition* (New York: Harcourt, Brace & Co., 1938), p. 25.
[2] Ibid. A useful brief account of this period is in Sheeler's manuscript autobiography, Archives of American Art, Smithsonian Institution, microfilm roll NSH1.
[3] Rourke, *Charles Sheeler*, p. 27.
[4] Ibid.
[5] Martin Friedman, Bartlett Hayes, Charles Millard, *Charles Sheeler* (Washington: Smithsonian Institution Press, 1968), p. 11.

# Joseph Stella

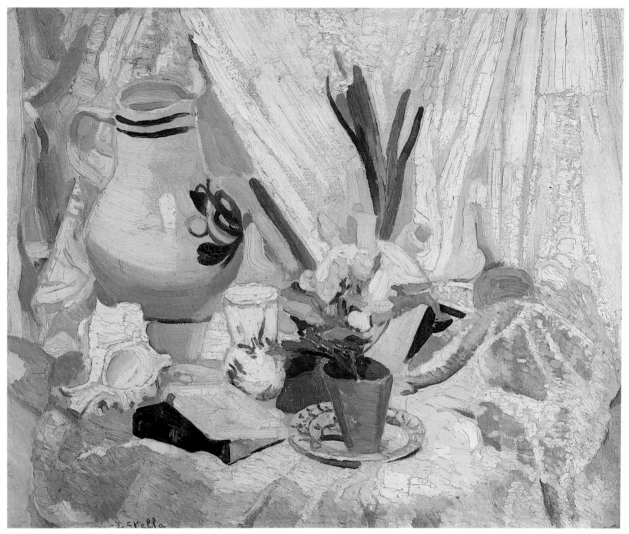

*Still Life*, ca. 1912

*Study for Battle of Lights, Coney Island, Mardi Gras*, 1913

Joseph Stella (1880-1946), a leading figure in the rise of the American avant-garde, has been linked to virtually every major trend in early modernism with the notable exception of Post-Impressionism. In his forty-year career, Stella produced masterful works of urban realism, Futurism, color abstraction, and personal symbolism. Yet his largely overlooked Post-Impressionist interlude in 1912-13 proved crucial to his development as a modern painter.

Born in an Italian mountain village, Stella received a classical education before he immigrated to the United States in 1896. He enrolled in the Art Students League the following year and later studied under William Merritt Chase at the New York School of Art. From 1905 to 1909, Stella produced hundreds of carefully rendered, realistic drawings, many of which served as magazine illustrations. His early style of sober realism was well suited to his immigrant and urban industrial subject matter. About 1909 Stella returned to Italy, where he adopted the Renaissance technique of glazing to create dark tonal paintings.

Following the advice of the American painter and critic Walter Pach, Stella left Italy in 1911 to travel to Paris. His decision to visit the center of the European vanguard completely altered his art. In Paris, he met such leading modern artists as Matisse, Picasso, and Modigliani and familiarized himself with the work of Cézanne and the Fauves. He later acknowledged his debt to the French Post-Impressionist masters:

> Paris had become the Mecca for any ambitious artist in search of the new verb in art—and in 1911, with great joy I flew to the Ville Lumière. The monumental work of Cézanne had been achieved and so the great efforts of Renoir, Van Gogh and Gauguin— efforts summing up the conquests . . .[of] luminous impressionism.
> At my arrival, Fauvism, Cubism and Futurism were in full swing.[1]

While Stella was deeply impressed with the full range of vanguard styles, from Cubism to Italian Futurism, it was the vibrant color of Post-Impressionist painting that initially inspired his conversion to modernism:

> What excited me the most was. . .a new panorama. . .of the most hyperbolic chromatic wealth. . . .alluring vivid colors, resonant as explosions of joy, the vermillion, green, violet, and orange. . .notes soaring upon the most luscious deep tonalities. To feel absolutely free to express this adventure was. . .bliss. . . .[2]

Stella immediately adapted the vivid Fauve palette to painterly still-life, landscape, and figure compositions.

Late in 1912 Stella returned to New York, a convert to the modern cause. He brought with him his brilliant Parisian still lifes, three of which were accepted for the Armory Show.[3] Within a year of his return, Stella began using a pointillist technique for studies of Coney Island's amusement park. Stella rendered the dazzling electric lights of Luna Park in a mosaic-like pattern of pure color. Reflecting the influence of Italian Futurist Gino Severini's pointillist canvases, Stella's studies of Luna Park exemplify the common Post-Impressionist foundation for European and American vanguard painting. His experimentation with pointillism prepared the way for his own Futurist *Battle of Lights, Coney Island, Mardi Gras* (1913, Yale University Art Gallery).

### Judith Zilczer

[1] Joseph Stella, "Autobiographical Notes" (typescript given to Lloyd Goodrich, February 1946), Joseph Stella File, Whitney Museum of American Art Papers, Archives of American Art, Smithsonian Institution, Washington, D.C. microfilm roll no. N689, frames 196-207.
[2] Ibid.
[3] Irma B. Jaffe. *Joseph Stella* (Cambridge, Massachusetts: Harvard University Press, 1970), pp. 178-79.

# Maurice Sterne

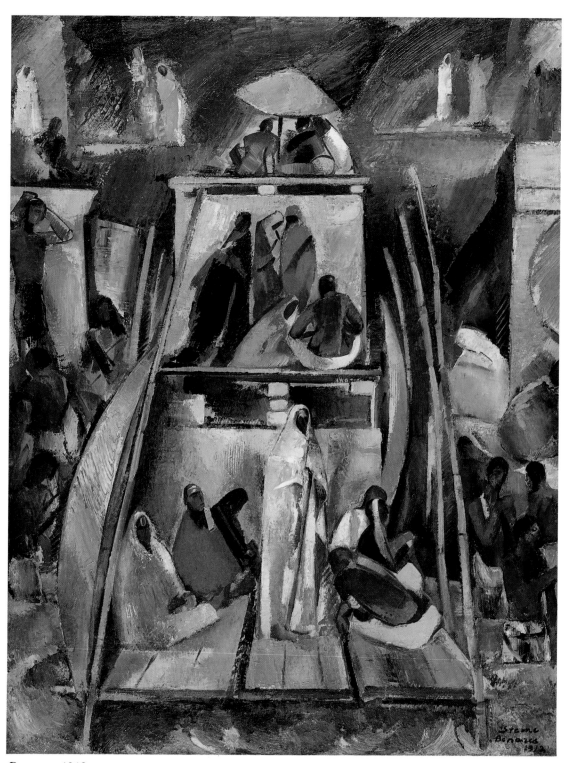

*Benares,* 1912

164

Maurice Sterne (1878-1957) was born in Memel, Latvia, and raised in the Jewish quarter of Libau, where his father served as a rabbi. The family moved to Moscow after his father's death, but Russian pogroms and economic hardship brought Sterne – like Walkowitz, Zorach, and other future modernists – to the United States late in the century.

Sterne labored on Manhattan's Lower East Side as an engraver's apprentice, took mechanical drawing at Cooper Union, and in 1894 began five years of study at the National Academy of Design. During this period, he befriended William Glackens and George "Pop" Hart, with whom he founded the Old Country Sketch Club. Sterne's early oils and figure drawings echo his training; only their sometimes severe economy of line and rhythmic juxtaposition of flat and fully modeled forms transcend academic convention.

In 1904, Sterne won the Academy's first Mooney Travelling Scholarship and left immediately for Paris. His new associates included Max Weber, Samuel Halpert, and other Russian-born Jewish artists on the threshold of modernist innovation. Sterne quickly discovered the Luxembourg's controversial Caillebotte bequest of Impressionist paintings, admired Rodin's recent work, and noted the significance of Seurat and Gauguin. He also visited that year's Salon d'Automne, where Cézanne's many canvases made a lasting impression on him:

> [To Cézanne] appearance was not a point of arrival; it was a point of departure, a journey not away from the motif... but a journey of exploration into the hidden secrets that reality may hold....Only when I realized that his distortion was not due to ...optical imperfection, but to reasons purely compositional – only then did I

comprehend that his malformations were in reality transformations.[1]

Sterne's close friendship with Leo Stein deepened his appreciation for Cézanne and soon led to other revelations, most notably Matisse's emotive mastery of line and color.

Sterne left France in 1908 and began a long journey through Eastern Europe, Egypt, and India. The free brushwork, vibrant palette, and dense spatial mosaic of his 1911-12 paintings put him fully in step with Post-Impressionist practice. He next explored the South Pacific, finally settling on Bali for two years. There Sterne's subjects, though more muted in color, became highly emotional emblems of island life and ritual. His Cézannesque *passage*, faceted space, and archaicized figures, contraposed with one another and the shapes of their environment, express a "harmony [that] is tangible in [the islanders'] every movement...particularly in groups [where] this coordination results in perfect patterns of changing composition."[2]

In 1915, Sterne returned to New York and held successful exhibitions at the Berlin Photographic Company and Montross Gallery. A preoccupation with the tactile nature of art and perception quickened his development as a sculptor. His brief marriage to Mabel Dodge and his affiliation with dealer Stephan Bourgeois kept him in touch with the artistic vanguard, but in his own work after World War I formal and technical refinements took precedence over stylistic invention. In 1933, Sterne was honored with a retrospective exhibition at The Museum of Modern Art.

Jeffrey R. Hayes

[1] Maurice Sterne, "Cézanne Today," *The American Scholar* 22, No. 1 (Winter 1952-53): 45, 54.

[2] Maurice Sterne, *Shadow And Light*, ed. by Charlotte Leon Mayerson (New York: Harcourt, Brace & World, 1965), p. 99.

# Tom Thomson

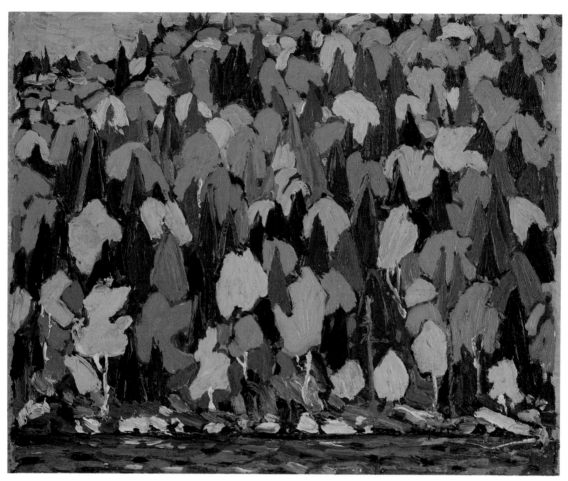

*Autumn Foliage*

The name Tom Thomson (1877-1917) conjures up a romantic image of the mysterious North. For many Canadians, he is the archetypal Canadian painter. His work (thirty canvases and four hundred sketches) in his five-year career ranged from joyous encomiums to nature to occasional explorations of abstraction (though only in sketches). Thomson's development was toward relaxed, brilliant handling of paint; at his best he disposes trees and bushes like notes in a symphony. His patterns interlock in finely phrased, intricate counterpoint.

What Thomson perceived in the woods of his favorite painting place, Ontario's Algonquin Park, was a space crossed by objects, often diagonally. The result is never claustrophobic because there is always a touch of sky or lake to open up the view. His was a traditional way of painting but not heavy-handed. His works have an unassuming, mischievous charm, even as they overwhelm with their sumptuous color.

Thomson's style as a mature painter falls entirely within the Post-Impressionist mode. His knowledge of the style was formed by his friendship with A. Y. Jackson, whom he met in April 1913 while still a commercial artist learning to paint. Jackson, who had been in France from 1907 to 1909, and again from 1911 to 1913, told Thomson about Pointillism and Seurat. Later Jackson remembered describing to Thomson the "clean cut dots" of color. He also told Thomson about Impressionism. Jackson felt that Thomson's style changed under his influence–when Thomson went to Petawawa in 1916.[1] Thomson's work of that date does show large turquoise and orange "dots." He also was influenced by the senior commercial artist J. E. H.

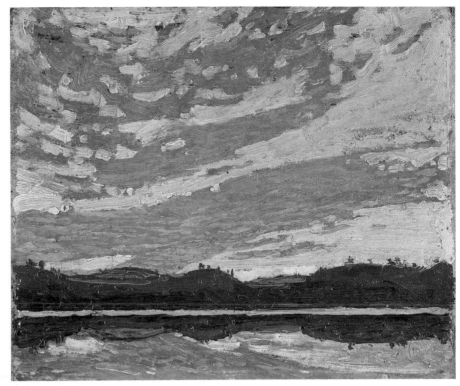

*Sunset*, 1915

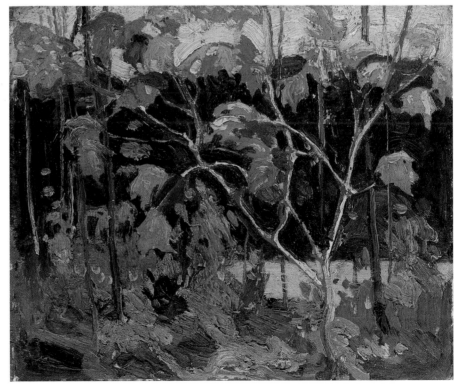

*Red Leaves*, ca. 1914

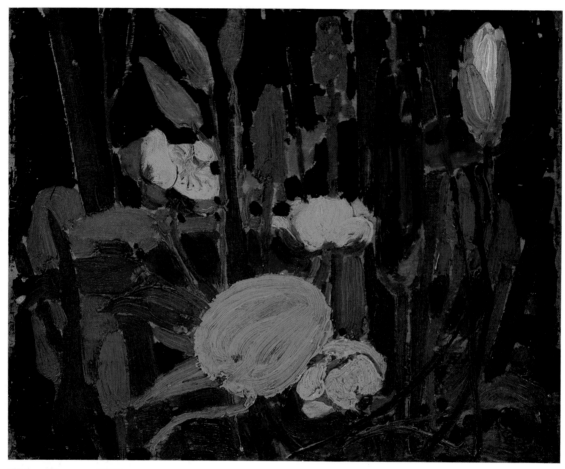

*Water Flowers*, 1916

MacDonald and his distinctive sense of design.

Throughout the period of his Post-Impressionism, Thomson composed whole canvases of dots and then broad swatches of color. He conveyed his affection for the northern Ontario landscape, using thick impasto and complementary color mixtures. Thomson probably also learned undercoating and glazing from Jackson (as Jackson said).

From an early date he learned to simplify forms for powerful effect — sometimes to the point of being called "cubist" by his friends. In the fall of 1914, Jackson wrote a mutual friend that Thomson was showing "decided cubistical tendencies."[2] F. H. Varley also wrote that "Tom is rapidly developing into a *new* cubist."[3] In fact Thomson's paintings are far quieter and more relaxed than those of European Cubism. Thomson's real contribution to Post-Impressionism lies in the use of the northern landscape — later members of the Group of Seven recall finding the first traces of the subject-matter crucial to their work in Thomson's work of 1912 — and Thomson's feeling for the structure of the land. If he had lived, Ontario would have achieved world-class status as an art centre before the 1950s.

Joan Murray

[1] Interview with A. Y. Jackson by Joan Murray, 4 March 1971.
[2] Letter from A. Y. Jackson to Dr. J. M. MacCallum, 13 October 1914, MacCallum Correspondence, The National Gallery of Canada, Ottawa.
[3] Letter from F. H. Varley to Dr. J. M. MacCallum, October 1914, MacCallum Correspondence, The National Gallery of Canada, Ottawa.

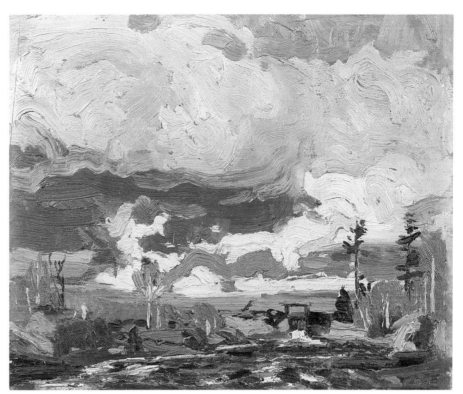

*Tea Lake Dam*, 1916

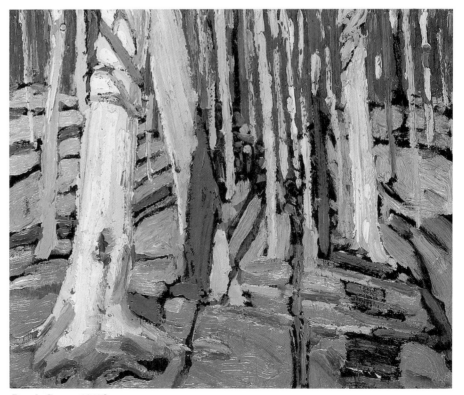

*Beech Grove*, 1915?

# Allen Tucker

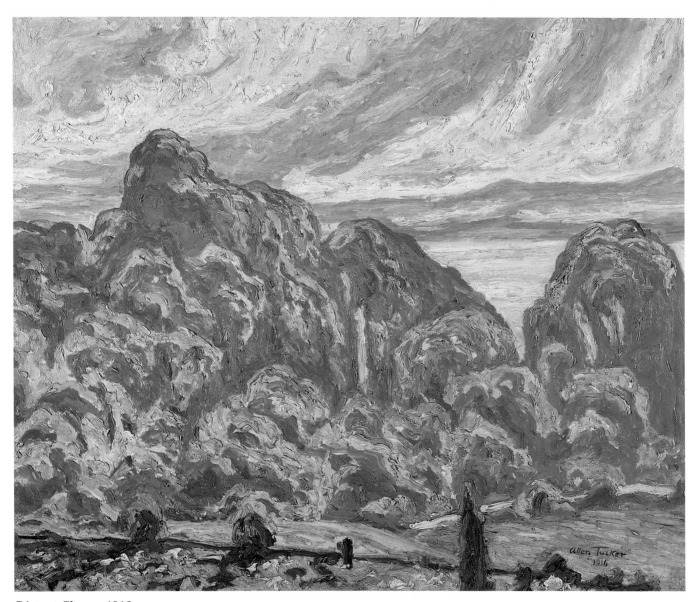

*Distant Shores*, 1916

Allen Tucker (1866-1939) was the first American follower of van Gogh.[1] Like many of the early generation of American modern artists, Tucker began working in an Impressionist style but later adopted Expressionism.

Born in Brooklyn, Tucker studied at Columbia University. He worked as an architect in the firm McIlvaine and Tucker from 1895 to 1904, but his primary interest was painting, and throughout the 1890s he took classes at the Art Students League under John Twachtman and traveled annually to Europe to study. After 1905, Tucker devoted himself to painting. His early paintings evidence a debt to Monet, especially *Cornshucks and Windmill*, in which the pastel purple and blue cornshucks echo Monet's haystacks.

Tucker's transition from Impressionism began with his association with the American Association of Painters and Sculptors and "The Eight," a group of painters who followed Robert Henri in opposing the conservatism of the National Academy of Design. Although Tucker was not one of "The Eight," his friendships with these artists were influential. Tucker was a founding member of the AAPS, which held its first meeting on December 19, 1911. Inspiration for the Association came from Walt Kuhn, who held the same anti-academic convictions which "The Eight" had espoused. Certainly the most important accomplishment of the AAPS was organizing the Armory Show in 1913, and Tucker was instrumental in producing the catalogue for that exhibition.

Tucker would have been familiar with a variety of Post-Impressionist trends, but his own style was modeled after van Gogh. In 1915, the Modern Gallery in New York City held the first American exhibition of van Gogh's work. Most likely Tucker was already familiar with van Gogh through his European travels and through articles in American journals.[2] Around 1914, Tucker's palette moved toward pure colors, and his heavily encrusted paint surface, like van Gogh's, became structured to suggest movement and energy. The heavy dark contours of van Gogh are apparent in Tucker's style, but the most obvious influence is seen in Tucker's choice of similar subjects. For example, Tucker's pine trees and poplars pointing skyward echo the cyprus trees in van Gogh's *The Starry Night*. *Field Corn* is a direct reference to van Gogh's *Sunflowers* and Tucker's interest in American factory workers repeats a familiar van Gogh theme.

Tucker was an instructor at the Art Students League from 1920 to 1928. He published several books on art theory, notably *Design and Idea* (1930), and wrote the first monograph on his teacher John Twachtman. Although Tucker's paintings do not approach van Gogh's power, his work serves as a prelude to Expressionism in North America art.

Judy L. Larson

[1] James W. Lane, "Vincent in America: Allen Tucker," *Art News*, 38 (Dec. 16, 1939): 17-18.
[2] William H. Gerdts, *American Impressionism* (New York: Abbeyville Press, 1984), p. 290. Gerdts makes reference to an 1892 article on Vincent van Gogh by Cecilia Waern.

# Abraham Walkowitz

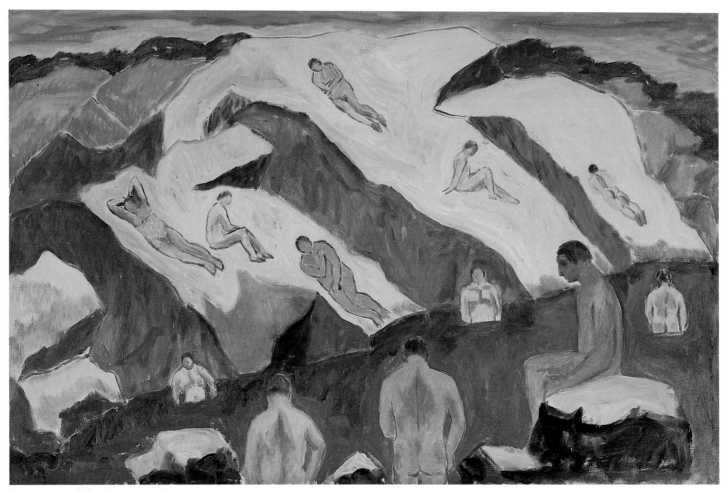

*Bathers and Rocks #2,* 1917

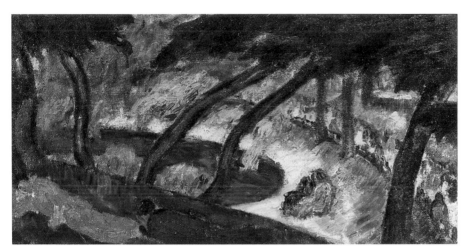

*Park Scene*, 1905-10

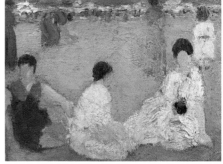

*Beach Scene*, 1905-10

Soon after arriving in the United States from Siberia in 1889, Abraham Walkowitz (1880-1965) began taking art lessons and painting misty tonalist views of New York City. Lured to Paris in 1906, he entered the Académie Julian and became friendly with Max Weber. Although Walkowitz arrived in Paris after the 1905 Fauve Salon and left before the inauguration of the Matisse class, his European paintings make a break from his early dark palette and demonstrate his exposure to Post-Impressionist ideas.

Back in New York in 1908, Walkowitz staged his first one-man show in the small framing shop of his friend Julius Haas on Madison Avenue. Because of the early date of this exhibition, Walkowitz later called himself the first modern artist in America but the paintings were not radically progressive and the exhibition was little noticed by critics. Sadly, Walkowitz remained one of the most ignored of the early moderns.

·When Max Weber returned to New York in 1909, he lived for a while with Walkowitz, and the more in-tellectually penetrating Weber may have exerted an influence on the Post-Impressionist direction of his friend's work. Like Weber, Walkowitz was essentially a figure painter. The works he created during the first years after his return to New York included bathers, city street scenes, and landscapes marked by Post-Impressionist flattening of space and form, bright, aggressive colors, heavy impasto, and touches of un-modulated color. *Beach Scene, Park Scene*, and *Bathers on Rocks* show a formal short-hand notation for construction of the figures and have a personal rhythmic quality that is related to Walkowitz's interest in music and dance. Walkowitz became interested in Cubist planar space and produced a large series of exciting paintings based on the dynamism of New York architecture that extended the range of his modernist aesthetic.

Although Weber was included in Alfred Stieglitz's *Younger American Painters* exhibition in 1910, Walkowitz did not show at "291" until 1912, when he had a one-man show there. Walkowitz's friendship with Stieglitz intensified after Weber broke with Stieglitz in 1911. In addition to another one-man show in 1913, Walkowitz organized several exhibitions of children's art at Stieglitz's gallery. The untrained spontaneity and freshness of vision of children were qualities that the mature Walkowitz tried to emulate. His obsessive lyrical studies of Isadora Duncan in motion are the most striking of his repeated attempts to capture the elemental nature of the free spirit.

Walkowitz was represented by eleven works in the Armory Show, so it is no wonder that the more progressive Weber was offended that the committee selected only two of his works. Although Walkowitz was included in the 1916 Forum Exhibition and the first Independents Exhibition the following year, his later work was not widely exhibited and he gradually fell into obscurity.

Percy North

# Max Weber

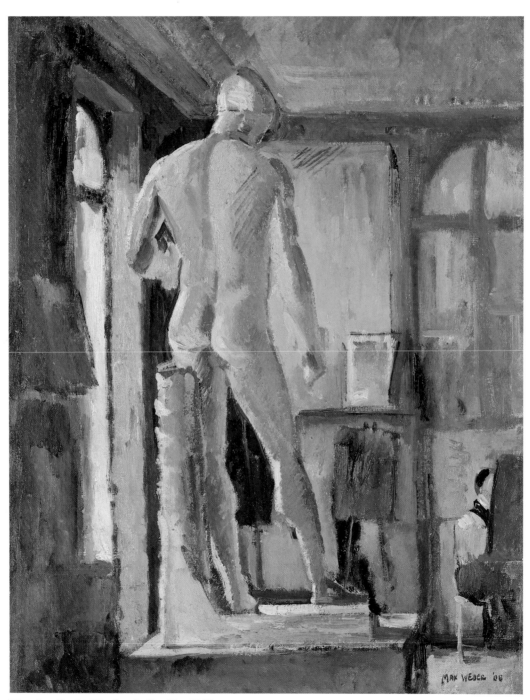

*The Apollo in Matisse's Studio,* 1908

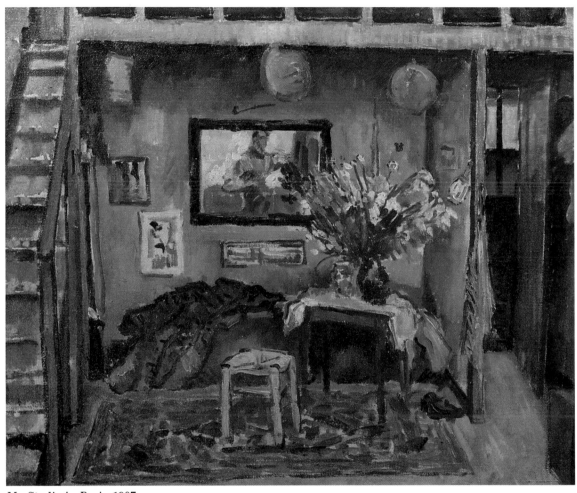

*My Studio in Paris,* 1907

Although Max Weber arrived in Paris in the autumn of 1905 too late to see the Fauve Salon, he brought with him progressive ideas about art from his studies with Arthur Wesley Dow at the Pratt Institute in Brooklyn. In Paris Weber entered the atelier of Jean-Paul Laurens at the Académie Julian, but he found the exercises— drawing from plaster casts in conformance with rigid academic standards —stultifying and left the class early in 1906. While at the Académie Julian, however, he met a group of young progressives including Dunnoyer de Segonzac and Hans Purrmann.

Weber considered seeing the ten paintings by Cézanne in the 1906 Salon d'Automne a turning point in his career. From that time he eliminated details and used large brushstrokes. The following year, nine of Weber's works were included in the Salon d'Automne along with fifty-six paintings by Cézanne that constituted a major retrospective examination of his work. Weber's 1907 portrait of his friend Abraham Walkowitz (Brooklyn Museum) attests to the influence of Cézanne in its brown palette, heavy impasto, and directional strokes.

In January 1908, Weber wrote to Walkowitz of his role in organizing a class with Purrmann for which Henri Matisse would give critiques. Under the influence of Matisse, Weber used freer colors and sketchier forms. Most of Weber's European works were pochades of landscapes or small panels with nude figures, notably a series of freely brushed female and

175

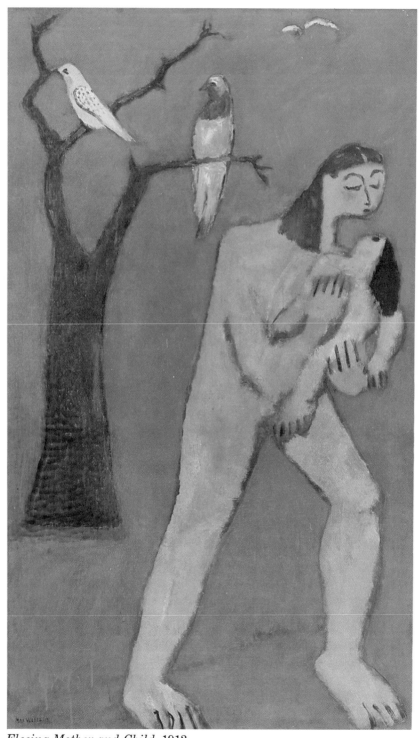

*Fleeing Mother and Child,* 1913

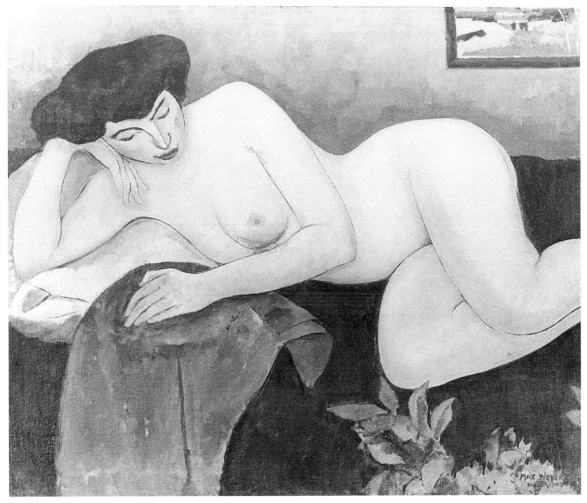

*La Parisienne*, 1907

male nudes sketched from the models in the Matisse class. His *Apollo in the Matisse Studio*, a small painting of a classical cast used by the students as a model, suggests Matisse's adherence to academic exercises for training, but the green and lavender complementary color scheme shows the influence of Matisse's Post-Impressionist color.

Weber's earlier *My Studio in Paris* had already indicated his debt to Matisse's freedom of form and color, and Weber continued to emulate his teacher's methods on his return to New York in January 1909. *The Bathers*, or *Bathers and Sails* (1909), with its broad brush strokes, broken outlines, flattened spaces, and distortion of form, serves as a transition between his work in Europe and the United States. In New York, however, Weber began to draw upon more diverse sources in his painting. By 1910 he was turning toward Cubism, and he rejected Matisse.[1] Nevertheless, Post-Impressionist tendencies occasionally surfaced in his works after 1910. *Fleeing Mother and Child* has the simplification of the figure, heavy outlines, and suffused color that characterized Matisse's work of 1911.

Weber was one of the earliest of the American Post-Impressionists to exhibit in New York when he staged his first one-man show at the small Haas Gallery in the spring of 1909. He was included in Alfred Stieglitz's *Younger American Painters* show the following year and was singled out for the harshest criticism for his use of formal distortions, a practice which made him the most advanced of the young moderns.

Although Weber exhibited with the foremost English Post-Impressionists in the third Grafton exhibition in London in 1913, he was absent from the Armory Show. By 1913, however, he was committed to a personal style of Cubo-Futurism that he continued to develop for the rest of the decade.

Percy North

[1] "Chinese Dolls and Modern Colorists," *Camera Work* (July 1910): 51.

177

# E. Ambrose Webster

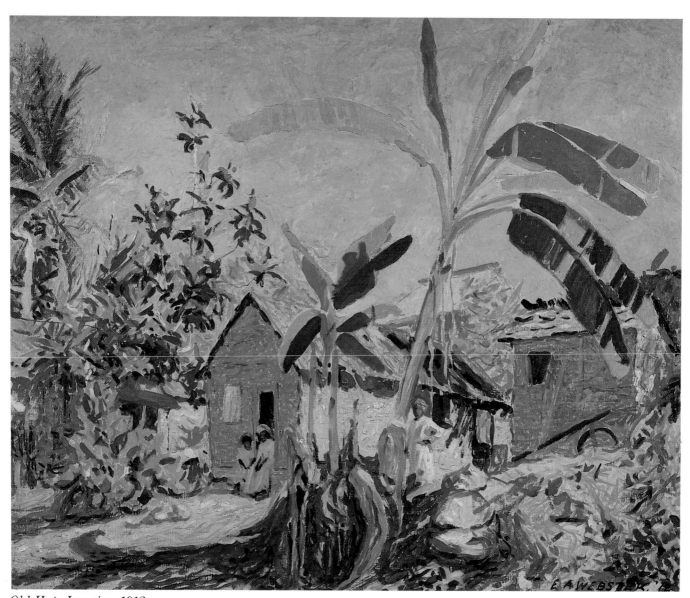

*Old Hut, Jamaica*, 1912

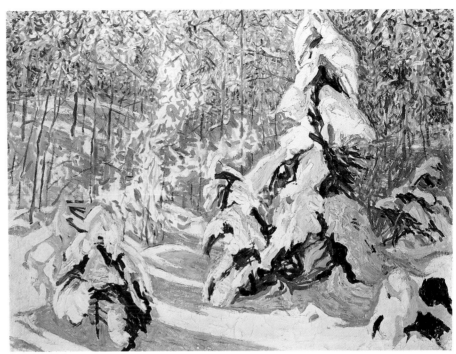

*Tamworth, New Hampshire,* 1914

Edwin Ambrose Webster (1869-1935) studied at the Boston Museum School with Edmund Tarbell and Frank Benson. In 1896 he went to Paris to study at the Académie Julian with Jean-Paul Laurens and Benjamin Constant, accompanied by his classmate and fellow artist, Carl G. Cutler. In 1898 Webster and Cutler visited Egmond, Holland, before returning home and undoubtedly were in contact there with Hitchcock and Gari Melchers. The strongest discernible influence on his work, however, was that of the Boston watercolorist Dodge MacKnight. MacKnight had studied in France a decade before Webster, and his watercolors and pastels temporarily held the interest of Vincent van Gogh.[1] In 1906 MacKnight and Webster travelled together to Jamaica to paint, and critics of the day noted their similarities in style and technique.[2]

Webster opened his Summer School of Art in Provincetown in 1900. Although he lived year-round in Provincetown, Webster was a member of the progressive circle of Boston artists centered around Charles Hovey Pepper. Pepper's contacts ranged afar; he was an ardent champion of the work of Maurice Prendergast and an early patron of Marsden Hartley.[3] Webster exhibited in four-person group shows with Pepper, Cutler, and Prendergast in Boston and Cleveland in 1913 and 1914.[4] Two of Webster's Jamaica paintings were included in the 1913 Armory Show.

In attitude Webster was a realist, but he sought motifs which would allow him to paint in a very high key. He believed that oppositions of complementary colors were inherent in nature: "The warm, yellow sunlight with the cool blue shadows; the red flowers with the green foliage; the green and yellow foliage with the violet branches."[5] Patterns of sunlight and shadow unify and flatten his compositions, but it was important to Webster in the teens to remain veristic. While he praised Prendergast, calling him "one of the few Americans who really knew color,"[6] he was disturbed that Prendergast's compositions "lean away from nature."[7] Webster believed that the straightforward study of the effects of light and shadow outdoors offered unsurpassed opportunities for obtaining brilliant contrasts of value and hue.

Typically, Webster's best canvases are thinly painted in transparent oils handled like watercolor. Webster's loose brushwork structures his compositions into rhythmic sequences—writhing branches of foliage, blocky walls and rooftops, impasto inflections in sky and ground. The boldness of Webster's attack and his penchant for broad, flat areas of paint clearly separate his work from Impressionism. Although he was initially celebrated for his New Hampshire snow scenes, much of his best early work was done in Bermuda and Jamaica, where the radiant light lent itself to his purposes.

The first, and for many years the only, proclaimed modernist in Provincetown, Webster helped to foster the climate of acceptance which made Provincetown, by 1916, a center for early twentieth century modernism.

Peter Morrin

[1] Johanna van Gogh-Bonger, translator, *The Complete Letters of Vincent van Gogh* (Greenwich: New York Graphic Society, [1958]), vol. 2, p. 556. There are frequent references to MacKnight in Arles in van Gogh's letters during the spring and summer of 1888.
[2] "Mr. Webster's Work," *Boston Transcript,* September 12, 1914.
[3] Joseph Coburn Smith, *Charles Hovey Pepper* (Portland: The Southworth-Anthoensen Press, 1945), pp. 39-40, 46.
[4] January 1913, Brooks Reid Gallery, Boston; December 1913, Gage Gallery, Cleveland; January 1914, Brooks Reid Gallery, Boston.
[5] E. Ambrose Webster, *Color: Drawing Painting* (Provincetown, ca. 1925), p. 33.
[6] Karl F. Rodgers, "Memoir," typescript, ca. 1940, Webster Papers, Archives of American Art, Washington, D.C.
[7] Pencil notation by Webster in *Color: Drawing Painting,* Webster Papers, Archives of American Art, pp. 6-7.

# Marguerite Thompson Zorach

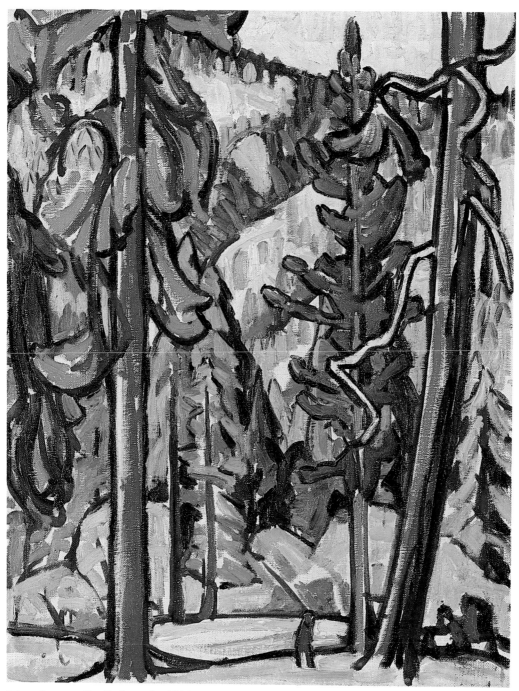

*Man Among the Redwoods*, 1912

On the day in 1908 that she arrived in Paris from her native California, Marguerite Thompson (1887-1968) visited the Salon d'Automne.[1] The painters Albert Marquet, Henri Manguin, André Derain, Othon Friesz, Anne Estelle Rice, John Duncan Fergusson, and Henri Matisse were represented in that exhibition. During the three years the young artist stayed in Paris, she saw the work of these painters in the Autumn and Independent Salons. At her first solo exhibition four years later, Thompson stated that it was the French Fauves and Pablo Picasso with whom she shared common goals.[2]

Thompson studied traditional art methods for a few months at the Ecole de la Grande Chaumière, but was more deeply impressed by the teachings of the progressive Scottish artist John Duncan Fergusson (1874-1961) at his school, La Palette. Jo Davidson, an American sculptor in Paris at that time, described Fergusson as "chef d'école of a group in Paris who called themselves Post-Impressionists."[3] Thompson shared a studio, attended school, and traveled and painted in the south of France with Jessie Dismorr, who in 1914 became a member of Wyndham Lewis's Vorticist circle in London.

Fauvist characteristics can be seen in *Luxembourg Gardens*, one of Thompson's earliest extant oils. The excitement and life of the gardens, where the artist loved to walk, are conveyed by the luminosity of the color and the agitation of the brushstrokes. The forceful drawing is executed with thick dark blue lines. The one-point perspective, chiaroscuro, and delineation of form which she used in her etchings are absent. Deliberate contrasts of intense green, blue, and purple against red, orange, and yellow produce a chromatic resonance.

Thompson left Paris in 1911 on a seven-month voyage east from Venice to Egypt, Palestine, India, China, and Japan, and then to San Francisco. Her paintings from this journey, exemplified by *Judea Hill in Palestine*, are landscapes composed of

*Luxembourg Gardens*, 1908

abstracted forms and boldly applied saturated pigments – lime green, lavender, purple, and orange, heightened by spots of white and light underpaint, cooled by blue lines and areas of blue greens. The style is reminiscent of Derain's, especially his 1907 *La Route dans la Montagne*, exhibited in Paris in 1908. Both paintings show landscapes composed of horizontal bands of flattened forms outlined in blue and accented with globular trees.

Thompson spent July and August 1912 camping with her family and friends in the Sierra Mountains, not far from her hometown of Fresno. Mountains fascinated her and she created some of the most brilliantly expressive paintings of her career that summer. *Man Among the Redwoods* was painted in pure hues with great spontaneity and authority. Many of the colors, including the orange foliage of the pine trees, can be found in nature, but they are heightened and intensified for expressive purposes. She wrote to her fiancé of "dead pines that were the most gorgeous orange colors" with magnificent blue mountain banks beyond.[4] The pastel yellow sky, light purple branches, vivid yellow and orange foreground, and scarlet

figures, however, are subjective interpretations.

The strength and vitality of Marguerite Thompson's California canvases spring from her joyous immersion in nature, expressed in the pictorial language she had discovered in Europe. After exhibiting what she called her Post-Impressionist canvases in Los Angeles and Fresno, she moved to New York, where she and William Zorach were married on December 24, 1912. The Zorachs were part of the small group of avant-garde writers and artists advancing the cause of modernism.

Roberta K. Tarbell

[1] This essay is adapted from Roberta K. Tarbell, *Marguerite Zorach: The Early Years, 1908-1920*, Washington, D.C.: Smithsonian Institution Press for the National Collection of Fine Arts (now the National Museum of American Art), 1973.

[2] Antony Anderson, "Art and Artists," *Los Angeles Times*, October 20, 1912.

[3] *Between Sittings: An Informal Autobiography of Jo Davidson* (New York: Dial Press, 1951), p. 38.

[4] Thompson to Zorach, July 17, 1912. Zorach Papers, Manuscript Division of the Library of Congress.

# William Zorach

*The Palace of the Popes at Avignon,* 1911

Although best known as a sculptor, the Russian-born William Zorach (1887-1966) was primarily a painter until he was thirty-three years old. Zorach spent his formative years in Cleveland, where he studied drawing and painting and worked as a commercial lithographer between 1902 and 1908.[1] He received academic training at the National Academy of Design from 1908 to 1910, and then traveled to France, arriving late in 1910. After attending a variety of conservative Parisian art schools, he decided upon La Palette, where in March 1911 he met Marguerite Thompson.

During the summer of 1911 Zorach painted increasingly free and spontaneous works in the south of France. The high key of his Provençal paintings is due to both his burgeoning modernism and the special brilliance and whiteness of the light of Provence. The painting in *The Palace of the Popes at Avignon* is applied thickly in choppy, unblended strokes. The composition (horizontal bands of sky and land), palette (cool analogous colors), and subject (steepled and castellated buildings near the river) echo canvases that Claude Monet painted between 1878 and 1887 in Vétheuil. However, the long, thick brushstrokes and the outlining of trees with a single brushstroke reflect the work of such Fauve artists as Émile-Othon Friesz, whom Zorach knew personally.

Zorach returned to La Palette in the fall of 1911, and wrote to Thompson, who was then traveling in the Middle East:

> This is my second week at La Palette. There are very few students and almost all painting a la Julians except Dismorr and Mac Neil and myself. I don't paint exactly Post Impressionistic. But at times I have gone absolutely wild.[2]

*New Hampshire,* 1917-18

In the voluminous correspondence they conducted during 1911 and 1912, Thompson and Zorach describe all modern artists, including themselves, as Post-Impressionistic.

For a few years after Thompson and Zorach were reunited in New York in 1912, their paintings were similar and were generally Fauve in color and figurative motifs.[3] William Zorach painted arcadian scenes like Matisse's *Luxe, Calme et Volupté* (1904-05, private collection, Paris) and *Joie de Vivre* (1905-06, Barnes Foundation, Merion, Pennsylvania). Zorach's sketchy thick outlines, lack of detail, and depiction of the human form unmodulated by chiaroscuro recall Matisse's *Pastorale* (1905, Musée de Petit Palais, Paris) and *Pink Nude* (1909, Musée de Grenoble). As late as 1917-18, when he painted *New Hampshire,* Zorach continued to produce Fauve paintings, even though he also painted in an American Cubist style.

The Fauves generally ignored such conventions for suggesting distance as foreshortening and the use of a horizon line, but Zorach held on to his academic training by retaining an illusion of depth through the application of paler colors in the background and through a series of planes. While Zorach applied some pure color, his palette was more harmonious than that of the French Fauves, and he used fewer violent juxtapositions of color. The few paintings that remain from Zorach's early years in New York indicate his preference for Fauvist and Expressionist forms and colors, ideas he labeled Post-Impressionist.

Roberta K. Tarbell

[1] See William Zorach, *Art Is My Life* (Cleveland and New York: World Publishing Co., 1967), and Roberta K. Tarbell, *Catalogue Raisonné of William Zorach's Carved Sculpture,* Ph.D. dissertation, University of Delaware, 1976.

[2] William Zorach to Marguerite Thompson [November] 21, 1911, Zorach Papers, Manuscript Division of the Library of Congress.

[3] In 1915, both Zorachs experimented with Cubism in their paintings.

# Checklist of the Exhibition

**Thomas Anshutz, 1851-1912**

*Steamship*
watercolor on cardboard
9⅞ x 7⅞ inches (25.1 x 20.0 cm)
Pennsylvania Academy of the Fine
Arts, Philadelphia
Gift of Mrs. Edward Anshutz
(Atlanta and Miami only)

*Landscape*
watercolor on cardboard
10 x 12 inches (25.4 x 30.5 cm)
Pennsylvania Academy of the Fine
Arts, Philadelphia
Gift of Mrs. Edward Anshutz
(Brooklyn and Calgary only)

**Ben Benn, 1884-1983**

*Landscape and Flowers*, 1915
oil on canvas
27⅛ x 22⅛ inches (68.9 x 56.2 cm)
Babcock Galleries, New York

*White Torso*, 1917
oil on canvas
36 x 30 inches (91.4 x 76.2 cm)
New Britain Museum of American
Art, Connecticut
Gift of Benn Associates

**Thomas Hart Benton, 1889-1975**

*Chataignier–Contre Soleil*, 1910
oil on canvas
16¼ x 20 inches (41.3 x 50.8 cm)
United Missouri Bank of Kansas
City, N.A., and Lyman Field, Co-
trustees of Thomas H. and Rita P.
Benton Testamentary Trusts

*Fauvist Landscape*, 1912
oil on panel
6¼ x 6¼ inches (15.9 x 15.9 cm)
United Missouri Bank of Kansas
City, N.A., and Lyman Field, Co-
trustees of Thomas H. and Rita P.
Benton Testamentary Trusts

**Oscar Bluemner, 1867-1938**

*First Painting Diary*, 1911-12
sketchbook
Oscar Bluemner Papers, Archives of
American Art, Smithsonian
Institution, Washington, D.C.

*Brickyard Canal (Güsen)*, 1913
watercolor and gouache on paper
15 x 20 inches (38.1 x 50.8 cm)
Collection of John Davis Hatch

**Jerome Blum, 1884-1956**

*Fauve Landscape*, ca. 1910
oil on canvas
18 x 22 inches (45.7 x 55.9 cm)
David David Gallery, Philadelphia

**Hugh Breckenridge, 1870-1937**

*Study for Grotto*, 1916
oil on canvas, mounted on cardboard
15 x 16 inches (38.1 x 40.6 cm)
Valley House Gallery, Inc., Dallas,
Texas

**Patrick Henry Bruce, 1881-1936**

*Still Life*, ca. 1911
oil, charcoal on canvas
18 x 23⅞ inches (45.7 x 60.6 cm)
Washburn Gallery, New York

*Leaves*, ca. 1912
oil on canvas
21½ x 17¼ inches (54.6 x 43.8 cm)
Washburn Gallery, New York

*Still Life with Tapestry*, ca. 1912
oil on canvas
19½ x 28 inches (49.5 x 71.1 cm)
Collection of Mr. and Mrs. Henry M.
Reed
(Atlanta and Brooklyn only)

**Charles Burchfield, 1893-1967**

*Trees and Fields, Noon Sunlight*,
1915
watercolor on paper
13⅞ x 20 inches (32.2 x 50.8 cm)
Munson-Williams-Proctor Institute,
Utica, New York
Edward W. Root Bequest

**Arthur B. Carles, 1882-1952**

*The Lake, Annecy*, 1912
oil on canvas
24½ x 29⅛ inches (62.2 x 74.0 cm)
Hirshhorn Museum and Sculpture
Garden, Smithsonian Institution,
Washington, D.C.

*Still Life*, 1913
oil on canvas
24⅜ x 23½ inches (61.9 x 59.7 cm)
Collection of Mr. and Mrs. Carl
Beren

*Landscape with Church*, ca. 1913
oil on panel
16 x 12⅞ inches (40.6 x 32.7 cm)
Collection of Mr. and Mrs. Donald L.
Symington

**Emily Carr, 1871-1945**

*Skidegate*, 1912
oil on board
25¾ x 12⅞ inches (65.4 x 32.5 cm)
Vancouver Art Gallery

*Old Village of Guyasdoms*, 1912
oil on cardboard
25⅞ x 38 inches (65.8 x 96.4 cm)
Vancouver Art Gallery

**Andrew Dasburg, 1887-1979**

*Floral Still Life*, 1914
oil on canvas
20 x 16 inches (50.8 x 40.6 cm)
The Regis Collection, Minneapolis,
Minnesota

*Finney Farm, Croton-on-Hudson*,
ca. 1917
oil on canvas
29½ x 23½ inches (74.9 x 59.7 cm)
Sid Deutsch Gallery, New York

## Stuart Davis, 1892-1964

*Portrait of a Man (Eugene O'Neill?)*,
1914
oil on canvas
30 x 23¾ inches (76.2 x 60.3 cm)
The Regis Collection, Minneapolis,
Minnesota

*Village with Countryside*, 1915
oil on canvas
23⅛ x 19⅛ inches (58.7 x 48.6 cm)
Mint Museum of Art, Charlotte,
North Carolina
Gift of Mr. Earl Davis

*Street in Gloucester*, ca. 1918
oil on canvas
21⅜ x 31½ inches (54.3 x 80.0 cm)
Collection of Mr. and Mrs. Elliott
Goldstein

## Charles Demuth, 1883-1935

*Peach Blossoms*, ca. 1915
watercolor and pencil on paper
8 x 10½ inches (20.0 x 26.7 cm)
Courtesy of Kennedy Galleries,
New York
(Miami and Brooklyn only)

*On Stage*, 1915
watercolor and pencil on paper
11 x 8¼ inches (27.9 x 21.0 cm)
Holly and Arthur Magill Collection
(Atlanta only)

*Acrobats – Balancing Act*, 1916
watercolor on paper
13 x 8 inches (33.0 x 20.3 cm)
The Blount Collection

*Study of a Tree*, ca. 1916
watercolor on paper
13¹¹⁄₁₆ x 12¹⁄₁₆ inches (34.8 x 30.8 cm)
High Museum of Art, Atlanta
Purchase, 1967.16
(Calgary only)

*Figures on the Beach, Gloucester*,
1918
watercolor and pencil on paper
10½ x 8 inches (25.4 x 20.3 cm)
Holly and Arthur Magill Collection
(Atlanta only)

## Arthur Dove, 1880-1946

*Landscape*, 1909
oil on wood
8¾ x 10¾ inches (22.2 x 27.3 cm)
Courtesy of Terry Dintenfass, Inc.,
New York

*Still Life Against Flowered
Wallpaper*, 1909
oil on canvas
25⅝ x 31⅞ inches (65.7 x 81.0 cm)
The Regis Collection, Minneapolis,
Minnesota

## Arthur Wesley Dow, 1857-1922

*Gay Head*, 1917
oil on canvas
30¼ x 40⅛ inches (76.8 x 101.9 cm)
Columbia University, New York

## A. B. Frost, Jr., 1887-1917

*Harlequin*, 1914
oil on canvas
13½ x 9½ inches (34.3 x 24.1 cm)
Collection of Mr. and Mrs. Henry M.
Reed, Montclair, New Jersey
(Atlanta and Brooklyn only)

## Anne Goldthwaite, 1875-1944

*House on the Hill*, ca. 1910
oil on linen
18 x 21½ inches (45.7 x 54.6 cm)
The Blount Collection

## Samuel Halpert, 1884-1930

*Pont Neuf*, 1911
oil on canvas
21½ x 25½ inches (54.6 x 64.8 cm)
Jordan-Volpe Gallery, Inc., New York

*The Park*, 1915
oil on canvas
13 x 16 inches (33.0 x 40.6 cm)
Collection of Dr. and Mrs. Wesley
Halpert

## Lawren Harris, 1885-1970

*Building the Icehouse, Hamilton*,
1912
oil on beaverboard panel
12 x 15 inches (30.5 x 38.1 cm)
Collection of Mrs. M. H. Knox

## Marsden Hartley, 1877-1943

*The Ice Hole, Maine*, 1908
oil on canvas
34 x 34 inches (86.3 x 86.3 cm)
New Orleans Museum of Art,
Louisiana
Museum Purchase through Ella West
Freeman Foundation Matching Fund

*Waterfall*, ca. 1909
oil on board
12 x 12 inches (30.5 x 30.5 cm)
University Art Museum, University
of Minnesota, Minneapolis
Bequest of Hudson Walker from the
Ione and Hudson Walker Collection

*Fruit Still Life*, ca. 1912
oil on canvas
19½ x 19½ inches (49.5 x 49.5 cm)
Georgia Museum of Art, The University of Georgia, Athens, Eva
Underhill Holbrook Memorial
Collection of American Art
Gift of Alfred H. Holbrook

*The Faenza Jar*, 1912
oil on canvas
20 x 16 inches (50.8 x 40.6 cm)
Private Collection

*Still Life No. 1*, 1912
oil on canvas
31½ x 25⅝ inches (50.0 x 65.9 cm)
Columbus Museum of Art, Ohio
Gift of Ferdinand Howald

## Childe Hassam, 1859-1935

*The Silver Veil and the Golden Gate*, 1914
oil on canvas
29⅝ x 31⅝ inches (75.2 x 80.3 cm)
Sloan Collection, Valparaiso University Art Galleries and Collections, Valparaiso, Indiana
Sloan Fund, 67.2

## A. Y. Jackson, 1882-1974

*Assisi from the Plain*, 1912
oil on canvas
25½ x 31¾ inches (64.7 x 80.6 cm)
Art Gallery of Ontario, Toronto
Purchase, 1946

*Springtime in Picardy*, 1919
oil on canvas
25⅝ x 30½ inches (65.1 x 77.5 cm)
Art Gallery of Ontario, Toronto
Gift from the Albert H. Robson Memorial Subscription Fund, 1940

## Walt Kuhn, 1880-1949

*Morning*, 1912
oil on canvas
33 x 40 inches (83.8 x 101.6 cm)
Norton Gallery and School of Art, West Palm Beach, Florida

*Girl with White Hat*, 1914-15
oil on canvas
20 x 16 inches (50.8 x 40.6 cm)
Collection of Raymond L. Balasny

*Bathers on the Beach*, 1915
oil on canvas
36 x 40 inches (91.4 x 101.6 cm)
Thyssen-Bornemisza Collection, Lugano, Switzerland
(Brooklyn and Calgary only)

*Tragic Comedians*, ca. 1916
oil on canvas
96 x 45 inches (243.8 x 114.3 cm)
Hirshhorn Museum and Sculpture Garden, Smithsonian Institution, Washington, D.C.

## Ernest Lawson, 1873-1939

*Washington Bridge, Harlem River*, ca. 1915
oil on canvas
20⅛ x 24¹/₁₆ inches (51.1 x 61.1 cm)
High Museum of Art, Atlanta
J. J. Haverty Collection, 49.38

*Winter, Spuyten Duyvil*
oil on canvas
25¼ x 30½ inches (64.1 x 77.5 cm)
Wadsworth Atheneum, Hartford, Connecticut
Bequest of George A. Gay

## John Lyman, 1886-1967

*Swiss Landscape*, 1911
oil on wood panel
12¾ x 16¼ inches (32.4 x 41.2 cm)
Maurice Corbeil Collection

*Portrait of the Artist*, ca. 1918
oil on canvas
28¾ x 25⅝ inches (73.3 x 65.0 cm)
Musée du Québec
(Atlanta only)

## Stanton Macdonald-Wright, 1890-1973

*Portrait of Jean Dracopoli*, 1912
oil on canvas, mounted on board
16¼ x 13⅛ inches (41.3 x 33.3 cm)
Collection of Roy R. Neuberger

*Still Life No. 1*, ca. 1916-17
oil on pasteboard
16 x 20 inches (40.6 x 50.8 cm)
Columbus Museum of Art, Ohio
Gift of Ferdinand Howald

## Edward Middleton Manigault, 1887-1922

*Procession*, 1911
oil on canvas
20 x 24 inches (50.8 x 61.0 cm)
Columbus Museum of Art, Ohio
Gift of Ferdinand Howald

## John Marin, 1870-1953

*Brooklyn Bridge*, 1912
watercolor on paper
15½ x 18½ inches (39.4 x 47.0 cm)
Colby College Museum of Art, Waterville, Maine
Gift of Mr. & Mrs. John Marin, Jr.

*The Little Maple Tree, Castorland, New York*, 1913
oil on canvas
27 x 22 inches (68.6 x 55.9 cm)
Courtesy of Kennedy Galleries, New York

*Landscape*, ca. 1914
oil on canvas board
8 x 10 inches (20.3 x 25.4 cm)
Courtesy of Kennedy Galleries, New York

*Weehawken Sequence #65*, ca. 1915
oil on canvas
12¼ x 9½ inches (31.1 x 24.1 cm)
Colby College Museum of Art, Waterville, Maine
Gift of Mr. and Mrs. John Marin, Jr.

*Weehawken Sequence #2*, ca. 1916
oil on canvas board
12 x 9 inches (30.5 x 22.9 cm)
Courtesy of Kennedy Galleries, New York

## Jan Matulka, 1890-1972

*Waterfall*, 1916
oil on canvas
26¼ x 19⅜ inches (66.7 x 49.2 cm)
Courtesy of Robert Schoelkopf Gallery, Ltd., New York

## Alfred Maurer, 1868-1932

*Woman with Hat*, 1907
oil on canvas, mounted on masonite
21½ x 18 inches (54.6 x 45.7 cm)
Sheldon Memorial Art Gallery,
University of Nebraska-Lincoln
Bertha Schaefer Bequest
(Atlanta, Miami, Brooklyn only)

*Woman with Blue Background*,
1907-08
oil on panel
21¾ x 18 inches (55.2 x 45.7 cm)
Sheldon Memorial Art Gallery,
University of Nebraska-Lincoln
Bertha Schaefer Bequest
(Atlanta, Miami, Brooklyn only)

*Landscape with Trees*, ca. 1908
oil on board
31⅞ x 24⅜ inches (81.0 x 61.9 cm)
University Art Museum, University
of Minnesota, Minneapolis
Gift of Ione and Hudson Walker

*Landscape with Train*, 1910
oil on masonite
17⅝ x 21⅝ inches (44.8 x 54.9 cm)
Mead Art Museum, Amherst
College, Massachusetts, 1976.91

*Landscape*, ca. 1911
oil on canvas
32 x 25½ inches (81.3 x 64.8 cm)
Museum of Art, Carnegie Institute,
Pittsburgh, Pennsylvania
Gift of Bertha Schaefer

*The Clowness*, 1911
oil on canvas
29¼ x 25⅛ inches (74.3 x 63.8 cm)
Hood Museum of Art, Dartmouth
College, Hanover, New Hampshire
(Calgary only)

*Pitcher and Three Croissants*,
ca. 1912
oil on canvas
18¼ x 23¾ inches
New Orleans Museum of Art,
Louisiana
Purchase through Ella West Freeman
Foundation Matching Fund

## Henry McCarter, 1886-1942

*The Green Tree/For Sale Here*, pub-
lished by Stone and Kimball, 1894
lithographic poster
16¼ x 12½ inches (41.3 x 31.8 cm)
Courtesy of Boston Public Library,
Print Department, Massachusetts

## Thomas Buford Meteyard, 1865-1928

*The Purple Trees*, ca. 1890
oil on canvas
12½ x 15½ inches (31.8 x 39.4 cm)
Collection of Montclair Art Museum,
Montclair, New Jersey

*Songs from Vagabondia*, 1895
lithographic poster
15⅜ x 10¾ inches (39.1 x 27.3 cm)
Courtesy of Boston Public Library,
Print Department, Massachusetts

## David Milne, 1882-1953

*Billboards*, 1912
oil on canvas
20 x 22 inches (50.8 x 56.2 cm)
National Gallery of Canada, Ottawa
Gift from the Douglas M. Duncan
Collection, Toronto, 1962

*Bright Rocks*, 1913
oil on canvas
18½ x 20⅛ inches (46.1 x 51.2 cm)
Milne Family Collection, Toronto

*Lilies*, 1914
oil on canvas
20 x 20 inches (51.0 x 51.0 cm)
The McMichael Canadian Collection,
Kleinburg, Ontario
Anonymous Donor

*The Bright Pillows*, ca. 1914
oil on canvas
19⅞ x 19⅞ inches (50.5 x 50.5 cm)
National Gallery of Canada, Ottawa

## James Wilson Morrice, 1865-1924

*Terrace at Capri*, 1910-1923
oil on wood panel
11⅘ x 9 inches (30 x 23 cm)
Collection of the Montreal Museum of
Fine Arts
David R. Morrice Bequest

*Fruit Market, Tangiers*, ca. 1911-12
oil on canvas
19¼ x 23½ inches (50 x 60 cm)
Collection of the Montreal Museum of
Fine Arts
David R. Morrice Bequest

*Scène de rue à Alger*, 1912
oil on wood
4⅞ x 6 inches (12.4 x 15.4 cm)
Musée du Québec

*Gibraltar*, ca. 1913
oil and graphite on panel
9 x 13 inches (26 x 32 cm)
Collection of the Montreal Museum of
Fine Arts
David R. Morrice Bequest

*House in Santiago*, ca. 1915
oil and graphite on panel
5 x 6½ inches (13 x 16.5 cm)
Collection of the Montreal Museum of
Fine Arts
David R. Morrice Bequest

*Scene in Havana*, 1915
oil on canvas
28½ x 21⅛ inches (72.4 x 53.7 cm)
Art Gallery of Ontario, Toronto
Purchase with assistance from
Wintario

## Carl Newman, 1858-1932

*Landscape*, 1909-14
oil on canvas, mounted on fiberboard
19⅞ x 24 inches (50.5 x 61.0 cm)
National Museum of American Art,
Smithsonian Institution, Washington,
D.C.
Gift of Anna McCleery Newton

## B. J. O. Nordfeldt, 1878-1955

*Steamship in Canal, Venice*, ca. 1910
oil on canvas
25 x 38 inches (63.5 x 96.5 cm)
Collection of Mrs. B. J. O. Nordfeldt
(Calgary only)

*Tangier*, ca. 1910
oil on canvas
25½ x 31 inches (10.0 x 12.2 cm)
Anonymous Loan

*Portrait of Robert Friedel*, ca. 1911
oil on canvas
42⅛ x 36 inches (107.0 x 91.4 cm)
Hirshhorn Museum and Sculpture
Garden, Smithsonian Institution,
Washington, D.C.
Gift of Joseph H. Hirshhorn

*The Red Cap*, 1912
oil on canvas
27 x 24 inches (68.6 x 61.0 cm)
Collection of Mrs. B. J. O. Nordfeldt

*Blue Plate*, ca. 1916
oil on canvas
24¼ x 20¼ inches (61.6 x 51.4 cm)
Hirshhorn Museum and Sculpture
Garden, Smithsonian Institution,
Washington, D.C.

*Figures on the Beach, Provincetown*,
1916
oil on canvas
29 x 36 inches (73.7 x 91.4 cm)
Courtesy of Richard York Gallery,
New York
(Atlanta, Miami, Brooklyn only)

## George Of, 1876-1954

*Landscape*, 1908
oil on board
7½ x 9½ inches (19.1 x 24.1 cm)
High Museum of Art, Atlanta
Purchase with The Mary E. Haverty
Fund and general funds in honor of
the 100th Anniversary of Haverty
Furniture Company, 1985.23

## Charles Prendergast, 1868-1948

*The Annunciation*, ca. 1912
engraved gesso on carved wooden
panel with tempera and gold leaf
20 x 27 inches (50.8 x 68.6 cm)
Collection of Mrs. Charles
Prendergast

*Decorative Composition*, 1918
oil, silver and gold leaf on panel
23¾ x 71 inches (60.3 x 100.3 cm)
London Collection

## Maurice Prendergast, 1859-1924

*Round Table Library*, Joseph Knight
Company Publishers, Boston, 1895
color lithograph
18⅞ x 13½ inches (47.9 x 34.3 cm)
Hood Museum of Art, Dartmouth
College, Hanover, New Hampshire

*La Rouge*, 1913
oil on canvas
27¾ x 30½ inches (70.5 x 77.5 cm)
Lehigh University Art Galleries,
Bethlehem, Pennsylvania

*Picnic*, 1914-15
oil on canvas
77 x 106½ inches (195.6 x 270.5 cm)
Museum of Art, Carnegie Institute
Gift of the People of Pittsburgh in
honor of the Sarah Scaife Gallery
through the Women's Committee of
the Museum of Art
(Atlanta and Brooklyn only)

*Cinerarias and Fruit*, 1915
oil on canvas
21 x 27 inches (53.3 x 68.6 cm)
Collection of Whitney Museum of
American Art, New York
Purchase, 32.48

*Bathers by the Sea*, 1917
oil on canvas
31 x 35⅛ inches (78.7 x 89.2 cm)
Williams College Museum of Art,
Williamstown, Massachusetts
Anonymous gift

## Man Ray, 1890-1976

*Landscape at Ridgefield*, 1913
oil on canvas
25 x 30 inches (63.5 x 76.2 cm)
Addison Gallery of American Art
Phillips Academy, Andover,
Massachusetts
(Atlanta only)

*Black Tray*, 1914
oil on canvas
18 x 24 inches (45.7 x 61.0 cm)
The Phillips Collection, Washington,
D.C.

## Morgan Russell, 1886-1953

*Still Life with Fruit*, ca. 1909-10
oil on board
20½ x 25¾ inches (52.1 x 65.4 cm)
Collection of Mr. and Mrs. Russ
Titelman

*Still Life with Bananas*, ca. 1912-13
oil on canvas
15⅘ x 18⅔ inches (40.1 x 47.4 cm)
Collection of Montclair Art Museum,
Montclair, New Jersey
Gift of Mr. and Mrs. Henry M. Reed

*Still Life with Flowers*, ca. 1913
oil on canvas
20 x 15 inches (50.8 x 38.1 cm)
Courtesy of Salander-O'Reilly
Galleries, Inc., New York

## H. Lyman Saÿen, 1875-1918

*Notre Dame*, 1907
oil on canvas
13¾ x 10⅜ inches (34.8 x 26.4 cm)
National Museum of American Art,
Smithsonian Institution, Washington,
D.C.
Gift of Col. Harrison K. Saÿen

*Decor Plat*, 1915
oil on canvas
25⅛ x 30⅛ inches (63.9 x 76.4 cm)
National Museum of American Art,
Smithsonian Institution, Washington,
D.C.
Gift of H. Lyman Saÿen to His
Nation

## Morton Livingston Schamberg, 1881-1918

*Landscape (Lake Placid)*, 1911
oil on canvas mounted on board
10 x 14 inches (25.4 x 35.6 cm)
Collection of Lisa Schamberg Siegel

*Portrait of Fanette Reider*, ca. 1912
oil on canvas
30⅞ x 22⅛ inches (78.4 x 56.2 cm)
Williams College Museum of Art,
Williamstown, Massachusetts
Bequest of Lawrence H. Bloedel

*Studio Interior*, ca. 1912
oil on canvas
24 x 20 inches (61.0 x 50.8 cm)
Collection of Lisa Schamberg Siegel

## Alice Schille, 1869-1955

*Pier, Shinnecock*, ca. 1915
watercolor on paper
11 x 14 inches (27.9 x 35.6 cm)
Private Collection
Courtesy of Keny and Johnson
Gallery, Columbus, Ohio

## Charles Sheeler, 1883-1965

*Chrysanthemums*, 1912
oil on canvas
24 x 20 inches (61.0 x 50.8 cm)
Collection of Whitney Museum of
American Art, New York
Gift of the Artist, 55.24

*White Tulips*, 1912
oil on panel
13⅞ x 10⅜ inches (35.2 x 26.4 cm)
Collection of Mrs. Glenn C. Janss

*Landscape*, 1912
oil on composition board
7½ x 9½ inches (19.1 x 24.1 cm)
Corcoran Gallery of Art, Washington,
D.C.
Gift of Mrs. F. H. Detweiler through
Mrs. Edith Gregor Halpert
(Atlanta only)

## Joseph Stella, 1880-1946

*Still Life*, ca. 1912
oil on canvas
23¼ x 28¼ inches (59.1 x 71.8 cm)
Collection of Alan Silber, New York

*Study for Battle of Lights, Coney
Island, Mardi Gras*, 1913
oil and brush and ink on canvas
10 x 12 inches (25.3 x 30.5 cm)
Hirshhorn Museum and Sculpture
Garden, Smithsonian Institution,
Washington, D.C.

## Maurice Sterne, 1878-1957

*Benares*, 1912
oil on canvas
39¾ x 30½ inches (101.0 x 77.5 cm)
The Phillips Collection, Washington,
D.C.

## Tom Thomson, 1877-1917

*Red Leaves*, ca. 1914
oil on panel
8½ x 10½ inches (21.6 x 26.7 cm)
National Gallery of Canada, Ottawa
Bequest of Dr. J. M. MacCallum

*Autumn Foliage*
oil on panel
8⁷/₁₆ x 10½ inches (21.6 x 26. 7 cm)
Art Gallery of Ontario, Toronto
Gift of Ruben and Kate Leonard
Canadian Fund, 1927

*Beech Grove*, 1915?
oil on panel
8½ x 10⅖ inches (21.6 x 26.5 cm)
The McMichael Canadian Collection,
Kleinburg, Ontario
Anonymous Donor

*Sunset*, 1915
oil on board
8½ x 10½ inches (21.6 x 26.7 cm)
National Gallery of Canada, Ottawa
Bequest of Dr. J. M. MacCallum

*Tea Lake Dam*, 1916
oil on canvas
8⅖ x 10⅖ inches (21.4 x 26.3 cm)
The McMichael Canadian Collection,
Kleinburg, Ontario
Purchase with funds donated by
R. A. Laidlaw, Kleinburg, Ontario

*Water Flowers*, 1916
oil on panel
8½ x 10½ inches (21.6 x 26.7 cm)
The McMichael Canadian Collection,
Kleinburg, Ontario
Anonymous Donor

## Allen Tucker, 1866-1939

*Distant Shores*, 1916
oil on canvas
27⅞ x 33⅞ inches (70.8 x 86.0 cm)
Georgia Museum of Art, University
of Georgia, Athens
Gift of the Allen Tucker Memorial

## Abraham Walkowitz, 1880-1965

*Beach Scene*, 1905-10
oil on canvas
10 x 14 inches (25.4 x 35.6 cm)
Collection of Whitney Museum of
American Art, New York
Gift of the artist (and exchange),
73.17

*Park Scene*, 1905-10
oil on canvas
12 x 24 inches (30.5 x 61.0 cm)
Collection of Whitney Museum of
American Art, New York
Gift of the artist (and exchange),
73.18

*Bathers and Rocks #2*, 1917
oil on canvas
26 x 40 inches (66.0 x 101.6 cm)
Collection of Bernice and Edwin
Mazo

## Max Weber, 1881-1961

*My Studio in Paris*, 1907
oil on canvas
22½ x 28 inches (57.2 x 71.1 cm)
Courtesy Forum Gallery, New York

*La Parisienne*, 1907
oil on canvas
32 x 39 inches (81.3 x 99.1 cm)
Collection of Neuberger Museum,
State University of New York,
Purchase
Gift of Roy R. Neuberger

*The Apollo in Matisse's Studio*, 1908
oil on canvas
23 x 18 inches (58.45 x 45.7 cm)
Courtesy Forum Gallery, New York

*Fleeing Mother and Child*, 1913
oil on canvas
39 x 23½ inches (99.1 x 59.7 cm)
New Jersey State Museum, Trenton
Gift of the Friends of the New Jersey
State Museum and Purchase,
FA 1974.41

## E. Ambrose Webster, 1869-1935

*Old Hut, Jamaica*, 1912
oil on canvas
28 x 34 inches (71.1 x 76.4 cm)
Babcock Galleries, New York

*Tamworth, New Hampshire*, 1914
oil on canvas
28½ x 38½ inches
Babcock Galleries, New York

## Marguerite Zorach, 1887-1968

*Luxembourg Gardens*, 1908
oil on wood
12¾ x 16 inches (32.4 x 40.6 cm)
Collection of Mrs. Keith S. Wellin

*Judea Hill in Palestine*, 1911
oil on canvas
20 x 25 inches (50.8 x 63.5 cm)
Collection of Mr. John Stokes

*Man Among the Redwoods*, 1912
oil on canvas
25 x 20 inches (63.5 x 50.8 cm)
Collection of Roberta K. Tarbell

## William Zorach, 1887-1966

*The Palace of the Popes at Avignon*,
1911
oil on board
26 x 20½ inches (66.0 x 52.1 cm)
Anonymous Loan

*New Hampshire*, 1917-18
oil on canvas
26 x 34 inches (66.0 x 86.4 cm)
Courtesy Barbara Mathes Gallery,
New York
(Atlanta and Miami only)

# Selected Bibliography

## General

Agee, William C. *Synchromism and Color Principles in American Painting, 1910-1930*. New York: M. Knoedler and Co., 1965.

————. "Willard Huntington Wright and the Synchromists: Notes on the Forum Exhibition." *Archives of American Art Journal* 24, no. 2 (1984): 10-15.

*American Paintings in the Ferdinand Howald Collection*. Columbus, Ohio: Columbus Gallery of Fine Arts, 1969.

*The Armory Show; International Exhibition of Modern Art, 1913*. 3 vols. New York: Arno Press, 1972.

"The Arthur Jerome Eddy Collection." *Bulletin of the Art Institute of Chicago* 25, no. 7 (October 1931): 127.

Barr, Alfred H. *Matisse: His Art and His Public*. New York: The Museum of Modern Art, 1951.

Baur, John I. H. *Revolution and Tradition in Modern American Art*. Cambridge: Harvard University Press, 1951.

Bell, Clive. *Art*. London: Chatto and Windus, 1914.

Binyon, Laurence. "Post-Impressionists." *Saturday Review* 110 (1910): 609-10.

Breeskin, Adelyn D. *Pennsylvania Academy Moderns, 1910-1940*. Washington, D.C.: National Collection of Fine Arts, 1975.

Brown, Milton W. *American Painting, from the Armory Show to the Depression*. Princeton, N.J.: Princeton University Press, 1955.

————. *The Modern Spirit: American Painting, 1908-1935*. London: Arts Council of Great Britain, 1977.

————. *The Story of the Armory Show*. Greenwich, Conn.: New York Graphic Society for the Joseph H. Hirshhorn Foundation, 1963.

Bulliet, C. J. "The Eddy Gift to Chicago." *Creative Art*, March 1932, 213-18.

Burgess, Gelett. "The Wild Men of Paris." *Architectural Record* 27 (May 1910): 400-414.

Bywater, William G., Jr. *Clive Bell's Eye*. Detroit: Wayne State University Press, 1975.

Clutton-Brock, A. "Post-Impressionists." *Burlington Magazine* 18 (1911): 216ff.

Corn, Wanda, and John Wilmerding. "The United States." In *Post-Impressionism: Cross-Currents in European and American Painting, 1880-1906*, 219-40. Washington, D.C.: National Gallery of Art, 1980.

Davidson, Abraham. *Early American Modernist Painting, 1910-1935*. New York: Harper & Row, 1981.

De Zayas, Marius. "How, When and Why Modern Art Came to New York." Introduction and notes by Francis M. Naumann. *Arts Magazine* 54, no. 8 (April 1980): 96-126.

Eddy, Arthur Jerome. *Cubists and Post-Impressionism*. Chicago: A. C. McClurg & Co., 1914.

Fenton, Terry. *Modern Painting in Canada: A Survey of Major Movements in Twentieth-Century Canadian Art*. Edmonton, Alberta: The Edmonton Art Gallery, 1978.

Flam, Jack D. *Matisse on Art*. London: Phaidon, 1973.

*Four Americans in Paris: The Collection of Gertrude Stein and Her Family*. New York: The Museum of Modern Art, 1970.

Fry, Roger. *Manet and the Post-Impressionists*. London: Grafton Galleries, 1910.

Gordon, Donald. *Modern Art Exhibitions: 1900-1916*. 2 vols. Munich: Prestel, 1974.

Hamilton, George Heard. "The Alfred Stieglitz Collection." *The Metropolitan Museum Journal* 3 (1970): 371-92.

Harrison, Charles. *English Art and Modernism: 1900-1939*. London: Allen Lane; Bloomington: Indiana University Press, 1981.

Herbert, Robert L., Eleanor S. Apter, and Elise K. Kenney. *The Société Anonyme and the Dreier Bequest at Yale University: A Catalogue Raisonné*. New Haven and London: Yale University Press, 1984.

Hind, C. Lewis. *The Post-Impressionists*. London: Methuen & Co., 1911.

Homer, William Innes. *Alfred Stieglitz and the American Avant-Garde*. Boston: New York Graphic Society, 1977.

————, ed. *Avant-Garde Painting and Sculpture in America, 1910-1925*. Wilmington: Delaware Art Museum, 1975.

Huneker, James. *Promenades of an Impressionist*. New York: Charles Scribner's Sons, 1910.

Hyland, Douglas K. S. "Agnes Ernst Meyer, Patron of American Modernism." *The American Art Journal* 12, no. 1 (Winter 1980): 64-81.

Levin, Gail. *Synchromism and American Color Abstraction 1910-1925*. New York: Whitney Museum of American Art and George Braziller, 1978.

McCausland, Elizabeth. "The Daniel Gallery and Modern American Art." *Magazine of Art* 44 (November 1951): 280-85.

Mellquist, Jerome. *The Emergence of an American Art*. New York: C. Scribner's Sons, 1942.

Naumann, Francis. "Walter Conrad Arensberg: Poet, Patron, and Participant in the New York Avant-Garde, 1915-20." *Philadelphia Museum of Art Bulletin* 76, no. 328 (Spring 1980): 3-32.

Nicholson, Benedict. "Post-Impressionism and Roger Fry." *Burlington Magazine* 93 (1951): 11-15.

Pach, Walter. *Queer Thing, Painting*. New York: Harper & Brothers, 1938.

*Philadelphia: Three Centuries of American Art*. Philadelphia: Philadelphia Museum of Art, 1976.

*The Phillips Collection in the Making: 1920-1930*. Washington, D.C.: The Phillips Collection and the Smithsonian Institution Traveling Exhibition Service, 1979-1981.

Plagens, Peter. "The Critics: Hartmann, Huneker, De Casseres." *Art in America* 4 (July-August 1973): 66-71.

Poore, Henry R. *The New Tendency in Art: Post Impressionism, Cubism, Futurism*. Garden City, New York: Doubleday, Page and Co., 1913.

Reid, B. L. *The Man From New York: John Quinn and His Friends*. New York: Oxford University Press, 1968.

Saarinen, Aline B. *The Proud Possessors*. New York: Random House, 1958.

Schack, William. *Art and Argyrol*. New York and London: Thomas Yoseloff, 1960.

Schwab, Arnold T. *James Gibbons Huneker*. Stanford, Calif.: Stanford University Press, 1963.

Spalding, Frances. *Roger Fry: Art and Life.* Berkeley and Los Angeles: University of California Press, 1980.

Sutton, Denys, ed. *The Letters of Roger Fry.* 2 vols. New York: Random House, 1972.

*Vision and Design: The Life, Work and Influence of Roger Fry, 1866-1934.* Arts Council of Great Britain and University of Nottingham, 1966.

Warshawsky, Abel G. *Memories of an American Impressionist.* Kent, Ohio: Kent State University Press, 1980.

Watson, Forbes. "American Collections: No. 1–The Ferdinand Howald Collection." *Arts* 8 (August 1925): 69-95.

———. "The Barnes Foundation. Parts I and II." *Arts* 3 (January- February 1923): 9-22, 140-49.

Zilczer, Judith K. "The Aesthetic Struggle in America, 1913-1918: Abstract Art and Theory in the Stieglitz Circle." Ph.D. diss., University of Delaware, 1975.

———. "The Armory Show and the American Avant-Garde: A Re-evaluation." *Arts Magazine* 53, no. 1 (September 1978): 126-30.

———. "The Dispersal of the John Quinn Collection." *Archives of American Art Journal* 19, no. 3 (1979): 15-21.

———. "The Eight on Tour, 1908-1909." *The American Art Journal* 16, no. 3 (Summer 1984): 20-48.

———. "John Quinn and Modern Art Collectors in America, 1913-1924." *The American Art Journal* 14, no. 1 (Winter 1982): 56-71.

———. *"The Noble Buyer": John Quinn, Patron of the Avant-Garde.* Washington, D.C.: Smithsonian Institution Press for the Hirshhorn Museum and Sculpture Garden, 1978.

———. "Robert J. Coady, Forgotten Spokesman for Avant-Garde Culture in America." *American Art Review* 11, no. 6 (November-December 1975): 77-89.

———. "The World's New Art Center': Modern Art Exhibitions in New York City," 1913-1918. *Archives of American Art Journal* 14, no. 3 (1974): 2-7.

## Thomas Anshutz

Heard, Sandra Denney. Essay in *Thomas P. Anshutz, 1851-1912.* Philadelphia: Pennsylvania Academy of the Fine Arts, 1973.

*Philadelphia: Three Centuries of American Art.* Philadelphia: Philadelphia Museum of Art, 1976.

## Ben Benn

*Ben Benn: An American Painter, 1884-1983.* Exhibition catalogue. New York: Hammer Galleries, 25 October-12 November 1983.

*The Forum Exhibition: Selections and Additions.* New York: Whitney Museum of American Art at Philip Morris, 1983.

Geist, Sidney. "Ben Benn." *Art Digest* 28, no. 1 (October 1, 1953): 15, 25-28.

Kramer, Hilton. "The Achievement of Ben Benn." *Arts* 30, no. 7 (April 1956): 24-29.

## Thomas Hart Benton

American Artists Group. *Thomas H. Benton.* Monograph No. 3. New York, 1945.

Baigell, Matthew. *Thomas Hart Benton.* New York: Abrams, 1974.

Benton, Thomas Hart. *An American in Art: A Professional and Technical Autobiography.* Lawrence: The University Press of Kansas, 1969.

———. *An Artist in America.* New York: Robert M. McBride and Co., 1937; rev. ed., Columbia: University of Missouri Press, 1968.

Cate, Phillip Dennis. Introduction to *Thomas Hart Benton: A Retrospective of His Early Years, 1907-1929.* New Brunswick, N.J.: Rutgers University, 1972.

## Oscar Bluemner

Bluemner, Oscar. "Audiator Et Altera Pars: Some Plain Sense On The Modern Art Movement." *Camera Work,* special no. (June 1913): 25-38.

———. "Explanatory Note." *The Forum Exhibition of Modern American Painters.* Exhibition catalogue. New York: Anderson Galleries, 1916.

———. "In Other Words." *Exhibition of Modern Art Arranged by a Group of European and American Artists in New York.* Exhibition catalogue. New York: Bourgeois Galleries, 1918.

———. "Kunst, Wissenschaft und Leben: Oskar Blümer [sic] über die Kölner Sonderbund-Austellung." *Kölner Tafelblatt,* 20 August 1912.

———. "Observations in Black and White." *Camera Work,* no. 47 (January 1915): 51-53.

Bourgeois, Stephan. "Foreword." *Oscar F. Bluemner 1867-1938.* Exhibition catalogue. New York: James Graham & Sons, 1956.

Brodsky, Joyce E. "Oscar Bluemner in Black and White." William Benton Museum of Art *Bulletin* 1, no. 5 (1977): 3-17.

Coggins, Clemency, Martha Holsclow, and Martha Hoppin. *Oscar Bluemner: American Colorist.* Exhibition catalogue. Cambridge, Mass.: Fogg Art Museum, 1967.

Gettings, Frank. "The Human Landscape: Subjective Symbolism in Oscar Bluemner's Painting." *Archives of American Art Journal* 19, no. 3 (1979): 9-14.

Hatch, John Davis. "Foreword." *Oscar Bluemner: Paintings, Drawings.* Exhibition catalogue. New York: New York Cultural Center, 1969.

Hayes, Jeffrey R. "Oscar Bluemner: Life, Art, and Theory." Ph.D. diss., University of Maryland, 1982.

———. "Oscar Bluemner–Romantic Modern." *Oscar Bluemner: A Retrospective Exhibition.* Exhibition catalogue. New York: Barbara Mathes Gallery, 1985.

Rosenfeld, Paul. "The Vermilionaire." *University Review,* Summer 1939, 250-52.

Zilczer, Judith. "Color Expressionism: The Art of Oscar Bluemner." *Oscar Bluemner.* Exhibition catalogue. Washington, D.C: Hirshhorn Museum and Sculpture Garden.

## Jerome Blum

Blum, Jerome S. Papers. Archives of American Art. Smithsonian Institution, Washington, D.C.

Davidson, Jo. *Between Sittings, An Informal Autobiography.* New York, 1951.

## Hugh Breckenridge

Breeskin, Adelyn D. *Pennsylvania Academy Moderns, 1910-1940*. Washington: National Collection of Fine Arts, 1975.

Carr, Gerald L. "Hugh Henry Breckenridge (1870-1937)." *American Art Review* 4 (May 1978): 92-99, 119-122.

d'Harnoncourt, Anne. "Hugh H. Breckenridge (1870-1937)." In *Philadelphia: Three Centuries of American Art*, 506-7. Philadelphia: Philadelphia Museum of Art, 1976.

Scott, Wilford W. "The Artistic Vanguard in Philadelphia, 1905-1920." Ph.D. diss., University of Delaware, 1983.

Vogel, Margaret. *The Paintings of Hugh H. Breckenridge (1870- 1937)*. Dallas: Valley House Gallery, 1967.

## Patrick Henry Bruce

Agee, William C. "Patrick Henry Bruce: A Major American Artist of Early Modernism." *Arts in Virginia* (Virginia Museum, Richmond) 17 (Spring 1977): 12-32.

———. *Synchromism and Color Principles in American Painting, 1910-1930*. New York: M. Knoedler and Co., 1965.

Agee, William C., and Barbara Rose. *Patrick Henry Bruce, American Modernist: A Catalogue Raisonné*. New York: The Museum of Modern Art, 1979.

Herbert, Robert L., Eleanor S. Apter, and Elise K. Kenney. *The Société Anonyme and the Dreier Bequest at Yale University: A Catalogue Raisonné*. New Haven and London: Yale University Press, 1984.

Levin, Gail. "Patrick Henry Bruce and Arthur Burdett Frost, Jr.: From the Henri Class to the Avant-Garde." *Arts*, April 1979, 102-6.

———. *Synchromism and American Color Abstraction 1910-1925*. New York: Whitney Museum of American Art and George Braziller, 1978.

Roché, Henri Pierre. "Memories of Patrick Henry Bruce." In *Collection of the Société Anonyme: Museum of Modern Art 1920*. New Haven: Yale University Art Gallery, 1950.

## Charles Burchfield

Baur, John I. H. *The Inlander: Life and Work of Charles Burchfield, 1893-1967*. Newark: University of Delaware Press; New York: Cornwall Books, 1982.

Trovato, Joseph S. *Charles Burchfield: Catalogue of Paintings in Public and Private Collections*. Utica, N.Y.: Museum of Art, Munson-Williams-Proctor Institute, 1970.

## Arthur B. Carles

Breeskin, Adelyn D. *Pennsylvania Academy Moderns, 1910-1940*. Washington, D.C.: National Collection of Fine Arts, 1975.

Gardiner, Henry G. "Arthur B. Carles: A Critical and Biographical Study." *Bulletin of Philadelphia Museum of Art* 64 (January- March 1970).

*Philadelphia: Three Centuries of American Art*. Philadelphia: Philadelphia Museum of Art, 1976.

Wolanin, Barbara A. *Arthur B. Carles (1882-1952): Painting with Color*. Philadelphia: Pennsylvania Academy of the Fine Arts, 1983.

## Emily Carr

Carr, Emily. *Growing Pains: The Autobiography of Emily Carr*. Toronto: Oxford University Press, 1946.

Hembroff-Schleicher, Edythe. *Emily Carr: The Untold Story*. Saanichton, B.C., and Seattle: Hancock House Publishers, 1978.

Tippett, Maria. *Emily Carr, A Biography*. Toronto and New York: Oxford University Press, 1979.

Shadbolt, Doris. *The Art of Emily Carr*. Toronto: Clarke, Irwin; Vancouver: Douglas and McIntyre, 1979.

## Andrew Dasburg

Brook, Alexander. "Andrew Dasburg." *The Arts* 6 (July 1924): 18-26.

Bywaters, Jerry. *Andrew Dasburg*. New York: American Federation of Arts, 1959.

Coke, Van Deren. *Andrew Dasburg*. Albuquerque: University of New Mexico Press, 1979.

Levin, Gail. "Andrew Dasburg: Recollections of the Avant-Garde." *Arts* 52 (June 1978): 126-30.

## Stuart Davis

Arnason, H. H. *Stuart Davis*. Minneapolis: Walker Art Center, 1957.

———. *Stuart Davis Memorial Exhibition*. Washington, D.C.: National Collection of Fine Arts, 1965.

Blesh, Rudi. *Stuart Davis*. New York: Grove Press, 1960.

Davis, Stuart. *Stuart Davis*. New York: American Artists Group, 1945.

Goossen, E. C. *Stuart Davis*. New York: George Braziller, 1959.

Kelder, Diane, ed., *Stuart Davis*. New York: Praeger Publishers, 1971.

Lane, John R. *Stuart Davis: Art and Art Theory*. New York: The Brooklyn Museum, 1978.

Sweeney, James Johnson. *Stuart Davis*. New York: The Museum of Modern Art, 1945.

Weber, Bruce. *Stuart Davis' New York*. West Palm Beach, Florida: Norton Gallery and School of Art, 1985.

Wilkin, Karen, with notes by William C. Agee. *Stuart Davis: Black and White*. New York: Salander-O'Reilly Galleries, 1985.

## Charles Demuth

Fahlman, Betsy. *Pennsylvania Modern: Charles Demuth of Lancaster*. Exhibition catalogue. Philadelphia Museum of Art, 1983.

Farnham, Emily. "Charles Demuth: His Life, Psychology and Works." Ph.D. diss., Ohio State University, 1959.

———. "Charles Demuth's Bermuda Landscapes." *Art Journal* 25 (Winter 1965/66): 130-37.

———. *Charles Demuth: Behind a Laughing Mask*. Norman: University of Oklahoma Press, 1971.

Ritchie, Andrew Carnduff. *Charles Demuth*. Exhibition catalogue. New York: Museum of Modern Art, 1950.

## Arthur Dove

Dove, Arthur. Papers. Archives of American Art. Smithsonian Institution, Washington, D.C.

Morgan, Ann Lee. *Arthur Dove: Life and Work with a Catalogue Raisonné*. Newark: University of Delaware Press; London and Toronto: Associated University Presses, 1984.

Newman, Sasha M. *Arthur Dove and Duncan Phillips: Artist and Patron.* Washington, D.C.: The Phillips Collection in association with George Braziller, Inc., New York, 1981.

Smith, Suzanne Mullet. Papers. Archives of American Art. Smithsonian Institution, Washington, D.C.

Wight, Frederick S. *Arthur G. Dove.* Berkeley and Los Angeles: Art Galleries, University of California, Los Angeles, 1958.

## Arthur Wesley Dow

Dow, Arthur Wesley. *Composition.* Boston: J. M Bowles, 1899.

Moffatt, Frederick C. *Arthur Wesley Dow (1857-1922).* Washington: Smithsonian Institution Press for the National Collection of Fine Arts, 1977.

## A. B. Frost, Jr.

Levin, Gail. "Patrick Henry Bruce and Arthur Burdett Frost, Jr.: From the Henri Class to the Avant-Garde." *Arts,* April 1979, 102-6.

——. *Synchromism and American Color Abstraction 1910-1925.* New York: Whitney Museum of American Art and George Braziller, 1978.

## Anne Goldthwaite

*Anne Goldthwaite, 1869-1944.* Exhibition catalogue. Montgomery, Ala.: Montgomery Museum of Fine Arts, 22 March-1 May 1977.

Birnbaum, Martin. *Exhibition of Paintings, Water Colors and Etchings by Anne Goldthwaite.* Exhibition catalogue. New York: Berlin Photographic Company, 1915.

Breeskin, Adelyn Dohme. *Anne Goldthwaite: A Catalogue Raisonné of the Graphic Work.* Montgomery, Ala.: Montgomery Museum of Fine Arts, 1982.

Defries, A. D. "Anne Goldthwaite as a Portrait Painter." *International Studio* 59, no. 233 (July 1916): 3-8.

"A Modern Painter with a Strong Sense of Style." *New York Times Magazine,* 24 October 1915, 21.

## Samuel Halpert

Black, Bernard. *Samuel Halpert 1884-1930, A Pioneer of Modern Art in America.* New York: Bernard Black Gallery, 1969.

Comstock, Helen. "Samuel Halpert: Post Impressionist." *International Studio* 75 (April 1922): 145-50.

Delaunay, Sonia. *Nous Irons Jusqu'au Soleil.* Paris: Editions Robert Laffont, 1978.

Downtown Gallery Papers. Samuel Halpert Scrapbook, Archives of American Art, Smithsonian Institution, Washington, D.C.

Kreymbourg, Alfred. *Troubadour: An Autobiography.* New York: Boni and Liveright, 1925.

Ray, Man. *Self Portrait.* New York: Little, Brown and Company, 1963.

Warshawsky, Abel G. *The Memories of an American Impressionist.* Kent, Ohio: Kent State University Press, 1980.

## Lawren Harris

Adamson, Jeremy. *Lawren S. Harris: Urban Scenes and Wilderness Landscapes, 1906-1930.* Toronto: Art Gallery of Ontario, 1978.

Harris, Bess, and R. G. P. Colgrove, eds. *Lawren Harris.* Toronto: Macmillan, 1969.

Murray, Joan, and Robert Fulford. *The Beginning of Vision: The Drawings of Lawren S. Harris.* Toronto: Douglas and McIntyre, 1982.

## Marsden Hartley

Hartley, Marsden. *Adventures in the Arts.* New York: Boni and Liveright, 1921.

——. *On Art.* Edited by Gail R. Scott. New York: Horizon Press, 1982.

Haskell, Barbara. *Marsden Hartley.* New York: Whitney Museum of American Art, 1980.

McCausland, Elizabeth. *Marsden Hartley.* Minneapolis: University of Minnesota Press, 1952.

*Marsden Hartley, 1908-1942: The Ione and Hudson D. Walker Collection.* Exhibition catalogue. Minneapolis: University Art Museum, University of Minnesota, 1984.

## Childe Hassam

Adams, Adeline. *Childe Hassam.* New York: American Academy of Arts and Letters, 1938.

*Childe Hassam 1859-1935.* Tucson: University of Arizona Museum of Art, 1972.

Gerdts, William H. *American Impressionism.* Seattle: University of Washington, 1980.

——. *American Impressionism.* New York: Abbeville Press, 1984.

Hoopes, Donelson F. *Childe Hassam.* New York: Watson-Guptill Publications, 1979.

## A. Y. Jackson

Groves, Naomi Jackson. *A. Y.'s Canada.* Toronto and Vancouver: Clarke, Irwin, 1968.

## Walt Kuhn

Adams, Philip Rhys. *Walt Kuhn, Painter: His Life and Work.* Columbus: Ohio State University Press, 1978.

——. "Walt Kuhn's *Salute.*" *Arts in Virginia* 25, nos. 2-3 (1985, Virginia Museum of Fine Arts): 2-11.

Kuhn, Walt. Papers. Archives of American Art. Smithsonian Institution, Washington, D.C.

——. *The Story of the Armory Show.* New York, 1938.

## Ernest Lawson

Anderson, Dennis. *Ernest Lawson Retrospective.* New York: ACA Galleries, 1976.

Berry-Hill, Henry, and Sidney Berry-Hill. *Ernest Lawson: American Impressionist, 1873-1939.* Leigh-on-Sea: F. Lewis, 1968.

Karpiscak, Adeline Lee. *Ernest Lawson, 1873-1939.* Tucson: University of Arizona Museum of Art, 1979.

O'Neal, Barbara. Essay in *Ernest Lawson, 1873-1939.* Ottawa: National Gallery of Canada, 1967.

Price, F. Newlin. *Ernest Lawson, Canadian-American.* New York: Feragil, 1930.

## John Lyman

Asselin, H., ed. *Inédits de John Lyman*. Montreal: Bibliothèque Nationale du Québec, Ministère des Affaires Culturelles, 1980.

Dompierre, Louise. *John Lyman: Je vis par les yeux/ I live by my eyes, 1886-1967*. Kingston: Agnes Etherington Art Centre, Queen's University, Kingston, September 1986.

Lawson, E. P. *John Lyman*. Montreal: Montreal Museum of Fine Arts, 1963.

Lyman, Corinne. "Avant Propos." *Exhibition of Paintings and Drawings by John G. Lyman*. Montreal: Art Association, 1913.

Lyman, John. "Letter to the Editor: Mr. John G. Lyman in Defence of Post-Impressionist Painting." *The Montreal Daily Star*, 17 May 1913, 12.

——. "Letter to the Editor: Mr. John G. Lyman Writes in Defence of 'Post-Impressionism.'" *The Montreal Daily Star*, 1 May 1913, 10.

——. Papers. Bibliothèque Nationale du Québec, Montreal.

Surrey, P. *John Lyman*. Quebec: Musée du Québec, 1966.

## Henry McCarter

Biddle, Francis. *A Casual Past*. Garden City, New York: Doubleday, 1961.

Breeskin, Adelyn D. *Pennsylvania Academy Moderns, 1910-1940*. Washington, D.C.: National Collection of Fine Arts, 1975.

d'Harnoncourt, Anne. "Henry Bainbridge McCarter." In *Philadelphia: Three Centuries of American Art*, 560-61. Philadelphia: Philadelphia Museum of Art, 1976.

Ingersoll, R. Sturgis. *Henry McCarter*. Cambridge: Riverside Press, 1944.

## Stanton Macdonald-Wright

Agee, William C. *Synchromism and Color Principles in American Painting*. New York: Knoedler, 1965.

Levin, Gail. *Synchromism and American Color Abstraction, 1910-1925*. New York: Braziller, 1978.

Scott, David W. *The Art of Stanton Macdonald-Wright*. Washington, D.C.: Smithsonian Press for the National Collection of Fine Arts, 1967.

*Stanton Macdonald-Wright: A Retrospective Exhibition, 1911- 1970*. Los Angeles: UCLA Art Galleries and Grunwald Graphic Arts Foundation, 1970.

## Edward Middleton Manigault

*American Paintings in the Ferdinand Howland Collection*. Columbus, Ohio: Columbus Gallery of Fine Arts, 1969.

*Paintings by E. Middleton Manigault*. West Palm Beach: Norton Gallery of Art, 1963.

## John Marin

Baur, John I. H. "John Marin's 'Warring, Pushing, Pulling' New York." *Art News* 80, no. 9 (November 1981): 106-110.

Helm, Mackinley. *John Marin*. With a foreword by John Marin. Boston: Pellegrini & Cudahy, 1948.

*John Marin: A Retrospective Exhibition*. Boston: Institute of Modern Art, 1947.

Marin, John. *Selected Writings*. Edited by Dorothy Norman. New York: Pellegrini & Cudahy, 1949.

Phillips, Duncan. Foreword to *John Marin Memorial Exhibition*. Los Angeles: University of California Art Galleries, 1955.

Reich, Sheldon. *John Marin Drawings 1886-1951*. University of Utah, 1969.

——. *John Marin: A Stylistic Analysis and Catalogue Raisonné*. 2 vols. Tucson: University of Arizona, 1970.

## Jan Matulka

Sims, Patterson, and Mary Foresta. *Jan Matulka*. Washington, D.C.: National Collection of Fine Arts, 1980.

## Alfred Maurer

Brinton, Christian. "Maurer and Expressionism." *The International Studio* 49, no. 193 (March 1913): 8-9.

Greenberg, Clement. "Van Gogh and Maurer." *Partisan Review* 17, no. 2 (February 1950): 170-73.

McCausland, Elizabeth. *A. H. Maurer*. Minneapolis: Walker Art Center, 1949.

——. *A. H. Maurer*. New York, 1951.

Madormo, Nick. "The Early Career of Alfred Maurer." *The American Art Journal* 15, no. 1 (1983): 4-34.

Pollack, Peter. "The Lost Years Rediscovered." In *Alfred Maurer and the Fauves*. New York: Bernard Danenberg Galleries, 1973.

Reich, Sheldon. *Alfred H. Maurer*. Washington, D.C., 1973.

Salander, Lawrence B. Essay in *Alfred H. Maurer*. New York: Salander-Ò'Reilly Galleries, 1983.

## Thomas Buford Meteyard

Alloway, Lawrence. "Art News from London." *Art News* 54, no. 7 (1955): 12.

*American Painters of the Impressionist Period Rediscovered*. Waterville, Maine: Colby College Art Museum, 1975.

Art League Publishing Company Papers. Archives of American Art. Smithsonian Institution, Washington, D.C.

Lee, Ellen Wardell. *The Aura of Neo-Impressionism: The W. J. Halliday Collection*. Bloomington, 1983.

## David Milne

Buchanan, Donald W. "David Milne as I Knew Him." *Canadian Art* 11 (Spring 1954): 89-92.

Frye, Northrop. "David Milne: An Appreciation." 1948. Reprinted in *The Bush Garden: Essays on the Canadian Imagination*. Toronto: Anansi, 1971.

Jarvis, Alan. *David Milne*. Toronto: McClelland and Stewart, 1962.

Milne, David. "Journals and Letters of 1920 and 1921: A Document of Survival." Edited by David Milne, Jr., and Nick Johnson. *Artscanada* 30 (August 1973): 15-55.

O'Brian, John. *David Milne: The New York Years 1903-1916*. Exhibition catalogue. Alberta: Edmonton Art Gallery, 1981.

——. *David Milne and the Modern Tradition of Painting*. Toronto: Coach House Press, 1983.

Tovell, Rosemarie L. *Reflections in a Quiet Pool: The Prints of David Milne*. Exhibition catalogue. Ottawa: National Gallery of Canada, 1980.

## James Wilson Morrice

Bell, Clive. *Old Friends: Personal Recollections*. London: Chatto & Windus, 1956.

Buchanan, Donald W. *James Wilson Morrice, A Biography*. Toronto: Ryerson Press, 1936.

Cloutier, Nicole, et al. *Morrice: A painter with a view*. Montreal: Museum of Fine Arts, 1985.

Dorais, Lucie. "Deux moments dans la vie et l'oeuvre de James Wilson Morrice." *The National Gallery of Canada Bulletin*, no. 30 (1977): 1935.

Johnston, William R. *James Wilson Morrice: 1865-1924*. Exhibition catalogue. Montreal: Museum of Fine Arts, 1965.

Langdale, Cecily. *Charles Condor, Robert Henri, James Morrice, Maurice Prendergast: The Formative Years*. Exhibition catalogue. New York: Davis & Long, 1975.

Lyman, John. *Morrice*. Montreal: L'Arbre, 1945.

O'Brian, John. "Morrice–O'Conor, Gauguin, Bonnard et Vuillard." *Revue de l'Université de Moncton* 15 (April-December 1982): 9-34.

Sutton, Denys. *James Wilson Morrice: 1865-1924*. Exhibition catalogue. Bath: Holburne of Menstrie Museum, 1968.

## Carl Newman

Breeskin, Adelyn D. *Pennsylvania Academy Moderns, 1910-1940*. Washington, D.C.: National Collection of Fine Arts, 1975.

Davidson, Abraham. *Early American Modernist Painting, 1910- 1935*. New York: Harper & Row, 1981.

## B. J. O. Nordfeldt

Coke, Van Deren. *Nordfeldt the Painter*. Albuquerque: University of New Mexico Press, 1972.

Flint, Janet Altic. *Provincetown Printers: A Woodcut Tradition*. Washington, D.C.: Smithsonian Institution Press for the National Museum of American Art, 1983.

Hunter, Sam. *B. J. O. Nordfeldt: An American Expressionist*. Catalogue for traveling exhibition organized by Richard Stuart Gallery, Pipersville, Pennsylvania, 1985.

Nordfeldt, B. J. O. Papers. Archives of American Art. Smithsonian Institution, Washington, D.C.

## George Of

Fahlman, Betsy. "George F. Of (1876-1954)." In *Avant-Garde Painting and Sculpture in America 1910-25* (exhibition catalogue), 106-7. Wilmington: Delaware Art Museum, 4 April-18 May 1975.

Pach, Walter. "Introducing the Paintings of George Of, 1876-1954." *Art News* 55 (October 1956): 36-38, 62-63.

———. "Submerged Artists." *Atlantic Monthly* 199 (February 1957): 68-72.

## Charles Prendergast

Anderson, Ross C. "The Panels of Charles Prendergast: Stylistic and Iconographic Sources." Graduate research paper, Harvard University, 1977.

Basso, Hamilton. "A Glimpse of Heaven." *The New Yorker*, 27 July 1946, 24-30; 3 August 1946, 28-37.

Wattenmaker, Richard J. *The Art of Charles Prendergast*. New Brunswick: Rutgers University Art Gallery, 1968.

## Maurice Prendergast

Green, Eleanor, et al. *Maurice Prendergast: Art of Impulse and Color*. College Park, Md.: University of Maryland Art Gallery, 1976.

Langdale, Cecily. *Monotypes by Maurice Prendergast in the Terra Museum of American Art*. Chicago: Terra Museum of American Art, 1984.

Owens, Gwendolyn. *Watercolors by Maurice Prendergast from New England Collections*. Williamstown, Mass.: Sterling and Francine Clark Art Institute, 1978.

Rhys, Hedley Howell. *Maurice Prendergast 1859-1924*. Boston: Museum of Fine Arts, 1960.

## Man Ray

Belz, Carl. "Man Ray and New York Dada." *The Art Journal* 23, no. 3 (Spring 1964): 207-13.

Janus, ed. *Man Ray: Tutti gli scritti*. Milan: Feltrinelli, 1981.

Naumann, Francis. "Man Ray: Early Paintings 1913-1916, Theory and Practice in the Art of Two Dimensions." *Artforum* 20, no. 9 (May 1982): 37-46.

Penrose, Roland. *Man Ray*. Boston: New York Graphic Society, 1975.

Ray, Man. *Self Portrait*. New York and London: Andre Deutsch, 1963.

Schwarz, Arturo. *Man Ray: The Rigour of Imagination*. New York: Rizzoli International Publications, 1977.

Wescher, Paul. "Man Ray as Painter." *Magazine of Art* 46 (January 1953): 31-37.

## Morgan Russell

Agee, William C. *Synchromism and Color Principles in American Painting*. New York: Knoedler, 1965.

Evans-Decker, Barbara. "Morgan Russell: A Re-evaluation." Master's thesis, State University of New York, Binghamton, 1973.

Levin, Gail. *Synchromism and American Color Abstraction, 1910-1925*. New York: Braziller, 1978.

*Morgan Russsell–An Exhibition in Memoriam*. New York: Rose Fried Gallery, 1953.

## H. Lyman Saÿen

Breeskin, Adelyn D. *H. Lyman Saÿen*. Washington, D.C.: Smithsonian Institution Press for the National Collection of Fine Arts, 1970.

———. *Pennsylvania Academy Moderns, 1910-1940*. Washington, D.C.: National Collection of Fine Arts, 1975.

d'Harnoncourt, Anne. "H. Lyman Saÿen (1875-1918)." In *Philadelphia: Three Centuries of American Art*, 502-4. Philadelphia: Philadelphia Museum of Art, 1976.

Scott, Wilford W. "The Artistic Vanguard in Philadelphia, 1905-1920." Ph.D. diss., University of Delaware, 1983.

## Morton Schamberg

Agee, William C. *Morton Livingston Schamberg.* New York: Salander-O'Reilly Galleries, 1982.

———. *Morton Livingston Schamberg: The Machine Pastels.* New York: Salander-O'Reilly Galleries, 1986.

———. "Morton Livingston Schamberg: Notes on the Machine Images." *Dada and Surrealism* (University of Iowa) 14 (1986).

Campbell, Lawrence. "Morton Livingston Schamberg: Review of Exhibition at Zabriskie Gallery." *Art News* 62 (January 1964): 14.

MacAgy, Douglas. "Five Rediscovered from the Lost Generation." *Art News* 59 (Summer 1960): 40.

McBride, Henry. "Posthumous Paintings by Schamberg." *New York Sun,* 25 May 1919, sec. 7: 12.

Pach, Walter. "The Schamberg Exhibition." *The Dial* 66 (May 17, 1919): 505-6.

Powell, Earl A. III. "Morton Schamberg: The Machine as Icon." *Arts Magazine* 51 (May 1977): 123.

Wolf, Ben. *Morton Livingston Schamberg.* Philadelphia: University of Pennsylvania Press, 1963.

## Alice Schille

Keny, James. *Alice Schille, A.W.S. (1869-1955).* Columbus, Ohio: Vose Galleries and Keny and Johnson Gallery, 1982.

Kuehn, Edmund. *Alice Schille Memorial Exhibition.* Columbus, Ohio: Columbus Gallery of Fine Arts, 2 April-3 May 1964.

Owings, Edna. "The Art of Alice Schille." *International Studio* 50, no. 198 (August 1913): 21-33.

*A Retrospective Exhibition of Portraits and Watercolors by Alice Schille.* Columbus, Ohio: Columbus Gallery of Fine Arts, 1-31 March 1932.

Stevens, George Washington. "Autobiography of Modern Artists," ca. 1910. Unpublished manuscript. George Washington Stevens Collection. Archives of American Art. Smithsonian Institution, Washington, D.C.

Wells, Gary. "Alice Schille: Painter from the Midwest." *Art & Antiques,* September-October 1973, 64-71.

## Charles Sheeler

Dochterman, Lillian. "The Stylistic Development of the Work of Charles Sheeler." Ph.D. diss., State University of Iowa, 1963.

Friedman, Martin. *Charles Sheeler.* New York: Watson-Guptill Publications, 1975.

Friedman, Martin, Bartlett Hayes, and Charles Millard. *Charles Sheeler.* Washington, D.C.: Smithsonian Institution Press for the National Collection of Fine Arts, 1968.

Rourke, Constance. *Charles Sheeler: Artist in the American Tradition.* New York: Harcourt, Brace & Co., 1938.

Stewart, Patrick L. "Charles Sheeler, William Carlos Williams, and the Development of the Precisionist Aesthetic." Ph.D. diss., University of Delaware, 1981.

Stewart, Rick. "Charles Sheeler, William Carlos Williams, and Precisionism: A Redefinition." *Arts Magazine* 58, no. 3 (November 1983): 100-114.

Williams, William Carlos. Introduction to *Charles Sheeler.* New York: Museum of Modern Art, 1939.

## Joseph Stella

Baur, John I. H. *Joseph Stella.* New York: Praeger Publishers, 1971.

Jaffe, Irma B. *Joseph Stella.* Cambridge, Mass: Harvard University Press, 1970.

Stella, Joseph. "Discovery of America: Autobiographical Notes." *Art News* 59 (November 1960): 41-43, 64-67.

Stella, Joseph. Papers. Archives of American Art. Smithsonian Institution, Washington, D.C.

Whitney Museum of American Art Papers. Archives of American Art. Smithsonian Institution, Washington, D.C.

Zilczer, Judith. *Joseph Stella: The Hirshhorn Museum and Sculpture Garden Collection.* Washington, D.C.: Smithsonian Institution Press for the Hirshhorn Museum and Sculpture Garden, 1983.

## Maurice Sterne

Martin S. Ackerman, ed. *Maurice Sterne Drawings.* New York: Arco Publishers, 1974.

Birnbaum, Martin. "Maurice Sterne." *International Studio* 46 (March 1912) (Supplement): 3-13.

Defries, A. D. "Maurice Sterne at Bali." *International Studio* 61 (April 1917) (Supplement): 53-55.

Kallen, H. M. *Maurice Sterne.* Exhibition catalogue. The Museum of Modern Art, 1933.

Kilmer, Joyce. "Interview with Maurice Sterne." *The New York Times,* 21 March 1915.

Stein, Leo. *Journey Into the Self.* New York: Crown Publishers, 1950.

———. "Tradition and Art." *The Arts* 7 (May 1925): 265-69.

Sterne, Maurice. "Cézanne Today." *The American Scholar* 22 (Winter 1952-53): 40-59.

———. *Shadow and Light.* Edited by Charlotte Leon Mayerson. New York: Harcourt, Brace & World, 1965.

## Tom Thomson

Murray, Joan. *The Art of Tom Thomson.* Catalogue. Toronto: Art Gallery of Ontario, 1971.

———. *The Best of Tom Thomson.* Edmonton: Hurtig, 1986.

Town, Harold, and David B. Silcox. *Tom Thomson.* Toronto: McClelland & Stewart, 1977.

## Allen Tucker

Gerdts, William H. *American Impressionism.* New York: Abbeville Press, 1984.

———. *Revealed Masters of 19th Century American Art.* New York: American Federation of Arts, 1974.

Lane, James W. "Vincent in America: Allen Tucker." *Art News* 38 (16 December 1939): 17-18.

Watson, Forbes. *Allen Tucker.* New York: Whitney Museum of American Art, 1932.

———. "Allen Tucker." *Magazine of Art* 32 (December 1939): 698-703.

## Abraham Walkowitz

Lerner, Abram, and Bartlett Cowdrey. "A Tape Recorded Interview with Abraham Walkowitz." *Journal of the Archives of American Art* 9 (January 1969): 72-83.

Mintz, Dale. *Abraham Walkowitz: New York Cityscapes*. Purchase, N.Y.: Neuberger Museum, 1982.

Sawin, Martica. *Abraham Walkowitz: 1878-1965*. Salt Lake City: Utah Museum of Fine Arts, 1975.

Smith, Kent. *Abraham Walkowitz: Figuration 1895-1945*. Long Beach, Calif.: Long Beach Museum of Art, 1982.

Walkowitz, Abraham. *A Demonstration of Objective, Abstract and Non-Objective Art*. Girard, Kansas: Haldeman-Julius, 1945.

## Max Weber

Cahill, Holger. *Max Weber*. New York: The Downtown Gallery, 1930.

Gerdts, William H. *Max Weber*. Newark: The Newark Museum, 1959.

Leonard, Sandra. *Henri Rousseau and Max Weber*. New York: Richard L. Feigen, 1970.

North, P. B. "Max Weber: The Early Paintings (1905-1920)." Ph.D. diss., University of Delaware, 1974.

North, Percy. *Max Weber: American Modern*. New York: The Jewish Museum, 1982.

Scott, Temple. "Fifth Avenue and the Boulevard St. Michel." *Forum* 44 (July/December 1910): 665-85.

Werner, Alfred. *Max Weber*. New York: Harry N. Abrams, 1975.

## E. Ambrose Webster

*E. Ambrose Webster, 1869-1935. A Retrospective of Paintings*. New York: Babcock Galleries, 1965.

Kuchta, Ronald A., ed. *Provincetown Painters 1890's-1970's*. Syracuse, N.Y.: Everson Museum of Art, 1977.

Moffett, Ross. *Art in Narrow Streets: The First Thirty-Three Years of the Provincetown Art Association*. Falmouth, Mass.: Kendall Printing Company, 1964.

## Marguerite Zorach

Tarbell, Roberta K. "Early Paintings by Marguerite Thompson Zorach." *American Art Review* 1 (March-April 1974): 43-57.

———. *Marguerite Zorach*. Washington, D.C.: Smithsonian Institution Press for the National Collection of Fine Arts, 1973.

## William Zorach

Tarbell, Roberta K. *Catalogue Raisonné of William Zorach's Carved Sculpture*. Ph.D. diss., University of Delaware, 1976.

Zorach, William. *Art Is My Life*. New York and Cleveland: World Publishing Co., 1967.

# Notes on Contributors

**William C. Agee** received an A.B. from Princeton (1960) and a master's degree from Yale University in 1963. From 1974 to 1982 he was director of the Museum of Fine Arts, Houston. He has organized several exhibitions related to the subject of this exhibition, including *Synchromism and Color Principles in American Painting* (1965), *Patrick Henry Bruce* (1979), *Morton Livingston Schamberg* (1982), and *Ralston Crawford* (1983).

**Ruth Ann Appelhof** is Curator of Paintings, Sculpture, and Graphic Arts at the Birmingham Museum of Art. She formerly held the position of Curator of Exhibitions at the Joe and Emily Lowe Art Gallery of Syracuse University. She received an M.Ph. in Humanities from Syracuse University in 1980, and is currently completing her Ph.D. dissertation on Emily Carr and her place in North American modernism.

**Louise Dompierre**, formerly Associate Curator at the Agnes Etherington Art Centre in Kingston, is now Curatorial Coordinator at the Art Gallery at Harbourfront in Toronto, Ontario. She is curator of the exhibition *John Goodwin Lyman 1886-1967*, which is travelling in Canada during 1986. She received her master's degree in Canadian Studies in Art History from Carleton University in Ottawa.

**Betsy Fahlman** is Assistant Professor of Art History at Old Dominion University, Norfolk, Virginia. She has written extensively on early modernism. She organized the 1983 exhibition *Pennsylvania Modern: Charles Demuth of Lancaster* at the Philadelphia Museum of Art.

**Sidney Geist** is a former faculty member of the Pratt Institute and Vassar College. A sculptor and critic, he has been honored with the Olivetti Award, the Silvermine Guild, and a Guggenheim Fellowship (1975-76). He has published *Brancusi: a Study of the Sculpture* (1968), *Constantin Brancusi: A Retrospective Exhibition* (1969), *Brancusi: Sculpture and Drawings* (1975), and *Brancusi: The Kiss* (1978).

**Jeffrey R. Hayes** is Assistant Professor of Art History at the University of Wisconsin-Milwaukee. He received his Ph.D. from the University of Maryland in 1982, and has lectured and published on early 20th century painters Maurice Prendergast, Jennings Tofel, and Vincent Canadé. He is currently writing a monograph entitled *Oscar Bluemner and the Modern Landscape*.

**Judy L. Larson** is Curator of American Art at the High Museum in Atlanta. She recently completed a catalogue raisonné of American copperplate engravings before 1820, sponsored by the NEH through the American Antiquarian Society in Worcester, Massachusetts. She organized the exhibition *American Illustration 1890-1925: Romance, Adventure and Suspense* from the collection of the Glenbow Museum in Calgary, Canada. That exhibition will travel in the United States and Canada in 1986-88.

**Gail Levin** received her M.A. from Tufts (1970) and her doctorate from Rutgers University in 1976. Formerly on the faculty of Connecticut College and the City University of New York, she has served as a guest curator at the Museum of Modern Art and the Tate Gallery. From 1976 to 1984 she was curator of the Hopper Collection at the Whitney Museum of American Art. Currently, in addition to being a free-lance curator and photographer, she teaches in the design department at Drexel University and is producer and host of *Art at Issue* on Manhattan Cable Television.

**Joan Murray** is the Director of the Robert McLaughlin Gallery in Oshawa, Ontario. From 1970 to 1973 she was Curator of Canadian Art at the Art Gallery of Ontario, serving as Chief Curator in 1973. Along with lecturing at universities and galleries in the United States, Canada, and England, Murray has organized many exhibitions, including *Painters Eleven in Retrospect*, *A Terrible Beauty: The Art of Canada at War*, and *The Vision of William Kurelek*. She is the author of six books, including *The Best of the Group of Seven*.

**Nick Madormo** is working on a dissertation at The Graduate School of the City University of New York on the career of Alfred Maurer between the years 1897 and 1914. He is Research Assistant on the Maurice and Charles Prendergast Systematic Catalogue Project at Williams College.

**Peter Morrin** has been Curator of 20th Century Art at the High Museum of Art since 1979. Relevant to this exhibition was his work at the Vassar College Art Gallery on the exhibition *Woodstock: An American Art Colony, 1907-1977*.

**Francis Naumann** is an instructor of Art History at the Parsons School of Design, New York. He is an author of *The William and Mary Sisler Collection*, published by the Museum of Modern Art, and his articles on the Dada movement and American art have appeared in *Artforum*, *Archives of American Art Journal*, *Arts Magazine*, and *Art Bulletin*. He is preparing a monograph on Marcel Duchamp and a book on Man Ray's early work.

**Percy North** is Visiting Professor of Art History at James Madison University. She has been a faculty member of George Mason University and Fulbright professor at Université Lyon II. She was guest curator for the exhibition *Max Weber: American Modern* at the Jewish Museum in Manhattan. Her published works on Weber include "Alexander Calder, Paul Manship, Ethyl Myers, Max Weber," in Elizabeth Hawkes's *American Painting and Sculpture* (1975), "Max Weber" in *Arts* (1981), and "Turmoil at '291'" in the *Archives of American Art Journal* (1984). She organized the 1984 exhibition *Into the Melting Pot: Immigration of American Modernism* at the Muscarelle Museum of the College of William and Mary.

**John O'Brian** is a Teaching Fellow in the Department of Fine Arts at Harvard University. He is the author of a monograph on David Milne (1983) and a catalogue on the Maurice Wertheim Collection of late 19th and early 20th century European art (forthcoming) for the Fogg Art Museum. For the University of Chicago Press he is editing the collected essays and criticism of Clement Greenberg. Among the exhibitions he has organized are *David Milne: The New York Years*, Edmonton Art Gallery (1981), and *Cézanne and Cubism*, Fogg Art Museum (1983).

**Gwendolyn Owens** is Curator of Painting and Sculpture at the Herbert F. Johnson Museum of Art at Cornell University, Ithaca, New York. She has published many articles and catalogues, including *The Water Colors of David Milne: A Survey Exhibition* (1984) and *Watercolors by Maurice Prendergast from New England Collections* (1978).

**Patricia E. Phagan**, Researcher at the High Museum of Art, is a doctoral candidate in Art History at the City University of New York Graduate Cultural Center. Besides doing research for Jimmy Ernst's *A Not-So-Still Life* (1983), she has written several articles and essays on early 20th century art, notably on Giacometti's first U.S. exhibition, in *Alberto Giacometti and the United States* (1984), and the title essay for the exhibition catalogue *George Bellows: The Personal Side* (1984).

**Patrick Stewart** is Chairman of American Painting and Decorative Arts at the Dallas Museum of Art. He earned his Ph.D. at the University of Delaware and was formerly an Assistant Professor of Art History and American Studies at Williams College. He has organized many exhibitions, including *Frederick Edwin Church: Painter of a New World Vision* (1985) and *Lone Star Regionalism: The Dallas Nine and Their Circle* (1985). He is currently working on an article entitled "Charles Sheeler: The Fortune Series."

**Roberta K. Tarbell**, Assistant Professor of Art History at Rutgers University, has just completed a book on 20th-century American sculpture for Yale University Press (co-authored with Joan M. Marter). She has published extensively on both Marguerite and William Zorach. Her discovery of five previously unknown Post-Impressionist paintings by Marguerite Zorach led to a re-evaluation of that artist's oeuvre in an exhibition and catalogue by the Smithsonian Institution.

**Diane Tepfer**, a former Smithsonian Fellow at the National Museum of American Art, has served on the faculties of Oberlin College and Colby College (Waterville, Maine). She has been a consultant to the reference work *American Art Analog* (1986). She is working on a dissertation on Edith Gregor Halpert's Downtown Gallery (1926-1970).

**Barbara Wolanin** holds degrees from Oberlin College and Harvard University, and received her Ph.D. from the University of Wisconsin-Madison. She is currently preparing a monograph and catalogue raisonné on the works of Arthur B. Carles. She organized *Arthur B. Carles: Painting with Color*, an exhibition for the Pennsylvania Academy of Fine Arts. Dr. Wolanin is Curator for the Office of the Architect of the U.S. Capitol.

**Judith Zilczer**, art historian and curator, received her B.A. (1969) and her M.A. (1971) from George Washington University. In 1975 she earned a doctorate in Art History from the University of Delaware. Her awards include a Smithsonian Institution Predoctoral Fellowship (1973-74) and a Penrose Postdoctoral Research Grant from the American Philosophical Society (1976-77). She is the author of many articles, exhibition catalogues, and the book *"The Noble Buyer": John Quinn, Patron of the Avant-Garde* (1978).